Treasures from the National Museum of American Art

Publication made possible by United Technologies Corporation

William Kloss

Treasures from the National Museum of American Art

National Museum of American Art

Smithsonian Institution Press, Washington and London 1985

This publication and accompanying exhibition have been organized
by the National Museum of American Art and made possible by
the generosity of United Technologies Corporation.

Seattle Art Museum, Washington: 20 February–13 April 1986

The Minneapolis Institute of Arts, Minnesota: 17 May–13 July 1986

Cleveland Museum of Art, Ohio: 13 August–5 October 1986

Amon Carter Museum, Fort Worth, Texas: 7 November 1986–4 January 1987

The High Museum of Art, Atlanta, Georgia: 3 February–29 March 1987

National Museum of American Art, Smithsonian Institution, Washington, D.C.: 8 May–7 June 1987

Library of Congress Cataloging-in-Publication Data

National Museum of American Art (U.S.)
 Treasures from the National Museum of American Art.

 Supt. of Docs. no.: SI 6.2:T71
 1. Art, American—Catalogs. 2. Art—Washington (D.C.)—Catalogs.
3. National Museum of American Art (U.S.)—Catalogs. I. Kloss, William. II. Title.
N6505.N3 1985 709′.73′0740153 85-61846
ISBN 0-87474-594-2
ISBN 0-87474-595-0 (pbk.)

Hardcover and paperback editions are available in the United States from
Smithsonian Institution Press, P.O. Box 4866, Hampden Station, Baltimore, Maryland 21211.

Designed by Derek Birdsall RDI

Typeset in Monotype Van Dijck and printed on Parilux cream art
in England by Balding + Mansell Limited. The paper used in this publication
meets the minimum requirements of the American National Standard for
Permanence of Paper for Printed Library Materials. Z39.48-1984

Photography by Michael Fischer, assisted by Marty Curry, Marianne Gurley,
Margaret Harman, and Edward Owen

Cover: *Young Omaha, War Eagle, Little Missouri, and Pawnees* Charles Bird King (see plate 10)

This book is the catalog for an exhibition of paintings and sculptures from the world's largest collection of works by American artists – in effect, the American people's collection.

The exhibition will be shown in six major cities across the United States and will give thousands of Americans their first look at an unusually rich, creative heritage.

We are pleased to support the exhibition *Treasures from the National Museum of American Art*, and to have helped with this catalog. We hope both stir pride and give pleasure wherever they are seen.

Robert F. Daniell
President and Chief Executive Officer
United Technologies Corporation

Foreword

When John Varden decided in 1829 that the Republic's rude capital beside the Potomac needed some of the cultural amenities that abounded in European and even some American centers, he established a National Institute to collect, preserve, and display the products of man's creative genius. He could not have foreseen the dramatic changes that would advance his modest initiative: James Smithson's bequest to the American nation and the subsequent absorption of the National Institute into the Smithsonian Institution, which today makes of once-rude Washington one of the world's greatest museum centers. More than a century and a half after Varden's enterprise, his intent to collect, preserve, and display the evidence of his country's creative aspirations is still the central mission of the Smithsonian's National Museum of American Art, heir to the fledgling National Institute.

The museum's name delineates its unique role among kindred institutions in the United States. *National* distinguishes it from those collections whose focus is more regional or parochial: the museum comprises all aspects of the country's rich and diverse tradition of visual creativity, from colonial to contemporary times. Major centers of art are well represented, but complementing these holdings are important examples by less familiar talents, many of whom worked outside the traditional urban mainstreams of art. In its special exhibitions and publications, as in its collection, the museum is as likely to explore artistic activity in New Mexico as New York, Chattanooga as Chicago or Los Angeles.

As a *National Museum*, the institution undertakes a range of activities beyond the acquisition and display of art. Static galleries would yield limited insight; hence, the museum conducts an ambitious program of temporary exhibitions that enhance and supplement the permanent collections. In addition, behind-the-scenes activities, such as conservation, research, and publication, are an essential aspect of this "full-service" museum. Visiting scholars complement the work of resident curators and staff; and through the Smithsonian Institution's Grants and Fellowships Program, the museum has become a lively center of investigation into the history and practice of the visual arts in America. The museum's national mandate is realized through projects far from Washington, as well as in the capital. Circulating exhibitions, special catalogues and other publications, video documentaries for public broadcast, and model education programs that support curricular instruction are part of its nationwide services. Unseen by most of the public, but essential to nearly all research programs in American art, are the museum's special visual archives and computerized indices, documenting hundreds of thousands of works of art. It is this type of fundamental support for scholarship and the museum profession that has traditionally distinguished the national mission of this Smithsonian collection.

The *American* aspect of the museum's collections and programs evolved gradually. The original National Institute was a cultural miscellany, studded with optimistically attributed Old Masters. Only in the early decades of this century did the

holdings take on the distinctly American note that was formally recognized with a change of name, by act of Congress, in 1980. Today the museum's domain encompasses the work of American men and women done here or abroad, as well as art produced by European, Asian, and other visitors to this country.

The *Art* acquired by the museum represents more than two hundred fifty years of painting, sculpture, drawing, printmaking, photography, and decorative arts. The total holdings – over 32,000 works – make the National Museum of American Art the largest as well as the oldest public collection of its type in the world.

For the coming decade and the new century, we envision the continuation of the institution's basic mission: the collection and preservation, research and presentation of America's artistic heritage. Coupled with other Smithsonian holdings of this country's creative achievement, the National Museum of American Art hopes to continue to play a central role as the premier center for the study and enjoyment of the nation's visual history.

This volume provides but a glimpse of the museum, the proverbial tip of the iceberg. Despite the obvious hazards of representing the riches and diversity of a large and historic collection in so relatively few selections, we hope that the reader will be intrigued by these treasures and moved to further exploration.

For their exceptional help and generosity in the preparation of this book and the related exhibition, I am most grateful to United Technologies Corporation. Without their fine support, and especially the faithful encouragement and generous interest of Gordon Bowman and Marie Dalton-Meyer, the venture could not have been realized. To William Kloss, for his insightful commentary on the works in the publication, and to Derek Birdsall, who designed the volume with his customary care and artistry, go my special thanks. A project of such scope and duration invariably involves nearly every aspect of museum life, and to my many colleagues whose contributions helped insure the successful completion of the project, I owe a sincere debt of gratitude. They feel the same delight as I do in sharing these treasures from the National Museum of American Art with people far and wide.

Charles C. Eldredge
Director

The opportunity to write a book describing the treasures of the National Museum of American Art was first held out to me by Barbara Shissler Nosanow, assistant director for museum programs. To her and to Chief Curator Elizabeth Broun and Director Charles C. Eldredge I am grateful for the confidence placed in me to undertake this large project. Dr. Broun and Dr. Eldredge read the manuscript and made detailed, thoughtful, and challenging criticisms and suggestions. They often saved me from error and caused me to rethink old assumptions.

Anne Timpano had the unenviable responsibility of coordinating the many aspects of the book's production, and she has discharged it with unfailing courtesy and efficiency.

William H. Truettner shared his deep knowledge of the collections with me, introduced me to curatorial files, and guided me to valuable resources of which I would otherwise have remained ignorant. Virginia M. Mecklenburg was of great help with the modern collection, both in terms of reference materials and stimulating conversations.

I am also grateful to W. Robert Johnston, the museum's registrar, and his staff. I would especially like to acknowledge Thomas W. Bower, assistant registrar for the permanent collections, for his practical assistance in studying works in storage and for his valuable comments regarding the works of art in his particular care. Lenore F. Gershuny in the registrar's office and Susanne O. Koenig in the curatorial office supplied me, on short notice and amidst hectic schedules, with museum records concerning the art works featured here.

I have been most fortunate in having the editorial guidance of Gaye L. Brown. She has been both demanding (not dogmatic) and flexible (not laissez-faire), and at all times a pleasure to work with. Sara C. Faulkner, her assistant, organized the randomly submitted texts and diligently entered the editorial changes, and Deborah D. Bennett was of aid in proofreading.

I am indebted to Dr. Lois M. Fink, research curator, for her knowledge of the history of the museum and her willingness to review the introduction. The Office of Research Support has supplied photographs for my reference. Aid in the use of computer resources was supplied by James Yarnall and Katharine L. Fox. For repeated help, cheerfully given, I wish to thank Margy L. Sharpe. Outside the museum, my deepest appreciation goes to Charles Timbrell for valuable criticism and invaluable support.

I would like to dedicate this text to Ellen H. Johnson, professor emeritus, Oberlin College, to whom I owe my first experience and lasting love of American art and much else besides; and to Harry Lowe, successively curator of exhibits, assistant director, acting director, and now deputy director emeritus of this museum, for whose professional counsel and personal courtesy and concern over many years I remain indebted.

William Kloss

Introducing the National Museum of American Art

The National Museum of American Art is a long-established institution with a relatively new name. The new name is the latest step in defining the intent and parameters of the oldest of the national art collections. Long without a permanent home, the collection is now elegantly installed in an architectural landmark – the old United States Patent Office Building – in which, ironically, some of the first paintings in the collection were displayed in the mid-nineteenth century.

The City of Washington, District of Columbia, was scarcely thirty years old when in 1829 an optimistic citizen named John Varden took it upon himself to begin a collection that would lend a patina of culture to the still-raw capital. By 1836 he had opened a public gallery in his home, enabling people to ponder a melange of historical, natural, and artistic curiosities altogether typical of the age. His efforts were seconded between 1816 and 1838 by the Columbian Institute for the Promotion of Arts and Sciences, which acquired a few works for exhibition. Then in 1840 a more ambitious organization was created. First called the National Institution for the Promotion of Science, it was incorporated in 1842 as the National Institute. Those objects not already dispersed from the defunct Columbian Institute were combined with John Varden's substantial holdings, and Varden himself became "curator" of the new collection. From 1841 it was installed on the top floor of the first completed wing of the new Patent Office Building rising grandly from the new city's mud. The quasi-official status suggested by the name of the new society and its location was underscored by the fact that its first president was Joel R. Poinsett, then secretary of war. Moreover, the act of incorporation provided that when the charter expired, the collection would become federal property.

In 1846 Congress passed legislation establishing the Smithsonian Institution with the bequest of the Englishman James Smithson. Its building, the now-familiar "Castle on the Mall," included two galleries for the exhibition of art; and in 1858 the paintings, sculpture, and other art objects in the National Institute were transferred to the Smithsonian Building, followed by the rest of the collections when the National Institute was disbanded in 1862. In addition to carved and painted portraits of important persons, there were a number of European "Old Master" paintings, optimistically attributed to those artists most admired in the period. They included gifts and loans from generous citizens.

But the largest and most significant early addition to this random accumulation were the more than three hundred paintings of Indians and Indian subjects by Charles Bird King and John Mix Stanley. King's works had been commissioned by the Department of War and thus belonged to the government. Stanley's were on loan until such time as the government should authorize their purchase. Tragically, they were virtually all destroyed by a fire that swept through the second floor of the Castle on 24 January 1865.

Following this disaster, in 1874 and 1879 the Regents of the Smithsonian deposited many of the art works in William Wilson Corcoran's new public gallery, and the national art collection fell prematurely dormant. The strongly scientific bent of the young institution tacitly buttressed this neglect, and despite intermittent urgings to recall and exhibit the art, only the happy legacy of a well-connected patron effected a change of policy.

Harriet Lane Johnston was the niece of James Buchanan and had served as official hostess in the White House during the incumbency of the bachelor president (1857–61). Mrs. Johnston's small art collection would not have attracted much attention had she not bequeathed it in 1903 to a "national gallery of art," which did not yet exist.

This posthumous prodding came on the heels of a remarkable proliferation of museums in the three decades after 1870. In addition to the Corcoran Gallery in Washington, those years saw the founding of the Metropolitan Museum of Art in New York, the Museum of Fine Arts in Boston, the Pennsylvania Museum (later the Philadelphia Museum of Art), the Art Institute of Chicago, and the M.H. de Young Museum of San Francisco. Spurred by the ambition to emulate and rival European culture and collections, and enabled by vast fortunes in industry and finance, American men and women undertook the formation of private collections that were ultimately destined to enrich (or become) the new public museums of the nation.

The Johnston bequest reawakened the Smithsonian Institution's interest in art, and in 1906 a federal court ruled that the 1846 legislation establishing the institution also constituted it as a National Gallery of Art, under which name the art collections were now officially gathered. The appellation held for thirty-one years, during which the collections of the museum were greatly increased. Understandably, donors were attracted by the prestigious name of the collection, the more so since they were able to decisively shape its character through their gifts. Thus Ralph Cross Johnson and his daughter, Mabel Johnson

Langhorne, left a considerable collection, primarily of European paintings, to the gallery beginning in 1919. This reflected the prevailing devotion to European art among American patrons.

In contrast, the lifetime gifts of William T. Evans, beginning in 1907, constituted an extraordinary legacy of late-nineteenth and early-twentieth-century American art. A second source of American art was established in 1916. This was the Henry Ward Ranger Fund, administered by the National Academy of Design. Ranger, himself a landscape artist whose works were collected by Evans, intended his unusual and complicated bequest to be used to purchase paintings by American artists through the National Academy, which would then distribute those paintings to public museums throughout the country. They would remain in those museums until and unless the National Gallery of Art should exercise its option to recall them during a five-year period beginning ten years after the individual artist's death. This advocacy of American contemporaries was shared by John Gellatly, on balance the most important of the museum's early patrons. With his generous gift of 1929, Gellatly put his indelible stamp on the collection through the range and perspicacity of his taste.

Unlike Evans, Gellatly also bought European, Oriental, and ancient art, with the intention of demonstrating the high level of our native art by comparing it with the work of other cultures and periods. The non-American art in his collection, however, was heavily weighted toward *objets d'art*, while paintings dominated the American portion. Like Evans, Gellatly for the most part was buying with the knowledge that his collection would reside in the National Gallery.

John Gellatly was devoted to certain artists and purchased large numbers of their works. Both Abbott Thayer and Thomas Dewing were so favored, as were Childe Hassam and John Twachtman; but the palm went to Albert Pinkham Ryder, seventeen of whose haunting paintings came to the museum through the agency of Gellatly. These remarkable groupings remain one of the unusual and important features of the collection today.

During this period of rapid growth of the collections, the problem of a suitable home for them remained unresolved. From 1906 they were given space in the second Smithsonian museum to be built, the 1881 Arts and Industries Building (then called the U.S. National Museum Building). In 1910 they moved to a long, skylit hall actually designed for their exhibition in the Natural History Building, where, though quickly outgrowing the space, they remained for fifty-eight years.

During that timespan, two independent structures were designed for the art collection but, due to insufficient funds, remained unbuilt. The designation of the National Gallery as a separately administered bureau of the Smithsonian in 1920 precipitated the first design, which was destined for the space between the Natural History Building and Seventh Street. The plans were submitted in 1925 by Charles A. Platt, whose much-admired Freer Gallery of Art had recently opened.

The second design was the result of radically changed circumstances in the museum's identity. In 1937 former Secretary of the Treasury Andrew Mellon gave the nation his collection, primarily of Old Masters, and the money to build a vast museum on the Mall, provided it be called the National Gallery of Art, in emulation of its inspiration in London. With no perceptible hesitation, Congress accepted the gift and the stipulation, and the Smithsonian's art collection was once again renamed. Now called the National Collection of Fine Arts, it had lost neither purpose nor supporters. Whereas the *new* National Gallery of Art explicitly excluded the work of living artists, the Smithsonian collection was especially rich in this area. In 1847 a Smithsonian Regents' committee had already expressed the desire to cooperate with artists' associations in exhibiting "the best results of talent" among living artists, and that desire was particularly strong among supporters of the New Deal art projects of the 1930s. The redefinition of the aims of the National Collection of Fine Arts that followed from the events of the late thirties thus resulted in increased emphasis on the acquisition and exhibition of American art. The European holdings – from the collections of Harriet Lane Johnston, Ralph Cross Johnson, and John Gellatly – would henceforth see little or no increase.

Congress proposed that the National Collection of Fine Arts be enlarged and its programs expanded as a Smithsonian Gallery of Art, and an architectural competition was held for the long-desired, independent museum building. The winner of this competition was the team of Eliel and Eero Saarinen and Robert Swanson. Their 1939 design would unquestionably have resulted in one of the most modern and functional museum structures in the United States. A conservative Commission of Fine Arts rejected the design, however, and thus the newly christened National Collection of Fine Arts remained in its long hall in the Natural History Museum until 1968.

The critical shortage of exhibition and storage space discouraged an active acquisition program, hence between 1940 and 1960 relatively little of importance entered the collection. Then, in 1957, came a Congressional bill to demolish the Old Patent Office Building, occupied by the Civil Service Commission, in favor of a parking garage. The winds of historic preservation were blowing, and the Eisenhower administration joined the chorus of opposition to the proposal. Instead, in 1958 the great Greek Revival structure was turned over to the Smithsonian Institution for the National Collection of Fine Arts. Although it was four years before the building was vacated and six more before it could be restored and refurbished for its new purpose, a permanent home for the collection was at last in view. In 1962 it was decided to create a new National Portrait Gallery, which, though a separate entity, would also be housed in the Old Patent Office.

* * *

It is appropriate to pause here to examine the history of the remarkable building, which celebrates the 150th anniversary of its inception in 1986. The site of the Patent Office was reserved on Pierre L'Enfant's capital city plan for a national church or, alternatively, a national mausoleum or pantheon for the country's heroes. Instead, it was destined to receive a fireproof replacement for the patent office destroyed by fire in 1836. This substitution says something about the nature of the American republic during its first century. As Mark Twain put it,

The popes have long been the patrons and preservers of art, just as our new, practical republic is the encourager and upholder of mechanics. In their Vatican is stored up all that is curious and beautiful in art; in our Patent Office is hoarded all that is curious or useful in mechanics. . . . We can make something of a guess at a man's character by the style of nose he carries on his face. The Vatican and the Patent Office are governmental noses, and they bear a deal of character about them. (The Innocents Abroad, 1869)

On the other hand, the fact that a portion of the Patent Office Building served from the outset as an exhibition hall for art, and that it is today entirely devoted to that purpose, attests to the complexities of national character and the ironies of history.

The erection of the massive structure involved several architects and consumed thirty years. William Parker Elliot was the young architect whose design was approved on the Fourth of July 1836. Robert Mills was the supervising architect on the project. Mills was a very busy man in Washington at the time, involved in either a design or supervisory capacity on the United States Capitol and the Treasury Building (and a few years later the Post Office), in addition to the Patent Office. Mills's primary engineering contribution to the building lay in his introduction (in the south wing) of masonry vaults to shield the wooden roofs in the event of fire. His primary aesthetic contributions were the elegant, cantilevered, curving double staircase leading to the top floor and, above all, the elegant elevation of the magnificently proportioned hall (now the Lincoln Gallery) on the top floor of the east wing. Thomas U. Walter, who was soon to undertake the new dome and House and Senate wings of the Capitol, oversaw the construction of this great hall; he introduced iron tie rods to reinforce the masonry vaults and replaced the wooden roofs with fireproof materials. Although only begun in 1849, this wing was finished by 1852.

Next came the west wing, where Walter introduced iron vaults, iron trusses, and an iron ceiling in an ongoing attempt to prevent destruction by fire. (The disastrous burning of the Library of Congress in 1851 gave the goal new urgency.) This wing was completed by 1856 and the north wing immediately begun. A new architect, Edward Clark, was employed there, and he capped the rush to iron construction by devising floors made of iron beams with segmental brick arches between them. The Civil War delayed final completion of the north wing (the entrance steps) until 1867. Despite the intense preoccupation with fire prevention, a great conflagration did break out in 1877, destroying the roofs and interiors of the iron west and north wings, while sparing the masonry and wood construction of the south wing.

The sandstone, granite, and marble used in the construction was all native, much of it from Virginia and Maryland quarries. The building's variation on the Greek Revival style — pedimented colonnades of Doric temples centered as porticoes on the long wings — had already been introduced into American architecture, notably in Philadelphia, but never on such a mammoth scale. The almost simultaneous appearance of the Patent Office, the Treasury, and the Post Office in an unpopulous and unpaved city provoked some bemused responses. "Public buildings that

need but a public to be complete," was Charles Dickens's summation, while to Henry Adams's freer fancy they were "like white Greek temples in the abandoned gravel-pits of a deserted Syrian City."

Throughout the Civil War, the City of Washington served as headquarters and hospital. At times the Union wounded were billeted even in the Capitol, and the Patent Office Building also became a hospital. In this "noblest of Washington buildings" Walt Whitman described "a curious scene, especially at night when lit up. The glass cases, the beds, the forms lying there, the gallery above, and the marble pavement under foot – the suffering and the fortitude to bear it in various degrees – occasionally, from some, the groan that could not be repress'd." There, among the symbols of creativity, Whitman witnessed frightful suffering and death, as he spent uncounted hours comforting the soldiers.

In 1865 Whitman revisited the building on the occasion of Lincoln's second inaugural ball, a splendid spectacle. The guests entered up the monumental steps, through the south portico, and from there up the curving staircase to the top floor, where they promenaded through the vaulted east wing, danced in the north wing, then dined in the west wing.

I could not help thinking, what a different scene they presented to my view a while since, fill'd with a crowded mass of the worst wounded of the war, brought in from second Bull Run, Antietam, and Fredericksburgh. To-night, beautiful women, perfumes, the violins' sweetness, the polka and the waltz; then the amputation, the blue face, the groan, the glassy eye of the dying, the clotted rag, the odor of wounds and blood.

* * *

In the 1960s, with the knowledge that a large and permanent museum building was in the offing, the administration of the National Collection of Fine Arts turned its attention to the conservation and cataloguing of the collection and an active program of acquisitions. From its establishment as a separate Smithsonian bureau in 1920 until the end of the Second World War, the museum had had two directors, William Henry Holmes (1920–32) and Ruel P. Tolman (1932–48). They had administered the heterogeneous collections as best they could with limited space and money during a period of varying congressional expectations and a change of name. Holmes, an accomplished painter as well as an anthropologist, made a distinguished contribution as illustrator with the Hayden expeditions to the Colorado Territory, and with the watercolors that filled the journals in which he recorded his own later expeditions. Tolman, also an artist, was responsible for acquiring most of the more than three hundred American miniatures owned by the museum.

The first post-war director, Thomas M. Beggs (1948–64), was instrumental in arranging the distinctive gift to the institution of the Alice Pike Barney Collection and Barney Studio House by her daughters. David Scott, who had overseen planning for the museum's eventual move to the Patent Office Building, was director (1964–70) during the strenuous and critical period of renovation of the building and preparation of the art collections for transfer and reinstallation. A vigorous program of collection expansion began during these same years, and the list of works officially accessioned in 1968, when the museum reopened, is imposing.

The emphasis on American art that had long been implicit in the museum's collections had steadily increased, clarified and focused by the need to distinguish it from the new National Gallery of Art. Now, with the move to its own home, the National Collection of Fine Arts was specifically defined as a museum of American art, although a selection of the finest non-American works in the collection was also to be exhibited. Under the directorship of Joshua C. Taylor (1970–81), an enlarged curatorial staff was able to devote scholarly scrutiny to the permanent collection and to special exhibitions properly documented by publications. Taylor, a noted scholar and educator, drew wider attention to the museum. As its goals and identity became evident, a final change of name, which would unequivocally convey its role to the public, was decided upon. Thus in 1980, by act of Congress, the museum was re-christened the National Museum of American Art. Harry Lowe, formerly assistant director, became acting director after Taylor's death and assured the continuity of the museum's evolution. Charles C. Eldredge, director since 1982, has confirmed the identity of the National Museum of American Art in the museum's acquisitions and exhibitions programs. The rich American holdings of the museum can now be seen properly, as a unit, for the first time.

The accelerated growth of the collection that began in the

1960s included major donations, among them the following: more than one hundred twentieth-century paintings from S.C. Johnson and Son, Inc.; more than one hundred fifty sculptures by Paul Manship, long-time chairman on the Smithsonian's Commission on American Art, from the artist; an equal number of sculptures by William Zorach, from the artist's children; the most important collection of the paintings and drawings of Romaine Brooks, from the artist; the complete work of Lyman Saÿen, from his daughter, Ann Saÿen; one hundred seventy-seven paintings by William H. Johnson, from the Harmon Foundation; ninety-six objects plus studio effects of Joseph Cornell; the Martha Jackson Memorial Collection, more than one hundred works by artists associated with her gallery, from Mr. and Mrs. David K. Anderson; the Sara Roby Foundation Collection of one hundred sixty-nine works of twentieth-century art; and three hundred eleven works commissioned for the Collection of the Container Corporation of America.

In 1968 the museum acquired the sculptural contents of Hiram Powers's nineteenth-century studio in Florence, Italy, which had been preserved largely intact. Transfer arrangements have also enriched the collection. Hundreds of works created under various New Deal programs have been and continue to be assigned; and since 1972 the General Services Administration has transferred sculpture studies, paintings, and other preparatory works from its Art-in-Architecture program for federal buildings. More recently, the museum has received a major group of photographs that are related to projects in the Visual Arts Program, funded by the National Endowment for the Arts. In addition, the National Museum of African Art transferred more than two hundred works by Afro-American artists to the museum.

In addition to the main museum building, two other structures are part of the National Museum of American Art. The Renwick Gallery, near the White House, is designated for craft and design exhibitions. Built as the first Corcoran Gallery of Art, it was designed by James Renwick, architect of the Smithsonian Castle, for whom it is now named. Barney Studio House was built on Sheridan Circle early in the century by socialite and painter Alice Pike Barney to fulfill her desire for a salon-like setting reminiscent of her Paris years. Given by her daughters to the Smithsonian in 1960, the house has been restored and is the occasional setting for musical and literary events as well as small exhibitions.

In 1984 Congress approved the transfer to the Smithsonian of Robert Mills's Old Post Office Building, which faces the south facade of the Patent Office. As venerable as its neighbor, it will eventually become another museum building, to be shared by the Archives of American Art, the National Portrait Gallery, and the National Museum of American Art.

The historic heart of Washington's downtown has become a vital center of art in the capital, just as it was in the early nineteenth century. There the National Museum of American Art, its purpose and its name unequivocal, stands in confident affirmation of its once-and-future role in the history of American art and museums.

I

Robert Feke (1707–1752)
Thomas Hopkinson 1746
oil on canvas
126.5 × 100.5 cm
George Buchanan Coale Collection

Although the pose is a stock one derived from engravings of
seventeenth-century European paintings, Feke invests this
portrait with an architectonic power that surpasses the more
decorative linearity of most of his contemporaries. His Thomas
Hopkinson is presented with a columnar trunk, pyramidal
spread of arms, and clean-cut curve of his open coat, all played
against rectilinear architecture.

The artist is capable of subtleties as well. The rich palette
is one of his happiest, with the high pink complexion of the
sitter's face in warm harmony with the chestnut maroon glow
of his outer coat and resonant blue of his long vest. The softly
textured, steel gray wig provides a gentle elision between the
wall and cypress trees. Highlights are surely and imaginatively
handled, as on the long left lapel of the coat. The horizontal
creases of his vest above the pocket echo the fingers pressed
against it.

Strength of bearing is a characteristic of Feke's male
portraits, and that of Thomas Hopkinson is no exception.
The spread arms with hands firmly placed, the coat pulled
open with the gesture, the sword hilt visible beneath his coat
at the right – all suggest a decisive personality. That was,
in fact, the case.

Thomas Hopkinson, born in London in 1709, arrived in
Philadelphia at age twenty-two and rose rapidly to a position
of eminence in that intellectual metropolis. A distinguished
jurist and natural scientist, Hopkinson was elected the first
president of the American Philosophical Society. It was at
this apogee of his career, when only thirty-seven years old,
that Feke painted him. He died young, in 1751. His son,
Francis, an equally notable figure in the intellectual life of the
colonies, was a signer of the Declaration of Independence.

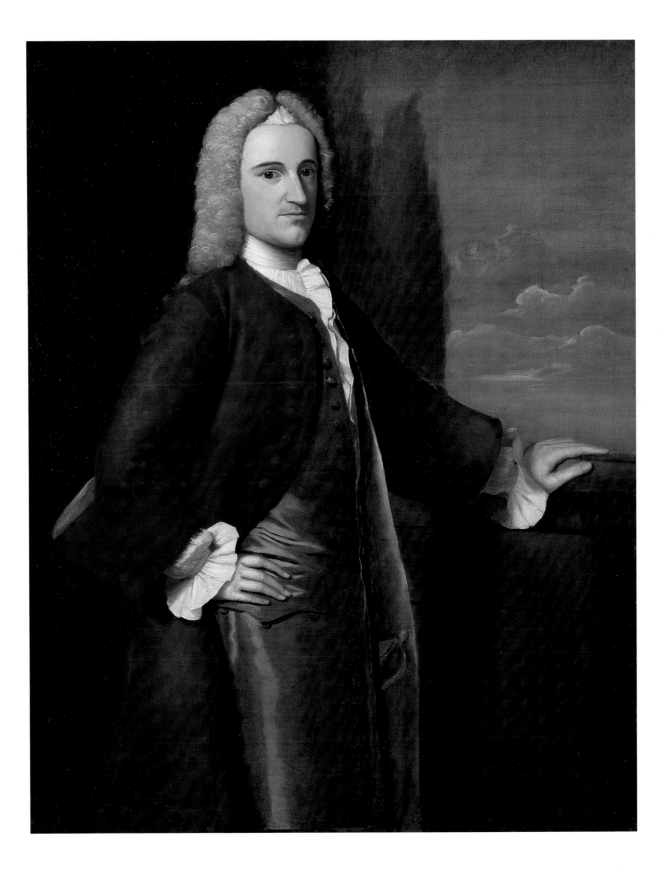

2

Ralph Earl (1751–1801)
Mrs. Richard Alsop 1792
oil on canvas
115.8 × 91.7 cm
Gift of Joseph Alsop and museum purchase

Mrs. Alsop exudes a lasting impression of rectitude and
provincial dignity that is characteristic of Ralph Earl's
portraiture. The European indebtedness of the painting is
implicit in the regal face and window view of an idealized
landscape, but the costume and somewhat stiff management
of the whole is pure Connecticut in the early years of the
Republic.

Earl shows a certain boldness as a colorist, playing the
glossy, deep green, satin dress against the bright, cherry red
chair and more muted red curtain, while softening his palette
in the landscape scene beyond. His brushwork is variable:
free, if not fluent, in the moiré pattern and highlights of
the dress; broad, but efficient, in the well-structured face.
The arms, which are a bit cruder, were probably repainted
at a later date.

He commands a vocabulary of forthright and decisive
shapes, such as the chair back, the dress, the remarkable
bonnet, and the rectangle of the window contrasted with the
oval of the foreshortened table top. Coupled with details such
as the concave fold of the stole at the sitter's neck, these
strengths show Earl to be a sophisticated limner.

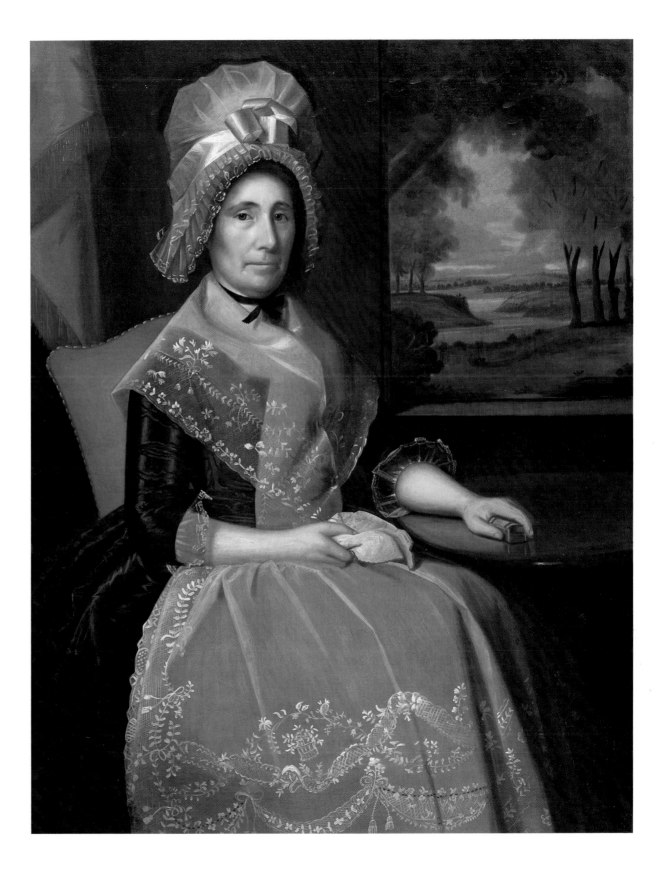

3

Charles Willson Peale (1741–1827)
Mrs. James Smith and Grandson 1776
oil on canvas
92.4 × 74.3 cm
Gift of Mr. and Mrs. Wilson L. Smith, Jr., and museum
purchase

Painted two months after the signing of the Declaration of
Independence, this quietly auspicious portrait of a grand-
mother and her grandson has intimations of nurturing and
growth, protection and independence. The boy, Campbell
Smith, holds a manual of rhetoric and oratorical study,
The Art of Speaking, which is opened to "Hamlet's Soliloquy."
This conjunction of literature and the profession of politics was
explained by John Adams, who wrote: "I must study Politicks
and War that my sons may have liberty to study Mathematics
and Philosophy . . . in order to give their Children a right to
study Painting, Poetry, Musick, Architecture." Indeed, "To be
or not to be" – clearly legible where Campbell Smith's finger
rests – might be the credo of every revolutionary.

 Peale's somewhat abbreviated training as a painter, which
culminated with some sixteen months in England under
Benjamin West, produced a style reasonably sophisticated
in drawing, textures, and modeling but less secure in the
depiction of space. The figures are set near the surface of the
painting and Peale develops them out from that shallow area.
The strong light on the heads pulls them toward us, and the
relief is enhanced by the patches of shadow where his coat falls
open and in the crook of her arm.

 The frank, immediate charm of this portrait typifies Peale's
attitude toward all his sitters and reflects his own candid
personality. Even the composition is telling: the strength
of Mrs. Smith's angled right arm, supporting and structural,
receives the yielding curve of her grandson's body, beautifully
expressed through the elegant sweep of his coat. Youthful
delicacy is expressed as well in the red, green, and gold
embroidery of his silver gray waistcoat, whose flowering
vine motif is emblematic of youth and promise.

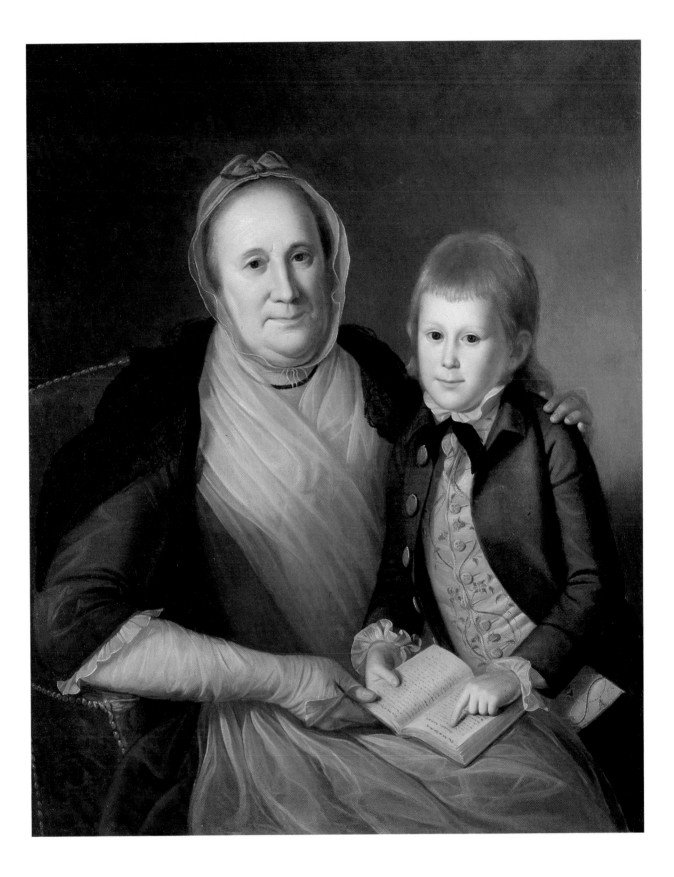

4

Benjamin West (1738–1820)
Helen Brought to Paris 1776
oil on canvas
143.3 × 198.3 cm
Museum purchase in memory of Ralph Cross Johnson

Paris, bribed by Venus to select her as most beautiful of goddesses, awaits entranced as his prize, Helen of Troy, is led in by Venus and Cupid. Venus whispers encouragingly to Helen, as she gently pushes her toward her intended. Cupid on the other hand tugs at her arm with open-mouthed urgency. West neatly places three hands on the central vertical axis of the painting – those of Cupid, Venus, and Helen – in an expressive conjoining of gestures.

These gestures are part of a sophisticated and subtle linear composition. There are the short arcs of hands, heads, and wings and the longer arc of the drapery undulating over Helen and Venus. There was once another significant arc, that of the original lunette shape of the painting (the upper corners of the present canvas are later additions). This curve, although not very pronounced, made greater compositional sense of the line running upwards from Paris's right arm, through his head and the contour of the cloud bank, and down past the heads of Helen and Venus.

The more active, highlighted group of Venus and Helen is contrasted with the shadowed reverie of Paris. The artist forgos both spatial complexity and sculptural relief in favor of linear elegance and the suave balance of shapes.

The erotic encounter of the future lovers is ignored. Cupid is probably the real focus of the narrative, for he sounds a prescient note. The wonderful shadow falling across his eyes is a deeply symbolic passage: this union will result in the Trojan War. One wonders if it was a coincidence that the picture was painted the year the American Revolution erupted. Despite his close friendship with George III, West remained a partisan of the rebel cause.

It is fascinating to compare this painting, squarely in the European tradition, with Charles Willson Peale's frank colonial family group done the same year (see p. 20). In 1759 West moved from Philadelphia to London, where Peale was among the first in a long line of American painters to study with him. In West's studio young Americans were received with courtesy and sympathy and taught to improve their technical skills. Through West's influence they also made valuable professional contacts.

Apart from portraiture, West devoted himself entirely to history painting, which encompassed subjects from mythology, religion, and ancient and modern literature as well. The pre-eminence of history painting in Europe and Great Britain was not echoed in North America, at least not among patrons. Many gifted American artists learned that fact, to their intense frustration.

Hence, although Benjamin West provided a valuable artistic link between the Old World and the New, the subjects he painted were not exportable. His career and influence, by and large, must be studied in its European context.

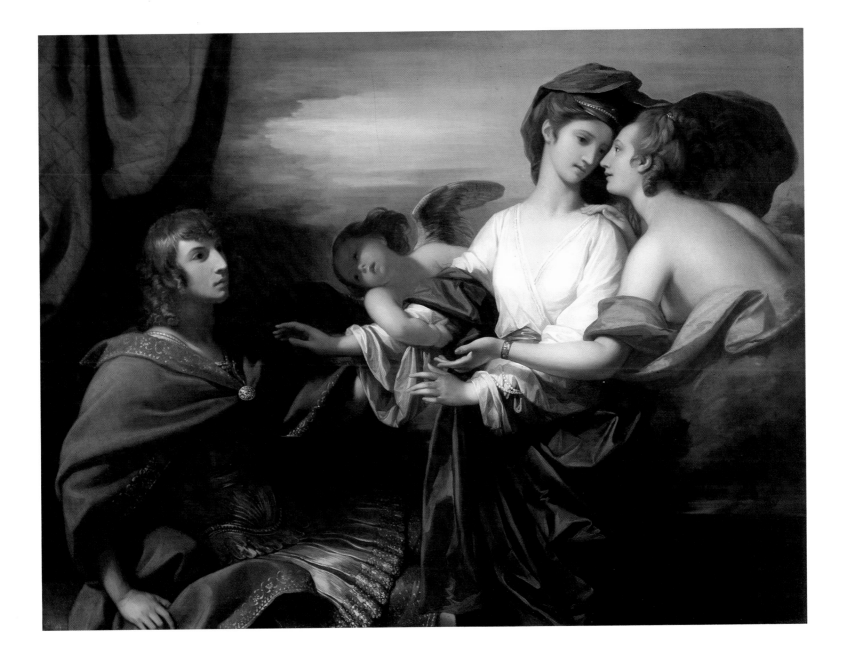

5

Thomas Sully (1783–1872)
Daniel LaMotte 1812–13
oil on canvas
92.3 × 73.8 cm
Gift of Mr. and Mrs. Ferdinand LaMotte III

Sully was the finest American portraitist of his day, excepting Gilbert Stuart (see p. 28), but his fluency and facility sometimes led him to paint superficial, though pleasing, likenesses. That is decidedly not the case, however, in his portrait of Daniel LaMotte. Fluent this work is, but the rapid brushwork is efficient in capturing the structure of the head and its highlights. The paint flows along the contours of the face and down the edge of the wall behind it.

The romantic, gently melancholic mood of the sitter is enhanced by the three-quarter-length, asymmetrical pose, one arm casually thrown over the back of the chair and the other hand resting tentatively on the table edge. LaMotte's introspection and disregard of the viewer are in harmony with the reverie of the evening landscape behind him.

LaMotte's costume is high fashion – that of a Beau Brummell – and the lovely color scheme of the portrait is keyed to it. The sitter's sage green coat and dark, disheveled hair advance from the dove gray wall. The superbly painted waistcoat, the modish frill of the shirt front, and the elaborate neckcloth/cravat are all white, yet each is differentiated in texture and the white expanse is modulated by yellow shadows.

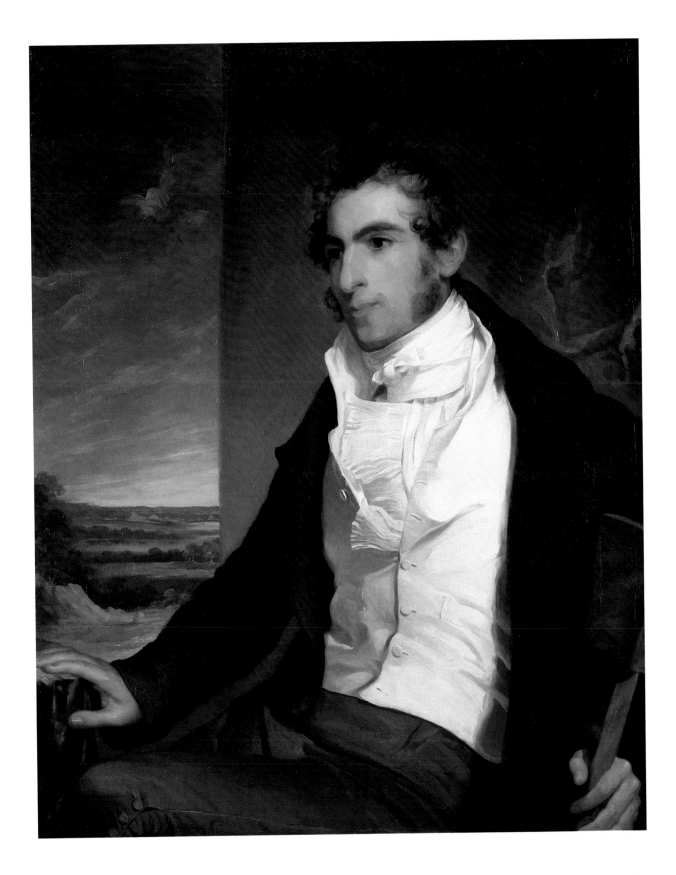

6

Raphaelle Peale (1774–1825)
Melons and Morning Glories 1813
oil on canvas
52.6 × 65.4 cm
Gift of Paul Mellon

Raphaelle, possibly the most talented of Charles Willson Peale's progeny of painters, completed this handsome still life in Philadelphia on 3 September 1813, which he duly noted after his signature. His fine reputation as a still-life specialist is well supported by the painting's strong composition, sure drawing, and lush textures.

The large watermelon is just at the point of over-ripeness, with a sagging and settling *corpus*. Juice dangles in droplets from its opalescent, pink-and-white flesh and forms a puddle on the table with a scattering of black seeds. The smaller piece of watermelon has a green and ochre rind and a salmon pulp. The small, uncut, orange melon, perhaps a cantaloupe or casaba – through which the ghostly pentimento of the contour of the large watermelon now appears – acts as a transition between its larger cousins. A fourth small fruit, perhaps an orange, peeks out from behind the melon at the right.

The subtlety and elegance of the painting reach an apogee in the glass vase, distinguished by its highlights, and the extraordinary vine of morning glory with two deep-blue blossoms. The tautly controlled melody of this vine joins with that of the melon's contour in a suave duet.

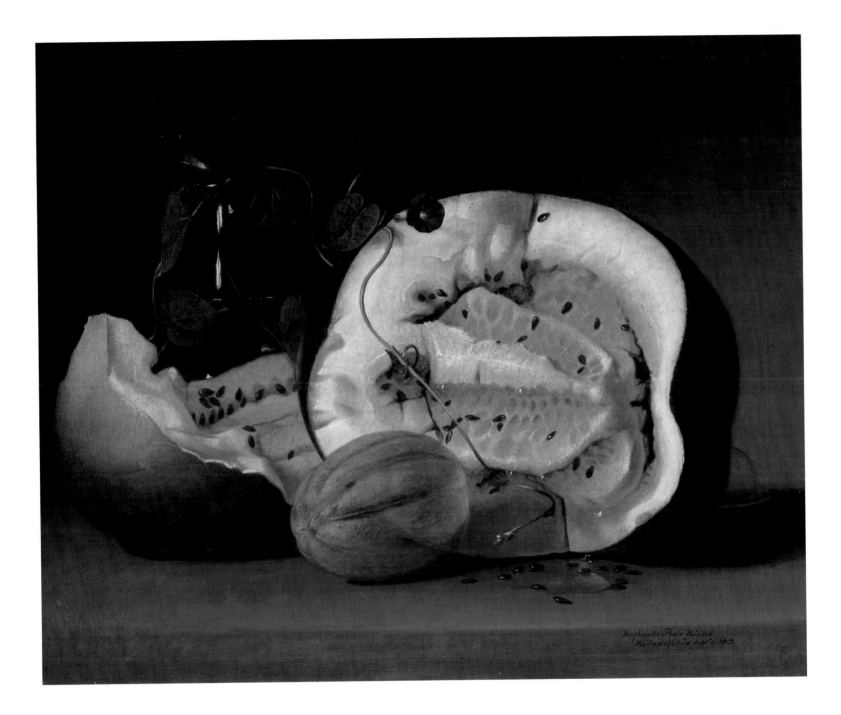

7

Gilbert Stuart (1755–1828)
John Adams 1826
oil on canvas
76.2 × 63.6 cm
The Adams-Clement Collection. Gift of Mary Louisa Adams
Clement in memory of her mother, Louisa Catherine Adams

"I wish to possess a likeness of him as he now is." Thus John
Quincy Adams commissioned Gilbert Stuart to create a last
portrait of the aged former president, his father, then nearing
his eighty-eighth birthday. Adams had sat to Stuart twice
before, first in 1798. Now the artist promised "to paint a
picture of Affection, and of curiosity for future times."
The painting, completed by October 1824, was sent to the
Adams family home in Quincy, Massachusetts. Soon after John
Adams's death on 4 July 1826, his son, himself now president,
asked Stuart to paint a replica of the final likeness. It was
ready by late 1826 and dispatched from Boston to Washington.
It is this replica that is now in the National Museum of
American Art.

A "picture of Affection" it surely is, brushed in with a
spare and loving gentleness unsurpassed in Stuart's career.
Cushioned in the protective corner of a cherry red sofa,
his arms folded, his right hand resting on a cane, Adams still
presents a formidable spirit. As the painter Washington
Allston described it, "The living tenant is there, – still
ennobling the ruin and upholding it, as it were, by the thought
of his own life." The hand is scarcely blocked in, the black
frock coat recedes into shadow, but above the dipping curve
of the sofa's back, the head projects intellectual prowess and
compelling strength of character.

The gray hair is not drawn but evoked in vague puffs and
wisps, and the head that it crowns is equally conjured with a
minimum of paint. Stuart's brush pushes the thin paint layer
this way and that, arranging features and conveying bone
structure with unfailing sureness. The illusion of the trans-
lucent skin and rheumy eyes of an old man is astonishing,
and the bluish hues around the left eye socket are the more
telling in contrast to the bright red of his cheek. This
distillation of body and spirit is capped by the acidulous twist
of the corner of Adams's mouth. This reflex of disdain reminds
us that, for all his virtues, John Adams was short on warmth,
long on stubbornness, and hard on fools.

Stuart was sixty-eight at the time of the sitting, and the
emotional resonance of his work may derive in part from
the empathy of one old man for another. The professional
eminence that each had achieved seems secondary to the
age each had attained. The painting also evidences a depth
of fellow feeling that was not a dominant trait of either man.
Although bowed with age, Adams had said that he would
"like to sit for Stuart from the first of January to the last of
December." Although Stuart's own health had declined to
the point that, as the painter John Neagle recalled, "his hand
shook at times so violently that I wondered how he could place
his brush where his mind directed," he nonetheless vowed to
"make a picture of it that should be admired as long as the
materials should hold together!" This characteristic remark,
as John Quincy Adams observed of another Stuart boast,
"is not very wide of the truth."

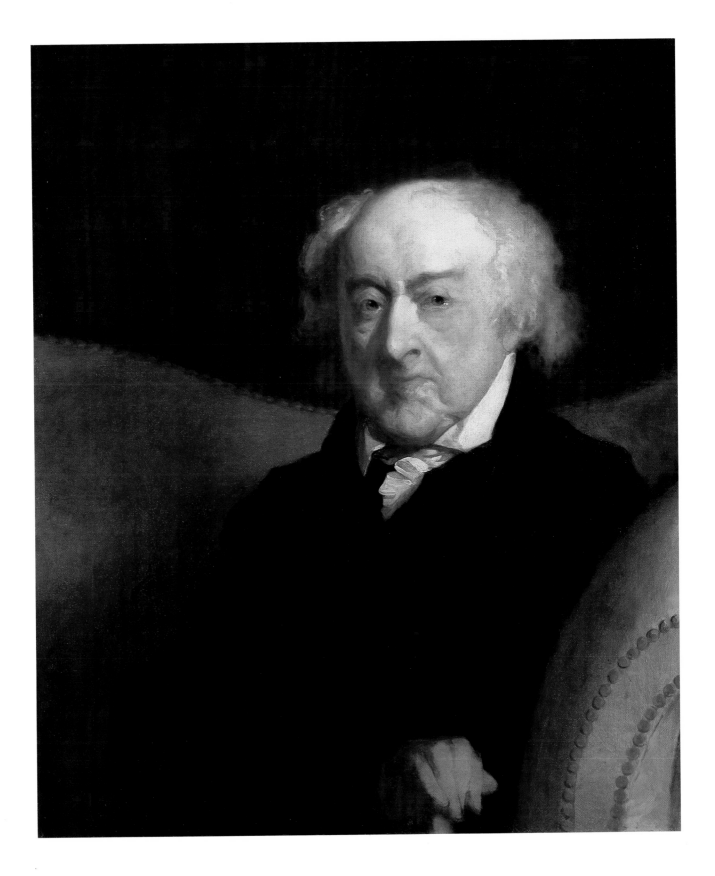

8

Alvan Fisher (1792–1863)
The Great Horseshoe Fall, Niagara 1820
oil on canvas
87.2 × 122 cm
Museum purchase

Because it was easily accessible, Niagara Falls was the first
natural wonder of the American landscape to claim the
attention of artists. Most of the early representations reflect
the picturesque aesthetic of the eighteenth century:
the viewer stands well away from the scene, and dramatic
impact is secondary to description.

 Alvan Fisher, who painted a second view of the falls the
same time as this one (also in the NMAA), moves toward
greater immediacy in his *Niagara*. The viewer still stands back
from the precipice overlooking the falls, but the young men
dramatically posed at the brink, the dog silhouetted against
the water, the young woman covering her ears against the
deafening roar – all convey a sense of the amazing spectacle
at closer range.

 At the same time, the viewer is treated to the full breadth
of the view, spanning the canvas from the sweep of clouds to
the rainbow arcing into the basin to the effective contrast of
the dark foreground with the bright falls. Yet to come in the
century were still more dramatic treatments, such as Frederic
Church's, in which the viewer is suspended, as it were,
over the falls, and visionary interpretations like those by
George Inness (see p. 80), for whom the spectacle became a
vehicle for meditation and introspection.

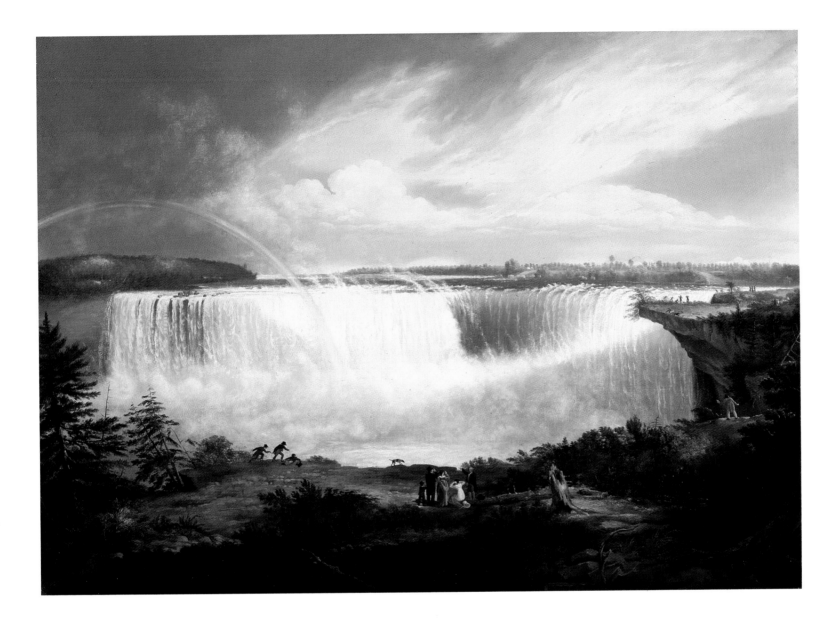

9

Thomas Cole (1801–1848)
The Subsiding of the Waters of the Deluge 1829
oil on canvas
90.8 × 121.4 cm
Gift of Mrs. Katie Dean in memory of Minnibel S. and James
Wallace Dean and museum purchase through the Major
Acquisitions Fund, Smithsonian Institution

This important painting from the first decade of Cole's career
was recently rediscovered after a 150-year disappearance from
public and scholarly awareness. The deeply felt romantic
symbolism of so much of Cole's oeuvre is much in evidence
here.

The most striking aspect of the painting is its point of view.
The spectator stands beneath a rocky overhang or within the
shadowy mouth of a great cavern, from which he looks toward
the bright glow of distant waters and sky. Given the title of
the painting, it is a hauntingly isolated vista that suggests the
viewer is a survivor of the Great Flood, together with the
unseen occupants of the ark – or else some other, omnipresent
eye.

The tonality of the picture is dominated by the strong
contrast of foreground shadow and distant brilliance, but there
is great subtlety in the graduated sequence of dark and light
areas in the spatial recession. The earthy palette shifts from
the deep gray browns of the cave to strong chestnut and
mahogany hues in the freely painted, sunlit rocks to mauve
and brown in the falls at the left. This gives way to the violet
tints of the distant rocks and the pale blue sky infused with
the yellow glow of the sun.

Although the sun appears to be on the far horizon radiating
from behind the center rocks, a higher light source seems to
bathe the rocks and pool of the foreground. This illogical
lighting contributes to the mysterious, unearthly mood of the
painting.

The sea is calm in the distance, where the ark floats, yet the
foreground is still turbulent. Water cascades down at the left,
streams more slowly from the rocky overhang, and overflows
the tidal pool at the lower edge of the painting to soak, as it
were, the viewer's feet. It is at the brink of this small waterfall
that Cole places a strongly lit and sharply defined skull,
a crystalline *memento mori*. The shattered ship's mast, set amidst
the debris of driftwood and seaweed in the left foreground,
is yet another reminder of man's mortality.

The dark rocks circumscribe a luminous circle of hope,
however, within which is set a tight, highly symbolic
grouping: the coffin-like ark, the tiny dove winging for shore,
and the cathedral-like spires of the distant rocks. Cole's
sermon in paint is delivered with epigrammatic conciseness.

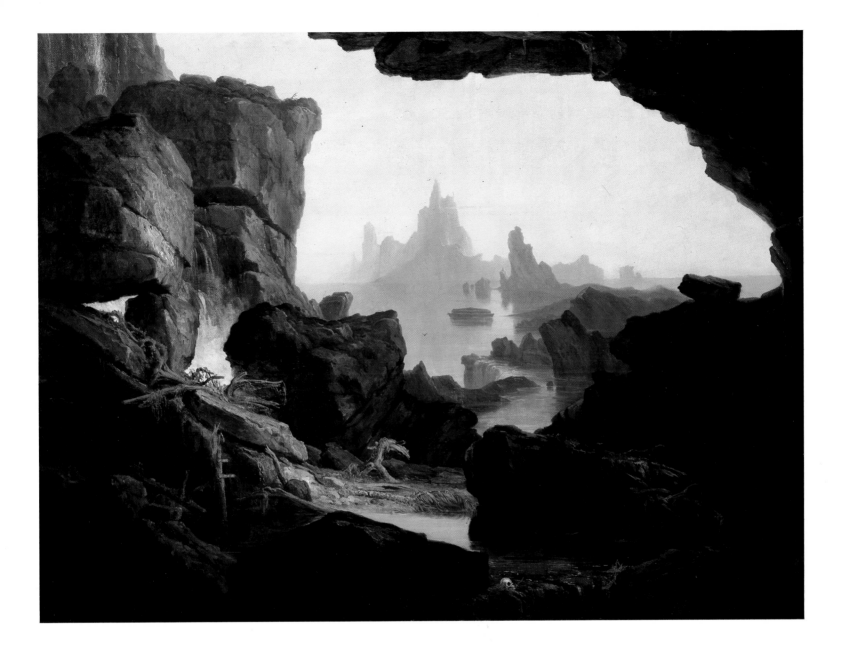

10

Charles Bird King (1785–1862)
Young Omahaw, War Eagle, Little Missouri, and Pawnees 1821
oil on canvas
91.8 × 71.1 cm
Gift of Helen Barlow to the Smithsonian Institution

As was the custom of the Pawnees, these Indians have slit their
ears and ear lobes and suspended wampum ornaments from
them. In addition, they wear bead necklaces, and the foremost
among them wears a silver "peace medal," a profile of
President Monroe suspended from a pink ribbon. In ironic
proximity to this, he holds a war club.

Three have ornamented the remaining tuft of hair on their
shaved heads with a crest, probably of dyed deer's hair,
to which the most prominent Indian has added a feather.
This crimson crest and the predominantly red face paint is
accentuated by the intermittent blue of the upper background.

The shallow, compact grouping of heads and torsos moves
subtly out of and back into the otherwise undefined picture
space, and an alternating current of light and dark areas
animates the surface. Especially rich is the pure profile,
like that on an ancient cameo, set above the muted black fur
robe of Little Missouri. On the other hand, there is a stillness
to the painting that derives largely from the avoidance of
interaction, of "conversation," among the Indians and between
them and the viewer. Their calm, noble bearing is eloquent.

The painting is striking in its technical accomplishment and
in its almost European persuasion. As a painter of Indians,
King stands in contrast to George Catlin in these respects (see
p. 36). Working a decade earlier, he painted his Noble Savages
not in their wilderness, but in Washington, D.C., where he had
his studio and where delegations of Indians came to safeguard
their rights in the forced sale of their lands.

The suave arrangement of the figures in a variety of poses
is reminiscent of Venetian Renaissance devotional pictures and,
more pertinently, of Baroque multiple portraits executed as
models for sculptors. During his six years of study in England,
King would have had ample opportunity to study both types
of painting. It was this training that enabled him to render his
Indian sitters with a mixture of realism and idealism that is
unforgettable.

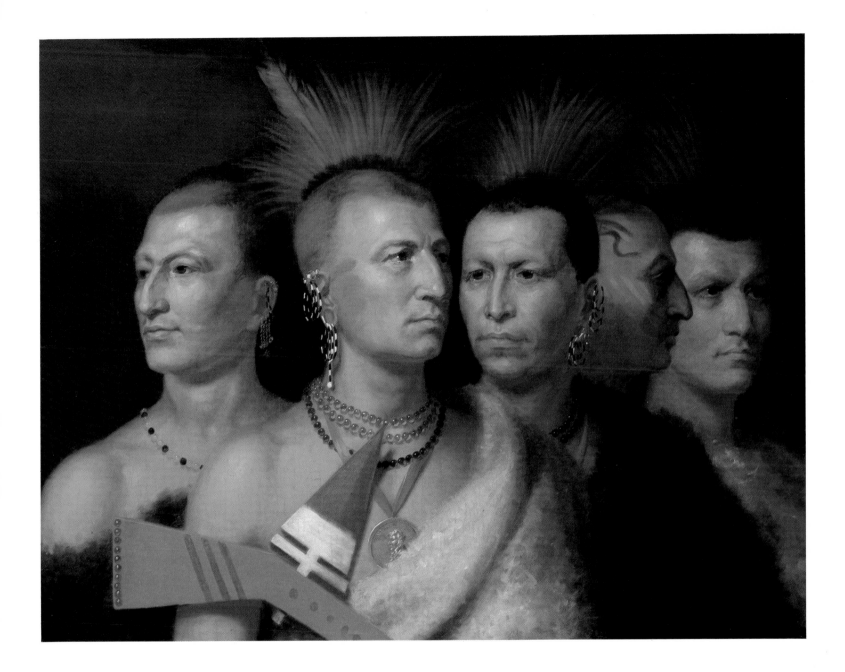

George Catlin (1796–1872)
Buffalo Bull's Back Fat, Head Chief, Blood Tribe 1832
oil on canvas mounted on aluminum
73.7 × 60.9 cm
Gift of Mrs. Joseph Harrison, Jr., to the Smithsonian Institution

George Catlin was a man on the move and in a hurry. He was determined to "rescue from oblivion so much of [the Indians'] primitive looks and customs as the industry and ardent enthusiasm of one lifetime could accomplish," and in little over six years he traveled many thousands of miles in a wilderness known to very few white men. He painted hundreds of portraits of Indians of some four dozen tribes, as well as landscapes and hunting and wildlife scenes. It is estimated that on some days he may have painted five or six portraits; but if haste is apparent in the backgrounds, details, or lower portions of the canvases, which are often unresolved, the heads are usually fixed with such sureness that all else pales in importance.

Until the last ten or fifteen years, Catlin has been considered more anthropologist than artist. Although Catlin himself fostered this attitude, perhaps as a way of evading aesthetic criticism, he nonetheless was capable of great power of communication and delineation of character.

None of Catlin's Indian portraits is more imposing than this stunning likeness of the Blackfoot chief. The head itself is almost perfectly symmetrical, accentuated by the wide forelock hanging to the bridge of the nose and giving an almost hypnotic intensity to the eyes. This is not the symmetry of a naive artist, however. With great subtlety, Catlin shifts the sitter slightly to the left of center, so that the vertical axis runs through the left eye. This shift combines with the strong diagonals of the feather and long pipe to produce an element of tension.

Catlin conveys the structure of the head even if the fullness of it somewhat eludes him. The projection of the chin, for instance, is only suggested in a perfunctory way. But his genius for penetrating into the character and inner strength of the Indians gives his portraits a memorable power lacking in many more technically adroit paintings.

In his invaluable journal, Catlin frequently makes comparisons between the American Indians and the ancient Greeks and Romans, finding them equal in beauty and inspiration. Europeans agreed with him when he took his "Indian Gallery," complete with real Indians, abroad. The French proved especially susceptible. The Rousseauian theme of the Noble Savage had been taken up wholeheartedly by the Romantic generation. Eugène Delacroix sketched Catlin's Indians and felt, as he had among the Arabs of North Africa, that in these people, free of the corruption of modern civilization, one was in the presence of innately noble beings like those of antiquity. Baudelaire, too, upon seeing this portrait and another in the Salon of 1846, wrote that "these savages make antique sculpture comprehensible." Many years later, he still recalled the impact of Catlin's Indians, who "made us dream of . . . Homeric grandeurs."

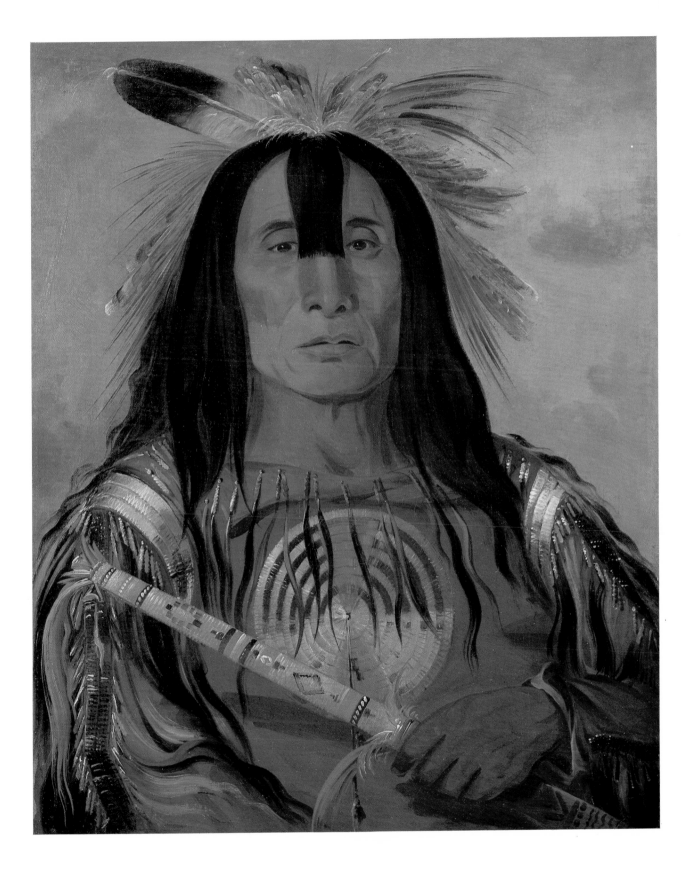

12

John Mix Stanley (1814–1872)
Osage Scalp Dance 1845
oil on canvas
103.5 × 153.6 cm
Gift of the Misses Henry

Shortly after George Catlin's heroic explorations of the American West, John Mix Stanley undertook his own travels as an itinerant portrait painter. For a dozen years beginning in 1838, he traveled as far as Hawaii recording Indian customs and likenesses. Like Catlin, he counted on a gallery of Indian paintings to make his reputation. Unlike Catlin, however, he created his paintings in the East from studies made on his travels, and he invented multi-figure compositions, as seen in *Osage Scalp Dance*.

The most striking feature of this painting is the attentiveness with which Stanley varied his poses and balanced his composition. His self-consciousness in this regard is that of a self-taught painter aware of traditional models. The complement of poses – from full face and full back to three-quarter right and left to pure profile – suggests he consulted a European academic manual on figure drawing or reproductions of engravings of antique sculpture. The main group is arranged in a shallow semi-circle, as though on a stage, an effect enhanced by the artificial spotlight on the woman and child. With equal care, he has arranged heads and weapons so that they describe an arc that unifies the group.

A schematic line drawing of the painting would show an almost abstract purity of design, his compositional control extending to the linear elements of spears, bows, shields, and the drums at the left.

The careful ethnological record of costume and custom is overshadowed by the central melodrama and the cultural biases it reveals. The tearful, but resolute, mother protects her child and raises a hand toward the attacking Indian warrior. His chief parries the war club with his spear. Given the pose of the victims, which recalls traditional portrayals of the Massacre of the Innocents, it is quite clear that these are un-Christian savages. At the same time, however, the popular theme of the Noble Savage, capable of magnanimity despite his heathen state, is sounded. The chieftan's presidential peace medal also suggests assimilation of the white man's "sense of honor." This unresolved conflict of attitudes parallels the barbarous Indian policy of the United States government during these years.

Approximately one hundred fifty paintings from Stanley's Indian and Western Gallery were placed on deposit in the Smithsonian Institution by 1851, awaiting purchase by the government. An 1865 fire in the Castle destroyed all the paintings as well as 187 more by Charles Bird King (p. 34). Five of Stanley's works, however, including *Osage Scalp Dance*, were not in the building at the time. The impoverished Stanley was ruined by the loss; the few salvaged works are prized for their rarity.

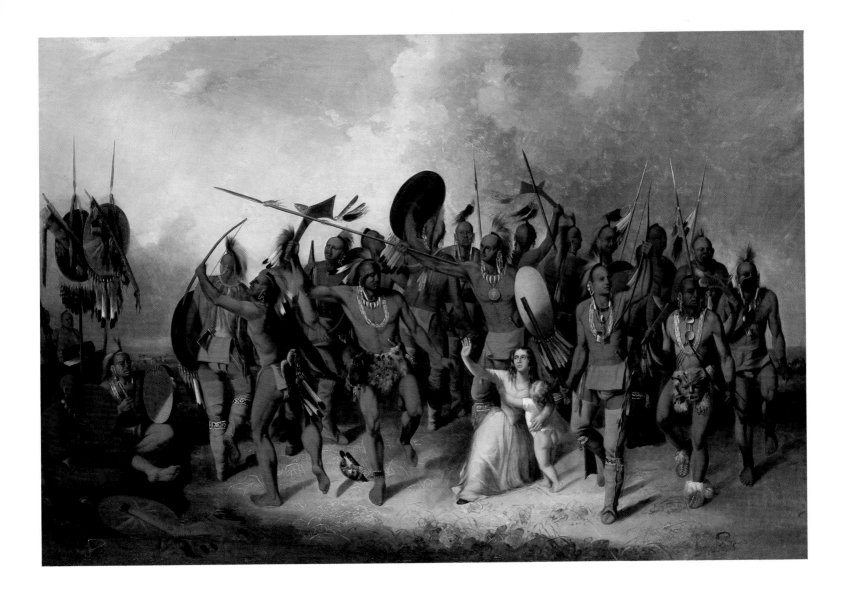

13

Robert W. Weir (1803–1889)
Saint Nicholas ca. 1837
oil on wood
75.5 × 62.1 cm
Museum purchase

Clad in a short, red-hooded cloak and high, flaring boots and carrying a wicker basket full of toys on his back, an elfin Saint Nicholas steps toward the fireplace, his holiday-eve visit finished. This gnome-like actor commands his little stage with authority, as he turns back to the viewer with a wide grin and eloquent gestures.

In the long blue stocking at the left is a birch-rod for a naughty boy; three more are attached to his sack. From the toe of the stocking hangs a clown-like doll with a dunce cap, and next to it stands a coal shovel – coal also being a traditional gift for bad children. At the right, a shorter red stocking bulges with presents, topped off by the legs and skirts of a doll stuffed into it in a witty, but slightly alarming, manner. Farther to the right, a dark blue stocking with elaborate embroidery appears to belong to Mother, for a yarn-ball with knitting needles is seen at the opening.

Saint Nicholas became one of the most popular figures in the calendar of the Catholic Church. His characterization as the giver of holiday gifts derived from legends of his charity. He became especially popular in Holland, where by the seventeenth century the celebration of the eve of Saint Nicholas was documented in paintings. The Dutch dialect form of his name, Sinte Klaas, gave rise in America to "Santa Claus."

Weir's painting is, in fact, reminiscent of Dutch painting in its descriptive detail and tonal palette. There is also a strong suggestion of *vanitas*, that favorite Dutch theme of the fleeting nature of life and material possessions. The overturned footstool, the broken clay pipe, the cut orange dropped on the floor, the dying embers of the fire, the smoke rising behind an andiron, which is in the form of Atlas supporting the globe, and finally the blades of a windmill – symbolic of fortune or chance – depicted in the cartouche above the fireplace all compose a sermon in paint. This is especially piquant in conjunction with the gift-giving theme of the eve of Saint Nicholas.

From the time Robert Weir created his *Saint Nicholas* (of which he did at least six versions), some viewers associated it with Clement Moore's popular verse "A Visit from St. Nicholas," published anonymously in 1822 and anthologized with the author's name in 1837. Weir, a friend of Moore, had surely known the poem for years. Two phrases in particular seem to indicate it was an inspiration: "the stockings were hung by the chimney with care" and, especially, "then turned with a jerk, and laying his finger aside of his nose." But in other particulars, Weir's painting is either independent of or actually contradicts Moore's description: "He was dressed all in fur from his head to his foot, / And his clothes were all tarnish'd with ashes and soot." In short, Moore's light verse cannot be regarded as Weir's source.

Instead, the inspiration for both painting and poem certainly came from Washington Irving, whose droll mock-epic *A History of New-York from the Beginning of the World to the End of the Dutch Dynasty* appeared under the pseudonym Diedrich Knickerbocker on Saint Nicholas's Day, 6 December 1809. It was "Knickerbocker's History" that established Saint Nicholas as patron saint of New Amsterdam (later New York). There are at least twenty-five references to him in Irving's classic, including the originals of some of Moore's descriptions, as well as details not found there that are shown in the painting, as for example "when St. Nicholas had smoked his pipe, he twisted it in his hatband."

Robert Weir had as a friend and patron a noted New Yorker of Dutch descent, Gulian C. Verplanck, who had used his political influence to get Weir a position teaching drawing at West Point. He was a member of the Knickerbocker Society (named for Irving's pseudonymous historian) and with Irving was a founder in 1835 of the Society of Saint Nicholas. Weir offered his first painting of Saint Nicholas (not this one) to Verplanck for purchase, and it has even been inferred that Weir painted the subject at Verplanck's suggestion.

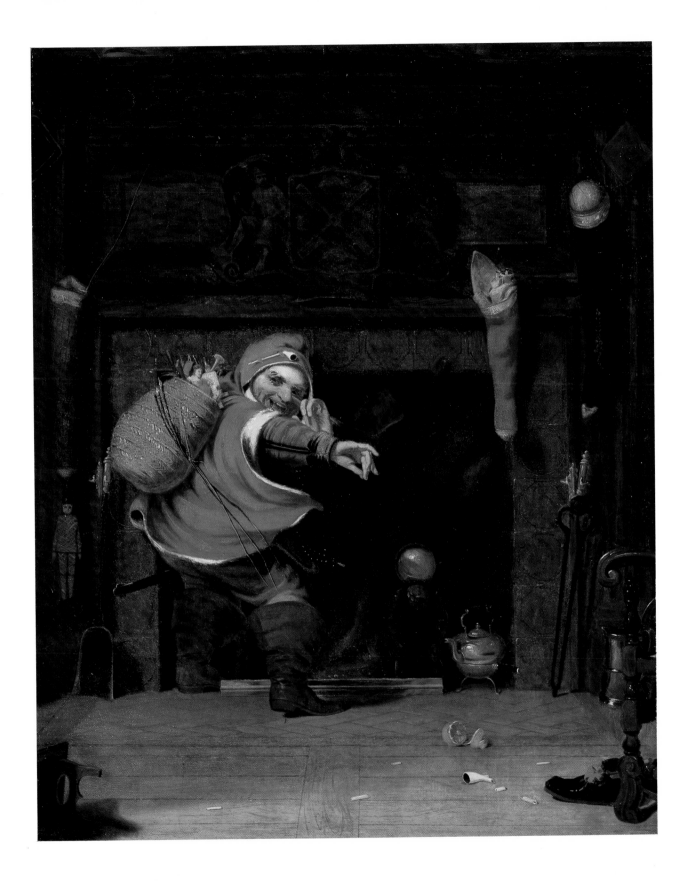

14

Hiram Powers (1805–1873)
Edmund Pendleton Gaines modeled in 1837; carved after 1840
marble
53 × 37.7 × 27.2 cm
Museum purchase in memory of Ralph Cross Johnson

In Hawthorne's *The Marble Faun* (1860), Miriam, an American painter, expresses her "belief that, except for portrait busts, sculpture has no longer a right to claim any place among living arts. It has wrought itself out. . . . There is never a new group nowadays; never even so much as a new attitude." Her statement, together with the Italian setting of Hawthorne's novel, points out the quandry in which American sculptors of the mid-nineteenth century found themselves. Often resident in Italy for long periods, they aspired to a classical purity alien to their era and their temperaments. What they achieved, by and large, might be called Victorian classicism, in which the sentimentalism of the age seemed somehow to seep through the stubbornly imitative forms and cool marble surfaces.

Hiram Powers's *Edmund Gaines* is superior to his many idealized busts of goddesses and sundry personifications. Gaines (1777–1849), a Virginia-born career soldier and Indian fighter, seems to have had a touch of paranoia and believed himself the object of a conspiracy. Bitterly at odds with General Winfield Scott, and court-martialed in the Mexican War for insubordination (the charges were dropped), he was passed over for promotion.

Gaines sat for Powers in Washington, D.C., in March of 1837, where a court of inquiry was investigating his failure in an Indian campaign in Florida. Powers obviously subjected him to a certain amount of classicizing and idealizing, for his armless torso is nude, save for the vaguely classical strap that lies across his shoulder and chest, and his hair has been stylized in the manner of Roman sculpture. Moreover, the eyeballs are blank, with no drilling to indicate the pupils.

The face, however, is modeled with considerable individuality, particularly in the set of the mouth and the lining of the chin and cheeks. The slightly puffy spread of the bridge of his nose, the veining of his left temple, and his small ears with close rather than pendant lobes are all evidence of Powers's intense naturalism. Although he counters that naturalism with the classicizing elements described above, the Gaines bust achieves lasting strength through its pose. The seemingly slight turn of the sitter's head to the left produces a strong cord on the right side of his neck. This cord, the veining in the neck, and the loose flesh beneath the chin achieve a convincing sense of presence.

The force of the head is the more surprising since Powers had little or no part in carving the sculpture. He modeled it in plaster, and master carvers transferred the design to the marble block. This was a common way of working in nineteenth-century studios, but it almost inevitably resulted in debilitating generalization. *Edmund Pendleton Gaines* is a happy exception.

The plaster original has disappeared, and this unique marble was never sold. It eventually passed, with the rest of the contents of Powers's studio, to the National Museum of American Art.

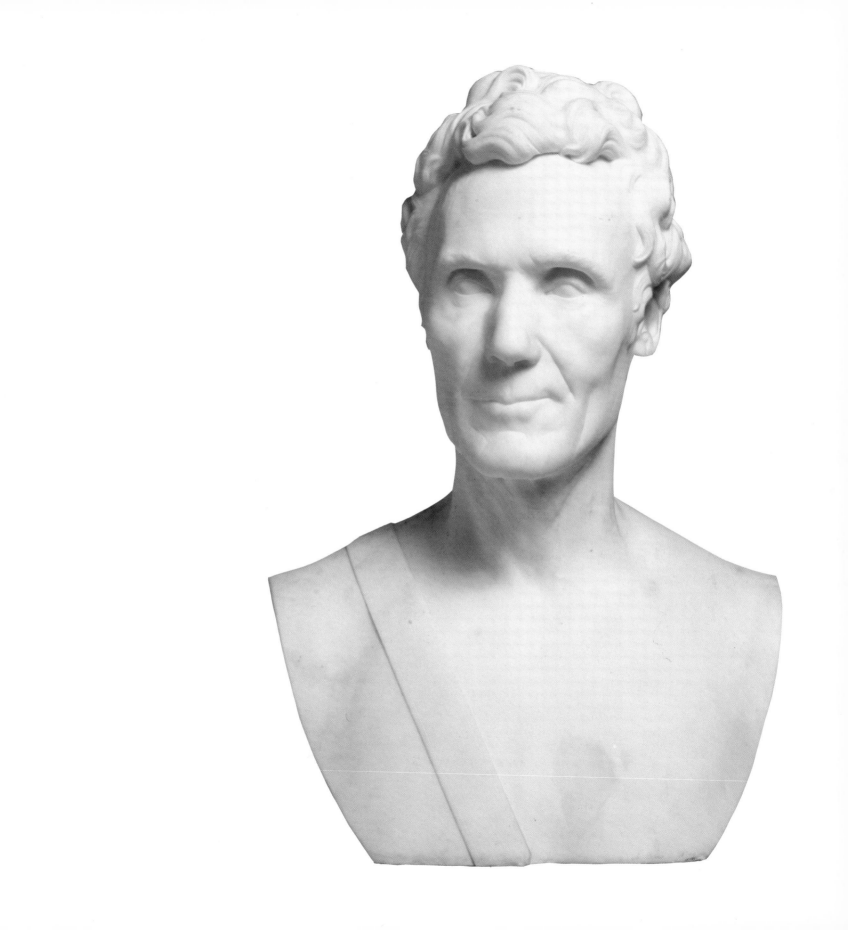

15

Asher Brown Durand (1796–1886)
Dover Plain, Dutchess County, New York 1848
oil on canvas
107.9 × 153.7 cm
Gift of Thomas M. Evans

This light-filled painting conveys a sense of tranquility and
harmony between man and nature. The fertile valley is tilled,
the fields laid out and bounded by rows of trees and more
densely forested areas. Yet the surrounding hills give little
evidence of human intervention, and there are few figures
or domestic animals in the sweeping landscape.

 To convey a pastoral vision of abundance, Durand has
borrowed a page from the poetic landscape tradition of Claude
Lorrain. The framing trees, the diagonal paths and alternating
strips of light and shadow, and the sure relationship of the
rocks in the left foreground to the hillock in the right middle
distance are all Claudian devices. Above all, the seventeenth-
century artist's style is apparent in Durand's masterly
rendering of haze, which lightly veils the plain like a
benediction.

 The movement of the eye through this peaceable kingdom
is measured and unhurried. It is actually a world remote from
reality. Durand, like most of his Hudson River School
contemporaries, ignored the advent of industrialization and the
intrusion of the railroad into rural America. Instead,
he nostalgically focused on unspoiled nature. Our first native-
born landscape painter to achieve technical mastery,
he bestowed his own idealistic spirit upon the American scene.

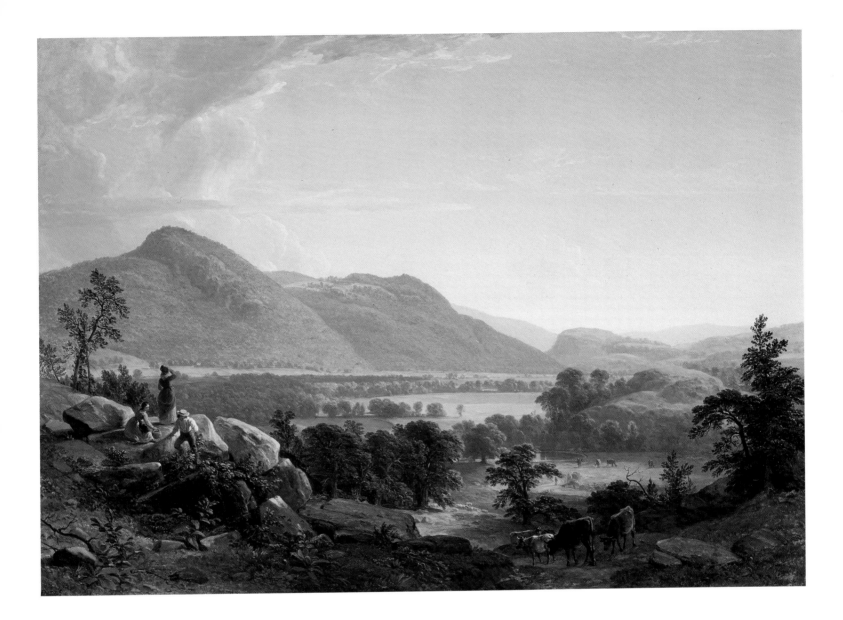

16

George Henry Durrie (1820–1863)
Winter Scene in New Haven, Connecticut ca. 1858
oil on canvas
45.6 × 60.9 cm
Museum purchase

This crisply painted evocation of rural life in mid-nineteenth-century New England conveys a sense of security. We witness a firmly controlled daily existence in which the season and the weather are squarely faced. This mood is suggested by the calm, stolid air of the men, women, and animals who betray no unease or alarm at the gathering storm clouds.

More important, everything is man-made – the house, its extension, and the barn, which occupy and control their space in a way that might be called "comfortable." They are fronted and backed up by trees that have been drawn with a different touch. Quirky and irregular, especially in the large foreground tree, the paint surface has a strong tactile quality. The trunk and limbs of this tree crackle with linear energy. From browns and grays with light green touches, it moves into the copper-red brown colors of its still-hanging leaves of the season past. Particularly luscious are the small squiggles of white paint representing patches of snow on the limbs. The warm red tones of the leaves are amplified in the house. The atmospheric grays of the hilly landscape beyond and the growing darkness of the imminent storm set off this domestic warmth, but do not threaten it.

Sadly, Durrie's greatest popularity was posthumous. At the end of his life, ten of his paintings, winter scenes like this one, were reproduced as lithographs by Currier and Ives. Appearing near the end of the Civil War, the serene self-reliance of his rural America must have been as welcome – and as poignantly beyond retrieval – as the lost New England paradise remembered in John Greenleaf Whittier's "Snow-Bound" (1866). "These Flemish pictures of old days" have ever since evoked nostalgia for a romanticized past; their diction was "the common unrhymed poetry of simple life and country ways."

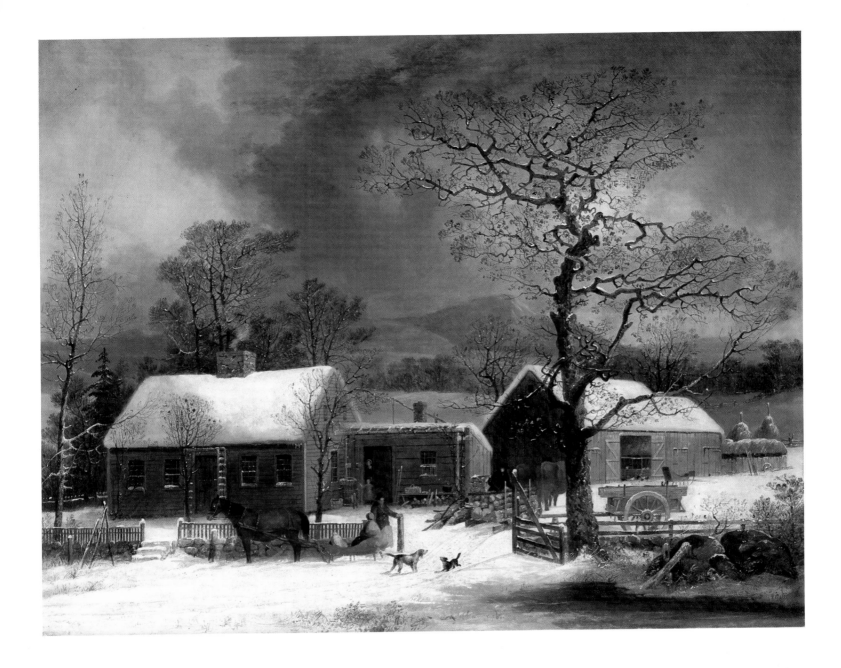

17

Frank Blackwell Mayer (1827–1899)
Independence (Squire Jack Porter) 1858
oil on paperboard
30.4 × 40.3 cm
Bequest of Harriet Lane Johnston

Squire Jack Porter, one-time captain in the War of 1812, was seventy-five years old when his young friend painted him in this genre-portrait at his farm "Rose Meadows," near Eckhart, Maryland. Widely known for his entrepreneurial accomplishments – he opened the first coal mines for domestic use in Allegany County – he was also recognized for his charitable spirit. *Independence*, the title given by the artist, may refer equally to the leisure years of the Squire's old age, his financial well-being, and his obvious strength of character and spirit.

An aura of alert contentment pervades this small painting. The drawing, like the man, is wiry and rangy, full of innate zest. On the shallow stage of a porch, Squire Porter is at ease but watchful, in tune with both human comfort and nature's restlessness. His corncob pipe is held at attention, his lips closed, eyes intent with thought, and hair electric with anticipation.

Painted as if in soft focus, the lovely greens and yellows of the landscape are a yielding cushion for the silent figure. The golden yellow sunflowers seen between the porch rails and climbing behind the corner post seem to elide the distance between the foliage and the sitter. The conjunction of legs and porch rails is one of the most winning passages in the painting. Squire Porter rests his legs in utter harmony on the rails, with the unconscious affinity humans have for much-lived-with objects. The domestic warmth of the scene is enhanced by the mellow colors and summarized by the unfinished knitting on the windowsill.

The spirit of contentment that emanates from this modest picture can be felt in many paintings done in the two decades preceding the Civil War (see Durand and Durrie, pp. 44, 46). The general satisfaction with everyday life during the pre-war years may have contributed to the fact that it is the richest period in American genre painting. In *Independence*, Mayer combines a perceptive likeness of a friend with an equally perceptive delineation of his friend's *place*. The interaction of the two is the real subject of this work.

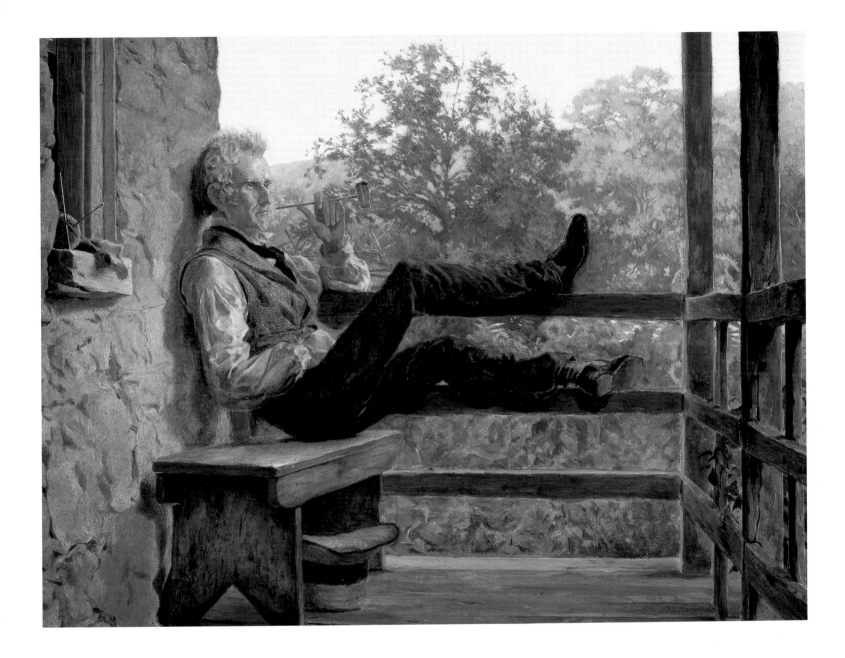

18

Worthington Whittredge (1820–1910)
The Amphitheatre of Tusculum and Albano Mountains, Rome 1860
oil on canvas
61 × 101.6 cm
Museum purchase

As a young painter in Cincinnati, Worthington Whittredge benefited from the enlightened patronage of Nicholas Longworth, a real-estate magnate who also was benefactor to Hiram Powers (p. 42) and Lilly Martin Spencer (p. 58). Longworth and others subscribed the funds to send Whittredge to Europe in 1849. After extensive travel and four years in Düsseldorf, he settled in Rome, where he spent four more years studying the landscape of the Roman Campagna and the Alban hills. Under the clear Italian light he developed a poetic style, intimate and quiet, which he carried home to record the American scene, east and west.

Climbing over the same terrain that Thomas Cole had explored a generation earlier, Whittredge looks out across the Alban valley in the direction of Rome. Though the view is expansive, the artist emphasizes less the sweep of the earth than its gentle undulations, the harmony of nature, and a sense of timelessness. Ancient ruins and contemporary shepherds tending their flocks are equally at peace within the calm ebb and flow of the hills and valleys. In the left middleground is the shepherds' habitation, a structure of a type unchanged for centuries, reasserting the continuity of the immemorial past and the pastoral present.

The curve of the amphitheater keys the composition, which is developed as a sequence of swinging curves and interlocking arcs. The play of light across the picture is equally consonant, never disrupting the eye's easy progress. In the center of the painting, a bright yellow patch of sun is a reposeful focus.

The title is inexact, though Whittredge may not have realized it. Tusculum, one of the most ancient Latin cities, has an amphitheater, still relatively unexcavated, which once seated 3,000 people. The subject of this painting, on the other hand, is clearly a charming little nearby theater excavated in 1839. It is from this theater, backed against the hill, that one sees this enchanting vista.

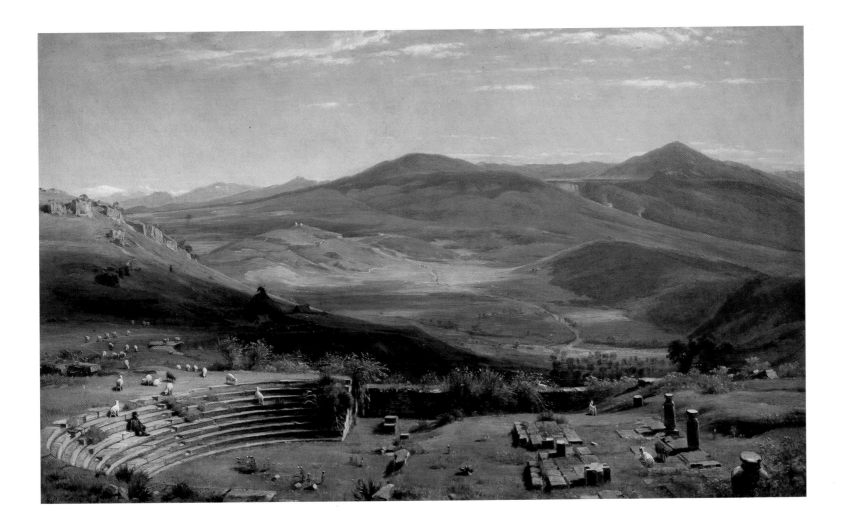

19

William Henry Rinehart (1825–1874)
Sleeping Children 1869 (first modeled 1859)
marble
38.9 × 93.3 × 47.6 cm
Gift of Mrs. Benjamin H. Warder

"I have just finished a group of sleeping children for Sison [*sic*].
I sent Walters a photograph of them," wrote William Henry
Rinehart, from Rome in 1859. He was referring to the original
"sleeping children" sculpture, conceived as a marker for the
grave of the children of Hugh and Sarah Sisson, in Greenmount
Cemetery, Baltimore. Presumably, the commission was for two
children who had recently died, but between 1855 and 1864
the Sissons lost five children altogether. This shocking
reminder of infant mortality in the last century explains the
mordant appeal of Rinehart's creation; there are twenty-five
known replicas in marble and plaster, including this one.
(The original plaster is at the Peabody Institute, Baltimore.)
They brought good prices, which probably accounts for
Rinehart's business-like tone in his letters. As with Hiram
Powers (see p. 42), the marbles were largely or entirely the
work of professional stone cutters in the artist's employ.

Funerary monuments that depict children and infants
merely "sleeping" were not without precedent. Indeed, sleep
is the usual metaphor for death in nineteenth-century funerary
sculpture. It is possible, however, that Rinehart's work had a
different prototype. About 1607 or 1608 Caravaggio had
painted a "Sleeping Cupid." This work, to which the Rinehart
group bears some resemblance, was in Florence by 1618,
when it was copied in fresco on a palace façade. In 1675 it
entered the Pitti Palace collection, where Rinehart could have
seen it while living in Italy. It is very likely that its meaning
derives from the "Amors," nude children, often with wings,
in Roman funerary sculpture who symbolize the soul and the
loss of earthly desire. Rinehart's borrowing, if such it was,
was in keeping with Victorian sentiment.

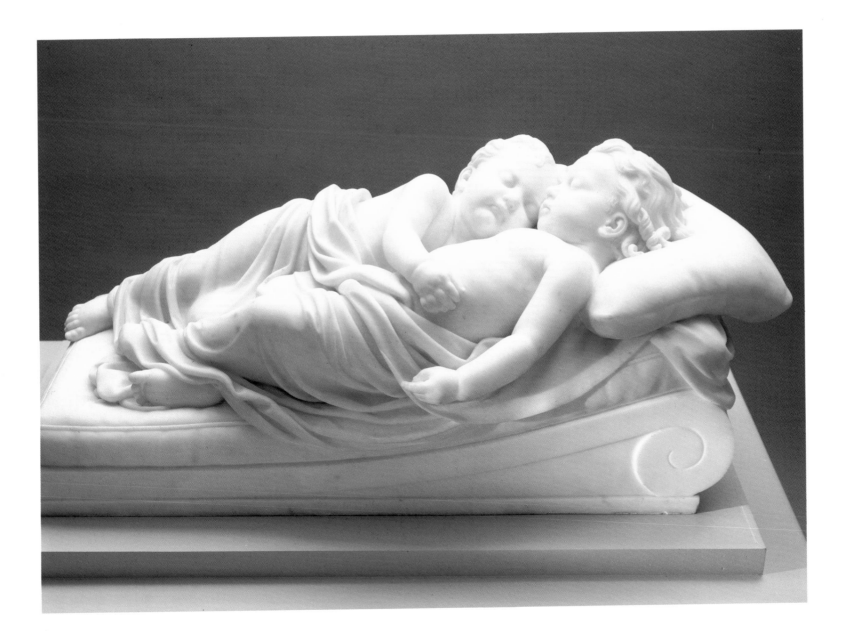

20

John F. Francis (1808–1886)
Luncheon Still Life ca. 1860
oil on canvas
64.6 × 77.2 cm
Museum purchase

Elegant, cool, graceful – John Francis's still life has presence, dignity, and self-confidence in abundance. The title is curious, and probably not the artist's, for the sky indicates it is late afternoon, and a luncheon of oyster crackers, grapes, oranges, walnuts, and almonds washed down with wines and water is pleasant, but unlikely.

The intensely studied objects yield secrets of volume and texture, color and translucency. At the same time, Francis has staged the scene superbly. The overall pyramid design unites contrasting sides. The left has fuller forms and is more compact and closed, both in the dominant basket and the wall behind. The right opens not only to the distant landscape, but also between the svelte verticals of the glasses. The positioning of the bottles and glassware, like notes on a staff, is accomplished with clarity and confidence; the subtle play of the heights of these containers and the liquids in them produces a passage of exquisite visual counterpoint.

Although Francis is remarkably free in his handling of paint, he is adept at imitating textures, as seen especially in the blue-and-white bisque porcelain pitcher. In general he prefers slightly matte surfaces and adjusts even glistening materials in that direction. His palette is dominated by orange and pale yellow, nut brown and straw tints, but a lovely note of pale blue threads through the painting. Generated by the prominent blue in the pitcher, the hue is picked up in reflections in the adjacent tumbler, echoed in the border of the cloth draping the basket, and then arbitrarily repeated as highlights on the wine glasses. The artist also delights in the skillful depiction of transparency, as in the tumbler overlapping the pitcher or the basket dimly seen through the bottle.

Although there does not seem to be any suggestion of the "interrupted meal" theme – with its intimations of mortality – from the Dutch still-life tradition, the painting has an elegiac mood. The red-streaked, darkening sky and the long shadows cast on the table recall Emily Dickinson's "certain slant of light . . . When it comes, the landscape listens, / Shadows hold their breath."

21

Emanuel Gottlieb Leutze (1816–1868)
Westward the Course of Empire Takes Its Way 1861
oil on canvas
84.5 × 110.1 cm
Bequest of Sara Carr Upton

Far more than his *Washington Crossing the Delaware*, with its improbable posturing, Leutze's *Westward the Course of Empire* occupies a meaningful niche in American history painting. Equally theatrical, it convincingly carries a more potent freight of national symbolism.

One of two oil studies for a huge staircase mural in the House of Representatives then under construction – the most important commission of the artist's career – this painting probably was the working model. The title is from stanza six of Bishop George Berkeley's poem, written during his sojourn in America between 1729 and 1731, "On the Prospect of Planting Arts and Learning in America": "Westward the course of empire takes its way;/The four first acts already past,/A fifth shall close the drama with the day:/Time's noblest offspring is the last."

Leutze presents his pioneer wagon train with a sure sense of drama. The canvas is divided diagonally into realms of light and shadow, and the majority of his figures struggle upward from the dark valley. Just short of the summit, marked by a cross, a burial is taking place. But Leutze's focus is on the rock platform in the middle distance, where a family gathers in a vignette of hope fulfilled. It is not merely the West they gaze upon, it is the Promised Land. The Great Divide was much more than a geological demarcation; crossing it was a symbol of redemption and the favor of divine providence. This metaphor of the New World as the New Eden was long established, but in his border vignettes Leutze left no possibility of misunderstanding.

Across the bottom border stretches a view of San Francisco Bay, the ultimate goal of the pilgrimage. It is flanked by medallions with likenesses of explorers Daniel Boone and William Clark. Above Boone, in the simulated relief carving, is the raven who brought bread to Elijah, balanced on the other side by the dove returning to the Ark with an olive branch. Above the raven is Moses descending with the Tablets of the Law, and on the right, Columbus with globe and compass. The next pair, left and right, are a Viking ship headed for the New World and the Hebrew spies returning from the Promised Land of Canaan with giant grapes, symbol of fertility as well as of the Eucharist. The upper left corner represents the Magi following their star, balanced on the right by Hercules with a scroll below him bearing a portion of the motto *ne plus ultra* ("nothing more beyond"). One and all, they are symbols of searching and salvation and divine intervention – in a phrase, of Manifest Destiny. The top border stars the eagle center stage, clutching an olive branch and arrows in its talons and flanked by Indians, a lion, and a tiger. As a symbolic collation, it is unsurpassed in American painting.

22

Lilly Martin Spencer (1822–1902)
We Both Must Fade (Mrs. Fithian) 1869
oil on canvas
182.8 × 136.3 cm
Museum purchase

Although a number of American women gained prominence as
sculptors in the mid-nineteenth century, Lilly Martin Spencer
was apparently the first woman painter to be ranked with her
male colleagues in this country. In an age that mistrusted
women in the arts and other professions, Mrs. Spencer seems
to have been lauded in part *because* "the hand that rocked the
cradle held the brush." Having had almost no formal training,
she nevertheless developed considerable skill in the detailed
rendering of various materials, as seen here in the satin and
lace. The popularity of this painting with her contemporaries,
however, must be traced to a timely blend of sentiment and
mood. Remarkably ambitious in size and detail, *We Both Must
Fade* clearly benefits from its implicit *vanitas* theme.

The young belle, in a splendid hoop-skirted, lace-trimmed
gown adorned with pearls, regards herself in the mirror with
a certain sangfroid. She holds, in the words of an admiring
poetaster, "the wreck of a full-blown rose, which has fallen to
pieces in her hand." The transience of the world's material
splendors is further enforced by two globe lamps – one sup-
ported by the Three Graces – both of which are extinguished.
A suggestion of amorous love as another transitory delight is
seen in two cupids, one a carved decoration on the crest of
the chair immediately behind the rose, and the other a similar
decoration beneath the table top on which the sitter leans.

Among the several objects whose reflections are seen on the
highly polished floor, the most curious is a dress-fitter's pin,
a final thematic footnote. It emphasizes the newness of the
lavish gown and plays it against the aura of mortality,
accentuating the theme of earthly vanity. Contemporary
response suggests that the painting was read as a melancholy
reflection or meditation on the aftermath of the Civil War.

23

Homer Dodge Martin (1836–1897)
The Iron Mine, Port Henry, New York ca. 1862
oil on canvas
76.5 × 127 cm
Gift of William T. Evans

Painted shortly after the artist established a studio in New
York City, *The Iron Mine* is a memorable youthful achievement.
Close to the work of John Frederick Kensett in its handling,
it is typically Martin in its subject and approach.

Out of simple elements, Martin constructs a solemn scene,
with the massive, richly textured cliff rising imposingly from
the bay. The serenity of the water's surface is in contrast to
the varied brushwork and impasto of the cliff. Martin uses
long, vibrant, curving strokes to describe the stratified rock
face; and where it has been penetrated by a mine access and
a natural cleft, the paint is kneaded and blended on the
canvas. At the right Martin's strokes are small and active,
almost impressionistic.

Although a miner's shack, a dock strewn with ore, and a
low-lying transport barge lie at the water's edge, there is no
life or activity here. In the absence of humanity, the shoreline
itself – a line of great finesse – is the mediator between the
rock and the water. These two elements are presented almost
as though they were competing philosophical principles.
The rock is dominant and restless, but the water along with the
layer of sky calms the agitated mass.

Martin probes his cliff diligently for its quirky details and
ponders its watery reflections, but in the end he subordinates
naturalism to invention. His friend Elihu Vedder reported that
on one occasion Martin "was found very busy painting some
plants in the foreground of a picture; on being asked what the
plant was, he said, 'Why, don't you know that plant? – that's
the foreground plant; I use lots of it.'"

24

Frederic Edwin Church (1826–1900)
Aurora Borealis 1865
oil on canvas
142.3 × 212.2 cm
Gift of Eleanor Blodgett

Within a vast polar landscape of blue green sits a tiny, ice-bound ship, two lamps bravely burning and a dog sled approaching. A huge, prow-like glacier looms behind it in an endless expanse of alien ice; and the awesome spectacle of the aurora borealis fans out to the heavens, its electric arc spanning the earth below.

In 1859 Church made a voyage to the Arctic, specifically Labrador and Newfoundland. As was his practice throughout his remarkable career of globe-trotting, he produced many oil sketches for subsequent use. But he was more than an artist-naturalist, a strong tradition in American art; he was also a liberal Calvinist, a nineteenth-century Puritan with fervent religious beliefs, as evidenced by his response to the Arctic scene: "Solemn, still, and half-celestial scene! . . . I said aloud, but low: 'The City of God! The sea of glass! the plains of heaven.'"

Church's remembrances and on-the-spot sketches remained unused until two more events, one political and one celestial, compelled him to develop them further. The Civil War was in its fourth violent year and terrible denouement in December 1864. General Sherman reached the sea on the tenth of that month, and General Thomas decimated Hood's army in Tennessee on the fifteenth. On the twenty-third, millions of northerners witnessed a majestic display of the aurora borealis. With the events of the preceding fortnight uppermost in mind, many saw the spectacle as an augury of approaching victory. One of the witnesses, Herman Melville, described the stupendous rays of the northern lights as a "million blades that glowed the muster and disbanding" of the armies. Church's masterpiece is a still richer testament to the belief that the event was an omen.

Although the ship is helpless, the approaching dog sled offers some small human hope of aid. This hope is amplified by the tip of a pyramid, with its associations of stability and eternity, rising behind and above the glacier, and especially in the calligraphic waves of light rolling grandly above, like a divine assurance of salvation.

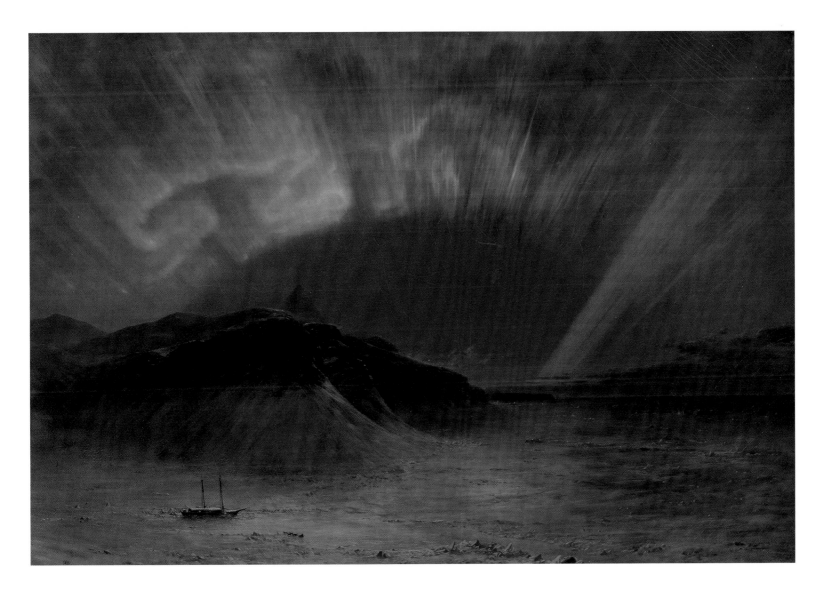

25

Samuel Colman (1832–1920)
Storm King on the Hudson 1866
oil on canvas
81.6 × 152 cm
Gift of John Gellatly

Of Walden Pond, Thoreau rhapsodized:

> *It is a mirror which no stone can crack,*
> *whose quicksilver will never wear off; . . .*
> *no storms, no dust, can dim its surface*
> *ever fresh; – a mirror in which all impurity*
> *presented to it sinks, swept and dusted by*
> *the sun's hazy brush, . . . which retains no*
> *breath that is breathed on it, but sends its*
> *own to float as clouds high above its surface,*
> *and be reflected in its bosom still.*

This description aptly fits the lake-like expanse of the Hudson River at Storm King Mountain, near West Point, as painted by Samuel Colman. Colman's image is more complex, however, for he is concerned with the place of steam-powered machines in the American landscape. Unlike Asher B. Durand in *Dover Plain* (see p. 44), he confronts the issue forthrightly and seems to reconcile the ideal of the New World paradise and the spirit of progress.

Three types of vessels are on the river. To the left, eight steam transport barges are moored side by side. In the right distance, two sailboats hug the shoreline. In the foreground are two rowboats – one plying toward shore and the occupants of the other gathering in a fishing net. The contrasts in motive power and use are clear, yet Colman effects a kind of parity. The steamboats, exultant machines of this brave new world, are physically dominant but motionless. The fishing boats are small but active. The sailboats, either pleasure craft or outmoded commercial vessels, are relegated to the background, but they are caught in brilliant sunlight that draws the eye to them. All of the boats are held in check by strong vertical reflections in the water, as if they were insects transfixed by a collector's pins.

Storm King is said to have been named for the meteorological phenomenon of storm clouds gathering at its peak. Here the bank of clouds is countered by the spumes of gray black smoke from the two nearest side-wheelers. Neither the boats' smoke nor the clouds are ominous, however; Colman simply uses their grays to weave a harmonious tapestry of the natural and the man-made. Although the work has been compared both to Turner and to French Salon painting, it is neither romanticized nor conventionalized. The union of close observation of nature and symbolic content, another example of Coleman's system of checks and balances, places this painting equidistant between the ideals of New England Transcendentalism and those of Manifest Destiny.

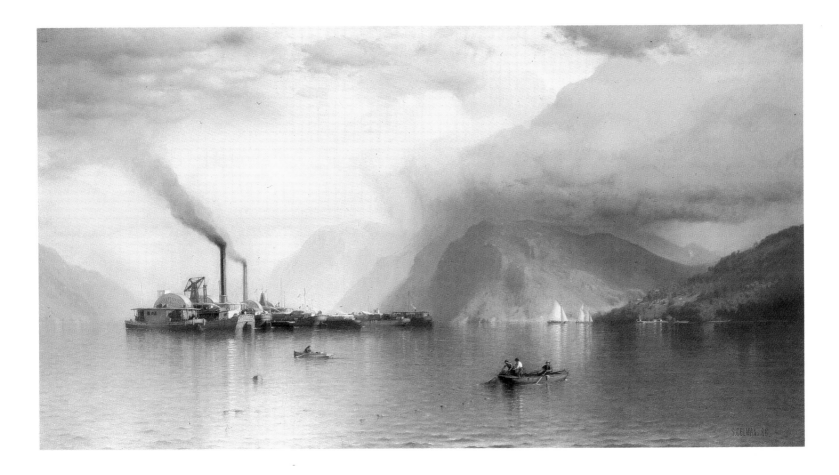

26

Albert Bierstadt (1830–1902)
Among the Sierra Nevada Mountains, California 1868
oil on canvas
183 × 305 cm
Bequest of Helen Huntington Hull

Bierstadt conveys the majesty of the western mountains so
convincingly that only a viewer already familiar with the
Sierra Nevadas – and few, if any, of Bierstadt's patrons
were – would recognize that the jagged profile of peaks in this
painting was a dramatic liberty. Memories of the Alps
embellished the American ranges, which Bierstadt had seen
and painted since 1859. In fact, Bierstadt had studied in Europe
and was touring the Continent from 1867 to 1869, when this
canvas was painted.

Although his smaller works were more informal and
spontaneous, Bierstadt invariably produced his large, studio
canvases as *coups de théâtre*. The scene is presented as if it were
a vast stage set, the proscenium effect enhanced by the dark
atmosphere of the mountains and sky at the left and stand of
trees at the right. The curving edge of the lake provides the
apron, the boundary and transition to the audience. Traditional
perspective leads the eye to the luminous core of the painting:
the gleaming lake surface, soaring mountain peaks, and
massive cloud banks.

But the major achievement of this painting lies in the
persuasive poetry Bierstadt distills from the landscape.
The grandeur is enhanced by a suspension of time and motion,
which transforms the scene into a magical realm. The small
herd of deer stand poised and listening, as if to the secret voice
of creation. Bierstadt's command of tonal effects is masterful,
and the eye bathes in an atmosphere as gentle as the peaks are
aggressive.

A passage of almost hypnotic intensity occurs where the
rocks meet the surface of the water. In their complex and
architectonic reflections, they frame the point where a torrent
cascades silently into the lake. The brilliance of light upon the
water at that juncture is startling. There, as elsewhere, nature
is transformed into a sort of American Valhalla, awaiting or
embodying its deity. This sense of sacredness is reinforced by
the absence of human life. The awestruck viewer is witness to
a miraculous landscape that he cannot enter.

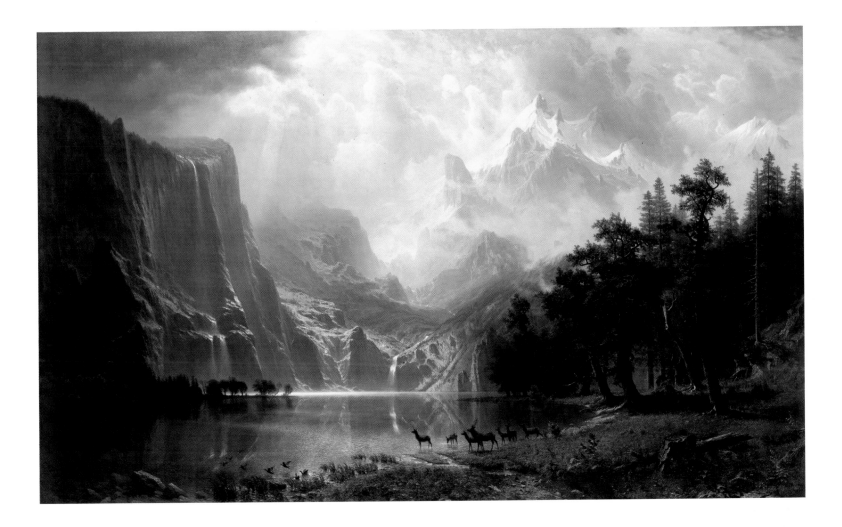

27

James McNeill Whistler (1834–1903)
Valparaiso Harbor 1866
oil on canvas
76.6 × 51.1 cm
Gift of John Gellatly

In 1866 Whistler sailed to Chile, avowedly to join Chileans in their war for independence from Spain. This bold altruism, one suspects, was an afterthought, for he took with him the tools of an artist not a soldier.

Of the handful of pictures painted there, all of them harbor or coastal scenes, this canvas is most closely related to *Nocturne: Blue and Gold – Valparaiso* in the Freer Gallery of Art and *Morning After the Revolution – Valparaiso* in Glasgow, for each of which it has sometimes been considered an unfinished study. It may be argued, however, that it is as complete as those pictures and that the three works are variations on the same motif from the same point of view.

Valparaiso Harbor was probably painted in the early morning, judging from the white-and-gray streaked sky. The hills, ships, and pier are veiled in smudgy, brownish grays, as though seen through rising morning mists. On the pier, the wispy figures are indeterminate and shifting. Whistler's interest here, as in most of his work, was tonal harmony. The limited palette, further muted by omnipresent grays, appealed to a refined and discriminating aesthetic temperament. In this sense the foggy morning scene aptly recalls Oscar Wilde's quip "Where the cultured catch an effect, the uncultured catch cold."

Whistler achieves a delicate equilibrium between painted surface and perspective depth. The high viewpoint and abruptly rising pier create forceful surface patterns. The Valparaiso paintings are acknowledged as the artist's first use of this compositional device, which derives from Japanese woodblock prints. Whistler made a bold adaptation, however, in that he applied it to a landscape composition; the Japanese had limited its use to interior scenes.

There is a certain resemblance – in composition, tonality, and subject – between Whistler's *Valparaiso Harbor* and Manet's *The Battle of the Kearsarge and the Alabama*, which was painted and exhibited in 1864. Whistler almost certainly knew the painting; he and Manet had shared the notoriety of exhibiting in the Salon des Refusés in 1863, and his early debt to Manet, not loudly acknowledged, is patent. Still, Whistler was (as Manet was once thought to be) far more interested in the "how" of art than the "what." His aesthetic abstractions, in the end, bespoke an utterly different temperament and intellect.

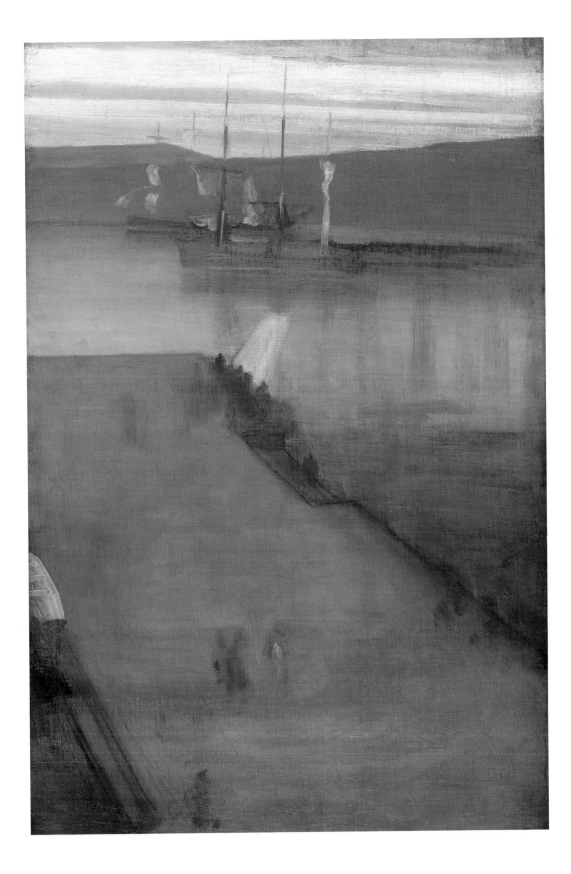

28

John La Farge (1835–1910)
Wreath of Flowers 1866
oil on canvas
61.1 × 33.1 cm
Gift of John Gellatly

Although this remarkable image is usually classified with still-life paintings, that does not do justice to the peculiar power and significance of La Farge's invention. In fact, the painting lies outside any category or definition.

A wreath hangs on a stuccoed wall, which is weathered and scarred. Oblong and off-center, with no visible means of suspension, it conveys a mood of isolation and longing. Even its shadow droops heavily. Although the flowers introduce pinks and yellows into the palette, the predominant hues are purples and the saturated green of the long leaves. The background is also somber, with grays, blues, and white scumbled over a dark plum primer.

The sense of time passed and pleasure lost is keen, and La Farge sustains it by the patient accumulation of paint, textured as if by exposure to natural forces. An inscription in Greek, seemingly scratched into the stucco, graffiti-like, provides an ironic, laconic footnote. It translates, "As summer was just beginning." Interruption of the "summer of life" is clearly inherent in the image, and it surely had special significance for La Farge at the time. Recovering from a serious illness and estranged from his wife, he had just sustained the further blow of the death of his infant son. It may have been these personal losses that inspired the image, or it may have been the premature death of Father Francis Aloysius Baker, an ardent disciple of Father Isaac Thomas Hecker, who had converted La Farge's wife at the time of their marriage. The theory that Father Hecker requested the painting is supported by the martyr's palm branch in the wreath and the fact that the first owner of the work was Father Hecker's brother. Here, loss and grief are compressed into a funereal icon.

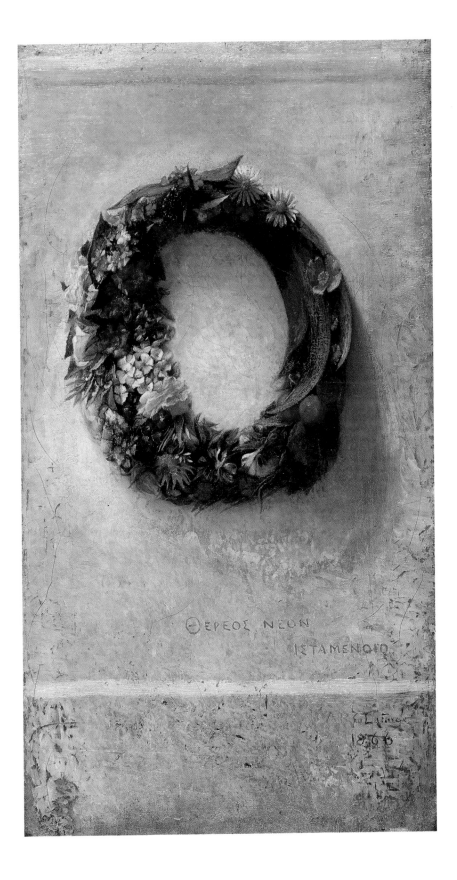

29

Thomas Moran (1837–1926)
Cliffs of the Upper Colorado River, Wyoming Territory 1882
oil on canvas
40.5 × 61 cm
Bequest of Henry Ward Ranger through the National Academy of Design

Painted, like all of Moran's oils, in his New York studio after the artist's return from a western expedition, *Cliffs of the Upper Colorado River* has an undiminished immediacy. The undulating rhythms of the foreground, dappled by shifting patches of light and shade, give way to the intense red browns and golden yellows of the sculptural bluffs. The phenomenal sky, a peach-and-buff tempest on a vibrant blue field, swirls and spires. No less theatrical than Albert Bierstadt (see p. 66) but less traditional in his dramatic mode, Moran employs a startling combination of grandeur and volatility. Whereas Bierstadt keeps us in our place as spectators before the proscenium, Moran permits entry into and interaction with the scene.

On his first western trip as part of Ferdinand V. Hayden's 1872 expedition, Moran discovered what would become his favorite, lifelong subject: the astonishing geological splendor of the American West. Unlike Bierstadt, who generally cast his eyes upward to the mountain peaks, Moran was particularly captivated by the great chasms and gorges of the Yellowstone and Colorado Rivers. From on high, he would paint the awesome gape of the earth beneath the sweep of the horizon.

The modest size of this painting is belied by a sensation of expansiveness. In part this is accomplished by the diagonal penetration of the soaring cliffs, in part by the small figures of mounted Indians riding toward a distant encampment. But above all, it is a result of the magnificence of color and flowing brushwork, which were characteristic of Moran's style. So convincing are his breath-taking panoramas that it is easy to overlook his pictorial inventiveness. Moran insisted that "topography in art is valueless," and he explained that "my general scope is not realistic; all my tendencies are toward idealization."

It is not known whether or not Moran accepted the doctrine of Manifest Destiny, with its uncomfortable blend of materialism and idealism and its overtones of land development. In any event, his pictorial idealizations, together with those of Bierstadt, were in some measure responsible for Congress's creation of a national-park system, which has come to be regarded as a paradigm of conservation.

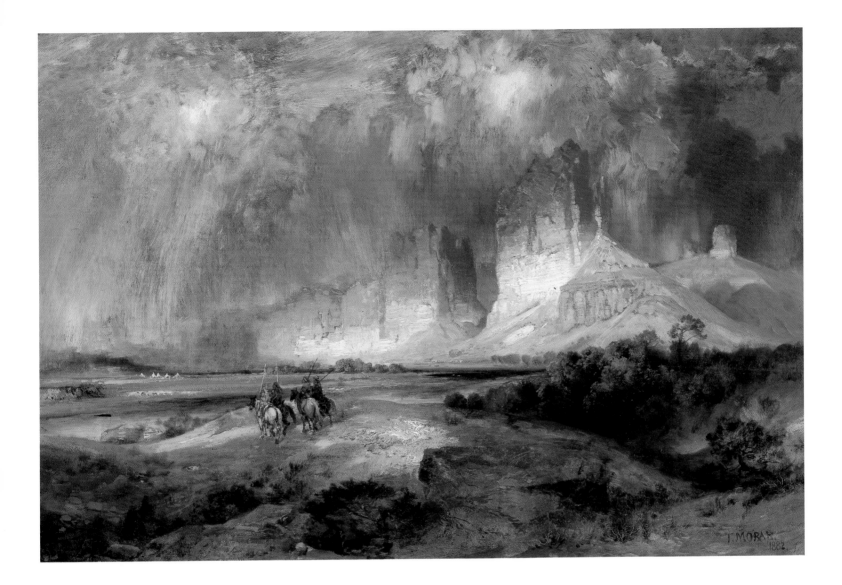

30

William Holbrook Beard (1824–1900)
The Lost Balloon 1882
oil on canvas
121.3 × 85.7 cm
Museum purchase

Ordinarily a painter of amusing scenes of animals dressed in human clothing and embodying human foibles, Beard passes from the merely fantastic to the visionary in this rare landscape.

At first glance a tonal landscape painting, *The Lost Balloon* is, upon closer inspection, a striking, mysterious work that piques the imagination. The cathedral rock at the right merges with the great sweeping bank of dark clouds that masks a brilliant sun, whose rays fan out toward shimmering waters below. The event set on this dramatic stage is a puzzling one. Nine brightly dressed children and a dog are clustered on a rocky plateau, which rises above the treetops of a surrounding forest. They all gaze upward to the left, where a silver gray, hot-air balloon with gondola is caught in its diagonal ascent by the spreading rays of the sun.

The innocence of childhood face-to-face with the unknown is captured in their incongruous presence on this seemingly inaccessible table-rock in a remote wilderness. The contrast of the gaily colored congregation with the subtle, somber values of the landscape evokes the wonderment and fantasies of the children's imaginations. Their rapt concentration on the fleeting vision of the balloon infects the viewer as well, who watches this wilderness Mary Poppins leaving him behind, questions unanswered.

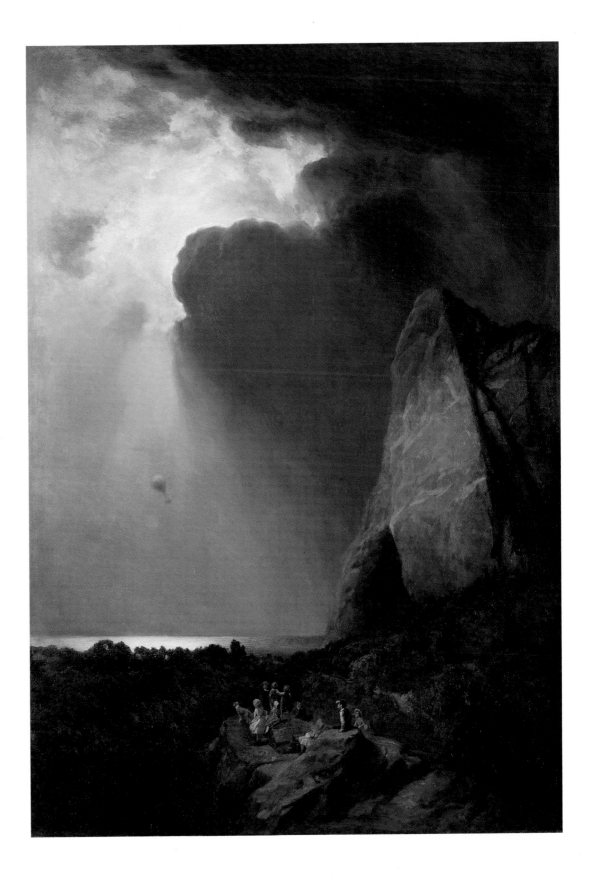

31

Albert Pinkham Ryder (1847–1917)
The Flying Dutchman ca. 1887
oil on canvas
36.1 × 43.8 cm
Gift of John Gellatly

A childhood in the old whaling port of New Bedford, Massachusetts, left an indelible mark on Ryder's psyche. Although he eventually moved to New York City, where he lived an eccentric and reclusive life, his imagination was most consistently stirred by the mysteries of the ocean. By the time he painted this work, he had crossed the Atlantic four times, less to tour Europe than to experience the sea.

Exhibited in 1887, his *Flying Dutchman* was inspired by a performance of Wagner's opera. The painting has little of Wagner and nothing of the theater in its appearance, though; its focus is the primal energies of nature in unceasing conflict, particularly the heaving sea. Yet more than any other American painter of his day, Ryder invented seascapes and landscapes of the mind, interior explorations. He has a certain kinship with Europeans like Edvard Munch, but his style, like his delvings into the subconscious, is more ingenuous.

In a small, dark boat, damaged and adrift, three figures gesture in terror at the apparition of the Dutchman's ship, looming large in russet tones against the orange yellow glow of the sun. The abrupt diagonal thrust of the clouds contrasts with the slewing sea – "such a lovely turmoil of boiling water," as Ryder said of another work.

The thrilling immediacy of Ryder's canvases was frequently the product of years of work and continual changes: "The canvas I began ten years ago . . . has been ripening under the sunlight of the years that come and go." The search was ultimately a metaphysical one. He compared himself to an inchworm, revolving in the air at the end of a twig: "I am trying to find something out there beyond the place on which I have a footing."

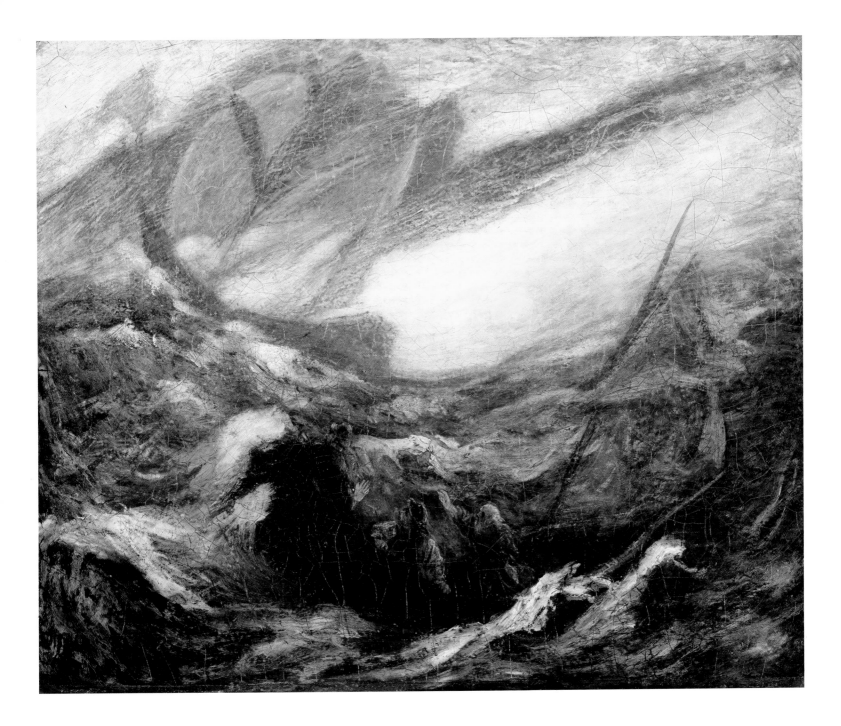

32

Ralph Albert Blakelock (1847–1919)
Moonlight, Indian Encampment 1885–89
oil on canvas
68.8 × 86.8 cm
Gift of John Gellatly

Blakelock, self-taught and inward-turning, inhabited a spiritual landscape of sunset and moonlight. In this painting he has taken a compositional page from Claude Lorrain, but turned the seventeenth-century artist's classical idylls into an eerie, nervous nocturne. The tight, obsessively drawn trees frame an opening into a spectral landscape glowing with an intense lunar light. But Blakelock painted out the full moon, so that the light has no apparent source. To the right in the dark foreground is an Indian encampment: two wigwams, four figures, a horse, and a campfire. To the left of the tall tree, an Indian stands silhouetted against the river as he contemplates the radiance.

It is difficult to peer into Blakelock's pictures and discern their contents. Always mysterious, they have darkened further over the years and seem to absorb their subjects into their very matter. The surface of this painting is densely worked. The black brown trees and foreground were laid in with a pigment containing bitumen, basically coal-tar. The warm depth of tone imparted by it unfortunately darkens irreversibly. Worse, its pliant consistency, so maleable under the brush, never totally disappears, and over the years the paint literally slips on, or even from, the surface.

In the river and the sky, Blakelock built up a network of pale colors, which he then scumbled and scraped down. His ceaseless brush applied conflicting strokes, and in places the paint seems to have been incised with a stylus, so that as the eye moves beyond the moonlit reverie it finds no rest. Blakelock's treatment leaves the surface scarred with runic markings, frequently serving no descriptive purpose.

In this idiosyncratic, compulsive working of the surface Blakelock was like an alchemist probing matter to create something more precious. The Indian group, the only warm note in this blue green and black canvas, has its own element of unreality. In the late 1880s, when the picture was painted, Indians could only have been a romantic evocation of a lost Eden. The artist's idealized, nostalgic ode suggests a desire for inner peace. In mood, however, it is closer to a threnody. That he signed his painting within the outline of an arrowhead, like a protective badge, is a subtle indication of his haunted personality.

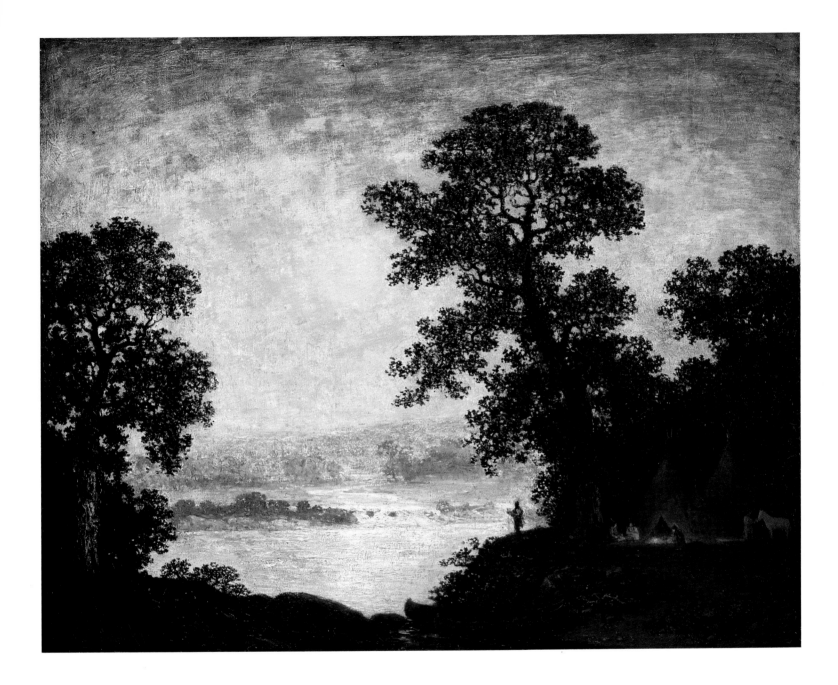

33

George Inness (1825–1894)
Niagara 1889
oil on canvas
76 × 114.3 cm
Gift of William T. Evans

Inness painted Niagara Falls numerous times but possibly only once directly from nature (another canvas in the collection of the NMAA). It was characteristic of the artist to return to a landscape motif through memory alone. His visual recall, while prodigious, was not literally descriptive. Particularly after 1880, he began to filter his recollections through his inherently mystical temperament.

For Inness, who embraced the pantheistic faith of the eighteenth-century scientist and mystic Emanuel Swedenborg, the landscape was less a subject for factual recording than a vehicle for contemplation of divine creation, a sort of spiritual sounding board. In *Niagara* he has labored to merge the finite with the infinite by rubbing and scraping his glazes until the layers are resolutely insubstantial. The painting is less a view of a specific site than an investigation of the elements of nature. It is not picturesque or topographic, not over-powering or brutal. Indeed, it is utterly inward-looking and silent.

The painting has virtually no drawing, no line. It is organized by tonal zones within which individual forms seem to dissolve and shift. The horizontal sweep of the falls is the essential structuring element, although this, too, is frequently indistinct. One striking, though diminutive, note in the composition has both pictorial and expressive significance. On the far bank, right of center, rises an industrial smokestack, from which clouds of smoke issue. The stack is a rare vertical in the painting, and its pinkish orange hue further draws our attention. Like Thomas Cole a generation before him, Inness forces the viewer to contemplate the antipathy between nature's majesty and man's trivial, but corrupting, intrusions.

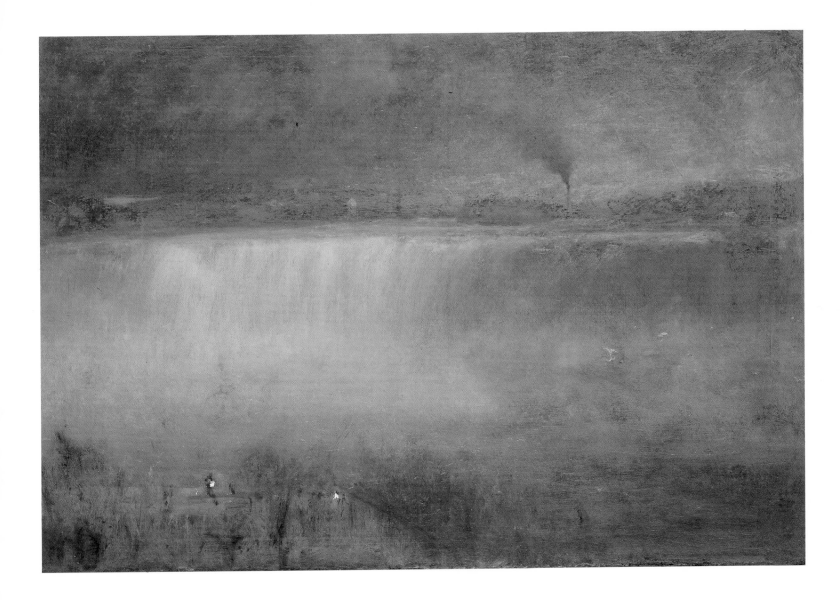

34

Thomas Wilmer Dewing (1851–1938)
Summer ca. 1890
oil on canvas
107 × 137.8 cm
Gift of William T. Evans

Among the most highly refined products of the Gilded Age were Thomas Dewing's exquisite fantasies of unknowable women in an impalpable Eden. Mounted in precious gilt frames of intricate craftsmanship, these effusions were avidly collected by wealthy esthetes. Charles Lang Freer, John Gellatly, and William T. Evans were among them, and each bought as if to own one Dewing picture was heavenly, to own ten might assure salvation.

Summer was, in the artist's words, "a decoration in the home of my friend Stanford White." (The eminent architect not only owned numerous Dewings, but also designed the frames for many of them.) In a meadow of pale greens against a cushion of deep green "trees" stand two young women in modish, yellow green gowns. One holds a fishing pole. On either side of center, they face a river of scattered blues and blue greens that runs toward the lower right. Despite the hints of the water's edge, the viewer feels no recession or spatial movement stronger than a soft palpitation of the yielding paint surface, like a momentary flutter of the pulse. The thin, blended brushwork is virtually directionless, increasing the sense of time suspended.

Disbelief must be suspended as well. Indeed, it takes a bit of effort to imagine the cushioned elegance that surrounded many of Dewing's paintings and their patrons, but it is worth it for the satisfaction of experiencing a tenuous dream skillfully sustained. It would be a disastrous disruption of mood if one dared to contemplate the dream lady actually catching a fish.

35

Abbott Handerson Thayer (1849–1921)
Angel ca. 1889
oil on canvas
92 × 71.5 cm
Gift of John Gellatly

Like other artists of the "American Renaissance," Thayer painted angels and madonnas, goddesses and classical personifications. His frames emulated Italian Renaissance examples, and there was a substantial moral thrust to his work. But he avoided decorative projects, such as the ambitious program at the new Library of Congress, and he was not a neo-classicist in the manner of Kenyon Cox (see p. 88).

One glance at the face of this celestial being, with her pale brown eyes, tousled hair, and individualized features, tells us that this is a most contemporary, unidealized angel. The fresh-faced model was, in fact, the artist's daughter Mary. It amused Thayer to nail the wings to a board and paint them and the background first, then pose Mary in front of them.

As first painted, the figure held a mandolin in one hand and lilies in the other. In the interest of simplicity and immediacy, Thayer removed the bottom of the canvas, accepting lack of resolution in exchange. The symmetry of the figure is not absolute. Her body is slightly turned on its axis to avoid a rigid effect.

While the face is striking in its fresh specificity and relatively high finish, the wings and the costume dominate the picture by their expanse of white. John Singer Sargent is recorded as saying, "No artist has painted white more beautifully" than Thayer. It is instructive to note that the strokes of white are intermingled with many other hues in the wings and in the costume. The brilliant immediacy of the work's high-toned palette, broad and energetic brushwork, and elaborate gilded frame combine for a stunning effect.

First shown at the 1889 Universal Exposition in Paris, under the title *Corps Ailé*, Thayer's *Angel* was a critical success from the start. More than thirty years later, at the Thayer Memorial Exhibition at the Metropolitan Museum of Art, the artist Maria Oakey Dewing (see p. 94) singled it out for its "spotless innocence and aspiration." As for Thayer, he never doubted its success. As he was completing the painting, he wrote, "I am blissful."

36

Elihu Vedder (1836–1923)
The Cup of Death 1885 and 1911
oil on canvas
113.9 × 57 cm
Gift of William T. Evans

So when the Angel of the darker Drink
At last shall find you by the river-brink,
And, offering his Cup, invite your Soul
Forth to your Lips to quaff — you shall not shrink.

These lines from the *Rubáiyát* of Omar Khayyám (in Edward
Fitzgerald's translation) were the inspiration for one of
Vedder's most compelling paintings.

With drooping forms and lugubrious movements,
two figures approach the verge of a dark stream. The Angel
of Death, whose great wings seem to suspend both figures
from the top of the canvas, leads and supports a young
woman. His right arm and hand presses a cup close to her
face with an angular urgency that is in striking contrast to
the full-weighted curves of the figures and their costumes.
The strength of that arm together with the ironic tenderness
of his attentions were perceived by a contemporary critic,
who described the angel as "full of might and mildness."

Within the vertical constriction of the space, the contours
of their bodies press tightly together as life passes into death.
The flowers that enliven the woman's hood contrast with
those falling from her nearly lifeless hand. The pink,
blue, and lavender that dominate the limited palette are
mixed with gray, casting a ghostly pallor over all. Shroud-like
draperies envelop the pair with a languorous, unceasing
movement. The shape of the rising moon, which is partly
obscured by clouds, echoes the hooded heads and connects the
figures with the night, even while its glow contrasts with the
dark river.

The formal relationship of Vedder's figures to Neo-classical
tomb sculptures such as Canova's *Monument to Maria Christina*
(Augustiner-Kirche, Vienna) has been noted by others.
The Romantic literary flavor of the painting is also close to
that of Keats's "Ode to a Nightingale," in which the poet,
"in embalméd darkness," is "half in love with easeful Death."

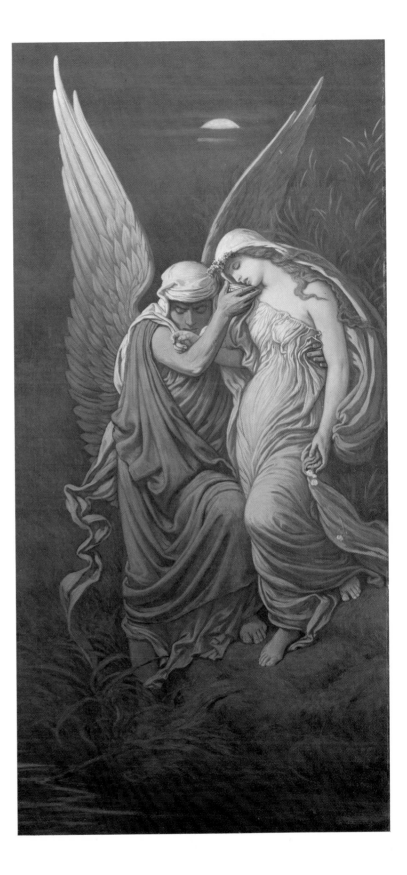

37

Kenyon Cox (1856–1919)
An Eclogue 1890
oil on canvas
122.5 × 153.6 cm
Gift of Allyn Cox

At the acme of his reputation between 1890 and 1910, Cox was equally renowned as a mural painter and an art critic.
His career paralleled a period of transformation in American and European art, however, and at the very moment he was refining his academic classicism for service in the "American Renaissance," radical changes in French painting – from Courbet, Manet, Monet, and Cézanne – were overtaking him. As a result, Cox's critical notes on his contemporaries sometimes became shrill as he saw his ideals dismissed by painters and collectors alike.

Although an easel painting, *An Eclogue* is fully representative of the artist's murals in subject and style.
The Vergilian title refers to a short, pastoral dialogue idealizing rural life. In a setting redolent of late summer and harvest, four young women gather in a meadow by an apple tree. The group as a whole is suavely composed. Three are "classically" nude or nearly so; the fourth wears a kimono-like robe. Three have apples, the symbol of the Three Graces, handmaidens of Venus who were described by Seneca as standing for the "threefold aspect of generosity, the giving, receiving and returning of gifts, or benefits." And the poses of the three figures correspond to the traditional representation of the Graces: two facing and one looking away from the viewer. The derivation of the partially draped nude from a classical Aphrodite is subtle, but clear.

The second seated nude does not interact with the others. She leans upon a sheaf of wheat, in front of which lies a sickle, and is clearly a personification of the harvest. The rising moon in the pale blue sky sounds an elegiac note. The painting might easily have been conceived as part of a set of the Four Seasons, or simply as a learned visual paraphrase of Vergil's eclogues, entitled "Bucolics."

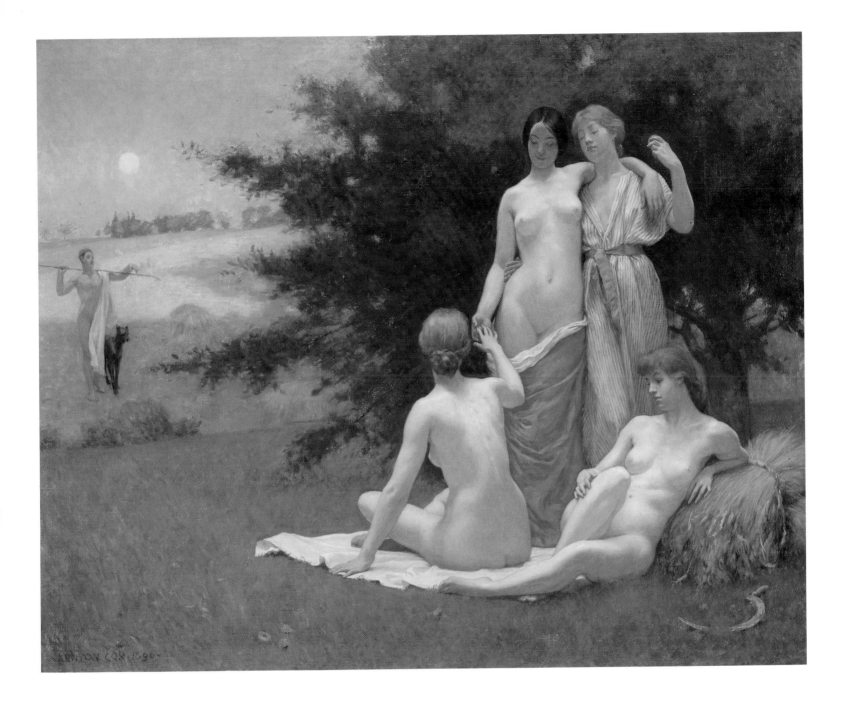

38

Augustus Saint-Gaudens (1848–1907)
Violet Sargent 1890
bronze
126.9 × 86.4 cm
Gift of Mrs. John L. Hughes

When Violet Sargent met Augustus Saint-Gaudens in February 1890, she was not yet twenty and on her first visit to America in the company of her illustrious brother, John Singer Sargent (see p. 102), both born in Italy of expatriate American parents. After their meeting in William Merritt Chase's famous Tenth Street studio in Manhattan, Saint-Gaudens asked her to pose for him. In exchange for this bronze portrait relief, her brother painted a portrait of Saint-Gaudens's young son, Homer.

Presumably executed in Saint-Gaudens's Cornish, New Hampshire, studio in the summer of 1890, this relief is a sensitive rendering of the delicate, young woman. Seated in profile, tuning a guitar, lips parted as if singing to herself, she conveys rapt absorption. The artist's modeling of her face and bosom, set off by the elaborate textures of her ruffled bodice and her hair, is smooth but varied. The graceful choker emphasizes her refinement.

The format and composition are rather startlingly adapted from Greek funeral stelae, from which the artist has drawn quiet poetry and dignity. The classically decorated chest upon which Violet sits is more like a sarcophagus than a bench, but the cartouche and scroll echo the shape of her guitar and even suggest musical symbols.

Saint-Gaudens's mastery of bronze relief sculpture is especially evident in the background, which is gently striated and undulating. The play of light over this richly modulated surface produces a remarkably pictorial effect. When the panel is examined from the side, it is also noticeably varied in thickness, with the greatest relief occurring at points of structural significance, like the top of the bench. The thinnest point is adjacent to the sitter's neck and head, thus accentuating their delicacy; while the relief of the figure is highest at the hand strumming the guitar, as though a swell of sound assumed physical dimension.

Saint-Gaudens's innovative use of the bronze portrait relief constitutes one of the most successful chapters in nineteenth-century American sculpture. In *Violet Sargent* he deftly packages charm and evanescence in a nearly monumental format.

39

Richard La Barre Goodwin (1840–1910)
Cabin-Door Still Life after 1886
oil on canvas
142.7 × 86.6 cm
Museum purchase in memory of the Reverend F. Ward Denys

Apart from portraits, which occupied the first twenty-five years of his professional life, cabin-door still lifes were Goodwin's primary subject. They were inspired by the enormous popularity of William Harnett's *After the Hunt*, exhibited in New York in 1886. Thereafter, Goodwin helped meet the demand for similar pictures, and any undated still lifes, like this one, can be ascribed to this period.

If he showed no inclination to experiment with other formats, Goodwin nonetheless produced his own distinctive treatment of the theme. His composition and coloring is harmonious and gentle, and an outdoorsman himself, he exhibits a somber respect for the birds and the artifacts of hunting.

Within the tall rectangle of the door, the birds, powder horn, and leather wallet or knapsack each describe a triangular shape and at the same time are united in one large triangle. Against this system of angles, a series of curves is played, beginning with little ones at the apex of the composition and swelling to broader curves in the large duck at the left and the powder horn.

As with other *trompe l'oeil* paintings in which the canvas imitates another surface or object, *Cabin-Door Still Life* is presented without a frame to break the illusion. At the same time, however, the gray green door establishes the color key of the painting and in so doing qualifies its illusionistic persuasiveness. Indeed, this is not a startlingly *trompe l'oeil* work. It is perhaps most illusionistic in the swelling breasts of the birds, but since they are tonally united to the door, the relief effect is mild. The handling of light is also reticent: it falls from the left but not at a dramatic angle, so shadows are short and of greater service to design than illusion.

There are, of course, some fascinating *trompe l'oeil* details, such as the paint worn away by the handle, the bent top hinge with missing screw, and the feathers clinging to the fringe of the wallet and surface of the door above the artist's "carved" signature. There is also the letter held by a large sliver of wood. The envelope's cancelled twenty-five-cent stamp and return address, which can be read as "La Barre," support the illusion, as does the letter peeking out from inside, but the address is illegible. Assuming that it was always so, it may be that it was a teasing gesture, drawing the viewer into the reality of the image and then frustrating his expectation.

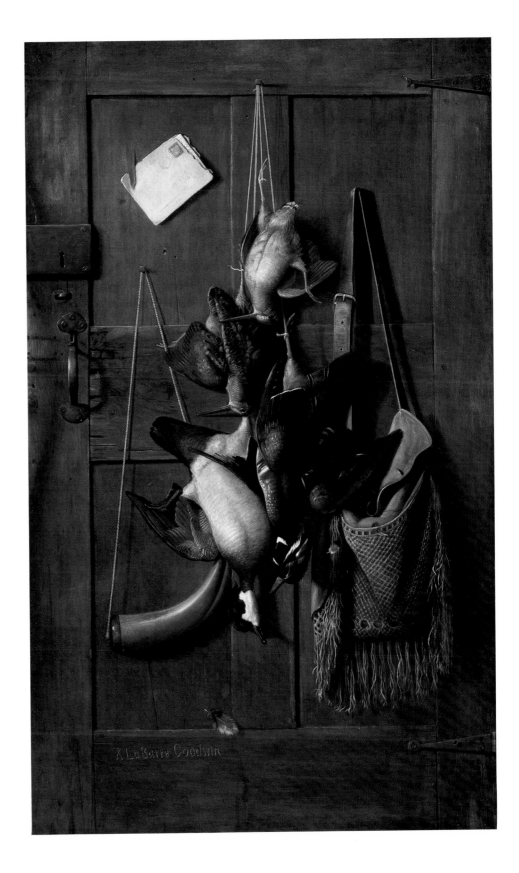

40

Maria Oakey Dewing (1845–1927)
Garden in May 1895
oil on canvas
60.1 × 82.5 cm
Gift of John Gellatly

Widely admired during her lifetime, the flower paintings of
Maria Oakey Dewing seem, in some respects, even more
remarkable today. When compared to French floral still lifes
of the same time, they appear strikingly original. Whereas
Monet, Fantin-Latour, Renoir, and even the fantasy-prone
Odilon Redon were all influenced by the still-life tradition of
the seventeenth-century Dutch masters, Dewing rejected that
tradition unequivocally. To her mind, the careful arrangement
of different species of flowers in a vase was an affront to nature
and the organic vitality of flowers.

 Garden in May is a corner of *her* garden seen in blooming
profusion. The hands-and-knees perspective of a gardener,
with no sky or horizon, thrusts us into the flowers' midst to
experience their luxuriance first-hand. In the riotous massing
of roses and tilting carnations, we feel the wafting of air and
the tugging of entwined stems and unseen weeds.

 The low, dark green hedge that fills the bottom right
foreground partly establishes a viewpoint. The bending
carnations move the eye across the canvas to the dense clutch
of roses in the top left corner. In the center, beneath a quiet
gathering of pink and white roses, an exquisite arrangement of
leaves and stems lends structural emphasis.

 Maria Dewing's sensitivity to nature's nuance is akin to that
of her husband, Thomas Wilmer Dewing (see p. 82), but more
robust, less a-quiver. Despite all the floral color in this garden,
it is green that dominates the palette and commands the eye.
No still life this, but nature alive and diverse.

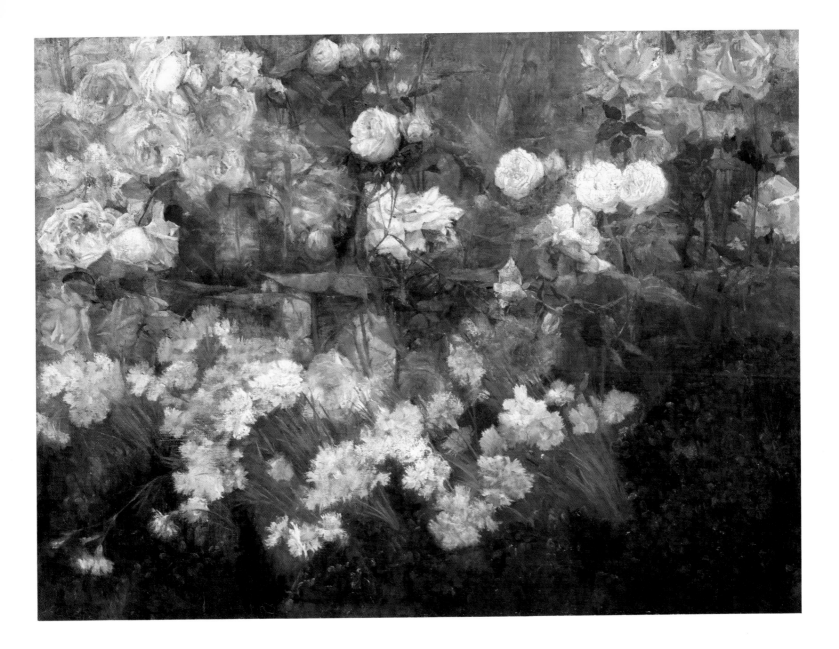

41

John Henry Twachtman (1853–1902)
Round Hill Road ca. 1890–1900
oil on canvas
76.8 × 76.2 cm
Gift of William T. Evans

One of the most well known of the American Impressionists,
John Twachtman is perhaps best understood when compared to
his older contemporary James Whistler (see p. 68), for both
were masters of tonal painting of the greatest subtlety.
Whereas Whistler focused on nocturnal scenes and seascapes of
gray, green, and blue, however, Twachtman's fascination was
with snow scenes.

At first glance *Round Hill Road* is little more than an
impalpable screen of snow and haze. On further inspection,
however, a simple composition becomes apparent. The
foreground is perfunctorily established by a wonderful
muddle of purplish blues in the road at the bottom left,
and the hedgerow, the line of poplars and houses, and the
nearly obliterated track of road hint at perspectival space
by funneling gently toward the right.

Nevertheless, the scene is filled with and flattened by the
substance of the paint and the dominance of the painting's
surface. There is a parallel here to Monet in his first maturity,
although it is closer to and anticipates his work at the end of
the century and the London paintings of 1903 and 1904.

The French Impressionists observed that neither pure black
nor pure white exists in nature, and snow was one of their
favorite devices for showing how white takes on all the colors
of its surroundings. By veiling his buff-colored prime coat with
blue and pink and then laying his snow-white over that,
Twachtman achieves a natural vibration of tones and colors
that convincingly supports this theory.

The sophisticated balance of his restricted palette is enhanced
by the even application of paint, the tight, regular weave
of the canvas, and the unusual square format. The regularity
is so persistent that each subtle variation – such as the pale
rose chimney of the house at the left – takes on special weight.
Such aesthetic finesse is typical of other artists of Twachtman's
day, but it also looks ahead to the color mysteries of Mark
Rothko and Ad Rinehart.

42

Winslow Homer (1836–1910)
High Cliff, Coast of Maine 1894
oil on canvas
76.5 × 97 cm
Gift of William T. Evans

Painted at the height of his powers, this view of High Cliff near Prout's Neck, Maine, the artist's refuge from civilization for thirty years, is remarkable in that the cliff dominates to an unusual degree. The mighty ocean is often the protagonist in Homer's pictures, but here the rugged wall of rock offers a formidable challenge – at the same time its deep furrows attest to the sea's ineluctable erosive power. Carved and softened by water, it seems to be the sea's other self, the stone hand awaiting the liquid glove.

Brushwork, palette, and texture join in faultless teamwork to articulate the natural drama. The water at the upper left is smoothly brushed in blue greens; the surface roughens approaching the shoreline, and the brushwork swirls where the surf spouts up from the rocks. There is no horizon, a device Homer often used to focus the viewer's attention.

The painterly vigor of the closer rocks in the lower right of the canvas so rivets our eye we feel that we are seeing all of High Cliff at close range. Then, abruptly, we catch sight of three tiny figures at the extreme top right, and our perspective shifts wildly as we measure the immensity of the cliff. This spatial push-pull, which never abates, is Homer's psychological coup-de-grâce. The absolute dominance of nature over man is established.

The canvas has been cut down along the right edge, and we can infer from a letter of Homer's that he made the change and did some retouching in 1901. One result of his alteration was that the tiny figures are squeezed into the corner, making them less immediately noticeable and thus delaying the punchline. For two years after this modification and much contemplation, the painting failed to sell, and Homer wrote bitterly: "I cannot do better than that. Why should I paint?"

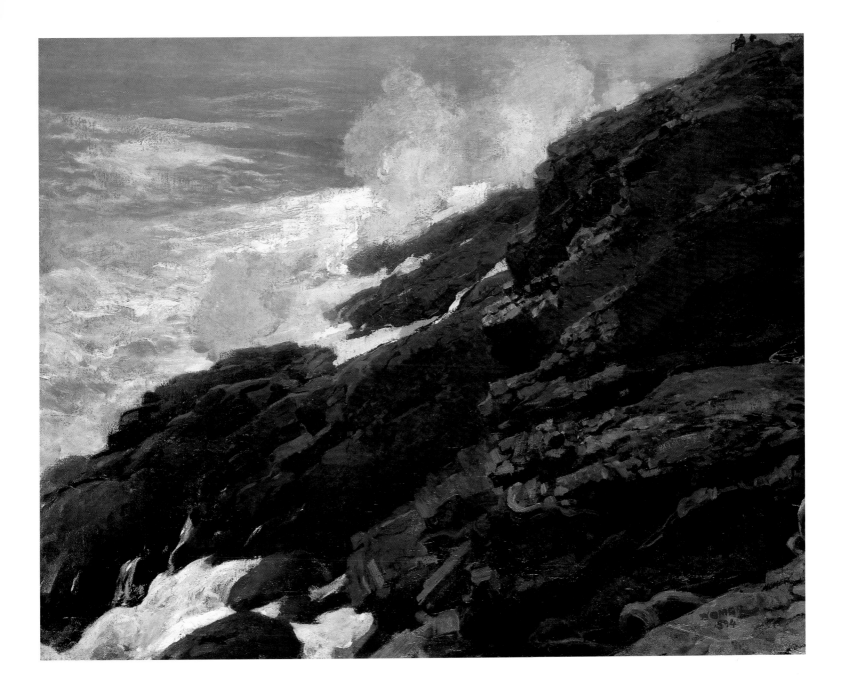

43

William Robinson Leigh (1866–1955)
Sophie Hunter Colston 1896
oil on canvas
183.8 × 103.9 cm
Museum purchase

Although this elegantly dressed young lady is obviously posed in the studio, the concept of placing her in a woodland glade instantly commands our attention. There are precedents for this conceit in English portrait painting, from Nicholas Hilliard to Wright of Derby, but they almost invariably convey a greater informality in pose than does this late-nineteenth-century version. Leigh emphasizes the disparity, rather than the harmony, between the formal sitter and the rustic setting.

The brilliant effect of the stunning white dress against the foliate background is achieved with consummate skill. The pyramidal construction of her strongly modeled figure and face impart a high degree of relief compared to the rather two-dimensional forest behind. The brushwork in the landscape is active, the strokes generally short and quick compared to the sturdy, broad brushwork of the figure.

Sophie Colston was Leigh's cousin, and the portrait was painted in his native West Virginia upon his return from twelve years' study abroad. It exhibits both the free brush-work of the Munich School and the shallow space and selective realism of the influential French artist Bastien-Lepage.

Admirable though the technical achievement is, it is the sharply honed personality of the young woman that makes a lasting impact. She radiates self-confidence and a will that will brook no contradiction. Her face conveys thought, not the reverie that the pastoral setting might suggest, and her parasol seems a potential weapon, so purposefully does she hold it. Her head is imbued with a physical and psychological presence that is enhanced by her golden scarf, which makes her neck a pillar of strength. The golden flowers on the underside of the bonnet and the glowing shadow on her forehead, together with the aureole formed around her head by the patch of sunlight in the glade, epitomize the dazzling light effects found throughout this memorable portrait.

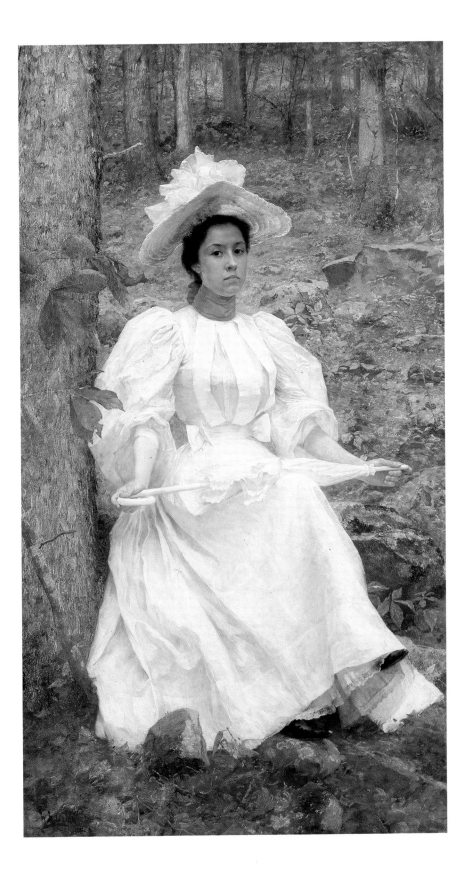

44

John Singer Sargent (1856–1925)
Elizabeth Winthrop Chanler 1893
oil on canvas
125.4 × 102.9 cm
Gift of Chanler A. Chapman

This young woman of spirit and determination – and an inner ardor under fierce control – was formerly identified as Mrs. John Jay Chapman, until a descendant pointed out that the portrait was painted five years before her marriage. This biographical fact is relevant to our understanding of the complex personality that Sargent has portrayed.

Elizabeth Chanler was the eldest of eight children of New York Congressman John Winthrop Chanler and his wife, Margaret Ward, a descendant of John Jacob Astor. After her mother's early death, Elizabeth raised her brothers and sisters, stabilizing the family. This responsibility as well as poor health during her childhood may have accounted for her withdrawn and sober temperament. Only twenty-six when Sargent (himself just thirty-seven) painted her, she looks more mature than her years. The sense of self-reliance is conveyed in the forthright presentation of the figure; the price of self-reliance is manifested in the set of the jaw, cords of the neck, and tensely interlocked hands. Especially noteworthy is the forced rotation of her right forearm and the twist of her hands such that the thumbs turn under and out.

Elizabeth Chanler's strength of purpose and nervous strain are adumbrated in a dozen other passages and details. The balloon sleeve on her left arm, for example, has a billowing, organic quality, like some fabulous black orchid. Its active, irregular contour contrasts with the brightly lit, symmetrical rigidity of her head. The shape of her jaw is mimicked by the carved pendant of the Renaissance-style picture frame behind her, and both are answered by the rising crest of that wonderful sleeve.

Throughout the composition there is a magnificent play between the rectilinear and the curvilinear. The firm grid formed by the picture frames and Louis XVI settee is reinforced by the placement of the sitter's nose precisely on the central axis, the vertical of her left upper arm, and the near horizontals of her lips, bodice, and right forearm. Within this framework are curves of varying latitude: small and controlled in the Renaissance frame and the sitter's head, larger in the sleeves and skirt, and expansive and loose in the richly colored brocade cushions on which she rests her arm.

The paintings on the wall behind the sitter have been tentatively identified as works belonging to Sargent. The one on the right may be an Italian school Virgin and Child, while the dark image on the left seems to be his copy of a figure from Frans Hals's portrait *Woman Regents of the Old Men's Home*. Although "studio props," not Miss Chanler's personal property, their themes of maternity, protection, and old age were then central to her life. That they are nearly illegible may indicate that they were a private reference shared by sitter and painter. In this vein it may also be significant that "Bessie" Chanler sat to Sargent in London, where she had gone for the wedding of a brother, and that the portrait was commissioned by a sister, perhaps as a token of gratitude for her devotion to the family. In any event, the bonds between sitter and painter seem to have been uncommonly strong, and the virtuoso Sargent, whose portraits were sometimes all flash and fluff, incisively captured the vulnerability and resilience of this wealthy, yet emotionally burdened, young woman.

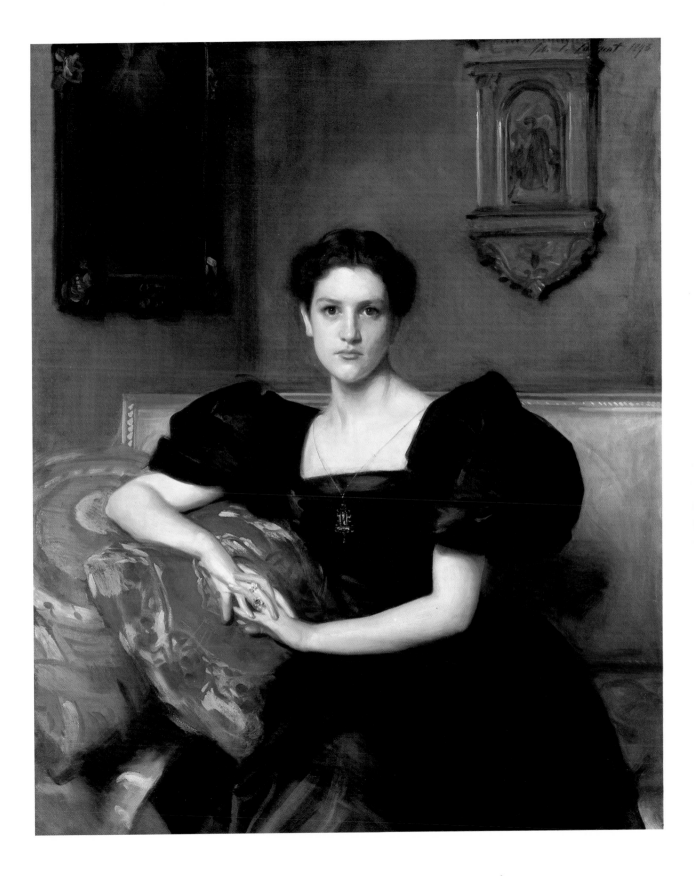

45

Cecilia Beaux (1855–1942)
Man with the Cat (Henry Sturgis Drinker) 1898
oil on canvas
121.9 × 87.8 cm
Bequest of Henry Ward Ranger through the National Academy of Design

Cecilia Beaux was forty-three and in the full maturity of her career as one of America's most distinguished portrait artists when she painted this work. The sitter here is Henry Sturgis Drinker, the artist's brother-in-law. Forty-eight years old at the time of the portrait, he had been general solicitor of the Lehigh Valley Railroad Company since 1880. In 1905 he became president of Lehigh University.

Man with the Cat confirms Beaux's high level of achievement and leaves one perplexed that her name is not better known to a wide public today. The artist's supple technique and luscious palette have an authority no less commanding than the sitter's forceful presence. His pose, combining the severe frontality of the head with the casual torsion of the body, seems keyed to the nervous poise of his splayed hand.

The forthright presentation of the head is reinforced by the smooth, slat-like strokes of the background, whose cool gray greens offer a foil to the warm-to-hot tan, pink, and red of the face. Below the shoulders, the freedom of the sitter's pose is expressed in the swinging brushstrokes and agitation of light and shade. The activity tapers off at the shadowed left thigh, lying calmly parallel to the picture plane and supported by the pyramidal legs of the hoop-back Windsor chair. The bravado of abbreviated brushstroke in the leg's turnings is only surpassed by the arm of the chair, which simply stops short on either side of the cat's head.

The warm mauve puddle of cat comes to life in the animal's head, with ears pointed and eyes narrowed. Beaux seems to play those narrowed eyes against Drinker's intense, staring ones. The combination in the cat, as in the man, of casual repose and high-strung intelligence suggests that the artist well understood the ambiguous relationship that exists between cats and their presumed masters. The cat is also related to the sitter through shared pinks and mauves, and through their respective side-whiskers. These wispy billows bring a touch of whimsy to the gentleman's stern demeanor.

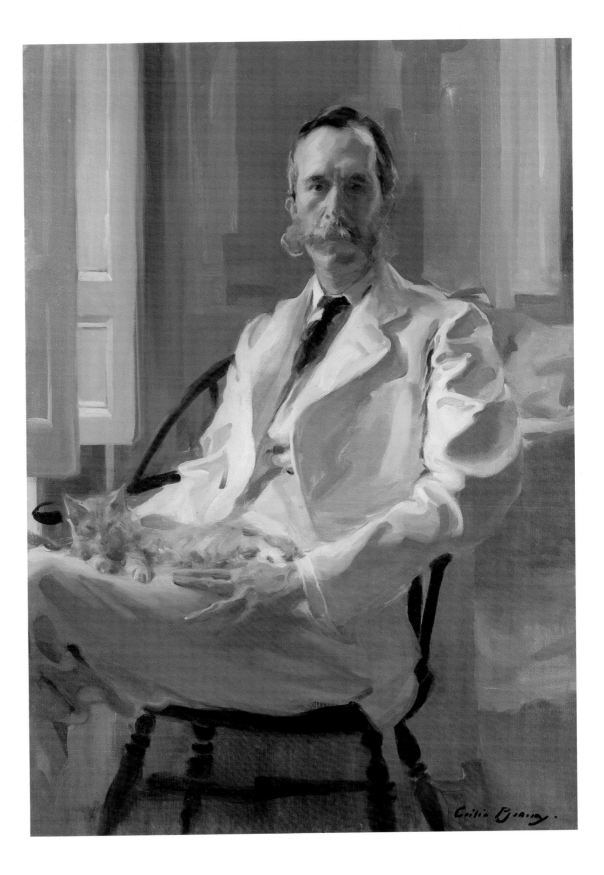

46

Mary Cassatt (1844–1926)
The Caress 1902
oil on canvas
83.4 × 69.4 cm
Gift of William T. Evans

The theme of Mother and Child was taken up by Cassatt in 1880, and after the turn of the century was virtually her only subject. Whereas many of her earlier paintings were portraits of family members or clients, the late works were generic pieces using a few professional models again and again. The young blonde model in this painting was named Sara; the woman, Reine Lefebvre. The nude baby can be seen in another painting of the same year in the Worcester (Mass.) Art Museum.

Cassatt roughly patterned her mother-and-child groups on Italian Renaissance paintings of the Madonna and Christ Child. In *The Caress*, a third figure recalls the infant John the Baptist, often included in this traditional theme; and the almost Mannerist curve of the baby's body suggests a possible source in Parmigianino, whom Cassatt had studied closely.

The tight composition is dominated by the sweep of the infant's body reinforced by the mother's right arm and the children's hands, all played against the acute angle of the woman's left arm, the strong verticals behind her head, and the prominent horizontal stroke above the girl. Cassatt was a splendid and innovative colorist, as seen in the woman's emerald blouse, pale yellow yoke and collar, and lavender skirt or shawl with multi-colored pattern, together with the blue green upholstery of the chair.

The bold poses and assertive palette are countered by the pronounced mood of abstraction conveyed by the disparate gazes of the figures. Physically they could not be closer, but psychologically there is little interaction, no intimate familial rapport. The general feeling of distance underscores the fact that the figures were not related and that formal design considerations were uppermost in Cassatt's mind. It was probably this combination of emotional distance, upper-middle-class costume, and Renaissance references that provoked Degas to say of a similar Cassatt, "It is the baby Jesus and his English nanny."

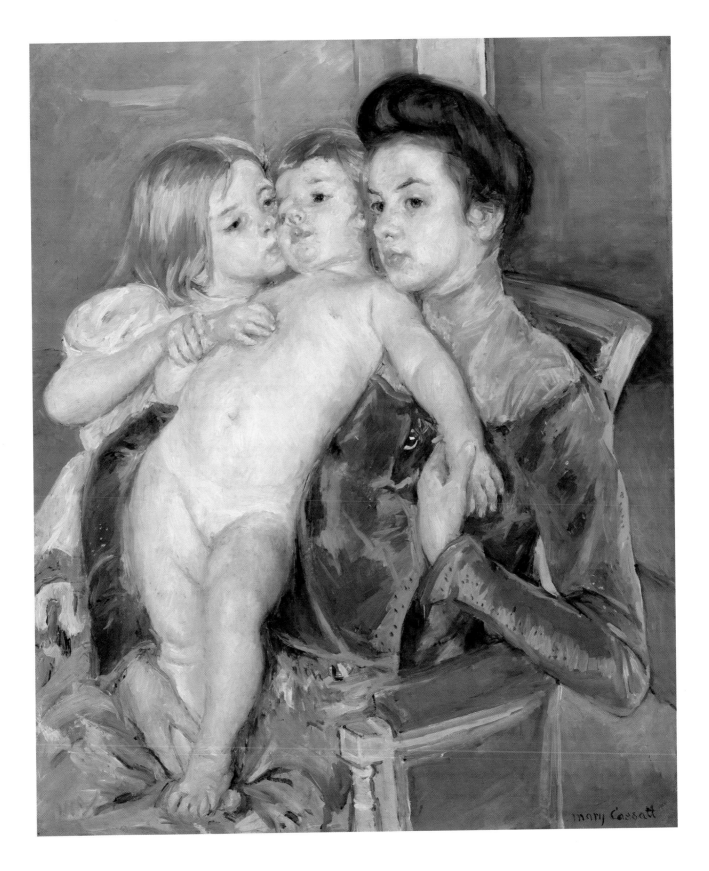

47

Julian Alden Weir (1852–1919)
Upland Pasture ca. 1905
oil on canvas
101.2 × 127.6 cm
Gift of William T. Evans

Throughout Weir's art there is a love of particular places.
The familiar fields and hills of the artist's Branchville,
Connecticut, farm provided him with the subject for many
paintings, including *Upland Pasture*. Mellow and unpretentious,
the scene is dominated by the chalky, gray green shadow that
falls across half the picture and establishes an introspective
mood.

Although Weir is usually classified as an American
Impressionist, the dense and weighty pigment of *Upland
Pasture*, which is often broadly brushed, suggests that modern
French painting held less fascination for him than for
compatriots like Childe Hassam (see p. 110). Weir's style in
this late work is in this way more reminiscent of the Barbizon
painting that he would have seen on his first trip to France in
1873 than to the mature Impressionism he encountered on his
second visit a decade later.

Here, as in the majority of his paintings, Weir is primarily
interested in achieving a sense of permanence by ordering the
surface with large patches of light and shadow, avoiding the
transience suggested by Impressionist flecks of color. Such
tonal painting is typical of much American landscape art,
which often expressed moods or ideas through the landscape,
unlike Impressionism, which strove for a more objective
recording of nature.

Weir's enduring and unsensuous pasture land is as much a
metaphor as William Cullen Bryant's "hills/Rock-ribbed and
ancient as the sun." His sober ruminations on the yellow gold
fields and the putty white rocks mark him, in collector Duncan
Phillips's words, as "the poet-painter who sang the song of
spring and summer and autumn in the American countryside."

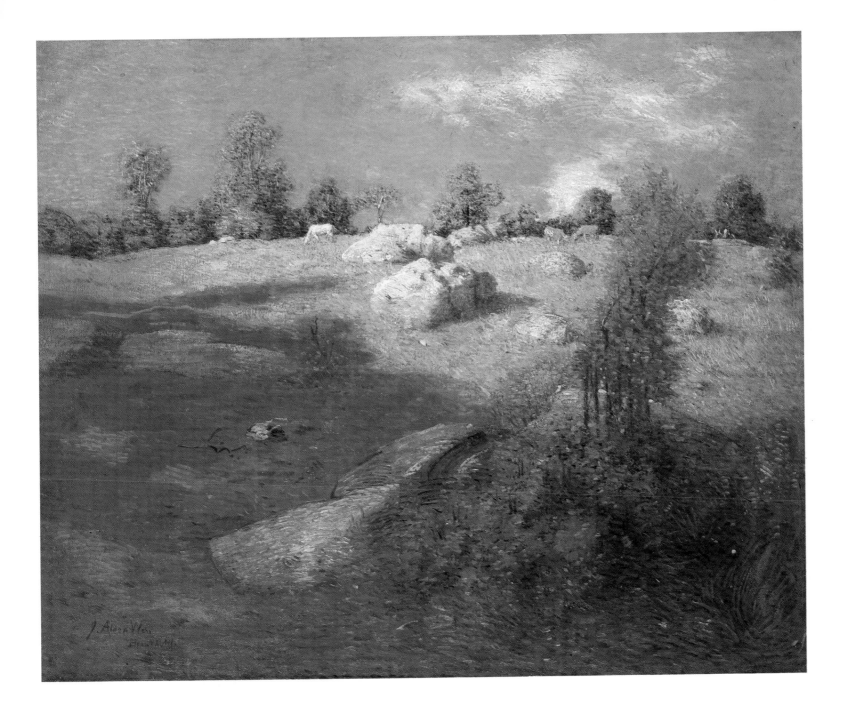

48

Childe Hassam (1859–1935)
The South Ledges, Appledore 1913
oil on canvas
87 × 91.6 cm
Gift of John Gellatly

Childe Hassam went to Appledore in the mid-1880s, drawn by a summer salon of artists and writers revolving around Celia Thaxter (1835–1894), an admired essayist and poet. Thaxter's opulent, informal flower garden was a favorite subject for Hassam and others, a contrast to the harsh, granite island itself, depicted here.

In this vibrant evocation of one of the Isles of Shoals off the coast of New Hampshire and Maine, Hassam takes his primary inspiration from Monet. The composition, with its high point of view and extremely high horizon, is particularly reminiscent of Monet's Belle Isle paintings. The diagonal of Hassam's coastline is charged with an irregular, craggy expressionism, while the sea that lies above and beyond it is laid in with regular horizontal strokes capped by the horizon. This clear division is emphasized by the nearly square canvas.

The painting is similarly divided into strongly contrasting areas of color and light. The sun-drenched foreground – dominated by a large, central rock – is a wonderful melange of gray flecked with yellow, orange, pale pink, vermilion, and green, all touched in with sparse and thinly blended strokes. This use of pure colors to re-create the effect of brilliant sunlight on the landscape is pure Impressionism. The ruggedness of the darker rocks beyond is rendered with denser, more emphatic strokes of orange brown with purple and cobalt blue.

The vibrant expanse of ocean, in contrast, is painted with a far more limited palette. Over the buff-colored primer, Hassam laid an intense blue, mixing it with green at the horizon and purple near the shore. The buff ground often shows through as rhythmical flecks in the water.

In the figure of the woman seated on the rocks, her back to us, Hassam achieves extraordinarily subtle effects of light and color. Her white dress, violet sash, and yellow white sun hat with deep purple band are expertly balanced with the surrounding rainbow of rock. There is something modish about her pose and her costume, which is typical of Hassam, whose figures often have the allure of a *Vogue* fashion model. On the other hand, there is a wistful, end-of-summer aura about her. In fact, Hassam never returned to Appledore after the summer of 1913.

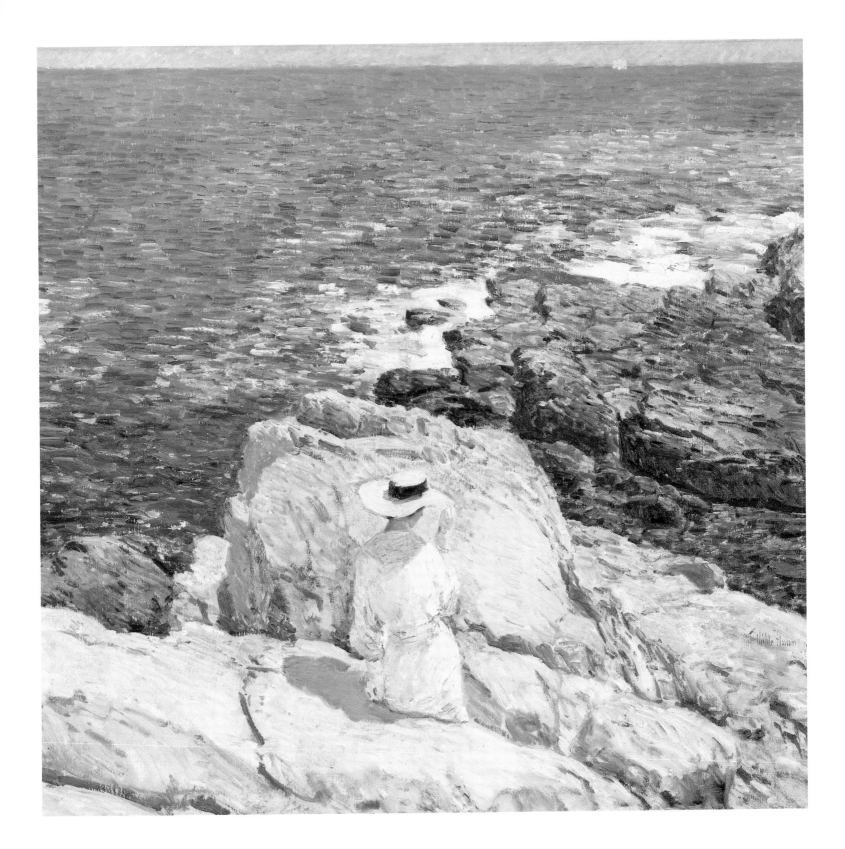

49

Maurice Prendergast (1859–1924)
Summer, New England 1912
oil on canvas
48.9 × 69.9 cm
Gift of Mrs. Charles Prendergast

This idyllic depiction of women and children strolling in a park-like setting evokes a mood of well-being and contentment, together with a certain detachment from reality. This is furthered by the exaggerated anonymity of the figures and the absence of a feeling of place. Anywhere and nowhere, the scene conveys a general, not a specific, sense of leisure and enjoyment.

The canvas is thickly covered with a wide range of intense colors applied in short, nubby strokes. The richly textured paint is stubbled and scrubbed in dense patches of color, almost in a finicky manner. These patches alternate with and are sometimes defined by cursive strokes of pure color, which set up an echoing rhythm across the surface. The repetition of small and regular elements produces a homogeneous surface, which is further regulated by the verticals of trees and figures overlaying the horizontal bands of the ground, water, river bank, and sky. All these parts are simply overlapped, with no serious attempt at either aerial or linear perspective.

Prendergast did not begin to paint seriously until 1891, the year of his first visit to France. Three years' study in Paris introduced him to some of the most recent developments in art. This included the work of the Neo-Impressionists, whose technique of pointillism (the juxtapositioning of small dots or commas of pure, primary colors) is echoed in Prendergast's less regimented work. In addition, he saw the intimate domestic scenes by the French painters Vuillard, Bonnard, and Denis, which were first exhibited at precisely this time. With these artists, Prendergast shared a predilection for strongly patterned surfaces as well as tranquil subjects.

Although he may be credited with introducing these currents of French modern art into the United States, Prendergast is never as radical in his own painting. His stylistic range was narrow, and his art seems more static and complacent. *Summer, New England* attests to this: its surface has something of the appearance of sea-worn pebbles on the strand, similarly textured and turned, motionless and with no inherent dynamic potential.

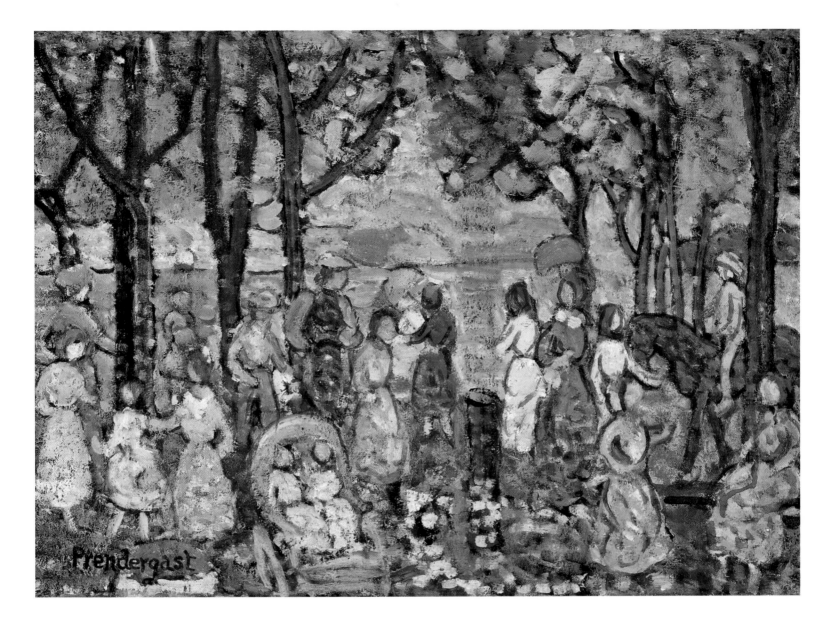

50

Rockwell Kent (1882–1971)
Snow Fields 1909
oil on canvas mounted on linen
96.5 × 111.7 cm
Bequest of Henry Ward Ranger through the National Academy
of Design

For the generation or two that grew up with his book illustrations and book plates, Rockwell Kent's distinguished achievements as a printmaker have obscured his abilities as a painter. To painting he brought the same breadth of form and bold contrasts that distinguish his graphic work, but his canvases were essentially free of the narrative content of many of his prints. His spare subject matter combined with the large scale of many of his easel paintings to produce some of the most powerful images of early American modernism.

Snow Fields, a vigorous example of the artist's youthful work, is divided into three expansive zones of snow, hills, and sky. This masterly simplicity carries through into the fluent brushwork. Kent loads on the paint but brushes it smooth, avoiding impasto in favor of a homogeneous surface.

The effects of a winter sun are skillfully translated into paint, with the women, children, and dogs becoming unmodeled patterns set against its brilliance. Shadows of brown, mauve, and blue evidence Kent's close observation of natural light, as does the primarily light green sky, which intensifies at the upper right, where the sun radiates through the haze.

Kent's handling of paint is partly indebted to John Sloan, George Luks, and Robert Henri (with whom he studied), all members of "The Eight," who had their first group exhibition in 1908, the year before *Snow Fields* was painted. Among his exact contemporaries, however, Kent most resembles Edward Hopper in the keen sense of isolation in his paintings and in his broadly conceived compositions.

Still, it may be more appropriate to look to an older generation for influences. Kent's apprenticeship with Abbott Thayer (p. 84) is relevant when one recalls the brio of Thayer's aggressive brushwork and their mutual love of rural retreats. Above all, Kent seems to be the true heir of Winslow Homer, whose solitary and iconoclastic spirit pulsates in the younger artist's full-bodied, deep-breathed landscapes. As the history of American modernist art is increasingly distinguished from its European counterpart, it seems certain that Rockwell Kent's critical stature will grow.

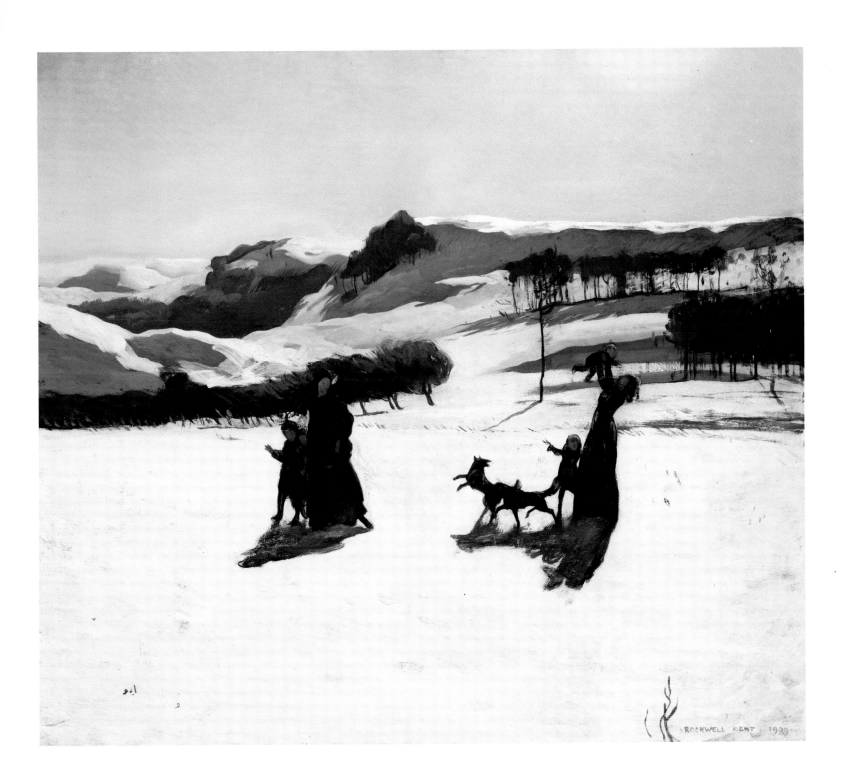

51

Robert Henri (1865–1929)
Blind Spanish Singer 1912
oil on canvas
104 × 84 cm
Gift of J.H. Smith

So influential was Henri as teacher and critic of a generation
of American modernists that the traditionalism of his own art
often comes as a surprise. *Blind Spanish Singer*, for example,
while reflecting the painter's proclivity for urban subjects and
the "realism" of poverty and deprivation, also emulates the
studio isolation and dramatic brushwork of Manet and Frans
Hals. This removal of the subject from its natural habitat
allows the artist to universalize it by concentrating on
essentials of physiognomy and characterization without the
distraction of secondary detail.

The woman is seated frontally, close to the viewer,
and holds her guitar almost parallel to the picture plane.
This immediacy is heightened by the strong vertical of the
figure and diagonal of the instrument. The bold security of the
composition supports the evident strength of spirit of the blind
musician, and Henri reinforces this characterization in the
distinctive bone structure of her face and muscular definition of
her hands. The right angle of her left elbow also conveys proud
dignity, as does the taut guitar strap snappily laid down in a
few long strokes.

The rapid brushwork is masterful, capturing both the
animation of her hands and her striking physiognomy. Around
the eyes, in particular, it at once emphasizes her sunken
sightlessness and suggests the spirit that endures. While the
palette is dominated by khakis and olives, grays and browns –
whose monochrome suggests blindness – the face is rendered in
defiantly warm pinks, red browns, and vermilion, beneath a
cap of gray-flecked, rich black hair. In every way, Henri gives
this face its complex due, for if it reveals great loss, it also
expresses great vitality.

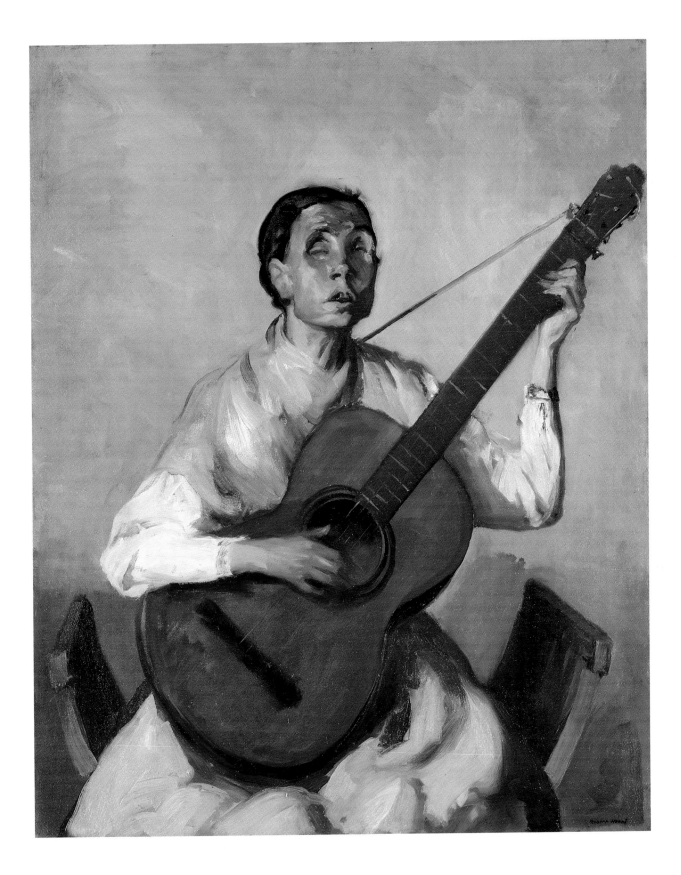

52

Ernest Lawson (1873–1939)
Gold Mining, Cripple Creek 1929
oil on canvas
101.6 × 127.4 cm
Bequest of Henry Ward Ranger through the National Academy
of Design

Early in this century, Lawson exhibited with a group of young realists whose generally somber palettes and gritty urban subjects earned them the tag "the Ash Can School." It was a label that never suited Lawson, however, since early study with John Twachtman predisposed him to the lighter palette of Impressionism. In this late work, light and color and landscape meet on a richly textured surface that suggests crushed jewels, not ashes.

The canvas is filled with a great, sweeping mountainside, save for the small arch of sky at the top. The viewpoint is high, apparently from another slope. It is the kind of massiveness that would have appealed to a more somber and weighty painter – Marsden Hartley, for example. But in Lawson's hands it has become a landslide of color, a vibrant and tactile field of paint. The whole palette seems present, but the dominant note is violet to deep purple, played against emerald and other greens. The focus of this color scheme is the large group of mine buildings right of center.

Energetic strokes of every description activate the surface. Brush and palette knife are used alternately, now laying on heavy impasto, now blending or squashing the paint. Lawson draws with color, and abstract passages sometimes result from the verve of his brush, as seen, for example, in the red shack left of center. It is also with brushstroke that Lawson structures his work. The thrust and counter-thrust of his brush, splashy though it is, does a brick-layer's work.

The paint field of the mountain is not neatly balanced or repetitive in its inner workings; it is composed of a free series of interlacing arcs (the swellings of the land, the contours of hills) and a diagonal falling from the dark cluster of trees at the left through the mine buildings to the dark right corner. It gives the impression of a skillfully controlled improvisation.

Lawson's essential modernism is perhaps more apparent to us today than it was to his contemporaries. Never adopting the distortions and abstractions that developed after the death of Cézanne, he instead probed the complexities of surface texture and the use of color to create space and volume. Indeed, his kinship with Cézanne and late Monet reveals his true measure as an artist.

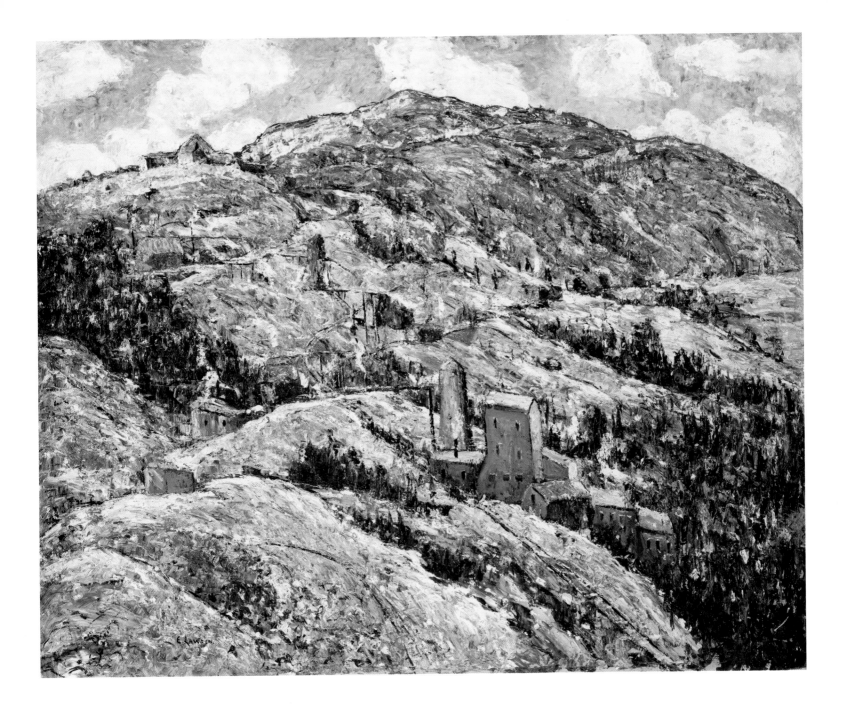

53

Paul Manship (1885–1966)
Salome 1915
bronze
48 × 34 × 26 cm
Gift of the estate of Paul Manship

For his *Salome*, Manship appropriately turned to the stylized
vocabulary of the ancient Near East, of Egyptian and Assyrian
art. This is apparent in the angular body, with right leg, arms,
and head pressed into the same plane, played against the
broad, concave curves of the robe that Salome is shedding.
Every movement is effectively checked by a counter-movement
and the dance is frozen. The artist's goal is not motion or
narrative, but a ritualized hieroglyph of the exotic and
macabre tale of Salome's lust for John the Baptist.

Manship's concept of Salome was influenced by the turn-of-
the-century reinterpretation of the biblical story in terms of
sexual pathology, exemplified by the shocking opera composed
by Richard Strauss to the libretto adapted from Oscar Wilde's
play. Manship compresses the narrative and introduces the
head of the Baptist on a salver while the princess is still
removing veils. In so doing, he achieves emotional impact
through a parallel relationship between their two heads.

Nonetheless, the artist's primary intent is decorative,
not expressive; the work invokes the elegance and artifice of
the sixteenth-century Renaissance bronze tradition. Manship's
extensive detailing of the hair, beard, eyelashes, jewels,
and elaborate girdle emphasizes the aesthetic rather than the
dramatic quality of the sculpture. The zig-zag pose of Salome,
the coy pointing of her toes toward the head of the Baptist,
and the elaborate plinth all reinforce this.

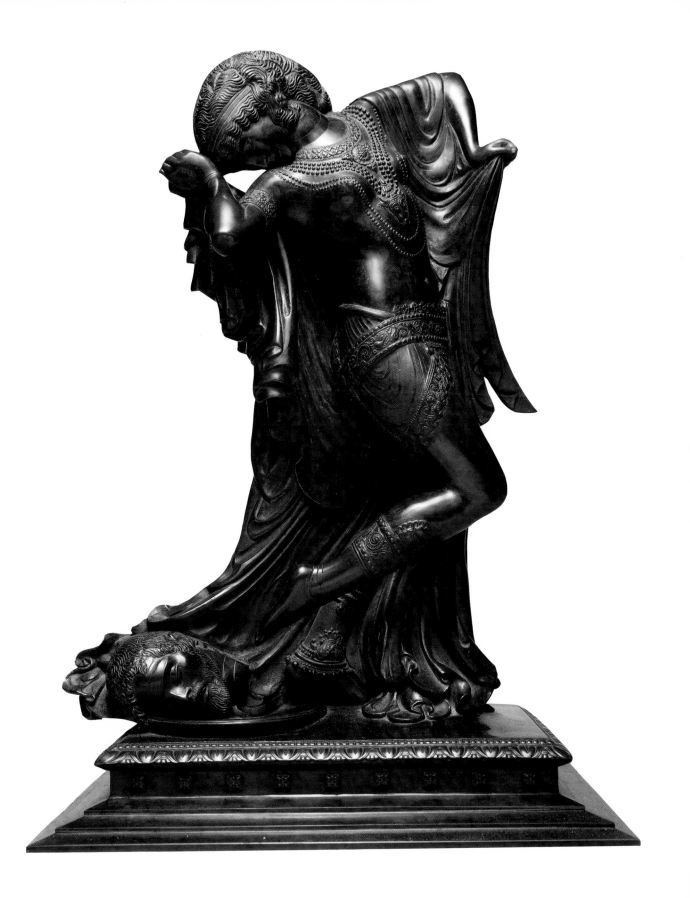

54

H. Lyman Saÿen (1875–1918)
The Thundershower 1917–18
tempera on wood
91.4 × 116.8 cm
Gift of H. Lyman Saÿen to his nation

The unhappy accident of a premature death has prevented Saÿen's name from being better known. One of the few American modernists directly sparked by Matisse and the Fauve love of brilliant color, he was artistically isolated to begin with; his death at forty-three left his oeuvre unresolved and essentially unnoticed.

Saÿen first trained as an electrical engineer and had patented a self-regulating X-ray tube in 1897, two years before he began to study painting and design at the Pennsylvania Academy of the Fine Arts. His inventiveness may well have predisposed him toward the avant-garde in art from the outset of his career. In 1906 he went to Paris, where the following year he joined an art class taught by Matisse. That experience and his exposure to the French avant-garde until the outbreak of war forced his departure in late 1914 were definitive influences on the brief decade of his maturity.

The Thundershower, probably his most rigorously organized painting, bears eloquent witness to his admiration for Matisse in its figures, smooth rolling curves, and unusual range of colors and patterns, which boldly collide with one another. But it is not only Matisse in evidence here. The *trompe l'oeil* wallpaper, with its flower and parrot design, derives from Cubist, and perhaps Futurist, collages in which newspaper, oil cloth, and wallpaper were sometimes incorporated or imitated in paint. In fact, Saÿen created a collage of *The Thundershower* (1916) before the painting. The combination of these two influences is an original formulation and accounts for the difficulty of placing the artist in context.

Another likely influence on Saÿen is the young American Morgan Russell, who was also in Paris at this time. Co-founder (and denominator) of the short-lived Synchromist style, Russell had both a painterly and structuralist approach to his centripetal color paintings of 1913 and 1914. In *The Thundershower*, the underlying scaffold of flat ground and forceful diagonals can be traced to his work.

Saÿen's palette is highly individualized. In addition to white, black, and gray he runs through red, orange, pink, blue, green, gold, cranberry, and maroon. The surface is matte and not particularly sensuous, in contrast to Matisse, and the underdrawing is often visible, making explicit the sense of deliberation projected by the painting. Ultimately it is this calculated, intellectual tone that dominates.

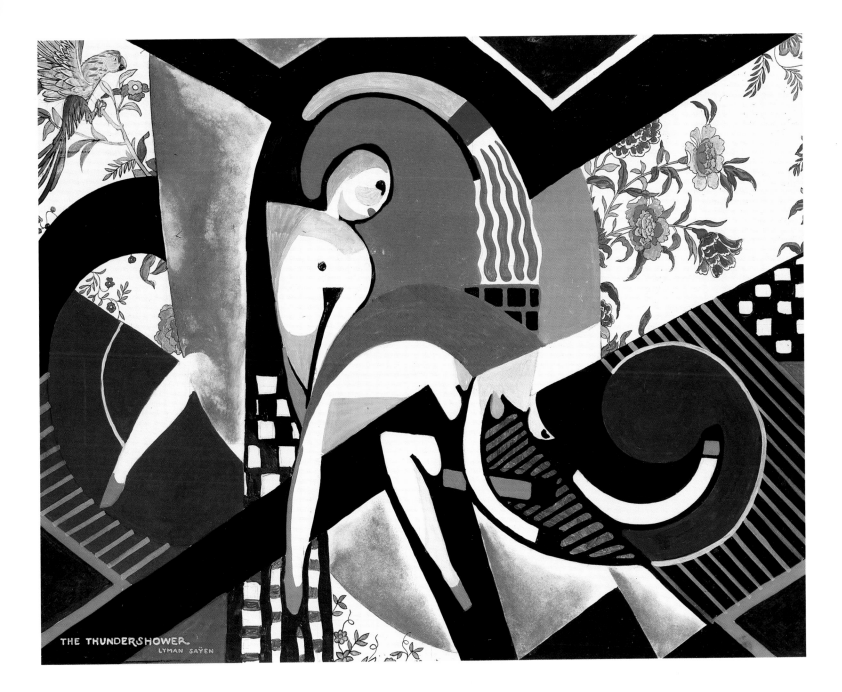

THE THUNDERSHOWER
LYMAN SAŸEN

55

Morris Kantor (1896–1974)
Synthetic Arrangement 1922
oil on canvas
196.5 × 141 cm
Museum purchase

Kantor's modernist work spanned little more than five years of his long career. It is these early paintings, like *Synthetic Arrangement*, however, that are now considered his finest achievements.

Arriving in America at the age of thirteen, Kantor commenced his New York art studies in the wake of the 1913 Armory Show. It was perhaps inevitable that his early style should spring from the modernist groundswell occasioned by that epochal exhibition. His work from 1919 to 1924 shows the influence of all the interrelated "isms" of the second decade: Cubism, Orphism, Synchromism, and Futurism.

Synthetic Arrangement is strikingly close to Marcel Duchamp's Futurist work. The linear, tilted verticals suggest Duchamp's *succes de scandale* of the Armory Show, *Nude Descending a Staircase*, a work known to have influenced Kantor. In fact, *Synthetic Arrangement* is much closer to Duchamp's *Sad Young Man on a Train* and in size and palette recalls Albert Gleizes's large painting *Man on a Balcony*, both of which were also in the Armory Show.

Not surprisingly, when compared to Duchamp's, Kantor's work seems more traditional, less resolved, for he had not absorbed the succession of modern styles from Post-Impressionism through Cubism that Duchamp had. One obvious example of his conservatism is Kantor's wrapping of dark tones around the painting's bright core. The Cubist paintings of Picasso and Braque reverse this, placing the lighter tones at the edges and building to darker ones, with the effect of three-dimensional relief strongest at the center. Kantor's framing device gives his painting a self-contained quality and forces the observer to view it as an isolated object.

The artist's strength lies in the complex alternation of advance and recession that he constructs from shifting planes. In some places he builds up a thin ridge of paint that defines an edge and suggests projection. The slight adjustments of the tilted diagonals and the saw-tooth and step motifs suggest movement similar to that of sequential photography. As the abstract title indicates, however, there is nothing figurative in this work.

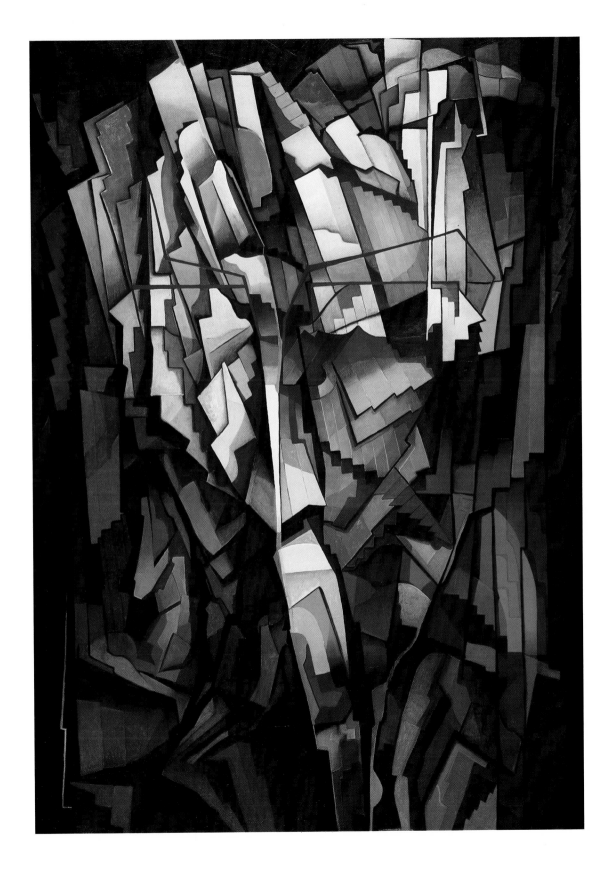

56

Romaine Brooks (1874–1970)
Self-Portrait 1923
oil on canvas
117.5 × 68.3 cm
Gift of the artist

The gray solitude of the paintings of Romaine Brooks seems, above all, a reflection of a childhood and adolescence devoid of love and marked by loss. She scarcely knew her father; she lived with her mother in an endless succession of Continental hotels, or alone in convent and boarding schools; her brother was insane and died young. As an adult, Brooks sought to fill the void through relationships with women. The tightly knit, lesbian circle of friends that sustained her included Natalie Barney, an admired poet, and Radclyffe Hall, author of the lesbian novel *The Well of Loneliness*.

Within this circle and the wider cultural milieu of Paris, a highly refined aestheticism in style and subject reigned. Among her other friends were Jean Cocteau and Gabriele d'Annunzio, avant-garde writers whose imagery was often symbolic and sensuous, probing of the subconscious. Such refinement had an earlier pictorial representative in Whistler, but while his art clearly made a profound impression on Brooks, she replaced the effete aura of his portraits with forceful physical and psychological projection.

Brooks's *Self-Portrait* is a typically formidable image.

At the time it was painted she was forty-nine, an established portraitist, and a prominent member of Parisian society, with the notoriety that accompanies the confirmed outsider. Her pose is self-contained, rigid, and proud but guarded. She is, as a contemporary described her, "a figure of intriguing importance, . . . a woman complete in herself, isolated mentally and physically from the rest of her kind, independent in her judgments, accepting or rejecting as she pleased." The ribbon of the Legion of Honor, a tiny strip of red adorning her lapel in the precise center of the painting, proclaims her achievements and her character, for it is the only strong note of color in the painting.

Still, this gray half-world is, in fact, less severe than it at first appears. The freely brushed background, and the fluid vitality of the lines of the figure soften the formality of her demeanor. The off-center pose and three-quarter turn of the body inject further life. The face is secure, even sculptural, in its modeling, the vague hint of color strengthening the effect.

Brooks was in revolt against the parti-colored, multi-patterned Victorian aesthetic and in love with the "mystery of grays," as she put it. Around 1911, her Paris town house was entirely decorated in delicate grays, with black accents and the slightest hints of color – just like this portrait. Appropriately, D'Annunzio proclaimed Brooks "the most profound and wise orchestrator of grays in modern painting."

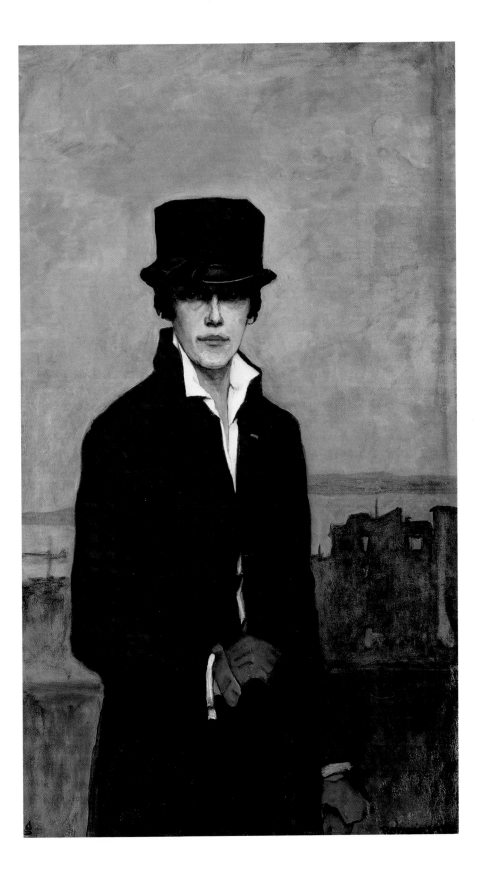

57

Helen Lundeberg (born 1908)
Double Portrait of the Artist in Time 1935
oil on fiberboard
121.3 × 101.6 cm
Museum purchase

Lundeberg's double portrait is a Surrealist meditation on
aging. The artist as a child sits in bright light on a low stool
at a table. On the latter, a clock, reading a quarter past two,
pins down a beige-colored length of parchment-like material.
Childishly, limply, she holds a budding flower stem like a
pencil. Both the clock and buds are symbolic of youth, and the
stem leads the eye to a faint legend on the edge of the
parchment: "Ages of Man." The child, with "shining morning
face" like Shakespeare's schoolboy, and with her "tabula rasa,"
is isolated upon a light gray rug.

A slim, purple shadow rises from the rug like a wraith,
a prefiguration of old age, and links the child with the portrait
on the green-gray and purple wall. In this painting within a
painting, the adult artist appears, but she is severely cropped.
In profile, introspective, she also holds a flower stem, now in
bloom and with more buds. She holds it firmly, exactly like a
pencil, and seems almost to have drawn those lengthening
shadows of mature flowers that slant across the table and onto
the wall. The spherical box, which takes the place of the clock,
is inscribed with a global map. This conjures up vast distances
traversed, or the gulf between childhood and adulthood. In the
dark and vacant interior of this box lies a sense of foreboding
and emptiness.

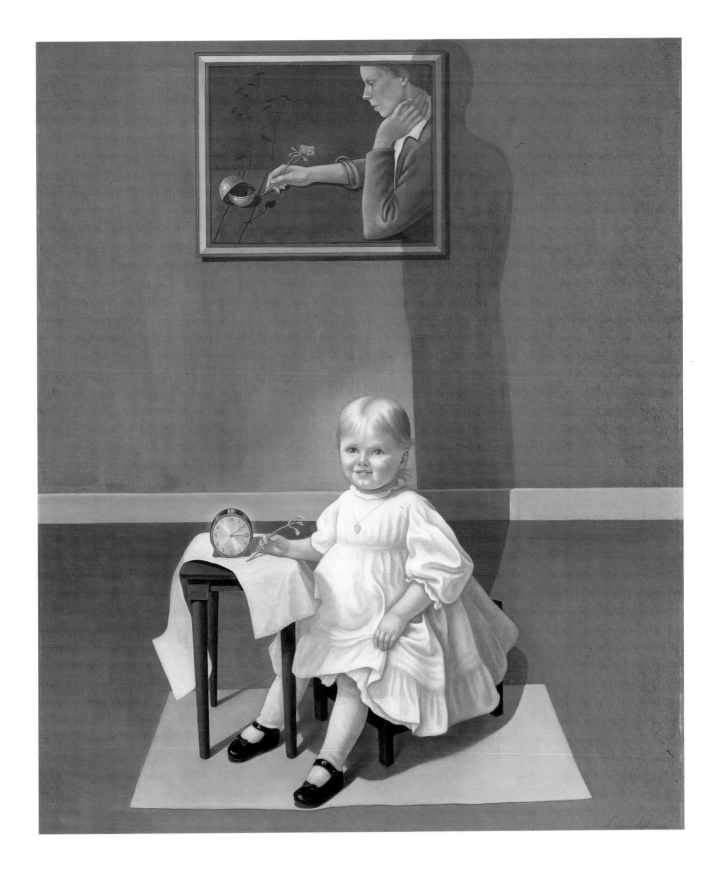

58

Ivan Le Lorraine Albright (1897–1983)
The Farmer's Kitchen ca. 1933–34
oil on canvas
91.5 × 76.5 cm
Transfer from U.S. Department of Labor

Cornered. The old woman, her manic cat, and her stove are scrunched together in the jumbled corner of a barely glimpsed kitchen. The picture space closes unrelentingly on her, with her legs and the stove cropped by the frame. The floor tilts illogically, and no door or window offers escape from the claustrophobic compression.

With an overall color scheme of blue, gray, pink, and red, Albright creates a confusion of patterns that badger the eye, from the conflicting designs of the floor coverings, to the floating flowers of the wallpaper, to the white-spattered dress and floral apron of the figure. An organic motion of curves and swellings also ebbs and flows, collides and fractures in a painterly maelstrom. In the midst of this, the farm woman's hands and face are relentlessly described, a painstaking record of furrows and creases and arthritic swellings.

The red of the radishes is reiterated in the woman's hands, her ochre forehead vies with a pink-and-red scalp, and her plum-framed glasses rest on a nose of violet, red, yellow, and white. But for the content, these hues would seem as beautiful as the floral wallpaper. Their use here, however, suggests putrefaction and decay.

The morbidity of Albright's artistic vision persisted for sixty years. It may have had its roots in his World War I service in an Army medical unit. It may have been further influenced by the fleshy Surrealism of Dali and the style called the "New Objectivity" of the German Georg Grosz and others, and reinforced by similar painters in the United States. In this work his morbidity sounds a note of social commentary, for it was painted during the Depression, under the sponsorship of a federal art program in Illinois. The despondent, resigned old woman and her not-so-genteel poverty are poignant signs of the time.

Albright's paintings attract and repulse unrelentingly. His idiosyncratic images and style are his alone, and his macabre images of death-in-life are engraved in our memories with gentle, deliberate means, not violent assaults on the canvas. His extraordinary effects of texture, for example, are achieved not with heavy impasto, but through line and pronounced color shifts. The nightmare palpability of his men and women in a world of perpetual decay and renewal is captured and held out for our shrinking contemplation.

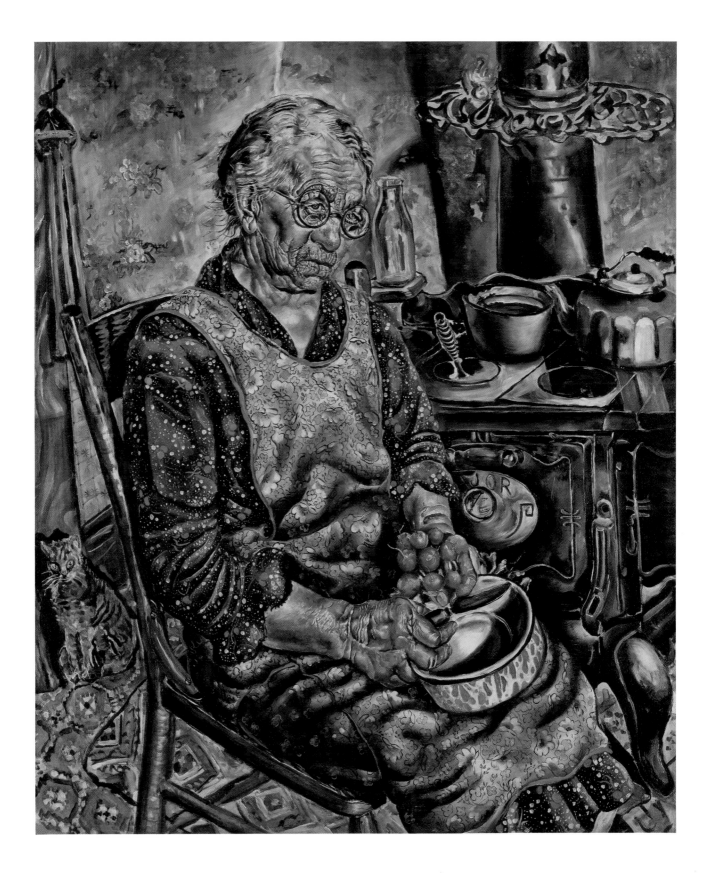

59

Douglass Crockwell (1904–1968)
Paper Workers 1934
oil on canvas
91.7 × 122.4 cm
Transfer from U.S. Department of Labor

Four workers with their backs to the viewer are in rapt
concentration on the huge machine they operate, or rather,
cooperate with in the manufacture of paper. The muted palette
of blue, green, black, and gray is shared by men and machine
alike, and the mass-produced simplicity of animate and
inanimate forms further unites them. Painted in the depths of
the Great Depression on a government-sponsored program,
this imposing image projects an aura of determination rather
than despair.

Stylistically, Crockwell is indebted to European modernism.
Similar to works by Ferdnand Léger in its forms and subject
matter, *Paper Workers* also reflects advanced theories of the
period. In their 1920 essay "Purism," Le Corbusier and
Amédée Ozenfant had detailed a "machine esthetic" by which
"forms are established which can almost be called permanent,
all interrelated, associated with human scale" and in "total
harmony, bringing together the only two things that interest
the human being: himself and what he makes."

It would be a mistake to assume that the anonymous,
economical forms of the workers, whose cubic geometry is
so perfectly balanced by the cylinders of the paper-milling
machines, were intended as ironic social commentary. Instead,
a Utopian harmony of communal progress seems to be the
optimistic message of the artist.

60

Ralston Crawford (1906–1978)
Buffalo Grain Elevators 1937
oil on canvas
102.1 × 127.6 cm
Museum purchase

Although some twenty years younger than the founders of
Precisionism, Crawford adopted their aesthetic and their
subject matter. Throughout the booming 1920s and the
collapsing 1930s, industrialization maintained its hold on the
imaginations of many. The spare, geometric forms of industry
seemed to proclaim the possibility of a rational ideal, an ideal
that incorporated abundant food and goods for every social
stratum. In this regard, grain elevators had added symbolic
significance during the Depression.

Still, Crawford betrays no emotion and no suggestion of
Utopia in his vision. Full attention is focused on the volumetric
geometry of the imposing structures, with their matte texture
and simple modeling of grays, wheat browns, and pale golds
against a flat, cloudless blue sky. No people, no play of light,
no animation of any kind is admitted into this totally
organized, formalist construction. Indeed, the artist's insistence
on utter objectivity results in a picture more still life than
landscape.

61

Moses Soyer (1899–1974)
Artists on WPA 1935
oil on canvas
91.7 × 107 cm
Gift of Mr. and Mrs. Moses Soyer

Moses Soyer, from a family of noted artists, represents the last great wave of nineteenth-century European immigration to America. This painting of 1935 bears quiet witness to a decade of profound social and artistic change, much of whose intellectual vigor and idealistic fervor was owed to these new citizens from an old world.

In *Artists on WPA*, six artists and one cigarette-smoking model work against a backdrop of paintings-in-progress in a somewhat airless, gray brown interior. The combination of the somber mood and creative activity is thoroughly apropos to a depiction of a Depression-era, government-sponsored work program for the nation's artists.

The profound impact of the Works Progress Administration and other federal programs on artists of all ages and stylistic persuasions cannot be overemphasized. It was not just a question of survival – the dole would have accomplished that – but of continuing the pursuit of one's creative goals. The WPA also had the perhaps unanticipated effect of bringing diverse artists together in a way that promoted fruitful exchange of ideas. Soyer recalled that it was "an exciting time. . . . It gave the artists a sense of dignity, of belonging, a feeling that they [were] needed. Consequently – they did good work."

The Portable Murals Project produced large-scale decorations intended for hospitals and libraries. All of the paintings seen in *Artists on WPA* were part of a specific Portable Murals Project for which Soyer was the supervising artist. The series comprised eight to ten panels, each measuring about 8-by-10 feet, and the subject, proposed by Soyer, was "Children at Play." His designs were sketched on the canvases and assistants executed them under his guidance. *Children at Play* was subsequently assigned to the Greenpoint Hospital children's ward in New York City.

While most of the artists in *Artists on WPA* are shown painting or contemplating their work, the seated model turns her attention elsewhere. Looking out of the picture, she seems to acknowledge Soyer's presence as he records the entire scene.

62

William H. Johnson (1901–1970)
Man in a Vest ca. 1939–40
oil on canvas mounted on board
76.2 × 61 cm
Gift of the Harmon Foundation

This solemn and forceful portrait reveals a sophisticated
modernist beneath the stylistic pose of a folk artist, which
Johnson adopted in his later work. After formal training and
a European career as an accomplished Expressionist painter,
he evolved this neo-primitivism as the appropriate mode for
the Black American subjects to which he finally turned.

The massive head dominates the picture by its dispro-
portionate size and its expressive drawing and color.
The swinging, scalloped curves of the left side of the sitter's
face (which roll unbroken across his arm) are played against
the angular linearity of his right ear. The chocolate brown skin
is highlighted with orange, yellow, and pink and capped with
superb blue hair. The hands are as out-sized as the head,
and the pink-and-white fingernails rivet the viewer's attention.
These Expressionistic devices, and the contrast of the
rectilinear strokes of the background with the curves of the
head, are reminiscent of Van Gogh and Chaim Soutine.

The pose is more elaborate than is at first apparent.
Straddling a diagonally placed chair, the sitter rests his left
forearm on the top rail, thus pulling his torso forward nearly
into alignment with the picture plane. This underscores the
bold shape of the body and its immediacy. The muted red
chair back with blade-like slats contributes to the painting's
somber intensity.

Again and again, however, our attention returns to the head
and large eyes. The pupil of the left one – big and irregularly
shaped – lies almost on the central axis. Our gaze is drawn to
it but not returned, for it looks inward.

63

Theodore Roszak (1907–1981)
Construction in White 1937
wood, masonite, plastic, acrylic, and plexiglass
203.8 × 203.8 × 46.4 cm
Gift of the artist

While in his early twenties, Roszak fell under the influence of the Constructivist aesthetic, an extension of the Bauhaus principles of purity of form, industrial precision, and geometric abstraction. His association with the Hungarian exile László Moholy-Nagy in Chicago and at the Design Laboratory in New York reinforced this style, which he developed for over a decade.

Jack Burnham, sculptor and critic, has written that "modern sculpture is given over, almost entirely, to the task of formal invention." In *Construction in White*, this is a matter of starting with perfect balance, disturbing it, then restoring equilibrium. Since the piece is a boxed relief, the balancing act takes place in two and three dimensions. The system is made even more complex by the transparent elements – three plexiglass pieces, which cast what may be called "transparent shadows," and by the strong shadows cast by the solid boxes. Although the light source is generally constant in a museum installation, the full potential of the sculpture is revealed in different lighting situations, such as a mechanically moving spotlight or even just the changing light of day.

The geometric foundation of *Construction in White* is classic: a circle within a square. It might be the floor plan of a model Renaissance church. Set within that circle, and intersecting its circumference, are boxes and planes that deliberately counter the harmony, but that are so cunningly disposed in a complex system of overlapping and intersecting planes they ultimately restore equilibrium. Although that final balance is not embodied in an actual church structure or tied to a theological or philosophical system, reason and measure are implicit in it. In this pure microcosm of white surfaces, transparencies, and light and shadow regulated by verticals, horizontals, and arcs, there is a delight in optical finesse and mathematical exactitude.

Construction in White is essentially a Utopian vision, reflecting an optimism that could not survive World War II. Although a new kind of minimalism arose in the 1960s, the reasoned precision of Roszak's early work, with its roots in the social revolutions of the early twentieth century, disappeared in the global catastrophe. His post-war work parallels that of some of the Abstract Expressionist painters in its inherent violence and threat.

64

George L.K. Morris (1905–1975)
Industrial Landscape 1936–50
oil on canvas
125.6 × 161.2 cm
Gift of anonymous donor

Morris belonged to the first generation of American artists who took abstraction as a given, an accepted mode in painting rather than a revolutionary thrust. Nonetheless, when he was beginning his career, the figurative style of the American regionalists was in its ascendancy; and abstract artists felt the need to counterattack, which they did by forming the American Abstract Artist group in 1936. Throughout his life, Morris was an advocate of and proselytizer for abstract art, in articles and lectures as well as his painting.

Industrial Landscape, like most of his work, is characterized by elaborate, post-Cubist spatial manipulation. Starting from an irregular polygon, which is anchored to the frame, he constructs an angular vortex. On the right side of the picture the lines are essentially vertical, but at the left they become increasingly slanted, creating a rocking or tumbling motion. Toward the center of the painting, rapidly receding perspective lines are intersected by transverse lines, producing a tiled or grid effect that increases the illusion of tunnel-like recession.

Suspended in front of this space and obstructing it is an intricate combination of opaque shapes dominated by a triangular cap. The oblique angles of this construction also suggest a gentle rocking motion, like that of a boat. But Morris's engineering is instinctively conservative, and he subtly moors the motif with lines and value relationships.

Played against the overall pattern of angular elements are numerous curvilinear passages, of which the most complex and interesting are those transparent and semi-transparent areas described by guitar-like double curves. The latter have the property of altering colors and their intensities in the areas over which they flow.

Morris's idiosyncratic palette is characterized by sandalwood brown, yellow, pale green, lilac, purplish red, black, and white. Somewhat antiseptic, it is less suggestive of heavy industry than of a laboratory. Rather than make clear reference to specific industrial forms, like those in Ralston Crawford's *Grain Elevators* (see p. 134), Morris, like many of his fellow abstractionists, preferred a symbolic language of form that would be more universal in its communication.

65

Richard Pousette-Dart (born 1916)
Untitled ca. 1936–40
bronze
63 × 49.8 × 60.5 cm
Gift of Mr. and Mrs. Frederic E. Ossorio

Better known as a painter, Pousette-Dart created this
daunting, totemic sculpture early in his career. His work in
the late thirties, when he was just out of college and living in
New York City, reflects both the insecurities of the Depression
and the interest in the subconscious and primitive art that
saturated the New York art world with the influx of the
Surrealists-in-exile, who were fleeing the European turmoil.

This armored bird-creature, crouching on stumpy legs, holds
its young before it in an attitude at once presentational and
protective. In the shadow of the maternal beak, the fledgling
opens its enormous mouth, presumably to be fed but with
pronounced aggression. Their heads aligned in absolute
symmetry, the main axis dominated by beaks and bulging
eyes, the brooding pair are compactly grouped in self-defense.

The image is unwelcoming, encased in helmet- or shell-like
protective plates. The surface is equally off-putting: dry and
unpolished, its patina is primarily black with scale-like patches
of blue green. Drawing close and peering inside, one perceives
that even the maternal breasts are menacing, sharply faceted
like a claw hammer. In form, attitude, surface, and color this
avian warrior projects a primal instinct for survival, a vigilant
being in a hostile world. The sculpture, like the creature it
represents, asks not to be liked but to be respected.

66

William Zorach (1887–1966)
Victory 1944
marble
107.3 × 39.9 × 31.4 cm
Gift of Mrs. Susan Morse Hilles

Classically serene yet sensuous, Zorach's *Victory* is posed
simply, in slight contrapposto. The partially draped nude
seduces the viewer with its Brancusi-like svelteness of volume
and contour, yet at the same time, it conveys a sense of purity.
The unusual rose-veined marble, splotched and streaked with
rich, paint-like markings, is also alluring, and its unusual
appearance causes one to dwell closely on the surface.

 The aesthetic impression of wholeness conveyed by the
sculpture is contradicted by its fragmentary state. Zorach has
not only translated the traditional Greco-Roman Victory figure
into modern language (the *Nike of Samothrace* is the most famous
example), but he has also used the classical model just as it has
come down to us: as a fragment. There can be little doubt that
his evocative borrowing relates to the approaching end of the
war in Europe. It is a beautiful, but ironic, "victory" that the
artist offers us; it has survived, but not fully intact. For Zorach,
a child-émigré from vanquished Lithuania, this testimonial
must have had profound resonance.

67

Andrew Wyeth (born 1917)
Dodges Ridge 1947
egg tempera on fiberboard
104.1 × 121.9 cm
Gift of S.C. Johnson & Son, Inc.

Andrew Wyeth has staked out two small corners of the world
as his territory: the Brandywine Valley of southeastern
Pennsylvania and the Port Clyde area of the Maine coast.
In these places he has explored the land in all seasons, as well
as the people – his friends and neighbors – with considerable
penetration.

The inter-relatedness of land and people is the true subject
of Wyeth's art, and *Dodge's Ridge* is no exception. A barren and
weathered hillside under a gloomy sky is crossed by tractor
tracks. This sign of man, the cultivator, moving uphill is an
optimistic symbol in a harsh and unforgiving landscape.

The tilted wooden stake with crossbar and tattered cloth
streaming from it are probably the skeleton of a farmer's
scarecrow. Their obvious religious symbolism cannot be
ignored, however, and it is probable that the painting
commemorates the accidental death of the artist's father,
the noted illustrator N.C. Wyeth, in late 1945. Wyeth has
often spoken of the loss of his father as the turning point in
his life and his career as an artist. The resemblance of the
composition to the 1946 tempera *Winter*, which Wyeth has
described as a "portrait" of his father, reinforces this
interpretation.

68

Paul Cadmus (born 1904)
Bar Italia 1953–55
tempera on pressed-wood panel
95.3 × 115.6 cm
Gift of S.C. Johnson & Son, Inc.

Teeming with ruthless caricatures, *Bar Italia* was, according to Paul Cadmus, "sort of a synthesis of all I knew about Italy . . . exposing the worst of everything I could think of." In fact, the artist's malevolent brush transfixed the collision of cultures in post-war Italy. The sensibilities of an ancient, proud, and independent people afflicted with political instability, cultural vulnerability, and economic dependence were exacerbated by the flood of tourists – primarily American, for no one else could afford to travel then – that followed the liberation.

The ambivalence of this culture in turmoil is reflected in the graffiti on the architecture and sculpture: "Drink Coca-Cola," "Victory to Italy," "Vote Communist," and "Go Away Americans." This last remark might understandably be directed toward the family anchoring the picture bottom center. Mama consults her phrase-book, Papa aims his expensive camera, and the unspeakable children repine in bored ignorance. Behind the parapet above them, three spinsterish tourists consult their guidebooks and point and peer dutifully.

Cadmus's poison brush is sometimes aimed at the sexual typology of Italians and Americans. A chic Italian couple at the right, as much in love with themselves as each other, are an adroit contrast to the American spinsters or the gelato-fattened *signora* and her unheeding spouse below. Our attention is especially drawn to the arrogant male hustler, descendant of Michelangelo's nudes, posing on the parapet and eyeing the flamboyant, American homosexuals. Openly gay himself, Cadmus does not hesitate to satirize these particular types; in fact, it is in this arena that he portrays himself, seated behind the hustler and eyeing him with more than artistic interest.

To the hustler's left another post-war entrepreneur offers black-market pens and cigarettes to the gossiping gays, while two uniformed *carabinieri* studiously ignore both propositions. The hustler is not ignored, however, by the furious waiter, who ineffectually orders him from the café. It is not by chance that the waiter's gesture is reminiscent of facism, and his features, of Mussolini.

Above and below the waiter are an old blind woman and an injured woman. These examples of Italy's post-war poor are carefully placed in context. The blind woman goes unnoticed by two degenerate-looking churchmen, who are preoccupied with a vendor of tourist views. The bandaged woman more aggressively thrusts her head and drooling lip at the spittle-spewing men, whose obstreperous discussion, surely political, leaves no room for social realities. In the roundel above these groups, a stonemason pauses and gazes out toward the viewer. It is possible this worker symbolizes the rebuilding of Italian society, for he is the only figure not caricatured by Cadmus.

The architectural and sculptural backdrop for this riotous vaudeville is worth examining. The mammoth sculpture group is not entirely of Cadmus's own invention. In fact, it is an amalgam of Gianbologna's *Rape of the Sabines* and Michelangelo's *Victory*, both of the sixteenth century and both in Florence. It is doubtful that its subject, *Hercules and Cacus*, is significant, although Hercules's wrath, magnified by the surrounding architecture, seems directed beyond the victim at his feet.

To the left of the sculpture, medieval Italy is recalled in the leaning battle towers of the sort found mainly in San Gimignano today, and in the crenelated tower similar to that of Palazzo Vecchio. To the right, in counterpoint, is an obelisk that is much larger than any ancient prototype. In fact, given its scale, it can only be the Washington Monument! Such a disruption of classical unity of place comes as no surprise in a work dedicated to cross-cultural conflict. This is the coup-de-grâce for Cadmus's long-suffering targets.

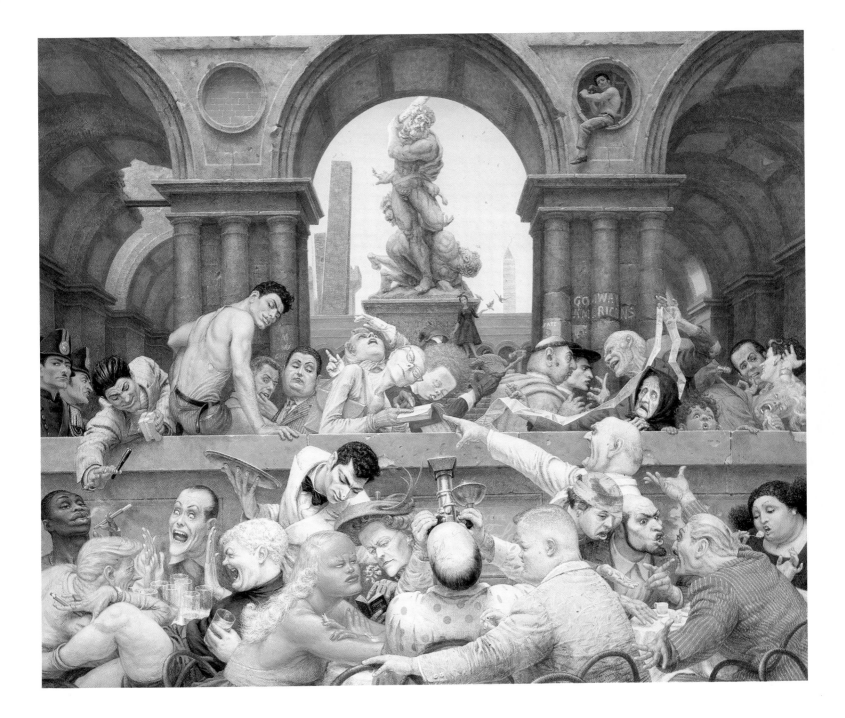

69

George Tooker (born 1920)
The Waiting Room 1959
egg tempera on wood
61 × 76.2 cm
Gift of S.C. Johnson & Son, Inc.

In numbered and numbing cubicles they stand, nearly faceless figures in a nameless place. They wait passively, with few gestures and waning emotion. They do not connect, not even the figures in cell 117, caught in an uncertain embrace. With 111 booths preceding these and an unknown number following, the scene resembles a conveyor belt of bodies, selfless, incapable of will or interaction. The fluorescent field above does nothing to lighten the units of despair.

Not one figure is seen in his entirety, and some are only known by heads or feet. The anonymity is most intense in the ironic image in cell 116. There, a black woman is engrossed in a magazine whose cover features the head of a blonde that replaces her own.

The figures in the cubicles are relatively young but are drained of energy and are little more than inert forms. In cell 118, two coats hanging heavily from the hooks speak of final absence. The older men seated and standing in the foreground are derelict, wrapped in sleep or guarded anger, lacking even the tentative hold on life of the others.

George Tooker is too fine an artist to offer literal explanations for his images of desperate melancholy, but the compression of the human spirit by the mindless repetition and classification of modern bureaucracies – totalitarian or otherwise – recalls Kafka and George Orwell. There are hints of Surrealism in Tooker's ability to render the ordinary with an unfamiliar, nightmare quality, and the simplified volumes and upright immobility of his figures recall Magritte's work in the 1950s.

But Tooker's style and approach are ultimately his own. His nightmares are subdued, not frantic, and his paintings radiate controlled resentment rather than biting satire or imminent madness. Through the painstaking medium of tempera, he has produced an impeccable surface and a laconic, rational image that underscores the debilitating uniformity of contemporary life. A skillful colorist, Tooker also has introduced unexpected notes of pink and orange in the clothes of the figures; this is repeated only once outside the cubicles, in the pink scrap of paper on the floor in the right foreground. There, among the older men, it has the poignance of a last fallen petal of summer.

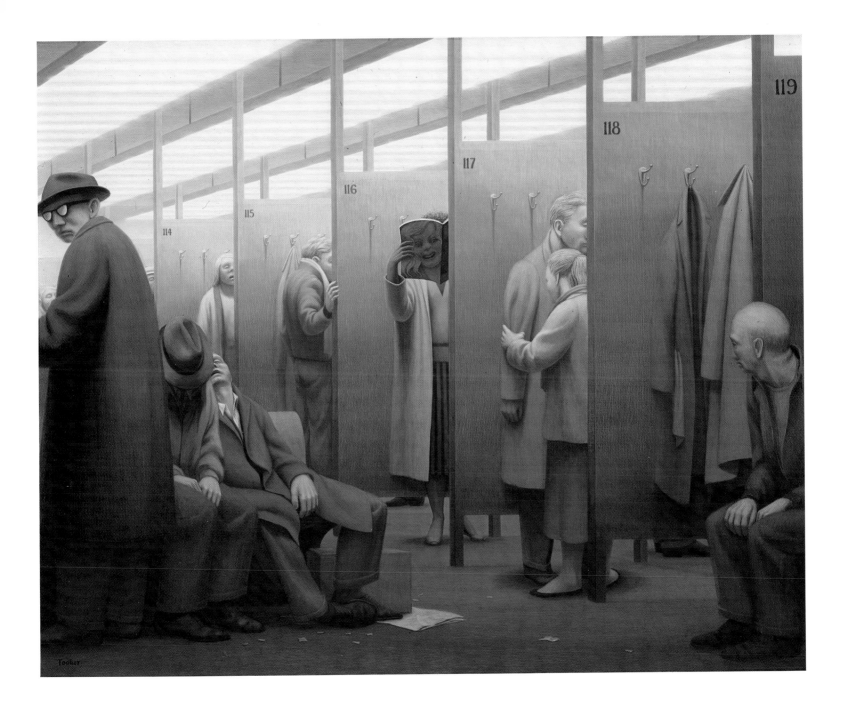

70

Edward Hopper (1882–1967)
People in the Sun 1960
oil on canvas
102.6 × 153.5 cm
Gift of S.C. Johnson & Son, Inc.

Five people, seated against a backdrop of mountains, face the
late afternoon sun, almost as if in unyielding opposition to it.
A crowd by Edward Hopper's spare measure, the three men
and two women are packed densely together, their forms
overlapping and echoing one another, yet they do not speak or
even acknowledge one another's presence. Fully, even formally,
clothed, they sit in self-imposed silence like passengers waiting
for take-off. The swept-back diagonals of shadows on the
pavement and the confinement of their bodies to half of the
canvas increase the sense of resistance to flight.

The setting is anonymous, though the corner of the building
suggests a motel. Even the mountains are generic, identifying
no particular locale. The strong characterization of each figure,
however, underscores their insistent suppression of emotion
and action. In their rigidity and obvious lack of pleasure in an
ostensibly pleasant setting, Hopper's "sunbathers" are
reminiscent of Georges Seurat's in his *Sunday Afternoon on the
Island of the Grand Jatte* and elsewhere. The mood of self-
containment and indifference is enhanced by the abrupt,
angular drawing and thin, dry paint surface.

Hopper's color scheme is dominated by an extraordinary
range and harmony of blues played against the ochre of the
field of grain and curtains on the windows. Smaller,
more intense notes of red, orange, and green enliven the
figures and their clothing, and scattered accents of pure, bright
yellow on the chairs and their occupants bind the figures still
more tightly together.

One wittily expressive passage should not be missed:
the pillow against which the most prominent man cushions
his head mimics the unreceptive bosom behind. In Hopper's
world, while people remain silent, shapes speak clearly.

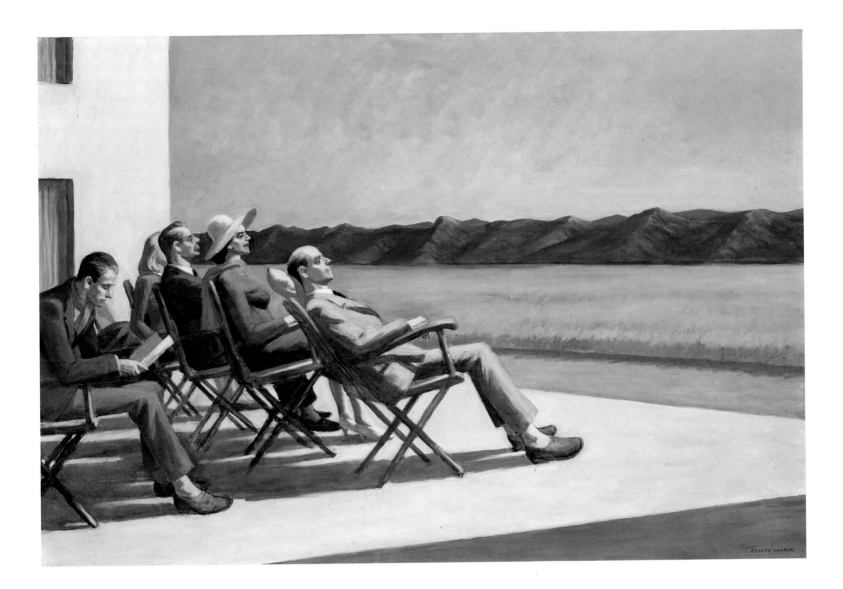

71
Jacob Lawrence (born 1917)
The Library 1960
tempera on fiberboard
60.9 × 75.8 cm
Gift of S.C. Johnson & Son, Inc.

As a young artist in the 1940s, Lawrence painted several series inspired by Black history, including ones on immigration, Harlem, and John Brown. These works belong to the later years of social realism, founded a generation before, and in style they often seem a synthesis of Ben Shahn and Stuart Davis. By 1960, when this work was executed, Lawrence was focusing more on the Black present and future than the past, and his style had matured.

The Library is a quiet, concentrated image whose suave technical skill is balanced with solemn didacticism. The influence of Ben Shahn is clearly an integral part of Lawrence's pictorial language. Lean and linear, the picture's rhythms are under sure control. In value, color, form, and direction, the balances are subtle and sophisticated.

All but one of the fourteen figures in *The Library* are absorbed in books. Interestingly, reading must be inferred, since printed pages are not shown; only pictures are seen in three books. These images are appropriate to the readers: one book appears to be illustrated with drawings, perhaps of modern sculpture; another reproduces part of a black man's head in profile; a third contains African sculpture. On the cover of the book at the lower left, the red flower is a graceful symbol of aspiration.

Since most of the heads are bent over books and features are indistinct, Lawrence uses hands to characterize almost every figure in the room. The hands of many of the readers embody concentration and probing, while those of the figure striding purposefully to the right are powerful and grasping, as if carrying an armload of treasure.

The Library is one of those modest paintings so modern in its vocabulary and authentic in its commitment to the nurturing of humanity that one feels confident that a century hence it will stand proudly as a tribute to the man and the moment that produced it.

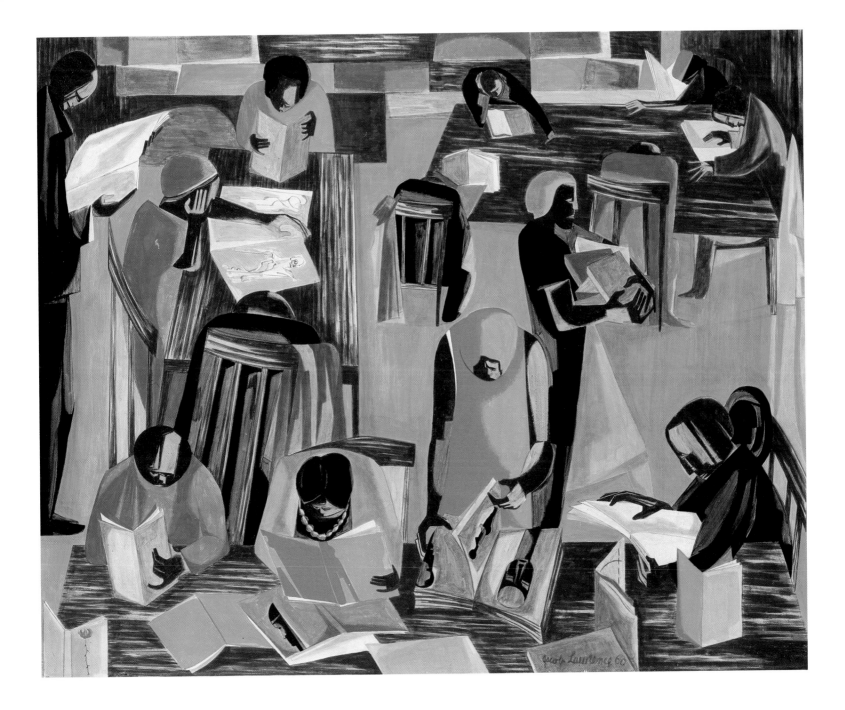

72

Charles Burchfield (1893–1967)
Orion in December 1959
watercolor on paper
101.6 × 76.2 cm
Gift of S.C. Johnson & Son, Inc.

This imposing watercolor is a culminating work in the career
of Charles Burchfield, who descended from a long line of
American pantheistic landscape painters. The deeply personal
interaction with nature that characterized the work of George
Inness (see p. 80) and Frederic Church (see p. 62), the
immersion of self in nature, and the ceaseless confrontation
of human aspiration and frailty with the elements, all are
embodied in Burchfield's intense visions.

It would be a mistake to read the star-chart of *Orion in
December* too literally, although the constellation, composed of
stars of the first magnitude, is identifiable in the star-bursts
just left of center. More important, perhaps, is the mythic
import of the constellation. Orion, the hunter, was loved by
Artemis, the huntress, but was accidentally killed by her.
He was then elevated to a pre-Christian heaven where eternal
remembrance, if not eternal life, was achieved through the
constellations. Of course, Burchfield is not narrating the myth,
but calling it to consciousness to enrich our experience of this
gleaming field of stars above a wintry forest.

One of the most haunting aspects of the painting is its
merging of heaven and earth. Some stars seem to have slipped
down among the trees, others have been overtaken and
encased by them. The pine forest, primeval in its abstraction,
rises from the frozen earth with irrepressible energy, soaring
even beyond the top of the frame. It is the artist's awe – his
fear and excitement – in the presence of nature that stimulates
his profoundly expressive exaggerations of its outward forms.
"The work of an artist," Burchfield once said, "is superior to
the surface appearance of nature, but not to its basic laws."

Burchfield's awe, nonetheless, is leavened with gentle
whimsy. Near the bottom center of the scene, amid the wintry
bushes and grasses, one little star is flitting about, butterfly-
like, aspiring perhaps to future "nova-dom."

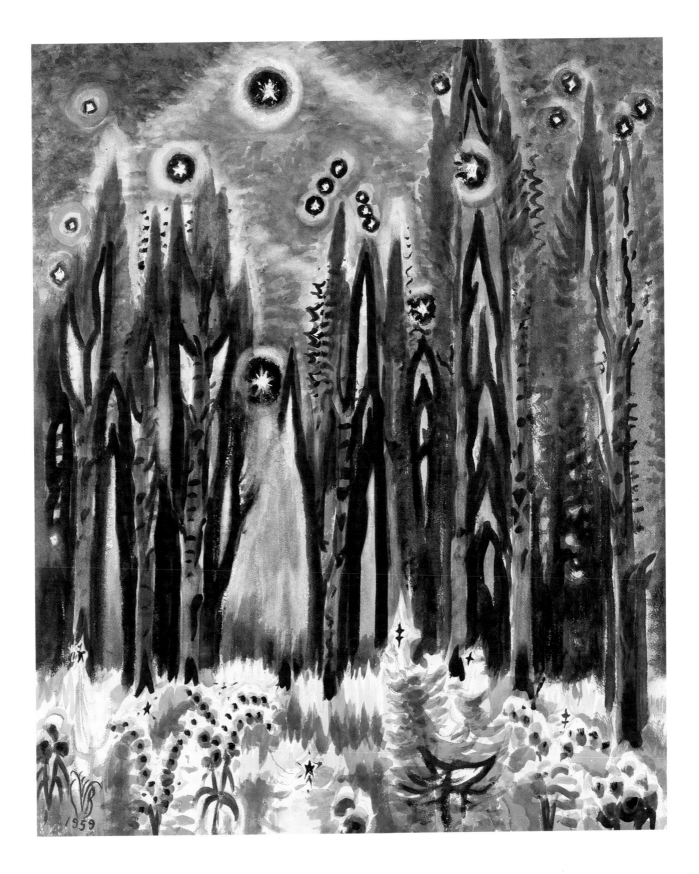

73

Milton Avery (1885–1965)
Spring Orchard 1959
oil on canvas
127 × 168.3 cm
Gift of S.C. Johnson & Son, Inc.

Avery was in his mid-sixties when he evolved his distinctive
style of extremely simplified forms and non-perspective space
with a palette that favored pale hues and high values. *Spring
Orchard*, painted when he was seventy-four, is wonderfully
representative of the high level of his achievement, though it
has an intensity of color that is rare in his oeuvre.

The painting is at once joyous and serene. Over the white
primer Avery brushed hot pink, the strokes moving in all
directions but often echoing the picture frame or the shapes
of the trees. The burgundy foliage rises in a unison chorus over
a dance-rhythm of tree trunks.

The topmost pink knob of this riot of bloom projects into
the muted slate and green of the mountain range. This gently
rolling band, and the cornice of lavender sky above it, resolves
the orchard's energies in its calm control. The evocative stain
effects of "wet-on-wet" painting in the mountains are typical
of the lyricism of late Avery. The simplicity of form of late
Matisse and the palette of late Bonnard come to mind,
yet even in this unusually festive painting Avery manifests
a characteristic reticence, bordering on austerity, not found
in the French masters.

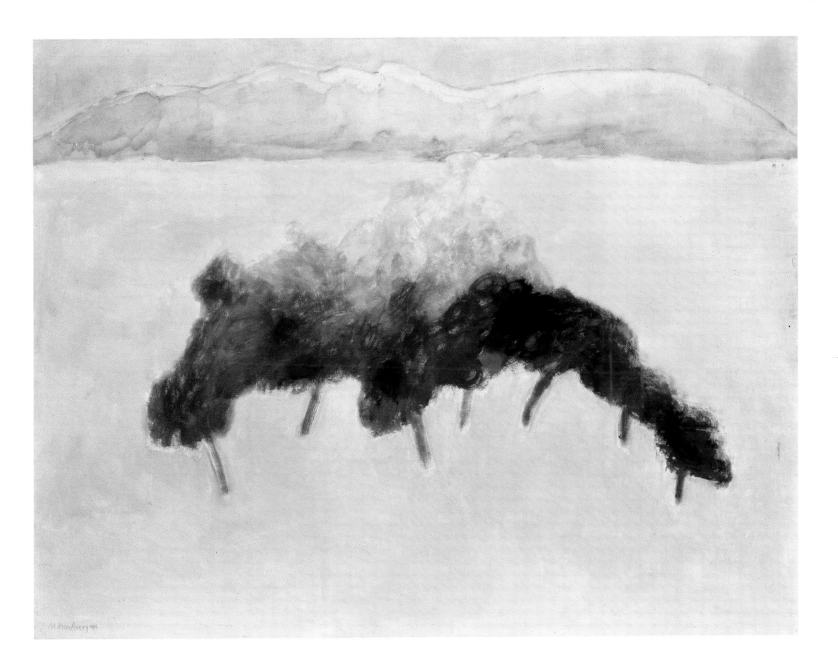

74

William Baziotes (1912–1963)
Scepter 1960–61
oil on canvas
167.6 × 198.4 cm
Gift of S.C. Johnson & Son, Inc.

Fluidity is the primary characteristic of this work by Baziotes.
Over a light prime coat he has washed a thin oil field of
mottled gray-blue green. The ground is more opaque at the
left, with higher values and a more cohesive surface. Against
this part of the field is placed a tall, persona-like hieroglyph,
the "scepter" of the title. Extending from top to bottom,
as though cropped by the frame, this blue-white sovereign
presides over the painting.

The right two-thirds of the canvas has a darker, lower
valued, mottled appearance, suggestive of vibrating space or
liquid. The gray and buff, somewhat amoeboid shape that
floats in this medium fades toward the right, as if emerging
from or slipping back into the murkiness. Above it a spidery
form is suspended like a bent-wire mobile and appears to be
in front of the field. Its linearity contrasts with the more stolid
form below it and the towering poise of the scepter.

This primitive drama played out by three biomorphic
elements in a pre-verbal environment reveals Baziotes's debt
to the Surrealists and their fascination with the preconscious
and subconscious, with myth and symbol. The hieratic scepter
seems to be a catalyst – the lightning bolt that creates life
from the primal soup.

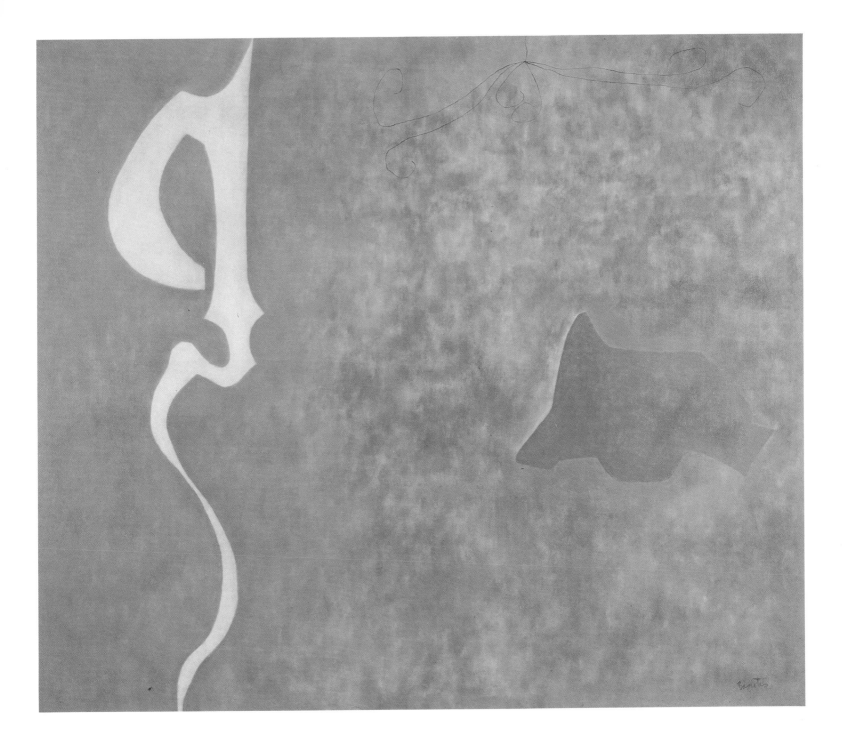

75

Helen Frankenthaler (born 1928)
Small's Paradise 1964
acrylic on canvas
254 × 237.7 cm
Gift of George L. Erion

Generally acknowledged as the inventor of the "soak-stain" method of painting, which has been widely influential among post-war artists (see Morris Louis, p. 166), Frankenthaler has a vitality and aggressiveness in her design and color that distinguishes her work from her contemporaries'. *Small's Paradise* is a superb example of her inventiveness and expressive panache.

Working on unprimed, unstretched canvas spread on the studio floor, she poured a thin solution of acrylic color onto the surface. The paint soaked into the canvas, dyeing it rather than covering it and creating a peculiar parity between paint and woven support. Introduced by Frankenthaler in 1959, the method has parallels in wash drawings and watercolors and has also been compared with Japanese painting in its effects.

Small's Paradise combines the measured quality of its almost traditional design (comprising symmetry, differentiation of background and foreground, and groundline) with joyous, scintillating color. The nearly square canvas is organized symmetrically, with outer bands of dark, forest green giving way to a band of lighter, shamrock green. These encase a field of indescribable pink above a band of dark blue over light blue, which is wonderfully wet in appearance. Against the pink field, Frankenthaler introduces an active, irregular shape of vivid orange. This form is almost portrait-like in its presence, and the same orange tone appears left and right below the blue patch, further fixing the central focus. The artist's insistence on the unity of canvas and color is maintained by the transparency of the stains, which everywhere knits the different color fields together.

"Small's Paradise" was the name of a cabaret that was the center of Harlem's nightlife from 1925 until 1959, when it was sold. The new owners retained the name, but it is unclear whether Frankenthaler intended a retrospective homage or not. As is common in contemporary art, such titles are often chosen precisely for their ambiguity.

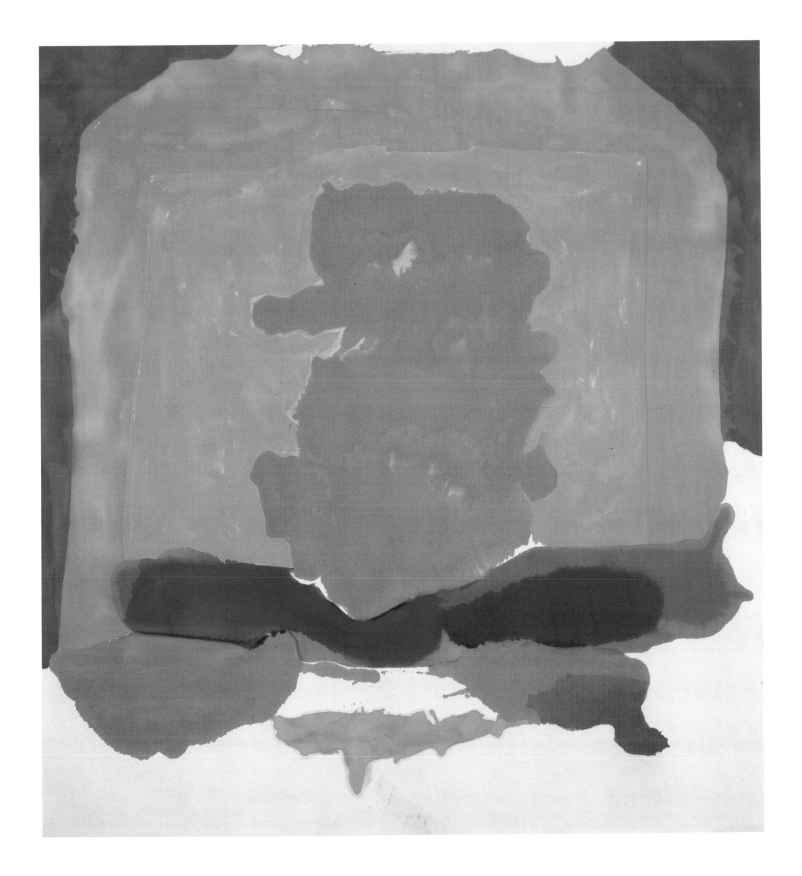

76

Morris Louis (1912–1962)
Faces 1959
acrylic on canvas
231.8 × 345.5 cm
Museum purchase from the Vincent Melzac Collection

We are accustomed to considering canvas as a support on which color is laid in various patterns and combinations. This was the case until Helen Frankenthaler changed the ground rules of painting (see p. 164) by inventing a staining technique, which she demonstrated to Morris Louis during a visit to her studio. Instead of a primed and sealed canvas or gessoed panel, Louis worked directly on unprimed cotton duck. The material soaked up the acrylic paints that he dripped or flooded over it such that canvas and pigment became one. He developed the potential of this technique in what he called his "Veil" paintings.

It is impossible to perceive the color field of *Faces* either as an object or as illusionistic space. Because the texture of the "veils" of color is clearly that of the canvas itself, the viewer cannot imagine that he is gazing into the sky or a colorful fog. The title should not be taken literally to suggest the presence of faces or masks, but simply to evoke the mysteries of the softly palpitating configurations. The evanescent quality of the color field is in considerable part due to the pouring technique.

Where no brush has intervened to mark and manipulate the surface, a somewhat impersonal relationship between viewer and canvas results, a relationship that is heightened by the canvas's large size.

The warm, earthy palette of *Faces* is romantic in a nocturnal, Keatsian vein. The field exhibits three general shifts of color, from the coppery area at the left with a darker, olive brown patch within, through the gray and green area with an edge of red brown, to the right-hand field of rust and green with a burgundy edge. The borders of these areas are blended and assimilated into one another, but to further complicate the image, a dark, wedge-like area seems to divide the field into two parts, like a tear in the veil.

The scale of *Faces* suggests an analogy with mural painting; but a traditional mural is read sequentially, temporally, whereas a Louis "Veil" is experienced all at once. The subtle and dramatic shifts of hue and value, like pulse beats or waves, are integral to the color field. Moreover, the shape of the field acknowledges the boundaries of the canvas and thus partially restores the pictorial unity of a traditional easel painting.

Louis painted on unstretched canvas and could, like Jackson Pollock and other action painters, work around the material on the floor or tack it to the wall, any side up. The result is that the washes of paint spread and run in contrary directions, a literal ebb and flow, with rhythms as natural as breathing.

77

Franz Kline (1910–1962)
Merce C 1961
oil on canvas
236.2 × 189.4 cm
Gift of S.C. Johnson & Son, Inc.

Although by definition the object is excluded from Abstract Expressionist art, it is increasingly clear that many of these paintings are concerned with more than existential psychological realities. They retain references to the visible world. Many of Jackson Pollock's mature works, for example, recreate the rhythms of nature on the canvas and acknowledge this source in their titles.

Franz Kline's preoccupation, in contrast, was with the muscular collisions, the exaggerated scale and tempo of the century. The urgent sweep of his house-painter's brush and the inability of even a large canvas to contain these battering-ram blows are the essence of Kline's expressionism. The direct communication of painting as physical act rather than a result of cogitation is central, yet cogitation is there. It may be seen as a New York painter's expression of John Dewey's statement that "art is a quality of doing and of what is done . . . an intrinsic quality of activity."

The title of this painting is *Merce C* – that is, Merce Cunningham, one of the most significant figures of experimental modern dance. For forty years he has collaborated with composer John Cage. Cage, in turn, has always had strong ties

with artists like Marcel Duchamp and Robert Rauschenberg. The inter-disciplinary experimentation that has flourished around Cunningham and Cage is one of the vital facts of much post-war art. Kline and Cunningham met in 1959 when they were both teaching at Black Mountain College, North Carolina.

In *Merce C* a dancer, or perhaps two in a *pas de deux*, is strongly suggested by the abstract shapes and the directional forces. One may also read in the loose and broken contours or in the cropped gestures that extend beyond the canvas a painterly reference to movement and to a photographic or cinematographic record of the dance.

It is likely, however, that the title was given to the painting after completion, when Kline himself first saw the suggestions of figuration. Close scrutiny of this vertical canvas discloses that it was painted in large part, if not entirely, in a horizontal position, lying on its right side. There are clear drip and run marks, especially in the strong diagonal at the lower right, that run left to right. Less demonstrable, but equally indicative, are the strong verticals, which seem to have been painted with a lateral gesture or sweep of the arm.

One may suppose that Kline painted the canvas in a horizontal position and then by chance or intention turned it to consider its other aspect, saw the dance configuration, and titled it. It recalls Kandinsky's famous experience of returning to his studio and being overwhelmed by a vision he could not immediately recognize: his own painting turned on its side.

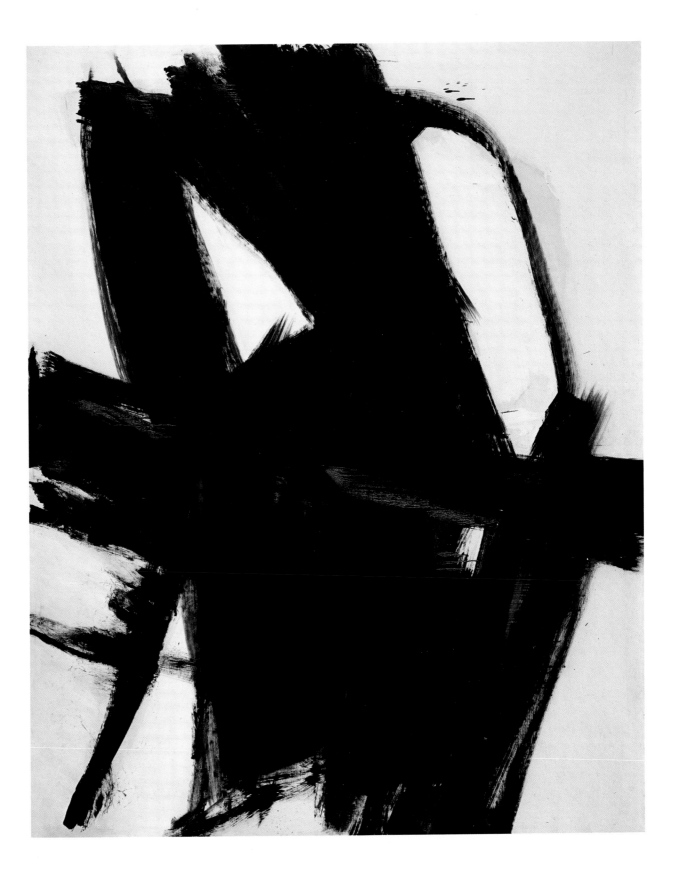

78

Robert Rauschenberg (born 1925)
Reservoir 1961
oil, pencil, fabric, wood, and metal on canvas, plus two electric
clocks, rubber tread wheel, and spoked wheel rim
217.2 × 158.7 × 37.4 cm
Gift of S.C. Johnson & Son, Inc.

"Setting out one day for a birthday party, I noticed the streets
were full of presents." The statement was made in an essay on
Rauschenberg by John Cage, composer and general *agent
provocateur* in contemporary American culture. It reveals their
shared view that the making of art is the offering of gifts,
as well as their adoption of at least one aspect of European
modernism: the incorporation of "found objects" in works of
art. Far from wishing to antagonize their audiences, as some
critics have accused them of doing, Cage and Rauschenberg
seek to make art more accessible by easing some of the
boundaries between the work of art and the day-to-day world
of experience.

The very title of this "combine painting" suggests a random
accumulation or extra supply of objects or options, as in things
fished out of a reservoir or a "reservoir of good will." Some of
the items strongly support this: crumpled cans, discarded
wheels from children's toys, pieces of wood whose original
purpose or source is unknown. The fluid, painterly surface,
with swirls and drips, especially around the accumulation of
these objects, supports the notion of junk tossed into the
water.

The complex multi-dimensionality of the work goes beyond
the projection of the wheel, cans, and boards attached to or
suspended from the surface of the painting. A spoked wheel
rim is inserted *into* the canvas like a window, and the shadows
it casts on the surface behind activate the composition,
introducing a variable element. Most noticeable, of course,
are the two clocks at the left. The dimension of time has been
increasingly invoked by artists of the past century, from
Monet and Cézanne to Marcel Duchamp. The latter, whose
influence on Rauschenberg is inescapable, was fascinated
with time, not only as a fourth dimension in the Einstein
formulation, but perhaps even more for its ambiguous nature.

Temporal ambiguity is teasingly played with in *Reservoir*.
According to Rauschenberg, he set the upper clock at the time
he began work on the painting and the lower clock when he
finished. This archival precision goes for naught, of course,
since there is no way to determine whether the times refer
to morning or evening or how many days elapsed between
commencement and conclusion. While time stands still in the
"real" clocks, however, the spoked wheel with its shifting
shadows mimics a sundial.

The composition and painterliness of the work clearly
acknowledge its debt to post-war action painting, particularly
that of Willem de Kooning. The surprise element of foreign
objects in a Rauschenberg sometimes obscures his more
traditional delight in surface and color. For example, the worn,
red paint of the old board laid aslant the upper part of the
canvas beautifully generates a burst of red and drift of pink.
Equally striking is the play of color and texture between the
silver gray of the crushed metal and the brown fabric fanning
out beneath it.

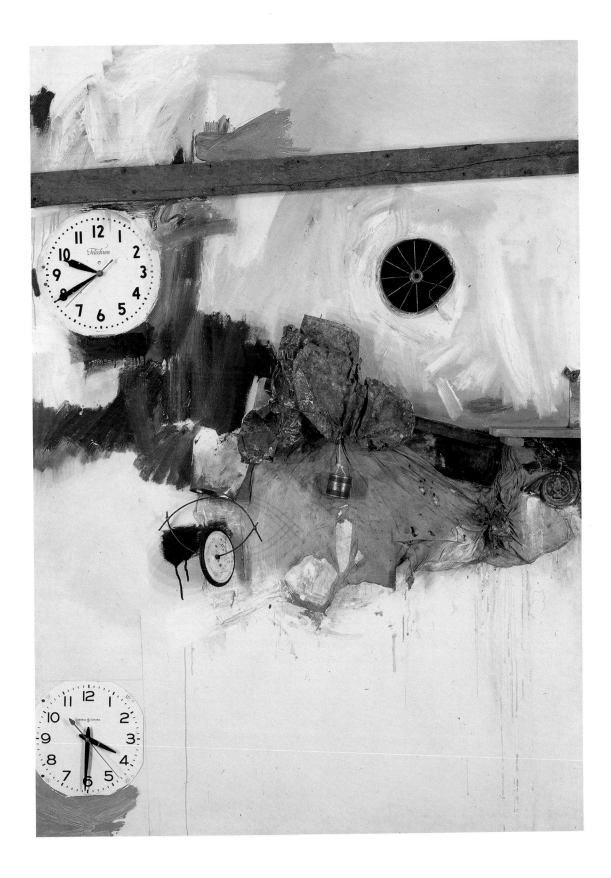

79

Stuart Davis (1894–1964)
Int'l Surface No. 1 1960
oil on canvas
144.8 × 114.3 cm
Gift of S.C. Johnson & Son, Inc.

During the 1950s, Davis produced a number of simplified, monumental works, sometimes omitting his customary words from the composition. In some of these paintings, he continued to play with pictorial space, at least to the extent of using overlapping planes. *Int'l Surface No. 1*, an assertive work from the artist's last years, continues his bold play with words, but all spatial recession is denied.

Although it has often been said that Davis's inclusion of words was purely pictorial, that their significance resided solely in their shapes, this is an overstatement. Not only is it impossible to drain all meaning from a word, regardless of its pictorial function, but Davis himself spoke of a pun in the title of one work. Chosen initially from the world of signs and advertisements, his words serve all at once as shapes, sounds, and symbols.

More is known about the genesis of *Int'l Surface No. 1* than of Davis's paintings. In 1956 *Fortune* magazine commissioned seven artists to look at "the stridently packaged goods of 1956" and paint what they saw "in a morning's haul from the supermarket." Davis did just that: "I bought a lot of groceries from the store and laid them down there on the floor and looked at them and made several compositions over a number of days until I found something in a drawing that looked like a painting, or was paintable." Entitling his creation *Package Deal*, he added, "The names in it . . . have a certain wit."

Subsequently, the artist painted two variants of *Package Deal* of which *Int'l Surface No. 1* is the later. He excerpted the lower right quadrant of the first, smaller painting and greatly enlarged it, changing the color scheme while retaining a nearly identical grouping of shapes and words. The earlier work clarifies the word cropped at the right edge of the canvas, *JUICE*, and partly explains the words *CAT* (food), *100%* (pure), *NEW*, and the apple-like shape on which it appears. However, in *Int'l Surface No. 1* Davis added the Spanish word *Calle* ("street"), possibly in association with *cat*, as in (c)alle(y) cat. And it should not go unmentioned that the words *cat* and *juice* have alternative meanings in the jazz world, whose idiom was so dear to Davis.

The oddly shaped *X* at the left appears frequently in the artist's paintings of the fifties. It is directional, sometimes structural, sometimes vaguely figural, and its apparent simplicity masks a rich ambiguity.

Cubist form, Fauve color, and the assertive simplicity of Fernand Léger are among the innovations of French modernism that Stuart Davis wedded to the dynamism of his urban vision. But his jazzy rhythms, clarity of shape, billboard scale, and solid areas of clarion color are unmistakably American.

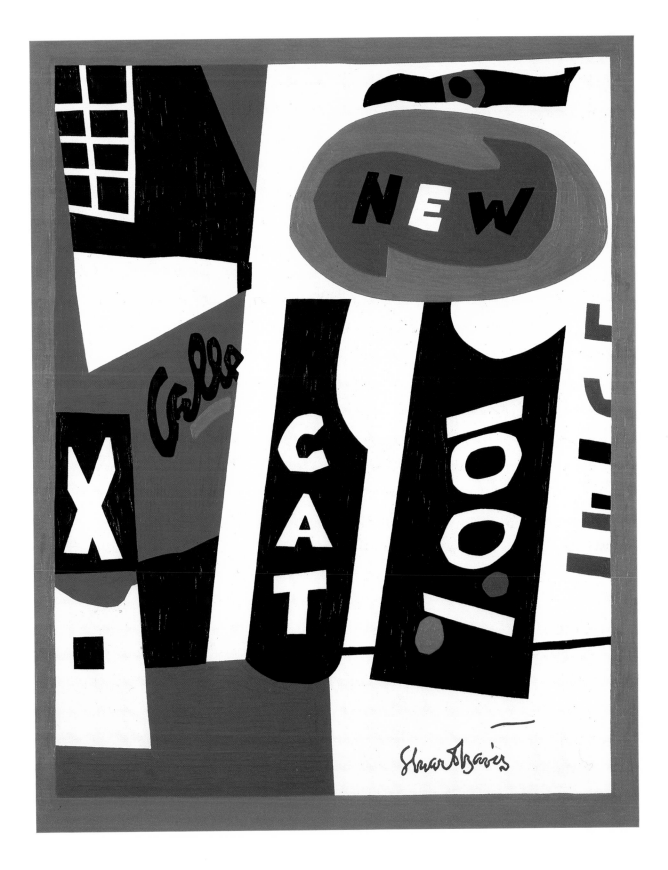

80

Robert Indiana (born 1928)
The Figure Five 1963
oil on canvas
152.4 × 127.2 cm
Museum purchase

Dubbing himself an "American painter of signs," Indiana became one of several artists in the early sixties to adopt the language of commercial advertising for his work. Stenciled letters and numbers were borrowed, as were strong colors and shapes because, like the ads themselves, they communicated directly and effectively.

Born in the Midwest and taking his name from the state of his birth, Indiana alludes in his work to the highways and signs and roadside diners that criss-cross and unite the nation. In addition, he often refers to earlier American writers and artists, sometimes simultaneously. His paintings about the Brooklyn Bridge, for example, borrowed forms invented by Joseph Stella in the twenties as well as imagery from the famous poem by Hart Crane.

In *The Figure Five*, Indiana pays homage to a well-known painting by Charles Demuth of 1928, the so-called poster-portrait of William Carlos Williams, from whose brief poem "The Great Figure" Demuth derived his central image: "Among the rain/and lights/I saw the figure 5 in gold/on a red/firetruck/moving/tense/unheeded/to gong clangs/siren howls/and wheels rumbling/through the dark city."

The very terseness of Williams's style no doubt inspired Demuth, who employed the same snappy rhythms in his own concise image. Demuth, however, uses a dynamic pictorial structure that atmospherically evokes light and rain and rapid movement.

Indiana, by contrast, avoids more traditional pictorial elements in favor of a contained, symmetrical icon. To this end he borrows only Demuth's three receding figure fives and ray-like background, which, however, he regularizes and makes opaque. Whereas Demuth used personal words – Bill, Carlos, Art Co. – Indiana uses impersonal, but highly loaded, words from the American lexicon: EAT, HOG, DIE, ERR, USA. Their monosyllabic punch and their insistence on both separateness and sequence, reminds one of the procession of Burma Shave signs that used to grace the roadsides.

Preoccupied with the Demuth image, Indiana produced a major series of works around 1963 that developed and varied the numerological theme. Sometimes he associated it with the American dream, a troublesome subject during the sixties, when patriotic and material aspirations were confronted with conflicting realities and ideals. Thus the star, USA, and EAT are countered with HOG, DIE, and ERR.

The painting's Pop power arises from its wedding of potent monosyllables with an equally condensed formal structure. This focused, large-scale image combines abstract design power with an undercurrent of nagging commentary. It raises its voice to get our attention, then mutters quietly and obsessively to itself.

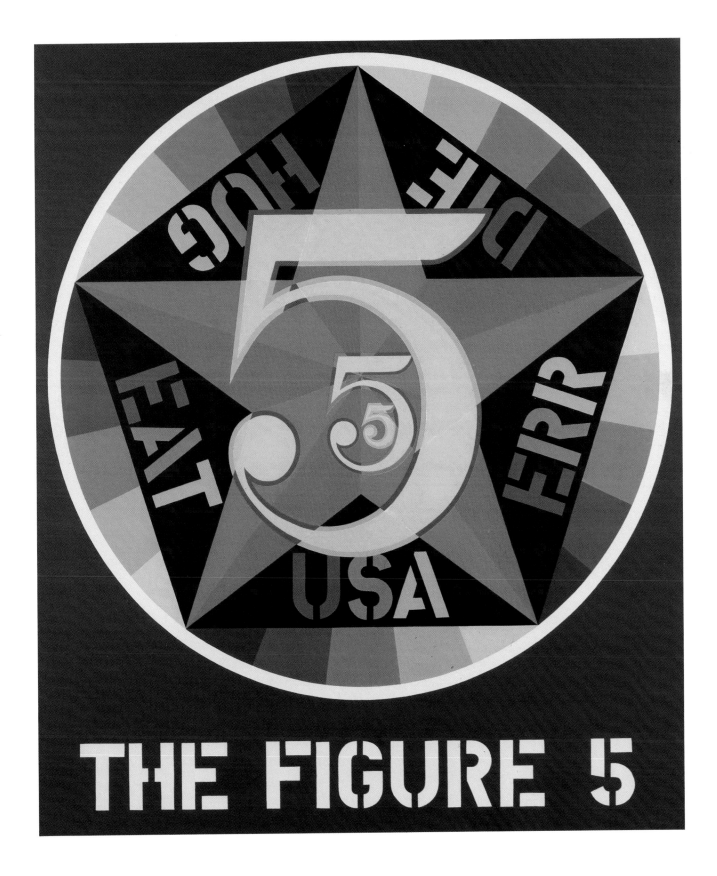

THE FIGURE 5

81

Ilya Bolotowsky (1907–1981)
Vibrant Reds 1971
acrylic on canvas
183.3 × 122.5 cm
Gift of Ira S. Agress

Aptly titled, this canvas dazzles the eye, while retaining an aura of serenity that holds the viewer rapt. It is an excellent example of the pristine abstractions that constitute the bulk of Bolotowsky's work. A disciple of "Neo-Plasticism," the style exemplified by Piet Mondrian, Bolotowsky proved himself an inspired practitioner of this mode of abstract painting as well as an unusually articulate spokesman for it.

> *My art is based on the relationship of the right angle and of straight lines which result in rectangles. Associations, images, literature do not belong in this style. It depends for its effects strictly on the tensions and rhythms created by the neutral, nonassociative, pure, plastic elements. The aim is to realize a feeling of timeless harmony and dynamic equilibrium.*

For Bolotowsky, as for Mondrian, "timeless harmony" was not an academic phrase but a philosophical ideal, the expression of a lifelong goal of creating paintings that approach the Platonic notion of the "real abstraction" – in other words, pictorial structures that are integral, like Plato's world of ideas, and thus embody (not represent) the underlying forces of nature.

Bolotowsky did not choose his style at random; the turmoil of his childhood was a governing factor. Born in Russia not long before World War I and the Russian Revolution, he fled with his family to the then-independent republic of Georgia, to Turkey, and finally to the United States. His style, he has said, is "my own reaction to whatever I experienced. . . . After I went through a lot of violent historical upheavals in my early life, I came to prefer a search for an ideal harmony and order which is still a free order, not militaristic, not symmetrical, not goose-stepping, not academic."

The demands of a style in the service of a governing ideal are not easily understood by the non-artist. It is almost startling, for example, to read Bolotowsky on the use of diagonals: "Although I hated to give up diagonals, I had to . . . because the space going back and forth was becoming too violent." In *Vibrant Reds*, a late work, the energies and spatial fluctuations of the red-and-white fields are restrained and held in dynamic balance, and the surface of the canvas retains its dominance. "Tensions on the canvas," Bolotowsky called these color areas, and he carefully avoided the hypnotic pulsations developed by some artists.

Three different reds – cherry, orange, and purple – are played against two "whites," one gray white, the other bright white. These hues are perceived differently as their juxta-positions change and as our eyes survey the surface. Their harmony is never static.

Sensuous, intense color was far more important to Bolotowsky than Mondrian. The former traced his love of color in part to William H. Johnson (see p. 138), "a fantastic colorist" in 1932. In his Neo-Plastic painting, Bolotowsky followed Mondrian in concentrating on the primary colors plus black and white, but he permitted himself a wider range of reds and blues and created effects of radiance and loveliness distinct from the more cerebral expression of the Dutch artist. In his late work, Bolotowsky began painting with acrylics, because it gave him the slightly dull finish he often sought. The architec-tonic quality of his work is underscored by the relative opacity of his surfaces.

It has been suggested that Bolotowsky's late work in some degree recalls the flat, hieratic boldness of Russian icons. The splendor of color he achieved justifies the comparison. Despite his early statements that associations have no place in his work, Bolotowsky agreed that "as one gets older, one's origins are reasserted."

Catalogue

In addition to documentary information for the eighty-one
paintings and sculptures highlighted in this book, this section
includes additional commentary on twenty-six of the artists
whose works, in quality or number, are a significant part of the
museum's collection. Quotations and specialized information in
the text come from catalogues and books listed under *Exhibition
History* and *References*. (Catalogues referred to under *Exhibition
History* are not repeated under *References*.) Two key resources
for the compilation of biographical information were the
catalogue section of *The Hirshhorn Museum and Sculpture Garden*
(New York, 1974), and the entries (by Barbara S. Krulik and
Dita Amory) in *Artists by Themselves: Artists' Portraits from the
National Academy of Design* (New York, 1983). Dimensions are
given in centimeters and inches, height preceding width.

1

Robert Feke
Thomas Hopkinson 1746
unsigned
oil on canvas, 126.5 × 100.5 cm ($49\frac{7}{8} \times 39\frac{5}{8}$ in.)
George Buchanan Coale Collection, 1926.6.2

PROVENANCE
Thomas Hopkinson; Anne Hopkinson (Mrs. Samuel Stringer) Coale (his daughter); George Buchanan Coale, Baltimore, Md.; Mrs. Francis T. Redwood, Baltimore (his daughter); gift of Mrs. Francis T. Redwood, 1926.

EXHIBITION HISTORY
Washington, D.C., Corcoran Gallery of Art, *Loan Exhibition of Portraits of the Signers and Deputies to the Convention of 1787 and Signers of the Declaration of Independence*, 27 November 1937–1 February 1938, cat. no. 122.

REFERENCES
Cuthbert Lee, *Early American Portrait Painters* (New Haven, 1929), p. 191 (illus.).
Theodore Bolton and Harry Lorin Binsse, "Robert Feke, First Painter to Colonial Aristocracy," *Antiquarian*, October 1930, pp. 78, 82.
Henry Wilder Foote, *Robert Feke* (Cambridge, Mass., 1930), pp. 69, 89, 103, 158–59.
R. Peter Mooz, "The Art of Robert Feke" (Ph.D. diss., University of Pennsylvania, 1970).
Michael Quick, *American Portraiture in the Grand Manner: 1720–1920* (Los Angeles, 1981), N.B. p. 88.

COMMENTS
The painting is undated, but Feke scholar Peter Mooz assigns its execution to Feke's 1746 visit to Philadelphia, arguing that by his 1749 visit, his style was more elaborate in pose and composition (oral communication, museum files, 26 March 1971).

BIOGRAPHY
Probably born 1707, Oyster Bay, N.Y. Lived there until about 1731. Possibly in New York City. Newport, R.I., by 1742, where he was married 23 September. Recorded as an established portraitist in Newport, July 1744. Known also as a mariner. Frequent travels for portrait commissions, including to Boston, 1741 and 1748–49, and Philadelphia, 1746 and 1750. Said to have gone to Bermuda about 1750 due to health. Died probably in 1752.

2

Ralph Earl
Mrs. Richard Alsop 1792
signed left side, near juncture of skirt and frame: *R. Earl Pinxt/1792*
oil on canvas, 115.9 × 91.7 cm ($45\frac{5}{8} \times 36\frac{1}{8}$ in.)
Gift of Joseph Alsop and museum purchase, 1975.49.1

PROVENANCE
Through descendants of the sitter; Joseph Alsop, Washington, D.C., with its pendant (see comments below) to NMAA, 1975.

EXHIBITION HISTORY
New Haven, Conn., Yale University, Gallery of Fine Arts, *Connecticut Portraits by Ralph Earl, 1751–1801*, 1 August–15 October 1935, cat. no. 9, p. 12.
New York, Whitney Museum of American Art, *Ralph Earl, 1751–1801*, 16 October–21 November 1945, cat. no. 30 (then to Worcester Art Museum).
New York, Hirschl & Adler, *Quality: An Experience in Collecting*, 12 November–7 December 1974, cat. no. 13.

REFERENCES
Karen M. Jones, "Museum Accessions," *Antiques*, June 1976.

COMMENTS
This portrait of Mrs. Richard (Mary) Alsop has a companion piece in the portrait of Mrs. Joseph (Hannah) Wright, her mother. The paintings have always been together. Mrs. Richard Alsop was painted by Earl at the family farm at Westfield, Conn.; the river seen through the window is the Mattabeesett River.

BIOGRAPHY
Born 1751, Worcester County, Mass. Family moved to Leicester, Mass., where he grew up. Art study unknown. 1774, established studio in New Haven, Conn. Married Sarah Gates, later divorced. A loyalist, he left Connecticut 1777, arrived in London, April 1778. Studied with Benjamin West; exhibited at Royal Academy. About 1784, married Ann Whiteside; two children. Returned to Boston, May 1785; same year, moved to New York City. Drinking and extravagance led to debtor's prison. Traveled in Connecticut, Massachusetts, and Vermont. Reversion in style led to synthesis of competence and naiveté in last decade. Died 16 August 1801, Bolton, Mass.; cause of death listed as "intemperance."

3

Charles Willson Peale
Mrs. James Smith and Grandson 1776
signed and dated upper left: *C.W. Peale, pinxt. 1775* (see *Comments* regarding date)
oil on canvas mounted on fiberglas, 92.4 × 74.3 cm ($36\frac{3}{8} \times 19\frac{1}{4}$ in.)
Gift of Mr. and Mrs. Wilson L. Smith, Jr., and museum purchase, 1980.93

PROVENANCE
Descended in the Smith family to Wilson Levering Smith, Jr.

EXHIBITION HISTORY
Washington, D.C., National Portrait Gallery, *Charles Willson Peale and His World*, 4 November 1982–2 January 1983, cat. no. 152, pp. 207 (illus.), 260 (then to Fort Worth, Tex., Amon Carter Museum, and New York, The Metropolitan Museum of Art).

REFERENCES
Charles Coleman Sellers, *Portraits and Miniatures by Charles Willson Peale*, Transactions of the American Philosophical Society, vol. 42, pt. 1 (Philadelphia, 1952), p. 196.
Eleanor H. Gustafson, "Museum Accessions," *Antiques*, April 1982.

COMMENTS
Peale's diary entry of 15 September 1776 records that he "began a ½ length of Mrs. Smith & child," and further sittings are recorded on 22 and 24 September and 11 November. It is likely that he signed and dated the painting years later and was mistaken in the year. According to Lillian B. Miller, editor of the Peale Papers, he did this with other paintings as well (memorandum, 15 April 1981, curatorial files). Although Peale recorded the sitter as Mrs. Smith, she had in fact remarried, to Patrick Campbell. Her son, William Smith, who must have commissioned the portrait, named his son (the boy in the picture) Campbell Smith in affection for his stepfather.

BIOGRAPHY
Born 15 April 1741, Queen Anne's County, Md. 1750, death of father. 1751, family moved to Annapolis. 1754, apprenticed to a saddler. 1761, established a shop in Annapolis. 1762, married Rachel Brewer. Became interested in painting; 1763, studied briefly with John Hesselius. 1764, joined Sons of Freedom in opposition to the "court" party of Maryland. 1765, sailed to Boston and Newburyport; met and studied briefly with

John Singleton Copley. 1766, moved to Accomac, Va., then Annapolis; in December sailed for England to study with Benjamin West. 1768, exhibited with Society of Artists of Great Britain. 1769, returned to Annapolis; painted in Maryland and Philadelphia. 1772, first portrait of George Washington. 1774, son Raphaelle born. 1775, daughter Angelica Kauffmann born. 1776, moved to Philadelphia and joined city militia. Fought in battles of Trenton and Princeton. 1777, chairman of Whig Society. 1778, son Rembrandt born. 1779, commissioned by Supreme Executive Council of Pennsylvania to paint portrait of Washington. Elected representative to General Assembly of Pennsylvania. 1780, son Titian Ramsay born. 1782, added exhibition room to his house; opened portrait gallery. 1784, son Rubens born; 1786, daughter Sophonisba Angusciola born. "Peale's Museum" (the Philadelphia Museum) opened. 1787, made mezzotints after his portraits. 1790, wife Rachel died. 1791, married Elizabeth DePeyster. 1794, son Charles Linnaeus born; 1795, son Benjamin Franklin. 1797, published "An Essay on Building Wooden Bridges"; developed the patent fireplace; daughter Sybilla Miriam born. 1799, son Titian Ramsay II born. Published first lecture, "Introduction to a Course of Lectures on Natural History Delivered in the University of Pennsylvania . . ." 1801, organized expedition for first American exhumation of a mastodon, which he exhibited. 1802, daughter Elizabeth DePeyster born. 1804, wife Elizabeth died. 1805, co-founder, Pennsylvania Academy of the Fine Arts; married Hannah Moore. 1810, retired to "Belfield," farm outside Philadelphia, turning musem over to Rubens. 1812, published "An Essay to Promote Domestic Happiness." 1818–19, in Washington, D.C. 1821, incorporated Philadelphia Museum Company; wife Hannah died. 1822, resumed management of museum. Experimented with manufacture of porcelain teeth. Died 22 February 1827, Philadelphia.

Benjamin West
Helen Brought to Paris 1776
signed lower right: *B. West./1776.*
oil on canvas, 143.5 × 191.4 cm ($56\frac{1}{2}$ × $75\frac{3}{8}$ in.)
Museum purchase in memory of Ralph Cross Johnson, 1969.33

PROVENANCE
Possibly "a family in Kent," England (mentioned by John Galt, 1820; see *References*); John Morant, Brockenhurst Park, Hampshire, England; purchased from Morant by husband of Charlotte Franklin, 1958; purchased from Appleby Collection by James Graham & Sons, Inc., New York, ca. 1962.

REFERENCES
John Galt, *Life, Studies, and Works of Benjamin West, Esq.* (London, 1820), p. 223.
Margaret R. Scherer, *The Legends of Troy in Art and Literature* (New York, 1963), p. 250 (quotes Galt citation).

COMMENTS
The observation that the painting was originally a lunette was made by Henri Marceau, formerly assistant director of the Philadelphia Museum of Art and a West scholar (memorandum in curatorial file, 9 February 1944).

BIOGRAPHY
Born 10 October 1738, Springfield, Pa. Earliest art study with William Williams, a minor English portraitist working in Philadelphia. Largely self-taught as an artist. 1759, with the aid of Philadelphia patrons, traveled to Italy, the first American-born artist to do so. Remained in Rome until 1763. Visited France and England, where he settled permanently. Quickly became leading history painter in England. 1768, charter member of Royal Academy of Arts. 1771, painted *The Death of General Wolfe*, which established a new genre, contemporary history painting. 1772–1811, "Historical Painter" to King George III. From 1771, engravings after his paintings widely distributed, increasing fame and income. His studio very popular, especially among visiting American artists, many of whom studied with him (including Charles Willson Peale, John Trumbull, Washington Allston, and Gilbert Stuart). 1780, royal commission to paint biblical series for private chapel at Windsor; later cancelled. 1792, succeeded Joshua Reynolds as second president of Royal Academy. Died 10 March 1820, London. Buried St. Paul's Cathedral.

The NMAA owns two paintings by West in addition to *Helen Brought to Paris*, each significant enough to warrant discussion here. Both are portraits, but they are separated by some fifty-five years and a great stylistic gulf.

The earlier is the portrait *Mary Hopkinson*, probably painted in London in 1764. West had arrived in London in late August 1763, and his style was still unformed and essentially colonial. He did not paint Miss Hopkinson from life, but from a miniature brought to England by her fiancé, Dr. John Morgan. Although the artist of the unlocated miniature is unknown, a colonial origin is certain, since Mary Hopkinson had not traveled abroad. (It is not impossible that the miniature was by West himself, for he had painted miniatures and known Miss Hopkinson's brother [see below] since about 1755.)

In costume and attitude, she is an elegant, if slightly stilted, figure. Her rose gown is trimmed with sable, pearls, and ornamental bows; a silver gray veil with gold stripes falls from her head to her shoulder, and her face is set off by pearl eardrops and choker. She holds a lute, specifically a cittern in an eighteenth-century form known as an English guitar. The strings of this handsome instrument have unfortunately disappeared from the painting due to abrasion.

Mary Hopkinson was the daughter of Thomas Hopkinson (see his portrait by Robert Feke, p. 16) and hence the sister of Francis Hopkinson, a signer of the Declaration of Independence, and a man whose political pamphleteering and other services were set off by his varied cultural pursuits. Even in cosmopolitan Philadelphia, he was a remarkable amateur – painting, writing, and above all composing music. Indeed, he is recognized as our first native-born composer.

Dr. Morgan, who commissioned the portrait, was a distinguished physician, founder of the University of Pennsylvania Medical School and later physician-in-chief to the Continental Army. He and Mary Hopkinson were married on 4 September 1765. Morgan may have sought out the young West because of his Philadelphia origins, but it is worth noting that he had already had his own portrait painted in Rome by the even younger Angelica Kauffmann, who, newly arrived in that city, established her reputation with a portrait of Johann Winckelmann. It would seem that Dr. Morgan had a sharp eye for new talent.

In October 1819, West painted an austere *Self-Portrait*, in which he regards himself with a measured and unflinching gaze. It is the sort of painting that goes beyond style. The colonial

Rococo mannerisms of *Mary Hopkinson* and the svelte Neo-classicism of *Helen Brought to Paris* are elements of the past. In their place, West projects an honest objectivity that one is tempted to characterize as Quaker. Although West was not actually a Quaker, he propagated the notion that he was, possibly because it suited his independent personality or the anomalous position of a colonist become painter-to-the-king and president of the Royal Academy. Or it may have been a sincere adoption of his parents' faith. In any event, he seems to have absorbed the Quaker principles of sobriety, moderation, and self-control. These characteristics are abundantly present in his self-portrait, which depicts him as still vigorous, though he was increasingly feeble during this last year of life. In his russet painter's smock, dignified by a tall beaver hat, he holds his drawing chalks above the sheet of paper and regards himself steadily. Here, in what he must have known would be his final self-portrait, West reasserts his dedication to the fundamentals of his art. The stylish subtleties of his large history paintings are set aside for a last blunt and penetrating look at himself. Within five months he was dead at eighty-one.

West, *Mary Hopkinson*, ca. 1764, oil on canvas, 127.8 × 96.9 cm (50¼ × 38⅛ in.). George Buchanan Coale Collection, 1926.6.1

West, *Self-Portrait*, 1819, oil on paperboard, 82.2 × 65 cm (32⅜ × 25⅝ in.). Transfer from the U.S. Capitol, 1917.2.3

Thomas Sully
Daniel LaMotte 1812–13
unsigned
oil on canvas, 92.3 × 73.8 cm (36⅜ × 29 in.)
Gift of Mr. and Mrs. Ferdinand LaMotte III, 1983.76

PROVENANCE
Descended through the sitter's family to Mr. and Mrs. Ferdinand LaMotte, Jr.; Mr. and Mrs. Ferdinand LaMotte III.

REFERENCES
Edward Biddle and Mantle Fielding, *The Life and Works of Thomas Sully* (Philadelphia, 1921), p. 204, cat. no. 1025.
Eleanor H. Gustafson, "Museum Accessions," *Antiques*, November 1984.

COMMENTS
Biddle and Fielding, drawing upon Sully's meticulous records, report: "Portrait begun May 25th, 1812, finished Jan., 1813. Size 29″ × 36″. Price, $100.00."

BIOGRAPHY
Born 19 June 1783, Horncastle, Lincolnshire, England. 1792, emigrated with actor parents to Charleston, S.C. Studied art with schoolmate Charles Fraser; brother-in-law, Jean Belzons; and brother, Lawrence Sully, all miniature painters. He, too, began as a miniaturist. Until his brother's death in 1803, they painted together. 1805, married widowed sister-in-law. 1806, moved to New York. Patronage from acquaintances in theater. 1807, brief study with Gilbert Stuart, Boston. 1808, moved permanently to Philadelphia, where he soon became a leading portraitist. 1809, with funds from Philadelphia patrons, spent nine months in London studying under Thomas Lawrence. 1812, elected academician, Pennsylvania Academy of the Fine Arts. After death of Charles Willson Peale, 1827, he was pre-eminent portrait painter of Philadelphia for remainder of life. 1837–38, London to paint portrait of Queen Victoria; major success. 1843, declined presidency of Pennsylvania Academy. Traveled frequently to other cities to execute portraits. His register of commissions lists over 2,600 paintings. Died 5 November 1872, Philadelphia.

6

Raphaelle Peale
Melons and Morning Glories 1813
signed and dated lower right: *Raphaelle Peale
Painted/Philadelphia Sept.ʳ 3ᵈ, 1813*
oil on canvas, 52.6 × 65.4 cm (20¾ × 25¾ in.)
Gift of Paul Mellon, 1967.39.2

PROVENANCE
Walter Stuempfig; Mr. and Mrs. Lawrence A.
Fleischman, Detroit; Kennedy Galleries, Inc.,
New York, 1960; to Paul Mellon, 1961.

EXHIBITION HISTORY
Chicago, The Art Institute of Chicago, *From
Colony to Nation*, cat. no. 72, p. 62 (illus.).
Milwaukee, Wis., Milwaukee Art Institute,
Raphaelle Peale, 1959 (then to New York,
M. Knoedler & Co.).
Milwaukee, Wis., Milwaukee Art Center,
American Painting 1760–1960, 3 March–3 April
1960, cat. no. 29, p. 29 (illus.).
Mexico City, Museo del Palacio de Bellas Artes,
*La Pintura de los Estados Unidos de museos de la
ciudad de Washington*, 15 November–
31 December 1980, cat. no. 8, p. 57 (illus.).

REFERENCES
William H. Gerdts and Russell Burke, *American
Still-Life Painting* (New York, 1971), pp. 30–31,
pl. 1.
William H. Gerdts, "Nature's Bounty: Early
American Still-Life Painting," *Portfolio*,
September/October 1981, p. 62 (illus.).

BIOGRAPHY
Born 17 February 1774, Annapolis, Md., eldest
son of Charles Willson Peale to survive infancy.
Studied with his father, with whom he also
collaborated on portraits. 1792, trip to South
America to collect specimens for "Peale's
Museum," Philadelphia. 1794, exhibited five
portraits and eight other paintings, probably still-
lifes, at the Columbianum, Philadelphia. With his
brother Rembrandt, traveled to Charleston, S.C.,
then Baltimore, where they attempted
unsuccessfully to establish a museum, 1797–99.
Late 1790s, painted mostly miniatures. Brief
financial success with the physiognotrace, a
profile making machine, with which he toured
Virginia, 1803–5. August 1808, hospitalized with
alcoholic "delirium"; suffered severely from gout.
By late 1813, unable to walk without crutches.
From 1810, concentrated on still-life painting
almost exclusively, becoming America's first
professional still-life painter. Exhibited frequently
at Pennsylvania Academy of the Fine Arts and
elsewhere, especially from 1814–18. Financially
dependent for most of his life on his father. Died
after night of heavy drinking, 5 March 1825,
Philadelphia.

7

Gilbert Stuart
John Adams 1826
unsigned
oil on canvas, 76.2 × 63.6 cm (30 × 25⅛ in.)
The Adams-Clement Collection. Gift of Mary
Louisa Adams Clement in memory of her mother,
Louisa Catherine Adams, 1950.6.11

PROVENANCE
John Quincy Adams; Mary Louisa Adams (Mrs.
William C.) Johnson (his granddaughter); Louisa
Adams Clement (Mrs. Clarence) Erskine (great-
great-great granddaughter of subject),
Newburyport, Mass.; Mary Louisa Adams
Clement (her daughter), Warrenton, Va.

EXHIBITION HISTORY
Moscow, *American Painting and Sculpture* (USIA),
25 July–5 September 1959.
Washington, D.C., National Gallery of Art,
Gilbert Stuart: Portraitist of the Young Republic,
29 June–20 August 1967, cat. no. 51, p. 109
(illus.; then to Providence, the Museum of Art,
Rhode Island School of Design).
Washington, D.C., National Portrait Gallery,
2 May–November 1983.

REFERENCES
Smithsonian Institution, *Annual Report*, 1951,
p. 42.
James T. Flexner, *Gilbert Stuart* (New York,
1955), p. 189.
Charles M. Mount, *Gilbert Stuart* (New York,
1964), pp. 321–22, 363.
Andrew Oliver, *Portraits of John and Abigail Adams*
(Cambridge, Mass., 1967), pp. 188–201 (illus.),
259.

BIOGRAPHY
Born 3 December 1755, North Kingstown
Township, R.I. 1769, first art training with
Cosmo Alexander, Newport, R.I.; accompanied
him to South Carolina, 1770–71, and Edinburgh,
Scotland, 1771. 1773, returned to Newport, began
career as a portraitist. Late 1775, settled in
London. 1777–82, studied with Benjamin West.
Exhibited *The Skater* at the Royal Academy, 1782;
established reputation. 1786, married Charlotte
Coates. Late 1787, moved to Dublin, where he
became a leading portraitist. 1793, returned to
U.S., to New York and Philadelphia (1794), with
intention of painting likeness of President
Washington (and evading his Irish creditors).
1795–96, painted Washington and established the
three "types": "Vaughan," "Athenaeum," and
"Lansdowne." 1796, moved to Germantown, Pa.;
1803, to Washington, D.C.; 1805, to Boston. Died
9 July 1828, Boston.

8

Alvan Fisher
The Great Horseshoe Fall, Niagara 1820
oil on canvas, 87.2 × 122 cm (34⅜ × 48⅛ in.)
Museum purchase, 1966.82.1

PROVENANCE
Daniel Appleton White, Salem, Mass. (purchased
from the artist, 1820); descended in family to
Miss Eliza Orne White, Brookline, Mass. (until
January 1947); Perkins Institute and
Massachusetts School for the Blind, Watertown,
Mass.; Charles Childs, Boston; Giovanni Castano,
Boston (by November 1947); jointly owned by
James Graham and Sons, New York, and Victor
Spark, New York (by November 1953); Mr. and
Mrs. Arthur Fleischman, Detroit (purchased from
Victor Spark by 1956); Mr. and Mrs. Lawrence
Fleischman, Detroit; Kennedy Galleries, New York.

EXHIBITION HISTORY
Detroit, Mich., The Detroit Institute of Arts,
Painting in America, 23 April–9 June 1957, cat.
no. 75.
Atlanta, Ga., The High Museum of Art, *The
Beckoning Land*, 18 April–13 June 1971.
Washington, D.C., Corcoran Gallery of Art,
*Niagara Falls: Two Centuries of Changing
Attitudes, 1697–1900*, 21 September–
25 November 1985, exh. cat. (then to Albright-
Knox Art Gallery, Buffalo, N.Y.).

REFERENCES
Alan Burroughs, "A Letter from Alvan Fisher,"
Art in America, July 1944, p. 123.
Edgar P. Richardson, *Painting in America* (New
York, 1956), p. 156.
Fred B. Adelson, "Alvan Fisher (1792–1863):
Pioneer in American Landscape Painting"
(Ph.D. diss., Columbia University, 1982),
pp. 167–87.

COMMENTS

Fisher's only known trip to Niagara, in July 1820, is datable from two dated drawings of the subject (Museum of Fine Arts and Vose Galleries, Boston). The painting has a companion piece, *A General View of the Falls of Niagara*, signed and dated 1820, also in the NMAA. It is probable that D.A. White commissioned the pair. Three other painted views of Niagara by Fisher are also known, as are numerous drawings. The original title of this work is known from a watercolor after the painting that Fisher sent to White in November 1820, which is inscribed: "The Great Horse-Shoe or Canada Fall." The pair of paintings was praised by E.P. Richardson (above) as "the best pictures I have seen by him."

BIOGRAPHY

Born 9 August 1792, Needham, Mass.; grew up in Dedham. Began painting about 1812; first instruction from John Ritto Penniman. Initially a portrait painter; turned about 1815 to rural genre scenes. After 1819, portrait painting again supplied his chief income. 1817, exhibited at Pennsylvania Academy of the Fine Arts; lived in Boston at that time. Traveled widely in search of commissions, including Charleston, S.C., and Hartford, Conn. 1825, went to Europe and studied briefly in Paris. 1826, returned to U.S. and settled permanently in Boston. Frequent exhibitions at the Boston Athenaeum, National Academy of Design, Pennsylvania Academy, Apollo Association, Maryland Historical Society. Honorary member, National Academy of Design. Died 13 or 14 February 1863, Dedham, Mass.

9

Thomas Cole
The Subsiding of the Waters of the Deluge 1829
signed and dated on rocks, lower left: *T. Cole/1829*
oil on canvas, 90.8 × 121.4 cm ($35\frac{3}{4} \times 47\frac{5}{8}$ in.)
Gift of Mrs. Katie Dean in memory of Minnibel S. and James Wallace Dean and museum purchase through the Major Acquisitions Fund, Smithsonian Institution, 1983.40

PROVENANCE

Dr. David Hofack, New York, 1829; Mr. I.T.B. Wellington, Brooklyn, before 1872; auctioned with Wellington collection, Leavitt Art Rooms, New York, 7 February 1872; about 1900 appeared in an unknown New York gallery, signature obscured and artist unknown; before

1904 purchased by Minnibel Smith (later Mrs. James Wallace Dean), New York; from Katie Dean (Wallace Dean's second wife and widow) through Berry-Hill Galleries, New York, to NMAA.

EXHIBITION HISTORY

New York, National Academy of Design, 1829.
New York, National Academy of Design, 1831.
New York, National Academy of Design, 1833.
Baltimore, Md., The Baltimore Museum of Art, 1867.
New York, Leavitt Art Rooms, 7–8 February 1872 (exhibition prior to sale of I.T.B. Wellington collection).

REFERENCES

New York Mirror, 1831
John Dillenberger, *The Visual Arts and Christianity in America: The Colonial Period through the Nineteenth Century* (Chico, Calif., 1984), pl. 42.

BIOGRAPHY

Born 1 February 1801, Bolton-le-Moor, Lancashire, England. About 1817 worked as engraver's assistant, Liverpool. 1818, moved with family to U.S. Stayed in Philadelphia while family continued to Steubenville, Ohio. Worked as textile print designer, also did engraved illustrations for Bunyan's *Holy War*. 1819, sailed to West Indies then joined family in Steubenville. In Ohio until early 1823. Studied painting with itinerant artist; painted portraits, landscapes, and religious scenes. 1823 to Pittsburgh, then Philadelphia. Studied at the Pennsylvania Academy of the Fine Arts. Exhibited a landscape there in 1824. 1825, moved to New York City. Traveled in Hudson River Valley. 1826, elected to National Academy of Design. Exhibited there and at the American Academy of Fine Arts. 1829, Niagara Falls in May, sailed for England in June. In London met John Constable and J.M.W. Turner; exhibited at British Institution and Royal Academy, 1830 and 1831. Visited Paris, Florence, Rome, Naples, and Paestum, 1831–32. Returned to New York, late 1832. 1835, wrote "Essay on American Scenery." 1836, married Maria Bartow; settled in Catskill, N.Y. 1839, began series *The Voyage of Life*. 1841–42 London, France, Switzerland, Rome, Sicily; returned to New York. 1844 became teacher of Frederic Church. Died 8 February 1848, Catskill.

Charles Bird King
Young Omahaw, War Eagle, Little Missouri, and Pawnees 1821
unsigned
oil on canvas, 91.8 × 71.1 cm ($36\frac{1}{8} \times 28$ in.)
Gift of Helen Barlow to the Smithsonian Institution, 1965.58.384.222

PROVENANCE

John Gadsby Chapman, by 1838; Dr. Wilson, Florence, Italy; by his bequest to Mr. Barlow, about 1900; to his daughter, Miss Helen Barlow, London; by her bequest to Smithsonian Institution, 1946.

EXHIBITION HISTORY

New York, National Academy of Design, 1838, cat. no. 54 (as property of J.G. Chapman).
Washington, D.C., National Collection of Fine Arts (now NMAA), *The Paintings of Charles Bird King (1785–1862)*, 4 November 1977–22 January 1978, cat. no. 484, pp. 63–67, fig. 49.
Mansfield, Ohio, The Mansfield Art Center, *The American Portrait: Smibert to Sargent*, 28 February–March 1982.

COMMENTS

A label formerly on the back of the stretcher bore the inscription: "Young Omahaw, War Eagle, Little Missouri, and Pawnees. Painted at Washington City, 1821, by C.R. [*sic*] King." When exhibited at the National Academy of Design, 1838, the entry (no. 54) read: "Young Omahaw, War Eagle, Little Missouri and Pawnees, Who Visited Washington in 1821. *J.G. Chapman*." Chapman, a student of King's, owned at least two of his paintings.

BIOGRAPHY

Born 26 September 1785, Newport, R.I. 1789, father killed by Indians at Marietta, Ohio. Childhood art lessons from his grandfather, Nathaniel Bird, and a neighbor, Samuel King. 1800–1805, apprenticeship with Edward Savage, New York. 1806–12, London, where he studied with Benjamin West and was widely acquainted with American and English artists. 1812, elected academician of Pennsylvania Academy of the Fine Arts; returned to U.S. and moved to Philadelphia. 1813, exhibited four paintings at Pennsylvania Academy. Apparently lived for a time in Richmond; then in Washington, 1814. 1815, moved to Baltimore. 1817 and 1818, exhibited at Pennsylvania Academy. Late 1818, settled permanently in Washington, his painting

rooms at Twelfth and F streets. 1822, began painting Indian portraits for the War Department – regularly until 1830, sporadically until 1842. 1825, appointed by President John Quincy Adams to three-man jury for a sculptural design for the Capitol. 1827, elected honorary member, National Academy of Design. Exhibited at Boston Athenaeum, 1831–32. 1837–38, two volumes of McKenney and Hall's *History of the Indian Tribes of North America* appeared, illustrated with lithographs based on King's Indian Gallery. 1850, opened a public gallery of art in his home; soon discontinued. 1854, Danish National Museum acquired nine of his Indian portraits. 1858, his Indian Gallery transferred from the Patent Office Building to Smithsonian Institution Building. 1859, gave seventy-eight paintings to Redwood Library and Athenaeum, Newport, R.I.; 1861, gave the library another forty-two paintings, as well as books, maps, and engravings. Died 18 March 1862, Washington, D.C. Bequest to Redwood Library included 75 paintings and 395 books.

I I

George Catlin
Buffalo Bull's Back Fat, Head Chief, Blood Tribe 1832
oil on canvas mounted on aluminum,
73.7 × 60.9 cm (29 × 24 in.)
Gift of Mrs. Joseph Harrison, Jr., to the
Smithsonian Institution, no. 386149

PROVENANCE
Joseph Harrison, Philadelphia, 1852; from Harrison's executors and Mrs. Harrison to the Smithsonian Institution, 1878.

EXHIBITION HISTORY
Paris, Musée Royal, Salon de 1846, cat. no. 315.
Montreal, Museum of Fine Arts, *The Painter and the New World*, 9 June–30 July 1967, cat. no. 178.
Fort Worth, Tex., Amon Carter Museum, *George Catlin: The Artist and the American Indian*, 19 November 1981–24 January 1982 (then to The Denver [Colo.] Art Museum).
Manitoba, Canada, The Winnipeg Art Gallery, *A Distant Harmony*, 8 October–21 November 1982.
Edinburgh, Scotland, Royal Scottish Museum, *Treasures of the Smithsonian*, 8 August–5 November 1984.

REFERENCES
Catalogue of Catlin's Indian Gallery (New York, 1837), cat. no. 132.
George Catlin, *Letters and Notes* (London, 1841).
Charles Baudelaire, *Art in Paris, 1845–1862*, ed. and trans. Jonathan Mayne (London, 1965), pp. 70–71.
Thomas Donaldson, "The George Catlin Indian Gallery," *Annual Report of the Smithsonian Institution for 1885*, pt. 5, pp. 101–2, pl. 43.
Lloyd Haberly, *Pursuit of the Horizon* (New York, 1948), p. 59.
John C. Ewers, "An Anthropologist Looks at Early Pictures of North American Indians," *New-York Historical Society Quarterly Bulletin* 33 (October 1949): 232 (illus.).
————, "George Catlin, Painter of Indians and the West," *Annual Report of the Smithsonian Institution for 1955*, pp. 504, 508, pl. 20.
Harold McCracken, *George Catlin and the Old Frontier* (New York, 1959), pp. 67–68, 73 (illus.).
Robert Beetem, "George Catlin in France: His Relationship to Delacroix and Baudelaire," *Art Quarterly* 24 (Summer 1961): 140–41.
George Catlin (Paris, 1963), no. 20, pl. 3.
John C. Ewers, *Artists of the Old West* (New York, 1965), p. 77 (illus.).
Marjorie Halpin, *Catlin's Indian Gallery* (Washington, D.C., 1965), cover illus.
Denys Sutton, "The Luminous Point," *Apollo* 85 (March 1967): 217.
Baudelaire (Paris, 1969), no. 178 (illus.).
Denys Sutton, "The Baudelaire Exhibition," *Apollo* 89 (March 1969): 180–81, 183 (illus.).
Mary Sayre Haverstock, *Indian Gallery: The Story of George Catlin* (New York, 1973), p. 68 (illus.).
Portraits USA, 1776–1976 (University of Pennsylvania, 1976), p. 46, 47 (illus.).
Time-Life Books, ed., *The Chroniclers* (New York, 1976), p. 105 (illus.).
William H. Truettner, *The Natural Man Observed: A Study of Catlin's Indian Gallery* (Washington, D.C., 1979), p. 184, no. 149.

COMMENTS
The sitter and the occasion are described by Catlin in his *Letters and Notes* (see above) from which this excerpt was taken.

I have this day been painting a portrait of the head chief of the (Blood tribe) . . . he is a good-looking and dignified Indian, about fifty years of age, and superbly dressed; whilst sitting for his picture he has been surrounded by his own braves and warriors, and also gazed at by his enemies, the Crows and the Knisteneaux, Assinneboins and Ojibbeways; a number of distinguished personages of each of which tribes have laid all day around the sides of my room; reciting to each other the battles they have fought, and pointing to the scalp-locks, worn as proofs of their victories, and attached to the seams of their shirts and leggings. . . .

The name of this dignitary of whom I have just spoken is Stu-mick-o-sucks (the buffalo's back fat), i.e., the "hump" or "fleece," the most delicious part of the buffalo's flesh. . . . The dress . . . of the chief . . . consists of a shirt or tunic, made of two deerskins finely dressed, and so placed together with the necks of the skins downwards, and the skins of the hind legs stitched together, the seams running down on each arm, from the neck to the knuckles of the hand; this seam is covered with a band of two inches in width, of very beautiful embroidery of porcupine quills, and suspended from the under edge of this, from the shoulders to the hands, is a fringe of the locks of black hair, which he has taken from the heads of victims slain by his own hand in battle. . . . In his hand he holds a very beautiful pipe, the stem of which is four or five feet long, and two inches wide, curiously wound with braids of the porcupine quills of various colours; and the bowl of the pipe ingeniously carved by himself from a piece of red steatite of an interesting character, and which they all tell me is procured somewhere between this place and the Falls of St. Anthony, on the head waters of the Mississippi (vol. 1, pp. 29–31, pl. 11).

BIOGRAPHY
Born 26 July 1796, Wilkes-Barre, Pa. Childhood there and rural New York. Studied at Litchfield (Conn.) Law School, 1817–18. Practiced law, 1818–21. Began painting, primarily miniatures. Philadelphia, 1821–25; exhibited Pennsylvania Academy of the Fine Arts, 1821. By 1826, New York City; decided to travel West to paint and chronicle Indian tribes still on their lands; member of the National Academy of Design, New York. Traveled upstate New York, making landscape lithographs and portraits. 1826, first Indian painting, done near Buffalo. 1828, full-length portrait of New York Governor DeWitt Clinton; married Clara Gregory. Group portrait of the 101 delegates to the Virginia Constitutional Convention, Richmond, 1829–30. Left for St. Louis and West, spring 1830. In subsequent years, returned often to the East, Mid-West, and South. Exhibited his Indian Gallery in Albany and New York City, 1837. Sailed to Charleston, S.C., to paint and interview captured Seminoles, including Osceola, 1838. Pressed U.S. Government to purchase Indian Gallery. Exhibited it in Baltimore, Philadelphia, Boston, and New York, 1838–39; London, 1840.

Published *Letters and Notes*, 1841. Toured England, 1842–43, with mock-Indian dancers; and 1843–45, with Ojibwa and Iowa Indians. 1845, France; exhibited at Louvre; death of his wife. Indians returned home, 1846. Paris, 1846–52. Heavily in debt, jailed in 1852. Joseph Harrison paid his debts in exchange for Indian Gallery. About 1853–60, South America, with trips to North America and Europe. Brussels, 1860–70. Painted a second Indian collection, largely duplicating first. 1870, returned to the U.S. Moved to Washington, D.C.; exhibited and lived in the Smithsonian Building, 1872. Died Jersey City, N.J., 23 December 1872.

<p style="text-align:center">*</p>

George Catlin is popularly thought of as the man who saw a delegation of Indians passing through Philadelphia and determined then and there that the "history and customs of such a people . . . are themes worthy of the lifetime of one man." Although his remarkable western travels were compressed into little more than six of his seventy-six years, they spawned his original Indian Gallery and did indeed determine the subject of his art for the rest of his long life. Exchanging the role of painter-historian for that of promoter-entrepreneur, Catlin also took Indians and artifacts back East and abroad, "displaying" them along with his paintings. Combined with his vivid written accounts of his adventures, these exhibitions and dance performances made a tremendous impact on most of those who paid admission.

Although the portraits are the most widely known and admired of Catlin's paintings, it is not as portraitist but as artist-naturalist that he is best understood. In Philadelphia, where the young artist established himself, the scientific spirit and interest in natural history had fascinated intellectuals since the late colonial period. The city became a kind of New World outpost of the European Enlightenment in the natural sciences as well as in politics.

This humanistic attitude manifested itself in Catlin as an unlimited curiosity about everything he encountered across thousands of miles of western travel. *River Bluffs* (1832), painted on the upper Missouri River, was one of two views Catlin says he painted on that spot: "I took my easel, and cavass [*sic*] and brushes, to the top of the bluff . . . [and] beheld, even to a line, what the reader has before him. . . . From this enchanting spot there was nothing to arrest the eye from ranging over its waters for the distance of twenty or thirty miles."

The immense herds of buffalo that roamed the prairies and often served as the Indians' primary sustenance were closely recorded by Catlin. He painted herds crossing the Missouri during the "running season" and often depicted buffalo hunts (those in the snow are especially stunning, with vivid contrasts of white, black, and red). He

Catlin, *River Bluffs, 1,320 Miles above St. Louis*, 1832, oil on canvas, 28.5 × 36.6 cm (11¼ × 14½ in.). Gift of Mrs. Joseph Harrison, Jr., L.1965.1.399

Catlin, *Dying Buffalo Shot with an Arrow*, 1832–33, oil on canvas, 60.9 × 73.7 cm (24 × 29 in.). Gift of Mrs. Joseph Harrison, Jr., L.1965.1.407

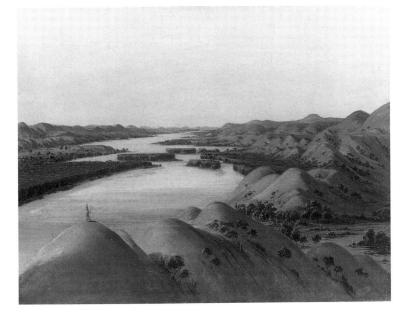

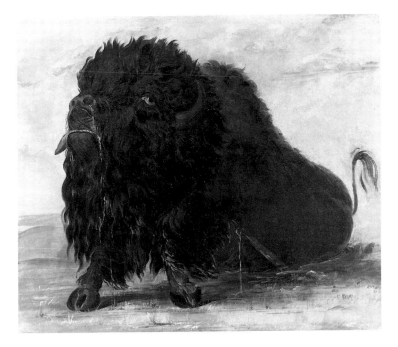

sometimes painted single animals and did so with a sense of the particular and the essential that rivals his human portraits. His *Dying Buffalo, Shot with an Arrow* (1832–33) is an icon of animal painting. Like a martyred saint, the beast casts a baleful eye on the viewer, while its great shoulders still express the strength that is draining away. That Catlin felt this anima is clear from his description of another buffalo, which he had shot with a rifle: "He stood stiffened up, and swelling with awful vengeance, which was sublime for a picture, but which he could not vent upon me." As the animal slowly died, the artist went to work: "[I] drew from my pocket my sketch-book, laid my gun across my lap, and commenced taking his likeness. . . . I rode around him and sketched him in numerous attitudes, sometimes he would lie down, and I would then sketch him; then throwing my cap at him, and rousing him on his legs, rally a new expression, and sketch him again." The buffalo seemed to Catlin intended "for the use and subsistence of the red men," and no foreboding of its eventual extinction shadowed his thoughts.

He was more farsighted in his attitude toward the Indians; indeed, it was his ambition to preserve the likeness of what he perceived as a doomed people. The inevitability of the Indians' fate was, at the time, commonly accepted, with romanticized sadness overshadowed by the ordained conquest of the frontier. Indeed, it was not just an American premise. In his *American Notes* of 1842, Charles Dickens reported a conversation he had had with a Choctaw chief (also painted by Catlin): "When I told him of that chamber in the British Museum wherein are preserved household memorials of a race that ceased to be, thousands of years ago, he was very attentive, and it was not hard to see that he had a reference in his mind to the gradual fading away of his own people."

Nonetheless, Catlin's sharp sense of the insoluble conflict of the races imparts the tinge of irony or tragedy that flavors so much of his work. His wonderful *Pigeon's Egg Head (The Light) Going to and Returning from Washington* (1837–39) is a case in point. He had first painted this Indian, "with eyes fixed like those of a statue, upon me," in 1831 when "The Light" was en route to Washington as an official guest. On his return to his tribe at Fort Union, 2,000 miles northwest of St. Louis, the following spring, The Light again encountered Catlin, who watched him disembark "with a complete suit *en militaire*, . . . with a beaver hat and feather, with epaulettes of gold . . . , with high-heeled boots – with a keg of whisky under his arm, and a blue umbrella in his hand." Thus co-opted, he was not only rejected by his astonished compatriots, but also later killed by one.

Catlin's subsequent invention combining before

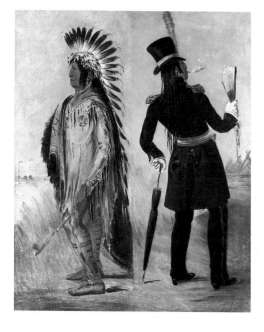

Catlin, *Pigeon's Egg Head (The Light) Going to and Returning from Washington*, 1837–39, oil on canvas, 73.6 × 60.9 cm (29 × 24 in.). Gift of Mrs. Joseph Harrison, Jr., L.1965.1.474

Catlin's Indian Gallery, in U.S. National Museum, Smithsonian Institution, ca. 1900

and after images of The Light is brilliant. In Indian costume he is presented statuesquely, in pure profile. In white-man's garb, his stance is elegant, artificial, and oblique. His ceremonial pipe is replaced by an effete umbrella and a cigarette, and Catlin departed from his verbal description to add a ridiculous fan and replace the keg with two bottles of whiskey protruding from the tail pockets. With the Capitol in the left background and teepees in the right, both figures are out of place.

Despite Catlin's keen appreciation of the incompatibility of the two cultures, he nonetheless took numerous Indians – men, women, and children – with him east and then to England and the Continent. In his desire to make his fortune, he thus exploited Indians in a way that he must have known might be calamitous. Personal tragedies did ensue, and ultimately those Indians who survived left Catlin and his traveling show in Europe.

The artist's expectations that the U.S. Congress would appropriate funds to purchase his Indian Gallery intact was not fulfilled, in spite of the efforts of many friends in and out of Congress. In 1852, faced with enormous debts, Catlin avoided dispersal of the paintings by giving them to an American manufacturer, Joseph Harrison, in exchange for settling his accounts. Although Catlin re-created much of this gallery in the following years, it is the original collection that eventually made its way to the NMAA. Between 1852 and 1879 it was stored, for the most part, in two of Harrison's Philadelphia boiler factories, where it suffered fire and water damage. In 1878, after Harrison's death, the collection came to the attention of Thomas Donaldson, a federal official, and his friend Spencer F. Baird, secretary of the Smithsonian Institution. That same year, Mrs. Harrison was persuaded to donate the collection to the Smithsonian. This windfall, supplemented by paintings from other sources, comprises the 618 paintings of the Catlin Collection. Unhappily, the artist not only failed to profit from this final transaction, but also did not live to see it. He died 23 December 1872.

Stanley, *Buffalo Hunt on the Southwestern Prairies*, 1845, oil on canvas, 154.3 × 102.8 cm (60¾ × 40½ in.). Gift of the Misses Henry, L.1965.58.248,932

John Mix Stanley
Osage Scalp Dance 1845
unsigned
oil on canvas, 103.5 × 153.6 cm (40¾ × 60½ in.)
Gift of the Misses Henry, L.1965.58.248,930

PROVENANCE
Placed on deposit with the Smithsonian Institution by 1851; the Misses Henry (daughters of Joseph Henry, first secretary of the Smithsonian); by their gift, 27 February 1908, to the Smithsonian Institution.

EXHIBITION HISTORY
New York, The Metropolitan Museum of Art, *Nineteenth-Century America*, 16 April– 7 September 1970, cat. no. 79 (illus.).
Houston, Tex., The Museum of Fine Arts, *Art of the American West*, 3 February–5 March 1972.
Los Angeles, Los Angeles County Museum of Art, *American Narrative Painting*, 29 August– 20 November 1974, p. 82, 83 (illus.), cat. no. 35.
Tampa, Fla., Tampa Museum, *Romantic America: The Middle Decades of the Nineteenth Century*, 15 September–26 November 1979.

BIOGRAPHY
Born 1814, Canandaigua, N.Y. 1828, orphaned; apprenticed to a coachmaker. 1834, moved to Detroit as house and sign painter. 1835, studied with James Bowman, a portraitist trained in Italy. 1836–38, painted portraits around Chicago. 1839, Fort Snelling, Minn., began to concentrate on Indian portraits and scenes. Returned East; saved enough painting portraits and taking daguerreotypes to enable him to go West again in 1842. Set up studio, Fort Gibson, Oklahoma Territory; painted frontiersmen and Indians. Lived in Indian country until 1845, painting grand Indian council at Tallequah (1843) and a second council of prairie Indians. 1846, became artist with Kearny military expedition to California. 1847, painted Indian portraits in Oregon Territory; 1848–49, Polynesian portraits in Hawaii. 1850–51, displayed his Indian Gallery in cities in the East. 1851, displayed 150 paintings in Smithsonian (catalogue, 1852); offered to U.S. government for $19,200 plus $12,000 in expenses. 1853, official artist for Stevens expedition, northern railway survey, from St. Paul, Minn., to Puget Sound, Wash. Used field sketches to paint enormous panorama containing forty-two scenes of western life (now lost). Married, 1854. Congress refused to purchase Indian Gallery; collection largely destroyed by fire, 1865. Fire at P.T. Barnum's American Museum, New York, destroyed more of his Indian paintings. Died 1872, Detroit, Mich.

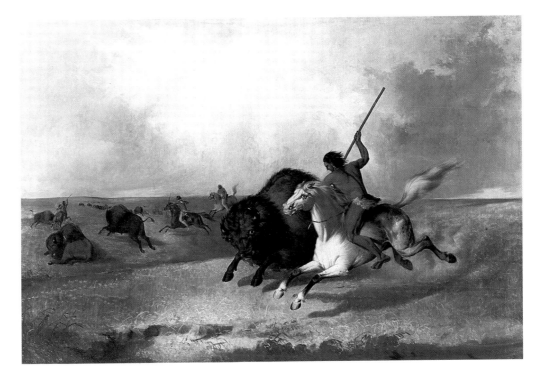

Although many works in Stanley's large oeuvre of Indian paintings were destroyed by fire, many more survive than is generally thought. The five in the NMAA constitute a significant group. Although he traveled as widely as George Catlin in quest of his subject, Stanley differs from Catlin in that he made his initial records of Indian life with camera and pencil and postponed execution of his paintings until after his expeditions. He also organized his canvases in a self-conscious, academic manner; and lacking Catlin's empathy with the Indians and their cultures, he viewed them as an outsider, with no little condescension. In one sense, his paintings are valuable precisely as documentation of that widely shared attitude.

In his *Buffalo Hunt* (1845) Stanley uses the artifice of a dominant, heroic group supported by secondary figures. He is conscious of his stage. His animals are stiffly drawn and have little animation or weight, but the sky over distant plains is another matter. Here the artist seems to come into his own, creating a sense of drama that evades him in his figure groups. *Black Knife, An Apache Warrior* (1846) exhibits the same disparity between surely handled atmospheric effects and convincing, if stock, landscape details, and a group of "central-casting" Indians who do not inhabit the landscape but stand before it as though it were a stage set.

On the other hand, his *International Indian Council* (1843), which records an event held at Tallequah, Indian Territory, that year, conveys a sense of historical accuracy and significance. This may be because Stanley had made photographic records of the scene; there is a sense of careful observation quite unlike the theatrical invention of the preceding two works. Even his academic devices serve him well here. The perspective of the great pitched roof structure under which the council congregates simultaneously emphasizes the size of the gathering and dignifies it with its monumentality. The effects of half lights and shadows beneath the roof and the band of misty sky beyond are skillfully realized and contribute to the sense of solemnity. Although Stanley does not seem to editorialize in this painting, he has placed a white soldier, surely a commander, in the center of the group. The officer leans against the supporting center pole, picked out by light, and looks directly at us. There is, to the modern viewer, something disquieting in this figure: one of relatively few whites amidst so very many Indians, he is confident in the possession of power.

Stanley, *Black Knife, An Apache Warrior*, 1846, oil on canvas, 107.8 × 132.1 cm (42$\frac{3}{8}$ × 52 in.). Gift of the Misses Henry, L.1965.58.248,933

Stanley, *International Indian Council*, 1843, oil on canvas, 102.8 × 80 cm (40$\frac{1}{2}$ × 31$\frac{1}{2}$ in.). Gift of the Misses Henry, L.1965.58.248,934B

13

Robert W. Weir
Saint Nicholas ca. 1837
unsigned
oil on panel, 75.5 × 62.1 cm (29¾ × 24½ in.)
Museum purchase, 1977.51

PROVENANCE
George P. Guerry, New York; to Albert Ten Eyck Gardner, May 1960; to Robert Ten Eyck Gardner (his brother), Philadelphia; to Robert Carlen, Philadelphia.

EXHIBITION HISTORY
Museum of the City of New York, July 1960.

REFERENCES
Lauretta Dimmick, "Robert Weir's *Saint Nicholas*: A Knickerbocker Icon," *Art Bulletin* 66, no. 3 (September 1984): pp. 465–83, fig. 5.

BIOGRAPHY
Born 18 June 1803, New York. 1811, family moved to New Rochelle; back to New York by 1817. First art training from Robert Cox (or Cook), an English heraldic painter; and, apparently, from John Wesley Jarvis. Attended American Academy, New York, and studied anatomy at New York University's medical school. 1821, began painting professionally. 1824, to Florence, Italy. About 1826, went to Rome; shared rooms with Horatio Greenough. 1828, returned to U.S. and opened New York studio. 1829, elected associate, National Academy of Design, New York; 1831, academician. 1834, named instructor of drawing at West Point. 1836, began *Embarkation of the Pilgrims* for the rotunda of the U.S. Capitol, where it was installed 1843. 1846, made professor, West Point. About the same time, designed and built Church of the Holy Innocents, Highland Falls, N.Y. 1876, retired from West Point and settled at Castle Point, Hoboken, N.J. Maintained studio in New York City. Sons Julian Alden and John Ferguson Weir became noted artists. Died 1 May 1889, Hoboken.

14

Hiram Powers
Edmund Pendleton Gaines modeled 1837; carved after 1840
marble, 53 × 37.7 × 27.2 cm (20⅞ × 14⅞ × 10⅞ in.)
Museum purchase in memory of Ralph Cross Johnson, 1968.155.14

PROVENANCE
Inventories of Powers's studio, 17 June 1873, 1881, and 1891; Louisa Powers (Mrs. Alfred B.) Ibbotson, 1891.

REFERENCES
Sylvia E. Crane, *White Silence: Greenough, Powers, and Crawford, American Sculptors in Nineteenth-Century Italy* (Coral Gables, Fla., 1972), p. 447.
Richard P. Wunder, "Hiram Powers: Vermont Sculptor, 1805–1873" (NMAA, 1978, Typescript).
Donald M. Reynolds, "The 'Unveiled Soul': Hiram Powers's Embodiment of the Ideal," *Art Bulletin* 59, no. 3 (September 1977): 394–414.

COMMENTS
The bust was commissioned by General Memucan Hunt, who also sat to Powers. The plaster "original" has not been located and is presumed to have been destroyed. General Hunt never ordered a marble replica as expected, but it was nonetheless cut by one of Powers's marble workers, Ambuchi, after 1840 and probably before 1847, to judge from Powers's correspondence. The marble is unique. It was never sold.

BIOGRAPHY
Born Woodstock, Vt., 1805. Studied sculpture with Frederick Eckstein, a Prussian artist working in Cincinnati. Repaired and mechanized wax figures for the Western Museum in Cincinnati. 1828, first portrait commissions. 1834, patron Nicholas Longworth sent him to Washington to produce portraits of leading Americans, among them Andrew Jackson; then to Europe, 1836. After Paris, went with family to Florence, 1837. Lived there the rest of his life, never returning to America. *The Greek Slave* exhibited in London, 1845 and again in 1851, establishing his international reputation. From that date, critical and financial success were assured. Died Florence, 27 June 1873.

Powers, *Andrew Jackson*, 1835, plaster, 72.1 × 59.3 × 40.8 cm (28⅜ × 23⅜ × 16⅛ in.). Museum purchase in memory of Ralph Cross Johnson, 1968.155.58

In terms of fame and financial success, Hiram Powers was the central American sculptor of the nineteenth century. He achieved this through the development – one might even say the "invention" – of a style that blended classical idealism, physical immediacy, and appealing subject matter with moral overtones. If to our eyes he seems less gifted than some of his colleagues, his place in the history of taste is nonetheless secure. The presence in the NMAA of the contents of his studio provides special insight not only into his art, but also into the working methods typical of the majority of nineteenth-century sculptors – specifically the use of mechanical devices and professional carvers under the artist's direction.

In his early sculpture, Powers reveals a taste and aptitude for naturalistic rendering. The outstanding example of this probing vision is his bust of Andrew Jackson, a work whose extraordinary incisiveness puts it in the forefront of American portrait sculpture. The sittings were obtained in 1835 through the intervention of his patron, Nicholas Longworth, and they provided Powers with a treasured anecdote as well as a superb likeness. He modeled the original clay bust (the plaster cast of which is now in the NMAA) with a fidelity that made the sixty-eight-year-old Jackson's toothlessness unmistakable. Asked what he thought of this, the president responded: "Make me as I am, Mr. Powers, and be true to nature always. It is the only safe rule to follow. I have no desire to *look* young as long as I *feel* old; and then it seems to me . . . that the only object in

making a bust is to get a representation of a man who sits, that it be as nearly as possible a perfect likeness. If he has not teeth, why then make him *with* teeth?" What makes both the bust and quotation remarkable is that Powers's naturalism, stunningly successful as it was, was progressively and rapidly abandoned by the sculptor.

By 1842, he had produced his first idealized female nude, *Eve Tempted*. The choice of subject permitted nudity without offending Victorian morality. In order to reconcile the conflict between pagan-inspired nudity and contemporary prudery, the artist explained to Elizabeth Barrett Browning that "the nude statue should be an unveiled soul." The purity of the marble, from Seravezza – a quarry about eighteen miles from Carrara – lent itself to spiritual idealism, while its quasi-flesh tone (as the sculptor saw it) together with Powers's careful simulation of skin texture conjured a physical reality. The notable lack of originality in *formal* invention or composition, however, vitiates Powers's ambitious intention in *Eve*. With a serpent decorously draped around the sculpture's base and up the supporting tree trunk, the figure looks at the apple in her flaccid hand with unsurpassed

blandness – neither curious, nor distrustful, nor even hungry. Her left hand holds another apple, perhaps from one of the "approved" trees in the Garden.

It is fascinating to note the presence of drill points in Eve's hair, indicating that although it was Powers's first ideal statue he never completed it. Remarkably, the sculpture survived shipwreck off the coast of Spain and was salvaged almost undamaged. Although Powers returned to the subject, he never replicated *Eve Tempted*.

Like George Inness, Powers was a Swedenborgian. Emanuel Swedenborg's theosophical writings had in the nineteenth century a remarkable following in many countries. Powers had encountered the New Church of Swedenborg's advocates in Cincinnati (his sculpture tutor, Frederick Eckstein was one), and he remained close to the society throughout his life. Swedenborg's tenet that "the form of the spirit of man is the human form" is clearly behind Powers's equating of the naked body with the "unveiled soul."

No naked body as unveiled soul more impressed the public, both in England and America, than *The Greek Slave*. Although banned in Boston, a roster of

Powers, *Eve Tempted*, 1842, marble, 174.9 × 75.8 × 52 cm (68⅞ × 29⅞ × 20½ in.). Museum purchase in memory of Ralph Cross Johnson, 1968.155.126

Powers, *The Greek Slave*, 1869, marble, 111.8 × 35.5 × 34.2 cm (44 × 14 × 13½ in.). Gift of Mrs. Benjamin H. Warder, 1920.3.3

Powers, *The Greek Slave*, 1841–43, plaster, 168.7 × 54 × 46.7 cm (66½ × 21⅜ × 18⅜ in.). Museum purchase in memory of Ralph Cross Johnson, 1968.155.8

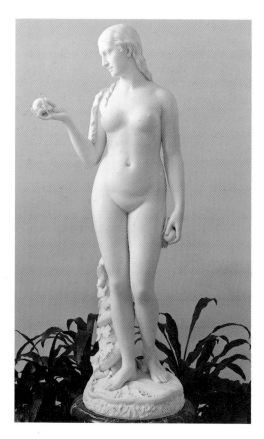
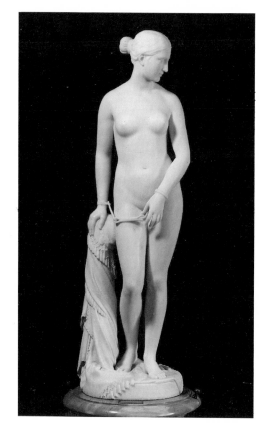
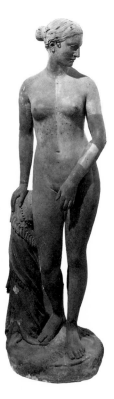

clergymen vouched for its purity. Essentially, the artist had managed to introduce taboo nudity under the sanction of sentimental morality. With its reference to the Turkish conquest of Greece, *The Greek Slave* suggested the intellectual superiority of Western culture, the spiritual superiority of Christianity, and (to more heated imaginations) the erotic debaucheries then often associated with the Near East. This colonial attitude, as we may call it, is implicit in Powers's published description of the sculpture, which invoked Divine Providence, noted the slave's "scorn for all [the Turks] around her," and concluded, 'It is not her person but her spirit that stands exposed."

Both of the plaster models for *The Greek Slave* are in the NMAA. The "original" plaster was made from Powers's own clay model, the "true original," which was destroyed in the process of casting the plaster. The plaster differs from the marble replicas (of which there are six) only in the omission of the manacles. The pattern of metal points protruding from the plaster was transferred to a marble block by the use of a pointing machine. The sculpture could thus be reproduced exactly in marble and then given its finish.

Nathaniel Hawthorne, reporting on an 1858 visit to Powers's studio, explained that although he saw two casts of the Uffizi *Venus de' Medici* there, the artist asserted "that the sculptor of the Venus de' Medici did not know what he was about." It is a remarkable statement considering that Powers's *Greek Slave* is virtually a copy of the ancient marble, excepting only the right arm and support and the slight downward cast of head and eyes. Perhaps Powers hoped to obscure his debt through this bit of misdirection.

Whether viewed in a European or an American context, Powers was not atypical among mid-nineteenth-century sculptors. The art of sculpture was in a quandry, with Zola announcing, "Let our sculptors repeat this to themselves every morning . . . sculpture, as Greece understood it, has become a dead language for us." Part of the problem was subject matter: modern or relevant themes were widely called for; part was the stifling formality of Neo-classical style. Although in his day Powers's religious themes were considered relevant, he did not depart from the established mode. Among his contemporaries, it may be that only Antoine-Louis Barye and Jean Baptiste Carpeaux were successful in finding a modern style. For both it was a naturalism highly charged with movement and emotion. Having rejected that alternative after his bust of Jackson, Powers preferred to cater to conventional taste.

Asher Brown Durand
Dover Plain, Dutchess County, New York 1848
signed lower left on rock: *A.B. Durand/1848*
oil on canvas, 107.9 × 153.7 cm (42½ × 60½ in.)
Gift of Thomas M. Evans, 1978.126

PROVENANCE
American Art Union, New York, 1848 (distributed to S.W. Allen, Mobile, Ala.); Daniel Seymour, 1850; possibly Samuel P. Avery, New York, 1870; Kennedy Galleries, New York; Mrs. Gerard Coster, New York, 1952–78; Coe Kerr Gallery, New York.

EXHIBITION HISTORY
New York, National Academy of Design, 1848, no. 95.
New York, American Art Union, 1848, no. 46.

REFERENCES
The Albion 7, n.s. 19 (6 May 1848): 225.
Literary World 3, no. 15 (13 May 1848): 287.
John Durand, *The Life and Times of A.B. Durand* (New York, 1894), p. 173.
David B. Lawall, *Asher B. Durand: A Documentary Catalogue of the Narrative and Landscape Paintings* (New York, 1978), cat. no. 124, pp. 72–74.
"Museum Accessions," *Antiques*, November 1979.

COMMENTS
The painting was engraved by James Smillie in 1850 for distribution to American Art Union subscribers, thus assuring wide knowledge of the composition, which influenced many copyists and naive artists. In a letter to John Durand (28 December 1870, New York Public Library) the dealer Samuel P. Avery said that he had an opportunity to buy the painting, and asked "if whether I purchase it [your father] would be willing to retouch it." It is not known whether Avery did buy it.

BIOGRAPHY
Born 21 August 1796, Jefferson, N.J. 1812–20, apprentice, then partner, to an engraver copying English book illustrations. 1821, married Lucy Baldwin; hired by John Trumbull to engrave *The Declaration of Independence*, which established reputation as printmaker. Widowed 1830; married Mary Frank, 1834. Early 1830s, painted portraits of the presidents; began to also work in landscape and traveled in the White Mountains and Adirondacks. 1840–41, to Europe with John Frederick Kensett and others, visiting England, the Netherlands, France, Germany, Switzerland, and Italy. On return to U.S., painted landscapes almost exclusively. 1845–61, second president of National Academy of Design, New York. 1849, painted *Kindred Spirits*, representing Thomas Cole and William Cullen Bryant. 1855, published "Letters on Landscape Painting" in *The Crayon*, influential journal published by his son, John. 1869, retired to Jefferson, N.J. 1878, stopped painting. Died 17 September 1886, Jefferson.

16

George Henry Durrie
Winter Scene in New Haven, Connecticut ca. 1858
signed lower right, on rock: *Durrie/N Haven*
oil on canvas, 45.6 × 60.9 cm (18 × 24 in.)
Museum purchase, 1978.124

PROVENANCE
Possibly acquired by Mr. Huston of Germantown, Pa., before 1900; Mrs. Helen M. Shoemaker, Philadelphia (his granddaughter, died 1977); Samuel T. Freeman & Co., Philadelphia, 14 March 1978, no. 313; to Kennedy Galleries, New York.

REFERENCES
"Museum Accessions," *Antiques*, February 1981.

BIOGRAPHY
Born 6 June 1820, Hartford, Conn. Before 1839, as self-taught artist painted portraits in area around New Haven and Bethany, Conn. 1839, instruction from Nathaniel Jocelyn, a New Haven engraver and painter of portraits and miniatures. 1840–42, divided time between Connecticut and New Jersey. Then settled in New Haven except for painting trips to New Jersey, New York, and Virginia. About 1850, turned to painting rural genre scenes and winter landscapes. After 1860, Currier and Ives produced ten prints after his paintings (six appeared posthumously). Died 15 October 1863, New Haven.

Frank Blackwell Mayer
Independence (Squire Jack Porter) 1858
signed and dated twice, lower left on bench leg
and lower right on floor: *F.B. Mayer 1858*
oil on paperboard, 30.4 × 40.3 cm (12 × 15⅞ in.)
Bequest of Harriet Lane Johnston, 1906.9.11

PROVENANCE
Henry E. Johnston, Baltimore, 1859; Harriet Lane
Johnston (his wife), 1906.

EXHIBITION HISTORY
Baltimore, Md., Maryland Historical Society,
 Sixth Annual Exhibition, 1858, no. 120.
Washington, D.C., Washington Art Association,
 Third Annual Exhibition, 1859, no. 29.
New York, National Academy of Design, *Thirty-
 sixth Annual Exhibition*, 1861, no. 278.
Baltimore, Md., Municipal Art Society (Fifth
 Regiment Armory), *Art Loan Exhibition*, March
 1902, no. 39.
Washington, D.C., National Gallery of Art (now
 NMAA), *Paintings and Other Art Objects Exhibited
 on the Occasion of the Opening of the National Gallery
 of Art in the New Building of the United States
 National Museum*, 17 March 1910, cat. no. 118
 (erroneously attributed to Klaus Meyer).
Richmond, Va., Virginia Museum of Fine Arts,
 Painting in the South, 14 September 1983–
 27 November 1983, cat. no. 74, pp. 82, 238
 (then to Birmingham [Ala.] Museum of Art;
 New York, National Academy of Design;
 Jackson, Miss., Mississippi Museum of Art;
 Louisville, Ky., J.B. Speed Art Museum; New
 Orleans Museum of Art).
College Park, Md., University of Maryland Art
 Gallery, *350 Years of Art and Architecture in
 Maryland*, 26 October–9 December 1984, cat.
 no. 26, p. 41.

REFERENCES
Highlights of the National Collection of Fine Arts (now
 NMAA; Washington, D.C., 1968), p. 19, pl. 9.
Jean Jepson Page, "Francis Blackwell Mayer,"
 Antiques, February 1976, pp. 316–23.

COMMENTS
Although baptized Francis, Mayer always called
himself Frank.

BIOGRAPHY
Born 27 December 1827, Baltimore, Md. Inspired
by the artist Alfred Jacob Miller, a family friend,
to become a painter. About 1844, studied drawing
with J. Prentiss. Early 1847, a founder of the
Maryland Art Association. 1847–48, for a
Philadelphia printer, drew lithographs illustrating
Mexican War; studied at Pennsylvania Academy
of the Fine Arts. April 1848, returned to
Baltimore and worked as librarian at Maryland
Historical Society. Began to paint small genre and
history scenes. Studied painting with Ernst
Fischer, European immigrant artist. 1850,
illustrated book about Mexico. 1851, traveled
with an official delegation to Indian country on
Minnesota Territory frontier. October 1851,
returned to Baltimore and resumed painting.
Founded Artists Association of Maryland, 1855,
and Allston Association, 1860. 1862, following
start of Civil War, left for Paris. Influenced by
Ernest Meissonnier. Entered studio of Charles
Gleyre; also studied with Alsation painter
Gustave Brion. Exhibited in annual Salons, 1865,
1866, 1868, 1869, 1870. Fled Paris October 1870,
during Franco-Prussian War; returned to
Baltimore. 1873, began to work in Annapolis;
1876, settled there permanently. 1893, fulfilled
commission for two large history paintings for the
State House, Annapolis. 1897, commissioned by
Henry Walters of Baltimore to do sixty-three
watercolors based on his 1851 Indian sketches,
which had never been published. Completed
thirty before his death in Annapolis, 1899.

Whittredge, *Interior of a Westphalian Cottage*, 1852,
oil on canvas, 70.2 × 50.4 cm (27⅝ × 19⅞ in.).
Museum purchase, 1967.142.2

Whittredge, *Sakonnet Point, Rhode Island*, ca. 1880,
oil on canvas, 34.7 × 53 cm (13¾ × 20⅞ in.).
Museum purchase, L.E. Katzenbach Fund,
1967.142.1

Whittredge, *Noon in the Orchard*, 1900, oil on
canvas, 46.3 × 76.8 cm (18¼ × 30¼ in.). Gift of
William T. Evans, 1909.7.74

Worthington Whittredge
*The Amphitheatre of Tusculum and Albano Mountains,
Rome* 1860
signed in script and dated lower left:
W. Whittredge 1860
oil on canvas, 61 × 101.6 cm (24 × 40 in.)
Museum purchase, 1980.25

PROVENANCE
James McKaye; Victor D. Spark, New York.

EXHIBITION HISTORY
New York, National Academy of Design, *Annual
 Exhibition*, 1860, cat. no. 588.
Lawrence, Kans., Spencer Museum of Art,
 University of Kansas, *The Arcadian Landscape:
 Nineteenth-Century American Painters in Italy*,
 1972, cat. no. 45 (illus.).

REFERENCES
*The Autobiography of Worthington Whittredge,
 1820–1910* (New York, 1969).
Mahonri Sharp Young, "Americans in Arcadia,"
 Apollo Magazine, March 1973.
Anthony F. Janson, "The Paintings of
 Worthington Whittredge" (Ph.D. diss.,
 Harvard University, 1975), pp. 58, 60, 176, 228.

———, "Worthington Whittredge: The Development of a Hudson River Painter, 1860–1868," *The American Art Journal* 11, no. 2 (April 1979): 71–84.

Cheryl A. Cibulka, *Quiet Places: The American Landscapes of Worthington Whittredge* (Washington, D.C., 1982).

COMMENTS

According to Janson ("Paintings of Worthington Whittredge"), this work dates early summer 1859 and "is unique among his European landscapes in retaining the *plein-air* color and directness of a painting from nature." Whittredge apparently left Europe in May (or possibly August) 1859. He spent the last months of that year at Joseph Longworth's estate near Cincinnati. Moving to New York in January 1860, he decided to submit four pictures painted in Europe to the annual exhibition at the National Academy of Design. The date *1860* was probably added to *The Amphitheatre at Tusculum* at that time.

BIOGRAPHY

Born Thomas Worthington Whittredge, 22 May 1820, near Springfield, Ohio. 1837, moved to Cincinnati to learn house and sign painting from his brother-in-law. Began studying art; ground colors and prepared canvases for Chester Harding. 1838, painted portraits. 1839, exhibited three landscapes, inaugural exhibition, Cincinnati Academy of Fine Arts. 1840, trained as daguerreotypist. Moved to Indianapolis, Ind.; established daguerreotype business, which failed.

Befriended by Henry Ward Beecher; painted portraits of Beecher family. 1841, worked in Cincinnati as landscape painter; exhibited at Cincinnati Academy. 1843, brief partnership with B.W. Jenks, itinerant portraitist; went to Charlestown, W.Va., to seek commissions. 1844, Cincinnati. 1846, exhibited, National Academy of Design, New York; praised by Asher B. Durand. 1847, exhibited, American Art-Union, New York. Sold paintings to Western Art-Union, Cincinnati. 1849, went to London, Belgium, Germany, Paris. 1849–56, settled in Düsseldorf; met Emanuel Leutze. 1856, left Düsseldorf on sketching trip with Leutze and William S. Haseltine; joined by Albert Bierstadt in Switzerland. 1857, settled in Rome; constant company of Bierstadt and Sanford Gifford. 1859, returned to U.S. 1860, opened studio in New York; exhibited at National Academy; elected associate member. 1861, elected academician, National Academy. 1862, member, Century Association. 1866, accompanied General John Pope to Colorado and New Mexico. 1867, married Euphemia Foot. 1870, second journey west, with John F. Kensett and Gifford. 1873, visited Catskills. 1875–76, president, National Academy. 1876, bronze medal, Centennial Exhibition, Philadelphia. 1879–80, built home, Summit, N.J. 1883, first prize, National Academy annual. 1896, trip to Mexico with Frederic E. Church. 1901, silver medal, Pan-American Exposition, Buffalo, N.Y. 1904, exhibited 125 paintings at Century Association. 1905, finished autobiography. Died 25 February 1910, Summit, N.J.

The five oil paintings by Whittredge in the NMAA span his artistic career – from his youthful sojourn in Europe to the last decade of his life – and reveal the artist's substantial talent and rather wide range of stylistic and thematic interests. His early studies with the Düsseldorf painter Andreas Achenbach resulted for a time in a dependence on the mannerisms of German landscape art (high-keyed palette and exaggerated grandeur of view, for example). Of the fellow Americans with whom he traveled and painted in Europe, only Sanford Gifford, whom he met in Rome, seems to have made an impression on his style. Throughout his career, though receptive to influences, Whittredge was seldom imitative for long. He exhibits, instead, an ability to assimilate the example of others in an individual manner.

His *Interior of a Westphalian Cottage* (1852), painted in Germany, has many parallels in contemporary European genre painting. Scenes of picturesque rural poverty, set in gloomy interiors romantically enhanced with rays and patches of light, can be found in pictures of Brittany (especially by French, English, and American artists), and in Dutch, German, and Swiss painting. Whittredge's effects of light are coupled with a spontaneous brushwork that both textures the surface and provides numerous linear accents. Later, in America, the artist produced a group of domestic, middle-class interiors (some in collaboration with Eastman Johnson), which are more realistic and less sentimental and condescending than their European counterparts, in which poverty is perfumed and prettified.

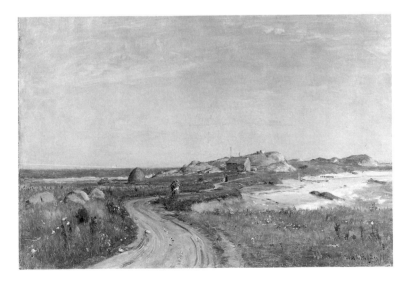

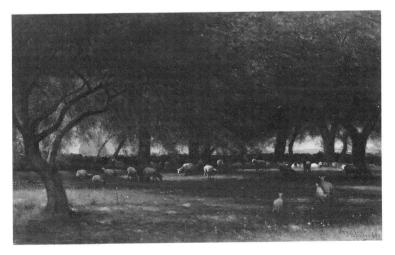

Sakonnet Point, Rhode Island (ca. 1880) handsomely represents a landscape type recurrent in Whittredge's work after his 1866 trip to the western plains: a simple, open horizontal view, uncluttered and tranquil. Especially important is a group of paintings done in Rhode Island in the early eighties, which recall the Newport work of John F. Kensett. Shoreline, dunes, and spits of land are arranged in quiet bands, articulated with simple curves (here the road) and orchestrated with a warm, gentle palette. Probably painted on the spot, *Sakonnet Point* is calm and unhurried, an intimate amble for the eye.

At the age of eighty Whittredge's eye may have been turning inward when he painted *Noon in the Orchard* (1900), a painting that evokes the spirit of New England Transcendentalism. Although there is a slight connection with the woodland interiors of the Barbizon School, which Whittredge was influenced by, the dreamy, pastoral scene is closer to the late work of George Inness, who at the time lived scarcely ten miles away. The soft focus, as though the landscape were seen through an intermediate glass or lens, recalls Emerson in his famous essay *Nature*: "The beauty that shimmers in the yellow afternoons of October, who ever could clutch it? Go forth to find it, and it is gone; 'tis only a mirage as you look from the windows of diligence."

19

William Henry Rinehart
Sleeping Children 1869 (first modeled 1859)
inscribed and dated, on base below feet: *Wm. H Rinehart sculp.ᵗ Roma 1869*
marble, 38.9 × 93.3 × 47.6 cm
($15\frac{3}{8} × 36\frac{3}{4} × 18\frac{3}{4}$ in.)
Gift of Mrs. Benjamin H. Warder, 1920.4.1

PROVENANCE
Unknown.

EXHIBITION HISTORY
College Park, Md., University of Maryland Art Gallery, *350 Years of Art and Architecture in Maryland*, 26 October–9 December 1984, p. 51, cat. no. 38 (illus.).

REFERENCES
Lorado Taft, *The History of American Sculpture*, rev. ed. (New York, 1924), pp. 178–79.
William Sener Rusk, *William Henry Rinehart, Sculptor* (Baltimore, 1939), p. 16 (illus. pl. 3).

Marvin Chauncey Ross and Anna Wells Rutledge, *A Catalogue of the Work of William Henry Rinehart* (Baltimore, 1948), pp. 33–34 (illus. pl. 8).
Lois Fink, "Children as Innocence from Cole to Cassatt," *Nineteenth Century* 3, no. 4 (Winter 1977): 71–75.

COMMENTS
Ross and Rutledge, citing Rinehart's account book and pertinent letters, list nineteen marble replicas (including this one) and the plaster original as issuing from the studio. In addition to these twenty pieces, two plaster casts (subsequently destroyed) were listed as in the studio at the time of Rinehart's death, and three plaster casts were made posthumously at the Maryland Institute, Baltimore, under the direction of Hans Schuler. The original Sisson grave monument is still in Greenmount Cemetery, Baltimore, but is ruined due to exposure.

BIOGRAPHY
Born 1825, near Union Bridge, Md. 1844, to Baltimore. Began work as a stonecutter. Studied art at night school, Maryland Institute, Baltimore. 1853, won medal, Maryland Institute. 1854, exhibited, Maryland Historical Society, Baltimore. 1855–57, under patronage of William T. Walters, studied in Florence. In 1856, sent work to exhibition at Maryland Historical Society; visited London. 1857, returned briefly to Baltimore. 1858, settled permanently in Rome. 1861, 1863, 1865–67, regular visits to Paris. 1868, probably traveled to England. 1871, won medal, Naples Exhibition. July 1872, to America for nine months – Baltimore, Philadelphia, San Francisco. March 1873, returned to Rome. Died there 28 October 1874.

20

John F. Francis
Luncheon Still Life ca. 1860
unsigned
oil on canvas, 64.6 × 77.2 cm ($25\frac{1}{2} × 30\frac{3}{8}$ in.)
Museum purchase, 1972.107

PROVENANCE
Descended from Elizabeth DeLance (sometimes Elizabeth Francis), half-sister of the artist, to Mrs. L.A. Poole, her granddaughter.

REFERENCES
William H. Gerdts and Russell Burke, *American Still-Life Painting* (New York, 1971), pp. 60–61.

COMMENTS
Francis's paintings fall into readily identifiable types. The NMAA painting is related to other canvases by the artist, including *Still Life with Wine Bottles and Basket of Fruit* in the Museum of Fine Arts, Boston, signed and dated 1857, in which, however, there is no landscape background.

BIOGRAPHY
Born Philadelphia, probably 1808; lived there in 1840–41 when first exhibited at the Artists' Fund Society. Kept ties with Philadelphia, but traveled widely in Pennsylvania for twenty-five years, painting in Pottstown, Harrisburg, Lewisburg, Milton, as well as in Delaware, Washington, D.C., Nashville. About 1886, settled in Jefferson, Pa., where he died 15 November 1886.

21

Emanuel Gottlieb Leutze
Westward the Course of Empire Takes Its Way 1861
signed and dated lower left: *E. Leutze. 1861*
oil on canvas, 84.5 × 110.1 cm ($33\frac{1}{4} × 43\frac{3}{8}$ in.)
Bequest of Sara Carr Upton, 1931.6.1

PROVENANCE
Given by the artist to William H. Seward; Olive Risley Seward (his adopted daughter); Sara Carr Upton.

EXHIBITION HISTORY
Detroit, Mich., The Detroit Institute of Arts, *The World of the Romantic Artist*, 22 December 1944–28 January 1946, cat. no. 21.
New York, The Century Association, exhibition held at W.S. Budworth & Sons, *Exhibition of Work by Emanuel Leutze*, 7 February–3 March 1946, cat. no. 3.
Akron, Ohio, Akron Art Institute, *The New Republic*, 3–26 September 1948.
Denver, Colo., The Denver Art Museum, *Art Tells the Story*, 1 March–26 April 1953.
Omaha, Nebr., Joslyn Art Museum, *Life on the Prairie: The Artist's Record*, 12 May–4 July 1954, p. 6.
Washington, D.C., The White House, March 1959.

Moscow, *American Painting and Sculpture* (USIA), 25 July–5 September 1959.

El Paso, Tex., El Paso Museum of Art, *Faces of America*, 11 December 1960–22 January 1961.

Richmond, Virginia Museum of Fine Arts, *Home Front, 1861*, 12 May–3 September 1961.

New York, IBM Gallery, *Art of the Western Frontier*, 23 March–18 April 1964, no. 17.

Washington, D.C., National Collection of Fine Arts (now NMAA), *American Landscape: A Changing Frontier*, 28 April–19 June 1966, p. 2, fig. 3.

New York, Whitney Museum of American Art, *Art of the United States: 1670–1966*, 28 September–27 November 1966, cat. no. 172.

New York, Whitney Museum of American Art, *The American Frontier: Images and Myths*, 26 June–16 September 1973 (then to five European cities).

Washington, D.C., National Collection of Fine Arts (now NMAA), *Emanuel Leutze, 1816–1868: Freedom Is the Only King*, 16 January–14 March 1976, cat. no. 100, pp. 60–62 (illus.).

REFERENCES

Edgar P. Richardson, *American Romantic Painting* (New York, 1944), p. 40, fig. 145.

Raymond L. Stehle, "Five Sketchbooks of Emanuel Leutze," *Quarterly Journal of the Library of Congress* 21 (April 1964): 81–93.

BIOGRAPHY

Born 24 May 1816, Schwäbisch-Gmünd, near Stuttgart, Germany. 1825, emigrated with family to Philadelphia. 1834, studied drawing from casts and portraiture with John Rubens Smith. 1836, commissioned by Longacre and Herring to paint portraits for a "National Portrait Gallery of Distinguished Americans" in Washington, D.C.; project cancelled due to financial crisis of 1837. 1837–39, itinerant portraitist in Virginia, Maryland, Pennsylvania. 1839, settled in Philadelphia; began painting literary subjects. 1841, Philadelphia patrons sent him to Düsseldorf to study at the academy; specialized in historical subjects. Left Düsseldorf 1843, dissatisfied with conservatism; traveled to Italy. Returned to Düsseldorf in 1845 to marry Juliane Lottner. Associated with founding of Malkasten, a dissident artists' group, which pressed for political unification of German states. 1849, due to political ties, forced to resign from Union of Düsseldorf Artists for Mutual Aid and Support;

began work on *Washington Crossing the Delaware*, which was damaged in an 1850 studio fire. January 1851, began work on second version, which was exhibited in New York and Washington to acclaim. 1852, petitioned Congress to commission replica of the painting, together with pendant, *Washington Rallying the Troops at Monmouth*; completed 1854. Traveled to southern Germany to help organize pan-Germanic congress of artists. 1859, returned to U.S. 1860, elected member, National Academy of Design. 1861, commissioned to paint mural, *Westward the Course of Empire*, in U.S. Capitol; completed 1862. 1863, returned to Düsseldorf to bring family to U.S. Died 18 July 1868, Washington D.C.

22

Lilly Martin Spencer
We Both Must Fade (Mrs. Fithian) 1869
unsigned
oil on canvas, 182.8 × 136.3 cm ($71\frac{5}{8} \times 53\frac{3}{4}$ in.)
Museum purchase, 1970.101

PROVENANCE

Commissioned by the sitter's father, Richard B. Connolly, controller of New York City. According to Schumer (see *References*), due to a technical difficulty Spencer decided to paint a replica (whereabouts unknown); apparently the artist retained the first version; descended through the artist's family to Mrs. Donald Robert (Lillian Spencer) Gates, granddaughter of the artist; purchased from Mrs. Gates.

EXHIBITION HISTORY

Philadelphia, Centennial Exposition, Women's Pavilion, 1876, p. 22, no. 370b (as *Fancy Portrait?*).

Baltimore, Md., Walters Art Gallery, *Old Mistresses: Women Artists of the Past*, 17 April–18 June 1972, cat. no. 20.

Washington, D.C., National Collection of Fine Arts (now NMAA), *The Joys of Sentiment*, 15 June–3 September 1973, pp. 64 (illus.), 211–12.

REFERENCES

Ann B. Schumer, "Aspects of Lilly Martin Spencer's Career in Newark, New Jersey," *Proceedings of the New Jersey Historical Society* 77 (1959): 244–55.

COMMENTS

This was one of four full-length portraits of the family of Richard B. Connolly that Spencer painted on commission. The date 1869 is assigned to them on the basis of a New York newspaper clipping reporting the commission. Subsequently, the paintings were supposedly "smuggled away to Europe . . . [to] escape the debris of that gentleman's fallen fortunes" (unidentified New York newspaper clipping of about 1899). According to contemporary correspondence, *We Both Must Fade* remained hanging until 1880 in the permanent exhibition that followed the Philadelphia Centennial.

BIOGRAPHY

Born 26 November 1822, Exeter, England, of French parents; christened Angelique Marie Martin. 1830, family emigrated to the U.S.; lived in New York. 1833, family moved to Marietta, Ohio. 1841, first exhibition at the Rectory of St. Luke's Episcopal Church, Marietta. Moved with father to Cincinnati to pursue profession as artist. Refused Nicholas Longworth's offer to send her to Europe to study. 1842, exhibited at the Society for the Promotion of Useful Knowledge. Studied with John Insco Williams. 1844, married Benjamin Rush Spencer. 1845, birth of the first of eight children (the last in 1866). 1846, visited Columbus, seeking commissions. 1847, exhibited at Western Art Union's opening exhibition. 1848–54, exhibited at National Academy of Design, New York. Sold two paintings to American Art-Union. Moved to New York. 1850, studied at National Academy; elected honorary member. 1851, sold paintings to Philadelphia Art Union and American Art-Union. 1856, exhibited Boston Athenaeum and National Academy. 1858, moved to Newark, N.J.; exhibited National Academy. 1861, exhibited at Boston Athenaeum. 1861 and 1862, exhibited at Pennsylvania Academy of the Fine Arts; 1865 and 1867, at Brooklyn Art Association; 1868, again at Brooklyn and National Academy; 1876, at Centennial Exposition, Philadelphia. 1879–80, moved to Highland, N.Y. 1886, one painting at National Academy. 1890, husband died. 1900, moved back to New York. Died 22 May 1902, New York City.

Homer Dodge Martin
The Iron Mine, Port Henry, New York ca. 1862
unsigned
oil on canvas, 76.5 × 127 cm (30⅛ × 50 in.)
Gift of William T. Evans, 1910.9.11

PROVENANCE
Knoedler Galleries, New York, before 1910, when it was bought by William T. Evans.

EXHIBITION HISTORY
Washington, D.C., National Collection of Fine Arts (now NMAA), *American Landscape: A Changing Frontier*, 28 April–19 June 1966, cat. insert p. 7.

REFERENCES
Dana H. Carroll, *Fifty-eight Paintings by Homer Martin* (New York, 1913), pp. 14, 15 (illus.).
"Lost Homer Martin Brings Aid to Widow," *New York Times*, 1 February 1910.

COMMENTS
The *New York Times* article (above) told the story of the rediscovery of this painting "in an unused room at the Knoedler Galleries." Identified as a Martin by the artist Edward Gay, who also recognized the subject, the painting was sold to Evans. When Martin's widow was located, she was found to be in some financial difficulty; according to the *Times*, Mr. Knoedler responded, "In that event, she shall have all the picture brings."

Martin, *A North Woods Lake*, 1867, oil on canvas, 46 × 81.3 cm (18⅛ × 32 in.). Gift of Mrs. Johnson Garrett, 1982.112

BIOGRAPHY
Born 28 October 1836, Albany, N.Y. Early experience as draughtsman in architect's office. Encouraged by the sculptor Erastus Dow Palmer to be an artist. Only formal instruction was a few weeks with the landscape painter James MacDougal Hart. By sixteen, earned small living from landscape paintings. About 1852 to 1870, many sketching trips in the Adirondacks, Catskills, Berkshires, and White Mountains. 1857, exhibited at National Academy of Design, New York. 1861, married Elizabeth Gilbert Davis. 1862 and 1863, brief sojourns in New York, where he shared studio with James Smillie. 1865, moved family to New York. 1866, election to Century Club, New York. 1868, elected associate, National Academy. Associated with John La Farge and Winslow Homer, whose studios were in the same building as his. 1870s, full membership in National Academy. 1876, to England, where he became friends with and was influenced by Whistler. Worked as illustrator to supplement income. 1879, his illustrations for Frank B. Sanborn's "The Homes and Haunts of Emerson" prompted *Century* magazine to send him to England to sketch in "George Eliot's country." Lived at Villerville and Honfleur, 1882–86. 1887, returned to New York. Eyesight grew progressively worse; still sold little work. 1892, wife had nervous breakdown and moved to St. Paul, Minn., where Martin soon joined her. 1896, he developed cancer of the throat. Died 12 February 1897, St. Paul.

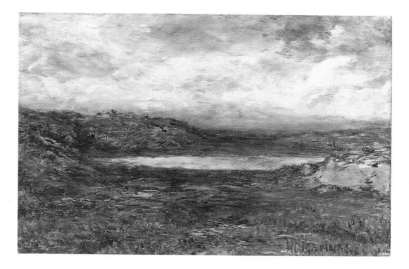

Homer Martin, self-taught except for two weeks of instruction, developed a skillful technique with which to present his personal vision. Although he depicted many of the same scenes as other landscapists of his and earlier generations, he instilled in his work a heightened sense of melancholy isolation that led a contemporary to remark, "Martin's landscapes look as if no one but God and himself had ever seen the places."

His early painting *A North Woods Lake* (1867) already possesses this aura of solitude. The broad expanse of water that spreads across the foreground of the picture leaves the viewer afloat at the edge of an American wilderness. Dark land masses push in from either side, concentrating our attention on the distant gleam of light on still waters and the mist-enshrouded hills and sky above. The half-fallen tree at the left and its reflection in the water helps convey the minor key of Martin's mood; in fact, it became a habitual device (see *Iron Mine*, p. 60).

Wild Coast, Newport (ca. 1885–95) shows Martin's much altered style after he had encountered the loose brushwork and vivid palette of French Impressionism. Sumptuous in the range and intensity of hue, the painting relies on evocative handling instead of evocation of place for its effect. It is instructive to contrast this fluid improvisation with Whittredge's calm, clear delineation of a similar Rhode Island coastline in a nearly contemporary work (see p. 193).

Undated but certainly from the last decade of the artist's life, *Evening on the Thames* is less impassioned, its surface smoother, more uniform. The spread of the last light of day across the picture, the desolation of the foreground tidal flat, and, as usual in Martin, the utter absence of man combine to create an unshakable feeling of poignance. Martin's emotional expression is convincing, and devoid of theatrical posturing.

Martin, *Wild Coast, Newport,* ca. 1885–95, oil on canvas, 38.1 × 61.1 cm (15 × 24¼ in.). Gift of John Gellatly, 1929.6.72

Martin, *Evening on the Thames,* oil on canvas, 46.4 × 76.6 cm (18¼ × 30⅛ in.). Gift of William T. Evans, 1909.7.45

Frederic Edwin Church
Aurora Borealis 1865
signed and dated lower left: *FC65*
oil on canvas, 142.3 × 212.2 cm (56⅛ × 83½ in.)
Gift of Eleanor Blodgett, 1911.4.1

PROVENANCE
Commissioned by William T. Blodgett, New York, 1865; William T. Blodgett estate sale, Chickering Hall, 27 April 1876, no. 63 (apparently purchased by his daughter, Eleanor Blodgett); gift of Eleanor Blodgett, 1907.

EXHIBITION HISTORY
London, McLean's Gallery, 1865.
New York, Kurtz Art Gallery, *The Blodgett Collection,* 27 April 1876 (prior to estate sale).
New York, The Metropolitan Museum of Art, *Paintings by Frederic E. Church, N.A.,* 28 May–15 October 1900, illus.
Washington, D.C., National Gallery of Art (now NMAA), *Catalogue of Paintings and Other Art Objects Exhibited on the Occasion of the Opening of the National Gallery of Art in the New Building of the United States National Museum,* 17 March 1910, cat. no. 122.
Richmond , Virginia Museum of Fine Arts, *The Main Currents in the Development of American Painting,* 16 January–1 March 1936, cat. no. 47.
Washington, D.C., National Collection of Fine Arts, *Frederic Edwin Church,* 12 February–13 March 1966, cat. no. 108, p. 71 (then to the Albany [N.Y.] Institute of History and Art and M. Knoedler and Company, New York).
Dallas, Tex., Dallas Museum of Fine Arts, *The Romantic Vision in America,* 9 October–28 November 1971.
Richmond, Virginia Museum, *American Marine Painting,* 27 September–31 October 1976, cat. no. 32, pp. 74–75 (illus.; then to Newport News, Va., The Mariners Museum).
Washington, D.C., The National Gallery of Art, *American Light: The Luminist Movement, 1850–1875,* 10 February–15 June 1980, fig. 190, pp. 154, 158, 178.
Mexico City, Museo del Palacio de Bellas Artes, *La pintura de los Estados Unidos de museos de la ciudad de Washington,* 15 November–31 December 1980.

REFERENCES
W. P. Bayley, "Mr. Church's Pictures: Cotopaxi, Chimborazo, and the Aurora Borealis," *Art Journal* (London), n.s. 2 (December 1865): 688–92.

Henry T. Tuckerman, *Book of the Artists* (New York, 1867), pp. 385, 623.
J. H. Moser, "The Church Exhibition," *Washington Morning Times,* 30 September 1900, pt. 2, p. 1.
————, "The National Gallery of Art," *Art and Progress* (April 1910): 153.
David C. Huntington, "Frederic Edwin Church: Painter of the Adamic New World Myth" (Ph.D. diss., Yale University, 1960), pp. 133–34.
————, *The Landscapes of Frederic Edwin Church* (New York, 1966), p. 62, pl. 69.

COMMENTS
William T. Blodgett, who commissioned this painting, was also on Dr. Isaac Hayes's voyage to the North Pole, during which Church made sketches for the work. It has been noted (NCFA exh. cat. 1966, p. 71) that the pyramidal form is "based on a chalk sketch by Dr. Isaac Hayes of Church's Peak, Labrador, named for the artist." This does not obviate the interpretation given in the commentary; that Church's metaphysics were expressed through natural phenomena is exactly the point. Hayes and Blodgett would have at least been party to Church's reactions to the arctic – if they did not share them.

BIOGRAPHY
Born 4 May 1826, Hartford, Conn. Studied with Thomas Cole, 1844–46. Moved to New York, 1847–48. Elected member National Academy of Design, 1849. Traveled and sketched in Catskills, Berkshires, Connecticut, Green and White Mountains. 1850–52, visited Grand Manan Island and Bay of Fundy, Mt. Desert Island and Mt. Katahdin, Maine. 1851, to Virginia, Kentucky, upper Mississippi River. 1853, first trip to South America. 1854, visited Annapolis, Md., and Nova Scotia; 1856, Niagara Falls; 1857, South America; 1859, Newfoundland and Labrador. 1867, his painting *Niagara* (Corcoran Gallery, Washington, D.C.) won second medal at Paris Universal Exposition. Traveled through Europe and the Near East, 1867–68. November 1868 to April 1869, in Rome. 1870–72, built home "Olana," Hudson, N.Y. In Vermont 1873–74. In Mt. Katahdin region, Lake George, and North Carolina, 1876–82. In 1876 or 1877, contracted "inflammatory rheumatism," which limited his painting. 1878, exhibited at Exposition Universelle, Paris. After 1880, painted only occasionally; spent summers at Olana, winters in Mexico. Died 7 April 1900, New York City.

Samuel Colman
Storm King on the Hudson 1866
signed lower right: *S. COLMAN. 66.*
oil on canvas, 81.6 × 152 cm (32⅛ × 59⅞ in.)
Gift of John Gellatly, 1929.6.20

PROVENANCE
George H. Bogert (died 1923), New York and
Montclair, N.J.; John Gellatly.

EXHIBITION HISTORY
Bloomington, Ind., Indiana University Art
Museum, *The American Scene: 1800–1900*,
18 January–28 February 1970.
New York, The Metropolitan Museum of Art,
19th Century America, 16 April–7 September
1970, cat. no. 135 (illus.).
Washington, D.C., National Gallery of Art,
*American Light: The Luminist Movement,
1850–1875*, 10 February–15 June 1980,
pp. 132–33, fig. 148.
Annandale-on-Hudson, N.Y., Blum Art Institute,
Bard College, *Industry along the Hudson*,
15 May–10 July 1983.
Yonkers, N.Y., The Hudson River Museum, *The
Book of Nature: American Painters and the Natural
Sublime*, 12 September 1983–4 February 1984.

REFERENCES
American Art News 14, no. 7 (20 November 1925):
7 (illus.).
Wayne Craven, "Samuel Colman (1832–1920):
Rediscovered Painter of Far-Away Places,"
American Art Journal, May 1976, pp. 16–37,
fig. 11.
Joseph S. Czestochowski, *The American Landscape
Tradition: A Study and Gallery of Paintings* (New
York, 1982), cat. no. 102 (illus.).
Kay Larson, "The Nature of the Machine," *New
York*, 15 August 1983, p. 50f.

BIOGRAPHY
Born 4 March 1832, Portland, Maine, son of a
bookseller, publisher, and dealer in fine
engravings; moved with family to New York as a
youth. By 1850, decided to become an artist. First
exhibited 1851, National Academy of Design.
Probably studied with Asher B. Durand around
this time. Established studio in New York, 1854;
elected associate member of the National
Academy. Exhibited Boston Athenaeum, 1855.
Traveled abroad, 1860–62: Paris, Rome,
Granada, Seville, Madrid, Tangiers. 1864,
academician, National Academy. 1866, a founder
and first president (until 1870) of the American
Society of Painters in Water Colors. Probably in
1870 traveled to the West, including California.
1871–75, returned to Europe (Italy, France,
Holland) and North Africa (Egypt, Morocco,
Algeria). 1877, a founder of the Society of
American Artists. 1878, exhibited at the Paris
Exhibition; active in the just-founded New York
Etching Club. 1881, exhibited work in *Exhibition
of American Etchers* at Boston Museum of Fine Arts
and in London. Had become an expert on and
collector of Oriental art; an exhibition of his
porcelains held in New York in 1880. Noted as an
interior designer. 1882, built home in Newport,
R.I., designed by McKim, Mead and White;
stained-glass windows of his own design. Mid-
1880s, resumed travels in the American and
Canadian West. 1904, traveled in Europe. 1912,
published "Nature's Harmonic Unity," a
theoretical treatise; in 1920, "Proportional
Form." Died in New York City, 26 March 1920.

Albert Bierstadt
Among the Sierra Nevada Mountains, California 1868
signed lower right: *ABierstadt.68* (the AB in
monogram)
oil on canvas, 183 × 305 cm (72 × 120 in.)
Bequest of Helen Huntington Hull, 1977.107.1

PROVENANCE
Alvin Adams, Watertown, Mass., 1869; William
Brown Dinsmore, Dutchess County, N.Y., 1873;
Madeleine I. Dinsmore; Helen Dinsmore
Huntington Hull.

EXHIBITION HISTORY
Berlin, 1868.
London, Langham Hotel, Summer 1868.
London, Royal Academy, *Annual Exhibition*, 1869,
cat. no. 309.
Boston, A.A. Childs & Co., 1869.
Mexico City, Museo del Palacio de Bellas Artes,
*La pintura de los Estados Unidos de museos de la
ciudad de Washington*, 15 November–
31 December 1980, cat. no. 18 (illus.).
Boston, Museum of Fine Arts, *A New World:
Masterpieces of American Painting, 1760–1910*,
7 September–13 November 1983, cat. no. 47,
pp. 250–51 (then to Washington, D.C.,
Corcoran Gallery of Art, and Paris, Grand
Palais).

REFERENCES
"Great Pictures by an American Artist," *Art-
Journal* (London), August 1868, pp. 159–60.
Gordon Hendricks, *Albert Bierstadt, Painter of the
American West* (Fort Worth, Tex., 1974),
pp. 182, 188.
Patricia Failing, *Best-Loved Art from American
Museums* (New York, 1983), p. 96.
Patricia Trenton, "Purple Mountains' Majesty,"
Portfolio, July/August 1983, pp. 30–37.

COMMENTS
The picture has had other titles. In 1869 it was
shown in Boston as *Among the Sierra Nevada
Mountains*, a title used frequently thereafter. But
the year before it was exhibited in Europe as *The
Sierra Nevada in California*. It has also been called
View in the Sierra Nevada. In addition to the
exhibitions cited above, the painting was
apparently also shown in Moscow and St.
Petersburg (Hendricks, p. 182). Typical of the
high praise lavished upon the painting by the
English in 1868–69 were the comments of Sir
Francis Grant, president of the Royal Academy of
Arts: "One of the finest landscapes that adorn
our walls"; and the anonymous critic of *The Art-
Journal*: "No finer landscape . . . has, so far as we
are aware, been produced in modern times."

BIOGRAPHY
Born 7 January 1830, Solingen, Germany. 1832,
emigrated with family to New Bedford, Mass. No
record of any early training. By 1850 was painting
landscapes and advertising lessons in mono-
chromatic painting (charcoal, pencil, or crayon
drawings). Exhibited in Boston, 1851–53. Late
1853, traveled to Germany; studied informally in
Düsseldorf until 1855. 1856–57, traveled in
Germany, Switzerland, and Italy with various
American artists, including Worthington
Whittredge, Stanley Haseltine, and Sanford
Gifford. Fall 1857, returned to New Bedford.
1858, exhibited at National Academy of Design.
Summer 1859, traveled to Rocky Mountains with
surveying expedition of Colonel Frederick W.
Lander. Upon return, painted from sketches and
photographs. 1860, visited White Mountains.
1863, traveled west again, visiting Yosemite
Valley, Oregon, and San Francisco. December
1863, returned to New York. 1864, exhibited *The
Rocky Mountains* (Metropolitan Museum of Art) at
New York City Metropolitan Fair, and
established reputation. 1866, married Rosalie
Osborne Ludlow. 1867, awarded Legion of Honor
by Napoleon III. 1867–69, in Rome, London, and

Paris. 1871–73, in California. 1875, completed *The Discovery of the Hudson* for U.S. Capitol. Repeated trips to the West from 1876. 1878, his *Expedition under Vizcaino Landing at Monterey, 1601* was purchased by the government. Despite popularity, critical acceptance waned during 1880s and 1890s. 1893, death of wife. 1894, married Mary Hicks Stewart, a wealthy widow. 1895, declared bankruptcy. Died 18 February 1902, New York City.

27

James McNeill Whistler
Valparaiso Harbor 1866
unsigned
oil on canvas, 76.6 × 51.1 cm (30¼ × 20⅛ in.)
Gift of John Gellatly, 1929.6.159

PROVENANCE
Purchased by Thomas Way, from the 1879 Whistler bankruptcy sale; given to his son, Thomas R. Way; bought from T.R. Way by Thomas Agnew & Sons, London, May 1907; sold to W.B. Paterson, London and Glasgow (dealer), November 1907; probably bought from Paterson by W.A. Coats (d. 1926), Paisley; bought from D.C. Thomson, Ltd., London, by E. & A. Milch, Inc., New York, 1927; John Gellatly, 1928 (provenance taken from *The Paintings of James McNeill Whistler*; see References below).

EXHIBITION HISTORY
West Berlin, Nationalgalerie, *James McNeill Whistler*, 1 October–27 November 1969.
Detroit, Mich., The Detroit Institute of Arts, *American Art and the Quest for Unity, 1876–1893*, 22 August–30 October 1983.

REFERENCES
T.R. Way and G.R. Dennis, *The Art of James McNeill Whistler* (London, 1904), pp. 62–63.
Elizabeth and Joseph Pennell, *The Life of James McNeill Whistler* (London, 1908), pp. 134–35 (illus. opp. p. 134).
———, *The Whistler Journal* (Philadelphia, 1921), pp. 42–43, 253.
Andrew McLaren Young et al., *The Paintings of James McNeill Whistler* (New Haven, 1980), pp. 43–44, cat. no. 74, pl. 68.
David Park Curry, *James McNeill Whistler at the Freer Gallery of Art* (New York, 1984), p. 119, pl. 22.I.

BIOGRAPHY
Born 11 July 1834, Lowell, Mass. 1843–47, lived with family in St. Petersburg, Russia, where his father, retired major in U.S. Army, was consulting engineer for new railroad to Moscow. In Russia, received first art training. 1848, in London with older sister, who was married to Seymour Hayden, surgeon and etcher. 1849, father died; returned to U.S. with mother; attended school at Pomfret, Conn. 1851–54, attended U.S. Military Academy, West Point; discharged for demerits and deficiency in chemistry. 1854–55, learned etching while working as cartographer, U.S. Coast and Geodetic Survey, Washington, D.C. 1855, moved to Paris. 1856, studied with Charles Gabriel Gleyre. 1859, exhibited (with Henri Fantin-Latour) in studio of François Bonvin; moved to London. 1860, exhibited at Royal Academy of Arts. 1863, included in notorious Salon des Refusés, Paris. 1865, met Monet; became interested in Japanese prints and Chinese porcelains. Associated with Pre-Raphaelites, especially Dante Gabriel Rossetti. 1867, exhibited Salon des Beaux-Arts, Paris; also at Exposition Universelle, American Section. 1872, exhibited *Arrangement in Grey and Black No. 1: The Artist's Mother* at Royal Academy, London. 1874, first one-man show, Flemish Gallery, London. Commissioned to decorate Peacock Room for Frederick Leyland house, London (now in Freer Gallery, Washington, D.C.). From 1877, exhibited at Grosvenor Gallery, London. 1878, "won" libel suit against John Ruskin; resulting bankruptcy forced him to leave England. 1879–80, worked in Venice. 1884, member, Society of British Artists; 1886, president; 1888, voted out of office. 1886 and 1888, included in Symbolist exhibitions of Les XX, Brussels. 1888, *Ten O'Clock Lecture* published. 1889, awarded Legion of Honor; made officer, 1891. 1892–1902, lived in Paris. 1898–1901, directed own art school, Académie Carmen, Paris. 1898–1903, president, International Society of Sculptors, Painters, and Gravers, London. 1900, Grand Prix for Painting and Etching, Exposition Universelle, Paris. Died 17 July 1903, London.

John La Farge
Wreath of Flowers 1866
signed and dated bottom right: *La Farge/1866*
oil on canvas, 61.1 × 33.1 cm (24⅛ × 13⅛ in.)
Gift of John Gellatly, 1929.6.68

PROVENANCE
George V. Hecker, New York; Mrs. Leverett Bradley (his daughter), New York; Mrs. J.A. Locke (her daughter), Philadelphia; John Gellatly.

EXHIBITION HISTORY
New York, National Academy of Design, 1869.
Philadelphia, *Centennial Exposition*, 1876, cat. no. 270.
New York, Kennedy Galleries, Inc., *Exhibition on the Brooklyn Art Association*, 2–14 November 1970.
New York, National Academy of Design, *A Century and a Half of American Art*, 15 October–30 November 1975.
Mexico City, Museo de Bellas Artes, *La Pintura de los Estados Unidos de museos de la ciudad de Washington*, 15 November–31 December 1980, cat. no. 28.
Tulsa, Okla., Philbrook Art Center, *Painters of the Humble Truth: Masterpieces of American Still Life, 1801–1939*, 27 September 1981–Summer 1982, pp. 143–45 (illus.; then to The Oakland [Calif.] Museum; The Baltimore [Md.] Museum of Art; New York, National Academy of Design).

REFERENCES
Maria Oakey Dewing, "Flower Painters and What the Flower Offers to Art," *Art and Progress* 6 (June 1915): 255–62, 256 (illus.).
Frederic Fairchild Sherman, "Some Early Oil Paintings by John La Farge," *Art in America* 8 (February 1920): 85–91, 87 (illus.).
E.P. Richardson, *Painting in America* (New York, 1956), pp. 298 (illus.), 331.
Richard B.K. McLanathan, *The American Tradition in the Arts* (New York, 1968), pp. 355–56 (illus.).
Kathleen A. Foster, "Still-Life Painting of John La Farge," *American Art Journal* 2 (July 1979): 4–37.
Henry Adams, "John La Farge, 1830–1870: From Amateur to Artist" (Ph.D. diss., Yale University, 1980), pp. 264–68.
Theodore E. Stebbins, Jr., et al. *A New World: Masterpieces of American Painting, 1760–1910*, exh. cat. (Boston, 1983), p. 280.
Henry A. La Farge, "The Early Drawings of John La Farge," *American Art Journal* 16, no. 2 (Spring 1984): 31–34, 38, n. 31.

COMMENTS

Originally exhibited as *Wreath of Flowers*, this painting became known as *Greek Love Token* through confusion with a similar, earlier (1862) painting of that name. Henry A. La Farge (above) had advanced the theory that the NMAA painting was inspired by losses in the artist's family; but he later believed that it referred to the death of Father Baker, who died in 1866 at an early age.

BIOGRAPHY

Born 31 March 1835, New York City, of prosperous French émigré parents; educated in French culture and language. Attended Columbia grammar school and St. John's College; graduated from Mount St. Mary's College, Md., 1853. As a child, studied drawing and painting with maternal grandfather, Binsse de Saint-Victor, a miniaturist. 1856–58, in Europe. Met Jean-Léon Gérôme and Théodore Chassériau; studied briefly with Thomas Couture. Traveled to Munich, Dresden, Copenhagen, Belgium, and England. Met some of the Pre-Raphaelites. Returned to U.S. and studied law briefly. By 1859, Newport, R.I., to study with William Morris Hunt. 1860, married Margaret Mason Perry. Unable to serve in Civil War, he studied optical phenomena and painting with a friend, John Bancroft; this interest anticipated Impressionism. Early work included landscapes and flower paintings and occasional magazine illustrations. 1870s, with the assistance of a glassmaker, developed "opalescent" glass; from that time on, made several hundred windows. 1876, invited by H.H. Richardson to produce murals and stained glass for Trinity Church, Boston. Important mural commissions in New York included those for the Church of the Incarnation, St. Thomas's (destroyed), music room of the Whitelaw Reid residence, and "The Ascension" in the Church of the Ascension (begun 1886). 1886, traveled with Henry Adams to Japan. His stained-glass window *The Watson Memorial* exhibited at 1889 Paris Exposition; earned a medal of the first class and Legion of Honor for the artist. 1890–91, Hawaii, Tahiti, Fiji, Ceylon, Samoa, and Europe. Published travel books, including *An Artist's Letters from Japan* (1897) and *Reminiscences of the South Seas* (1912), and art books, including *Great Masters* (1903). Died 14 November 1910, Providence, R.I.

Thomas Moran

Cliffs of the Upper Colorado River, Wyoming Territory
1882

signed and dated lower right: *T. Moran. 1882*
oil on canvas mounted on masonite, 40.5 × 61 cm
(16 × 24 in.)
Bequest of Henry Ward Ranger through the National Academy of Design, 1936.12.4

PROVENANCE

Mrs. Franklin Murphy; Macbeth Gallery, New York; purchased by the National Academy of Design with the Henry Ward Ranger Fund, November 1925; assigned to the Louisville (Ky.) Free Public Library, May 1926; recalled by the terms of the Ranger Bequest.

EXHIBITION HISTORY

New York, Whitney Museum of American Art, *A Century of American Landscape Painting, 1800–1900*, 19 January–27 February 1938, p. 58, cat. no. 51.
Springfield, Mass., Museum of Fine Arts, *A Century of American Landscape Painting, 1800–1900*, 8–28 March 1938, cat. no. 47 (also in New York, Whitney Museum of American Art).
Washington, D.C., Howard University, *Exhibition of American Paintings*, 2 May–14 June 1938.
Pittsburgh, Pa., Carnegie Institute, *A Century of American Landscape Painting*, 22 March–30 April 1939.
Pittsburgh, Pa., Carnegie Institute, *Survey of American Painting*, 24 October–15 December 1940, cat. no. 133.
New York, The Museum of Modern Art, *Romantic Painting in America*, 17 November 1943–6 February 1944, cat. no. 150.
Washington, D.C., Howard University, *May Festival Exhibition*, 1 May–15 June 1951.
New York, American Federation of Arts, *Exhibition of Nineteenth Century Paintings*, circulated in Germany, 1953–23 May 1954.
St. Louis, Mo., The St. Louis Art Museum, *Westward the Way: The Character and Development of the Louisiana Territory as Seen by Artists and Writers of the Nineteenth Century*, 22 October–6 December 1954, cat. no. 38, p. 69 (illus.; as *Cliffs of the Green River, Wyoming Territory*; then to Minneapolis, Minn., Walker Art Center).
University Park, Pa., Pennsylvania State University, *Pennsylvania Painters*, 7 October–6 November 1955.

New York, National Academy of Design, *Henry Ward Ranger: Centennial Exhibition*, 25 September–12 October 1958 (then to Washington, D.C., National Collection of Fine Arts [now NMAA]; Charlotte, N.C., The Mint Museum of Art; Bradenton, Fla., Art League of Manatee County; Jacksonville [Fla.] Art Museum; Charleston, S.C., Gibbes Art Gallery).
Raleigh, North Carolina Museum of Art, 6 June–5 July 1959.
Moscow, *American Painting and Sculpture* (USIA), 25 July–5 September 1959.
Washington, D.C., National Collection of Fine Arts (now NMAA), *American Landscape: A Changing Frontier*, 28 April–19 June 1966.
Huntington, N.Y., Heckscher Museum, *Land of Whitman*, 2 October–7 November 1982.
Kobe, Japan, Hyogo Prefectural Museum of Modern Art, *The Rediscovery of Nature*, 2–27 November 1983 (then to four other locations in Japan through 25 March 1984).
Edinburgh, Royal Scottish Museum, *Treasures of the Smithsonian*, 8 August–5 November 1984.

REFERENCES

Edwards Park, *Treasures of the Smithsonian* (New York, 1983), pp. 66 (illus.), 69.

BIOGRAPHY

Born 12 January 1837, Bolton, Lancashire, England. 1844, to America with family; settled in Philadelphia. Apprenticed to a wood engraver for two years. 1856, shared studio with brother, Edward. Painted first in watercolors; 1860, began painting in oils. Advised by marine painter James Hamilton. 1862, in England, where he copied Turner's paintings in the National Gallery; married Mary Nimmo, one of his pupils. 1866–71, visited England, France, Italy. 1871, joined F.V. Hayden's U.S. Geological Expedition to Yellowstone. 1873, second western expedition with Major John Wesley Powell, to the Rockies and the Grand Canyon of the Colorado. 1874, again with Hayden, to Mountain of the Holy Cross, Colo. Sketches from these expeditions served as the basis for his oil paintings. 1876, medal at Centennial Exposition, Philadelphia. Two panoramas, *Grand Canyon of the Yellowstone* (1872) and *Chasm of the Colorado* (1873–74) – the earliest painted records of the territory – were purchased by Congress for the U.S. Capitol. His name given to two sites: Mount Moran, Teton Range, Wyo., and Moran Point, Ariz. Lived in Philadelphia until 1872; Newark, N.J., until 1881;

then New York. 1884, built a studio in East Hampton, Long Island. In the 1880s, visited England, Mexico, and Italy. Several trips to the Pacific Coast. Elected to British Society of Painter-Etchers. 1916, moved to Santa Barbara, Calif., where he died 25 August 1926.

<p style="text-align:center">✳</p>

When Moran joined Ferdinand V. Hayden's expedition to Yellowstone in 1871 on two-weeks notice, he had never ridden a horse. A representative of the Northern Pacific Railroad, the artist's co-sponsor with Scribner's publishing house, was careful not to mention this fact in his letter (7 June 1871) to Hayden:

> I think that Mr. Moran will be a very desirable addition to your expedition, and . . . he will be almost no trouble at all, and it will be a great accommodation to both our house [Jay Cooke and Co.] and the road, if you will assist him in his efforts.

The experienced members of Hayden's team were in for a surprise. William H. Jackson, the official photographer, later recalled that when he first saw Moran he looked "frail, almost cadaverous, [and] seemed incapable of surviving the rigors of camp life and camp food." But Moran was obviously more resilient than he looked, for he not only withstood the rigors of the trip, but subsequently participated in numerous other expeditions.

The artistic interaction between Moran and Jackson is of considerable interest, for it is probable that Moran worked from some of Jackson's photos as well as his own sketches when painting his large canvases in New York. On the other hand, it is important to remember the topographical freedom of Moran's paintings and the artist's habit of merging diverse views into an imaginary whole.

Of the abundant store of works by Moran in the NMAA (eight oils, four watercolors, and a great number of notational and preparatory sketches), the most significant are three vast canvases, two depicting the Grand Canyon of the Yellowstone and one the Grand Canyon of the Colorado. Following his 1871 initiation into western exploration, Moran produced his first masterpiece, the 1872 *Grand Canyon of the Yellowstone*. Congress established Yellowstone as a national park on 1 March of that year and subsequently authorized purchase of the painting for $10,000. The acquisition may be viewed as a sort of imprimatur for the historic legislation.

Interestingly, at the time there was already growing competition among artists in the field of western painting. The greatly talented Sanford Gifford had accompanied the 1870 Hayden expedition and was invited to go again in 1871. Henry W. Elliott, Hayden's official painter, also accompanied this and previous expeditions, but his art has somehow vanished. Above all, there was Albert Bierstadt, who had preceded Moran to the West (though not to Yellowstone) and established the taste and standard for paintings of this terrain. In a letter of introduction of 16 June 1871, written by the above-mentioned railroad agent and presented by Moran to Hayden, we read: "Mr. Moran is an artist (Landscape painter) of much genius. . . . That he will surpass Bierstadt's Yosemite we who know him best fully believe."

The 1872 *Grand Canyon of the Yellowstone* introduced a new spaciousness into painting of

Moran, *The Grand Canyon of the Yellowstone*, 1872, oil on canvas, 213 × 266.3 cm (84 × 144¼ in.). Lent by the U.S. Department of the Interior, National Park Service, L.1968.84.1

Moran, *The Chasm of the Colorado*, 1873–74, oil on canvas, 214.3 × 367.6 cm (84⅜ × 144¾ in.). Lent by the U.S. Department of the Interior, National Park Service, L.1968.84.2

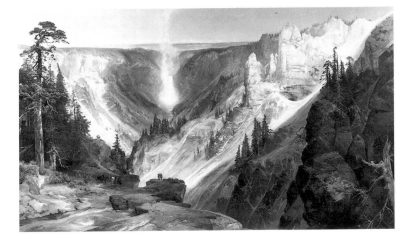

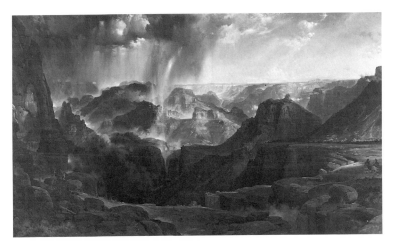

the West. Through precise and accomplished draughtsmanship the artist creates a credible panorama that is at the same time sharply in focus. The unnatural clarity actually enhances the realism. In addition to the remarkable rock formations and colors, the artist also recorded the hot springs for which the area is famous. Steam from three of them can be seen in the distance, beyond the canyon's rim left of center. In his early maturity, Moran also used traditional pictorial devices like the darkened foreground, which sets off the brilliantly lit distance with theatrical panache.

Moran next accompanied Major John Wesley Powell's expedition into the Arizona Territory and the Grand Canyon of the Colorado, whose majesty he captured in *The Chasm of the Colorado* (1873–74). Once again Congress authorized payment of $10,000 to purchase the canvas. Although he still framed his view in proscenium fashion, he distributed his dark tones more evenly throughout the landscape and achieved greater continuity between foreground and background. Moreover, he activated the atmosphere with swirling storm clouds, whose painterly freedom contrasts with the linearity of the rocks. The artist's personal association with his subject matter is reflected in the monogram with which he signed his picture: *TYM* for "Thomas Yellowstone Moran," the epithet by which he would henceforth be known.

Between 1893 and 1901, Moran worked on yet another monumental treatment of the Grand Canyon of the Yellowstone. This time, however, he

took greater liberties with the motif and painted with an expressive freedom in texture and color. The length of time he worked and reworked the painting suggests that the new approach was deliberate. Although the view is the same as that in the 1872 painting, Moran did not hesitate to alter the shapes of geological formations. More significant, however, was his decision to modify the foreground to suggest that the viewer is suspended in air. The framing elements of the earlier work are absent, with the result that the earlier succession of parallel planes gives way to an enveloping immediacy. The greater horizontal sweep and closeness of the gorge create a strong pull into the space. Color is intensified, and flowing brushwork sets the plunging slope at the right into hot, liquid motion. Although he was in fact speaking of the 1872 Yellowstone, the following statement by Moran seems more pertinent to this work: "The motive or incentive of my 'Grand Canyon of the Yellowstones' [*sic*] was the gorgeous display of color that impressed itself upon me. . . . I did not wish to realize the scene literally, but to preserve and convey its true impression."

The superiority of artistic license to prosaic naturalism was self-evident to Moran, and it clearly delighted him to report the effect of his mediations with nature in *Yellowstone*: "The precipitous rocks on the right were really at my back when I stood at that point, yet . . . every member of the expedition with which I was connected declared, when he saw the painting, that he knew the exact spot which had been reproduced."

William Holbrook Beard
The Lost Balloon 1882
signed lower left: *W.H. Beard 1882*
oil on canvas, 121.3 × 85.7 cm (47¾ × 33¾ in.)
Museum purchase, 1982.41.1

PROVENANCE
Victor D. Spark, New York, "in the 1930s–40s";
Nicholas Smith, Brooklyn, N.Y.

EXHIBITION HISTORY
New York, The Finch College Museum of Art, 1974 (lent by Nicholas Smith).
New York, Alexander Gallery, *William Holbrook Beard: Animals in Fantasy*, 21 April–16 May 1981, cat. no. 30.

REFERENCES
National Cyclopedia of American Biography, 1909, pp. 294–95.

COMMENTS
Beard is best known for his humorous scenes of animals engaged in human activities, but he also produced allegorical paintings in a poetic vein.

BIOGRAPHY
Born 13 April 1824, Painesville, Ohio. 1846, moved to New York City. 1856, went to Europe for three years; studied in Düsseldorf, traveled in Italy, Switzerland, and France. 1859, returned to New York. 1861, elected Associate Member, National Academy of Design; 1862, elected academician. Traveled through the South and West. In addition to painting, he designed mausoleums, museums, fountains, and monuments and was a writer and poet. Died 21 February 1900, New York City.

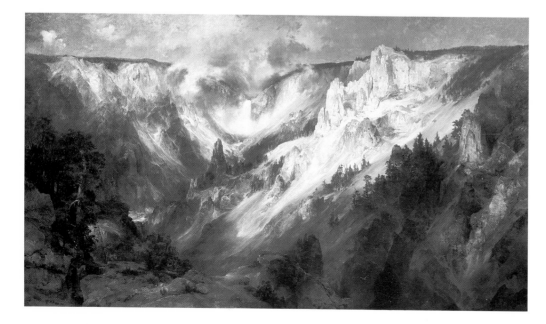

Moran, *The Grand Canyon of the Yellowstone*, 1893–1901, oil on canvas, 245.1 × 427.8 cm (96½ × 168⅜ in.). Gift of George D. Pratt, 1928.7.1

31

Albert Pinkham Ryder
The Flying Dutchman ca. 1887
unsigned
oil on canvas, 36.1 × 43.8 cm (14¼ × 17¼ in.)
Gift of John Gellatly, 1929.6.95

PROVENANCE
James S. Inglis, New York, 1890; John Gellatly,
New York, purchased about 1897–1900 from
Cottier & Co., New York.

EXHIBITION HISTORY
New York, The Galleries of the American Fine
 Arts Society, *Comparative Exhibition of Native and
 Foreign Art*, 1904, cat. no. 147 (lent by John
 Gellatly).
New York, The Metropolitan Museum of Art,
 Loan Exhibition of the Works of Albert P. Ryder,
 11 March–14 April 1918, cat. no. 20 (illus.;
 lent by John Gellatly).
New York, Whitney Museum of American Art,
 Art of the United States, 1670–1966,
 28 September–27 November 1966, cat. no. 238,
 p. 52.
New York, Center for Inter-American Relations,
 Inc., *Artists of the Western Hemisphere: Precursors
 of Modernism, 1860–1930*, 19 September–
 12 November 1967, cat. no. 27, pl. 27, p. 55.
New York, Whitney Museum of American Art,
 Seascape and the American Imagination, 9 June–
 7 September 1975.

REFERENCES
Henry Eckford, "A Modern Colorist, Albert
 Pinkham Ryder," *The Century Illustrated Monthly
 Magazine* 40 (June 1890): 258.
Sadakichi Hartmann, *A History of American Art*,
 vol. 1 (Boston, 1901), pp. 318, 319 (illus.).
Charles H. Caffin, *The Story of American Painting*
 (New York, 1907), pp. 218, 219 (illus.).
Walter Pach, "On Albert P. Ryder," *Scribner's
 Magazine* 49 (January 1911): 125 (illus.).
Duncan Phillips, "Albert P. Ryder," *American
 Magazine of Art* 7 (August 1916): 387.
Marsden Hartley, "Albert P. Ryder," *Seven Arts* 2
 (May 1917): 94.
Elliott Daingerfield, "Albert Pinkham Ryder,
 Artist and Dreamer," *Scribner's Magazine* 63
 (March 1918): 381.
"Albert P. Ryder and His Pictures," *Bulletin of the
 Metropolitan Museum of Art* 13 (April 1918): 84.
Frederic Fairchild Sherman, *Albert Pinkham Ryder*
 (New York, 1920), pp. 39, 50 (illus. opp.
 p. 30).

Samuel Isham, *The History of American Painting*
 (New York, 1927), pp. 394, 391 (illus.).
Suzanne LaFollette, *Art in America* (New York,
 1929), p. 199.
Virgil Barker, "Albert Pinkham Ryder," *Creative
 Art*, December 1929, p. 842.
Frank Jewett Mather, Jr., *Estimates in Art*, 2d ser.,
 1931, pp. 172–74, 176.
Lewis Mumford, *The Brown Decades* (New York,
 1931), p. 229.
F.N. Price, *Ryder* (New York, 1932), no. 42
 (illus.).
Holger Cahill and Alfred H. Barr, Jr., *Art in
 America in Modern Times* (New York, 1934),
 p. 15 (illus.).
Alan Burroughs, *Limners and Likenesses* (New York,
 1936), p. 156, fig. 123.
S. Hartmann, "Albert Pinkham Ryder," *Magazine
 of Art*, September 1938, pp. 501–51 (illus.).
Allen Weller, "An Unpublished Letter by Albert
 P. Ryder," *Art in America* 27 (April 1939): 102.
Richard Braddock, "The Literary World of
 Albert Pinkham Ryder," *Gazette des Beaux-Arts*
 33 (January 1948): 50 (illus.), 51.
V. Barker, *American Painting* (New York, 1950),
 p. 635.
National Collection of Fine Arts (now NMAA),
 *Catalog of American and European Paintings in the
 Gellatly Collection* (Washington, 1954), no. 95.
John I.H. Baur, *Revolution and Tradition in Modern
 American Art* (Cambridge, Mass., 1958),
 pp. 110, 114, pl. 179.
Lloyd Goodrich, *Albert P. Ryder* (New York,
 1959), no. 54, p. 115.
John Wilmerding, *A History of American Marine
 Painting* (Boston, 1968), pp. 232, 234 (illus.).
Lloyd Goodrich, "Ryder Rediscovered," *Art in
 America* 56 (November/December 1968): 36,
 40–41 (illus.).

COMMENTS
Ryder's working methods are of paramount
interest in any consideration of his paintings. Like
English painters of the 18th century, he used a
transparent, brown pigment called bitumen as a
ground color or a glaze to impart an especially
rich tone. Bitumen is more widely known as
asphaltum, the material used in paving roads. As
anyone who has ever walked on asphalt paving in
summer knows, the substance never completely
hardens. If used as underpainting, the continual
movement of the pigment causes severe
craquelure, a network of chasm-like cracks, which
is irreversible. As a glaze, it may cause similar
cracks. In addition, as it ages bitumen turns

opaque and blackens, resulting in the loss of both
tone and legibility.
 Ryder compounded this inherent catastrophe
by using bitumen for underpainting and glazing;
experimenting with mediums like candlegrease
and wax; and constantly reworking his paintings,
applying countless layers of pigment, often over a
period of years. He would even borrow his
pictures from their owners in order to rework
them. Childe Hassam remarked that "it was a
pretty delicate operation to get a good grip on a
Ryder when it was finished and to hold on to it
hard!"
 The complete text of the poem written by
Ryder for *The Flying Dutchman* follows.

*Who hath seen the Phantom Ship,
Her lordly rise and lowly dip,
Careening o'er the lonesome main
No port shall know her keel again.*

*But how about that hapless soul,
Doomed forever on that ship to roll,
Doth grief claim her despairing own
And reason hath it ever flown
Or in the loneliness around
Is a sort of joy found,
And one wild ecstasy into another flow
As onward that fateful ship doth go.*

*But no, Hark! Help! Help! Vanderdecken cries,
Help! Help! on the ship it flies;
Ah, woe is in that awful sight,
The sailor finds there eternal night,
'Neath the waters he shall ever sleep,
And Ocean will the secret keep.*

(As printed in the catalogue of the 1918 Ryder
Memorial Exhibition at the Metropolitan
Museum of Art.)

BIOGRAPHY
Born New Bedford, Mass., 19 March 1847. Self-
taught; began painting landscapes. Moved with
family to New York around 1870 for remainder of
life. At this time studied informally with William
Edgar Marshall, portrait painter and engraver.
Study at National Academy of Design, 1870–72,
1874–75. Exhibited in National Academy Spring
Exhibition, 1873. 1875, with four other painters
also rejected by the academy, held exhibition at
Cottier & Co., New York. Brief trip to London,
1877; one of twenty-two founders, Society of
American Artists. Exhibited there, 1878 to 1887.
Traveled in 1882 to England, France, Holland,

Italy, Spain, Tangier. Atlantic crossings on boat of his friend Captain John Robinson in 1887 and 1896; no significant time spent abroad. Seldom exhibited after 1887. Late 1890s, mainly reworked earlier canvases; few new paintings after 1900. Attracted a small circle of admirers, including J. Alden Weir, the art dealer Daniel Cottier, and Marsden Hartley. Ten paintings included in 1913 Armory Show. In 1915, following a serious illness, went to live with friends at Elmhurst, Long Island, where he died 28 March 1917. Memorial exhibition, Metropolitan Museum of Art, New York, 1918.

*

There is no more important treasure in the NMAA than its collection of works by Ryder. The eighteen paintings constitute the most extensive holdings of the artist and include several of the most well-known examples. As the leading representative of visionary painting in America, Ryder has been valued both as a deeply personal voice and a precursor of expressionist and abstract art. It is easy to find echoes of Ryder in representational painters like Marsden Hartley and non-objective painters like Franz Kline. Indeed, Ryder's critical and popular favor in the 1950s and 1960s was to some extent linked to that of the Abstract Expressionists.

Ryder's *Moonlight* (ca. 1880–85) is a strong example of his nocturnal evocations "imbued with the witchery . . . of night," as a contemporary critic aptly described them. Its arrangement of shapes is strikingly similar to *The Flying Dutchman*, but the backlit silhouettes of the boat and clouds and the

suppression of the ocean's heaving drama result in a stark, minimal pattern.

The work is on a mahogany panel, once painted on both sides, which has been sawed in two. The painting formerly joined to it, *The Temple of the Mind* (now in the Albright-Knox Art Gallery, Buffalo), was inspired by Poe's poem of the same title in "Fall of the House of Usher." *The Flying Dutchman* and *Moonlight* each demonstrate Ryder's habit of adding forms in a transparent wash over prior, heavier layers of paint. This is true of the small sail in *Moonlight* and the phantom ship and sail in *Dutchman*. Such elements should not be considered afterthoughts, however. Through this technique, Ryder attempted to increase the ghostly effect of his images.

Jonah, painted about 1885, is one of Ryder's most famous works. The extraordinary ferment of the sea dominates the biblical scene. Only gradually does the viewer discern the ladle-like boat with cowering sailors, Jonah with arms upstretched from the sea, the whale rounding at the right to swallow up the reluctant prophet, and the gold-on-gold figure of God holding an orb, while with his left hand indicating the whale. It may well be, as Abraham A. Davidson in *The Eccentrics and Other American Visionary Painters* has suggested, that the impulse for Ryder's *Jonah* came from "Father Maple's Hymn" in Melville's *Moby Dick*: "Awful, yet bright as lightning shone/The face of my Deliverer God."

Like the majority of Ryder's paintings, *Jonah* has suffered grievously from the continual darkening of color and actual movement of the painting's surface, both of which resulted from the

use of bitumen. But patient conservation has restored more of the golden glow of this work ("the scheme of color that haunts me") than might have been thought possible.

In view of Ryder's infamous technical short-comings, it is especially instructive to examine his unfinished *Landscape with Trees and Cattle* (ca. 1880–85). Using a thin oil, he established the cows, sloping hillside in the distance, and leafy arch springing from the intertwined trees at the left with the transparency and flow of light that is usually found in plein-air painting. Only in the unnatural congruity of the arching branches, which blend into a circle, do we detect the beginnings of Ryder's obsession with rhythmic pulsation. Having probed the objective, natural world, he proceeded to interpret and stylize it to create something "better than nature, . . . vibrating with the thrill of a new creation."

Ryder, *Moonlight*, ca. 1880–85, oil on panel, 40.4 × 45 cm (15⅞ × 17¾ in.). Gift of William T. Evans, 1909.10.2

Ryder, *Jonah*, ca. 1885, oil on canvas, 69.2 × 87.3 cm (27¼ × 34⅜ in.). Gift of John Gellatly, 1929.6.98

Ryder, *Landscape with Trees and Cattle*, ca. 1880–85, oil on canvas, 96.2 × 84.5 cm (37⅞ × 33¼ in.). Gift of John Gellatly, 1929.6.100

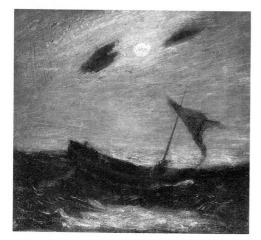

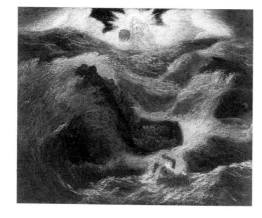

Ralph Albert Blakelock
Moonlight, Indian Encampment 1885–89
signed lower left, within arrowhead outline:
R.A. Blakelock
oil on canvas, 68.8 × 86.8 cm ($27\frac{1}{8}$ × $34\frac{1}{8}$ in.)
Gift of John Gellatly, 1929.6.3

PROVENANCE
Sold by the artist to Lew Bloom, 1889; purchased
by Milch Galleries, New York; purchased by
John Gellatly, New York, 1928.

EXHIBITION HISTORY
New York, Whitney Museum of American Art,
 Art of the United States: 1670–1966,
 28 September–27 November 1966, no. 22.

REFERENCES
Ralph Seymour and Arthur Riggs, "The Gellatly
 Collection," *Art and Archaeology* 35 (May/June
 1934): 120.
Index of Twentieth Century Artists, December 1936,
 p. 368.
Harold McCracken, *Portrait of the Old West* (New
 York, 1952), pp. 146, 153 (illus.).
Oliver Larkin, *Art and Life in America* (New York,
 1960), p. 268 (illus.).
Alan Burroughs, *Limners and Likenesses* (New York,
 1965), p. 151, fig. 122.
David Gebhard and Phyllis Stuurman, *The Enigma
 of Ralph A. Blakelock, 1847–1919*, exh. cat.
 (Santa Barbara, Calif., 1969), N.B. pp. 5–8.

BIOGRAPHY
Born 1847, New York City. 1864–66, attended
Free Academy of New York. Self-taught as an
artist. Exhibited at National Academy of Design,
New York, 1867–73. 1869–72, traveled alone in
the West, spending much time among Indians.
Sketches from this trip, enhanced by imagination,
became primary source of his imagery. Married
Cora Rebecca Bailey in 1877. Exhibited at
National Academy, 1879–88. Received awards
from National Academy, 1889, and Pennsylvania
Academy of the Fine Arts, 1892. 1891, first
mental breakdown. Desperately poor, could
scarcely support his large family. Another
breakdown 12 September 1899, the day his ninth
child was born; hospitalized in a New York State
asylum until 1916. Transferred to New Jersey
sanitarium, where he had a studio, 1916–18.
During his incarceration, was elected academician
of National Academy of Design (1916). Returned
to New York asylum, 1918–19. His by-then
popular work much forged during these years.
Removed by legal guardian to private cottage in
Adirondacks, July 1919. Somewhat regained
sanity, but died 19 August 1919.

George Inness
Niagara 1889
signed lower left: *G. Inness 1889*
oil on canvas, 76 × 114.3 cm (30 × 45 in.)
Gift of William T. Evans, 1909.7.31.G

PROVENANCE
Fifth Avenue Galleries, New York, Inness
Executor's Sale, 11–13 February 1904, cat. no. 18;
William T. Evans, New York.

EXHIBITION HISTORY
Montclair, N.J., Wentworth Manor, *American
 Paintings in the Collection of William T. Evans*,
 April 1906 (exh. cat.).
Washington, D.C., National Gallery of Art,
 *Paintings and Other Art Objects Exhibited on the
 Occasion of the Opening of the National Gallery of
 Art in the New Building of the United States
 National Museum*, 17 March 1910, p. 9.
Washington, D.C., The White House,
 17 September–30 November 1954.
Washington, D.C., National Collection of Fine
 Arts (now NMAA), *Turn-of-the-Century Painting
 from the William T. Evans Collection*, 23 April–
 1 June 1959.
Atlanta, Ga., The High Museum of Art, *The
 Beckoning Land*, 18 April–13 June 1971.
Oakland, Calif., The Oakland Museum, *George
 Inness Landscapes: His Signature Years, 1884–1894*,
 28 November 1978–28 January 1979, pp. 20, 41
 (illus.), 57 (then to Santa Barbara [Calif.]
 Museum).

REFERENCES
Washington Star, 6 April 1907.
W.H. Holmes, *The National Gallery of Art Catalogue
 of Collections* (now NMAA; Washington, D.C.,
 1909), p. 123; 1916, p. 137; 1922, p. 41; 1929,
 p. 51.
Art and Progress, no. 6 (April 1910): 150.
International Studio 48, no. 192 (February 1913).
LeRoy Ireland, *The Works of George Inness: An
 Illustrated Catalogue Raisonné* (Austin and
 London, 1965), p. 327, cat. no. 1296.

Inness, *September Afternoon*, 1887, oil on canvas,
95.1 × 73.6 cm ($37\frac{1}{2}$ × 29 in.). Gift of William T.
Evans, 1909.7.34

BIOGRAPHY
Born near Newburgh, N.Y., 1 May 1825.
Childhood in New York City and Newark, N.J.
Studied with Regis Gignoux, a French painter
living in Brooklyn, about 1843. Influence of
Thomas Cole and Asher Durand. European trips
in 1847, 1850–52, 1854. Associate member,
National Academy of Design, 1853. Studio in
New York, 1855–60. During 1860s, lived in
Medfield, Mass., Eaglewood, N.J., and Brooklyn.
Exhibited, Universal Exposition, Paris, 1867.
Member, National Academy of Design, 1868.
Europe, 1870–72, 1873–75. Exhibited in London,
Royal Academy, 1872. New York City, 1876.
Settled in Montclair, N.J., 1878; remained, except
for frequent travel, until his death. Exhibited in
Paris, Universal Exposition, 1889 and 1891; in
Munich, 1892. Died while traveling in Scotland,
3 August 1894.

*

The paintings by Inness in the museum's collection
are all important, late works. They thus provide an
opportunity for close study of the mature and
deeply personal style that Inness himself prized
most highly. Although one will not find here
examples of his more varied and structured earlier
style, epitomized by his work in Italy and France in
the mid-1870s, there is still enough variety among
the uniformly high-quality paintings of his last
decade to invite comment.

September Afternoon of 1887 is a tightly controlled painting with an emphasis on a few motifs – the unit of trees, the almost spherical white cloud, and the saturated blue sky – that draw us into the artist's deep empathy with nature. These large masses are counter-pointed with smaller, clearly defined units to give a spatial cohesion and rhythm increasingly rare in these years. Inness spoke of "unity of thought," through which we learn to see nature. The concept owes much to the mysticism of Emanuel Swedenborg, as does his statement that he was open "to any impression which I am satisfied comes from the region of truth." This idealism also relates to New England Transcendentalism, which evolved earlier in the century. In 1841 Emerson, a leading figure of the movement, had said, "In the divine order, intellect is primary; nature, secondary; it is the memory of the mind." In its vagueness, the remark is comparable to some of Swedenborg's nebulous formulations.

In *Georgia Pines*, painted in early 1890, Inness's youthful admiration for the Barbizon landscapists is apparent, but it has been translated into the personal idiom of his old age. On the small mahogany panel he presents a broadly conceived scene. The few figures in this somber grove of trees are very small and do nothing to animate the subdued picture, but rather underscore its muted, unfathomed spaciousness. The landscape was painted near Thomasville, Georgia, where Inness was staying in a hotel. There he encountered Frederic Church, who remarked that the "endless number of slim straight trunks [in the pine woods] get very tiresome," but that Inness, whose "theory is 'Subject is nothing treatment makes the picture,' . . . thinks it very attractive."

Possessing a broad grandeur and radiance, *Sundown* (1894) has the comforting quality of a benediction in the warmth of its palette and its dual suggestion of permanence and transience. In her simplicity, the silent woman in the center is one with the earth and the season of harvest. The rounded forms of hayrick, trees, and sun, and the broad, nearly equal bands of earth and sky set the stage for this final act, while the sun suffuses everything from its small corner of the painting. The essence of maturation or fulfillment and its impending absence is poignant.

Not many months later, while visiting Scotland, Inness went out to witness the sunset. His son recorded that "just as the big red ball went down below the horizon he threw his hands into the air and exclaimed, 'My God! oh, how beautiful!' and fell stricken to the ground." The artist would have agreed with Shakespeare's Edgar in *King Lear*: "Ripeness is all."

Inness, *Georgia Pines*, 1890, oil on wood, 45.3 × 61 cm ($17\frac{7}{8}$ × 24 in.). Gift of William T. Evans, 1909.7.33

Inness, *Sundown*, 1894, oil on canvas, 114.3 × 177.8 cm (45 × 70 in.). Gift of William T. Evans, 1909.7.32

Thomas Wilmer Dewing
Summer ca. 1890
signed lower left (nearly illegible): *T.W. Dewing*
oil on canvas, 107 × 137.8 cm ($42\frac{1}{8}$ × $54\frac{1}{4}$ in.)
Gift of William T. Evans, 1909.7.21

PROVENANCE
Painted for Stanford White, New York; Stanford White sale, The American Art Association, New York, 1907; William T. Evans, New York.

EXHIBITION HISTORY
Washington, D.C., Corcoran Gallery of Art, on loan, 1909.
Washington, D.C., National Gallery of Art (now NMAA), *Catalogue of Paintings and Other Art Objects Exhibited on the Occasion of the Opening of the National Gallery of Art in the New Building of the United States National Museum*, 17 March 1910, cat. no. 21.
New York, American Federation of Arts, traveling exhibition (title unknown), 1923–24, shown at: New York, National Academy of Design and Grand Central Galleries; Washington, D.C., Corcoran Gallery of Art.
Washington, D.C., National Collection of Fine Arts (now NMAA), *Turn-of-the-Century Paintings from the William T. Evans Collection*, 23 April– 1 June 1959.
New York, Durlacher Brothers, *A Loan Exhibition: Thomas W. Dewing*, 26 March– 20 April 1963, cat. no. 7.

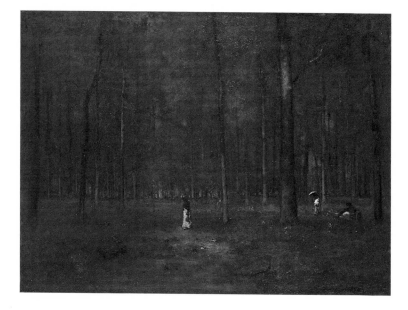

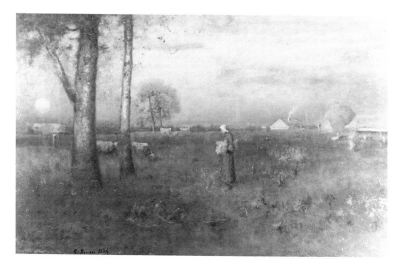

New York, American Federation of Arts, traveling exhibition, *American Impressionists: Two Generations*, October 1963–31 May 1965.

REFERENCES

James Henry Moser, "The National Gallery of Art," *Art and Progress* 1 (April 1910): 152 (as *Summer Pastime*).

Rilla Evelyn Jackman, *American Arts* (New York, 1928), pl. 53.

Mahonri Sharp Young, "Infinite Variety," *Apollo* 85 (May 1967): 383 (illus.).

COMMENTS

The number *90* written in pencil appears below the signature. That it is intended to date the picture is clear, but it is not known who placed it there.

BIOGRAPHY

Born 4 May 1851, Boston. Trained in lithography and portrait drawing in Boston and Albany. 1876–78, studied in Paris at Académie Julian. 1880, settled in New York City; elected to Society of American Artists. Married painter Maria Richards Oakey (see p. 94), 1881. Taught at Art Students League, 1881–88. 1887, elected associate, National Academy of Design, New York; 1888, academician. 1908, National Institute of Arts and Letters. Virtually ceased painting after 1920. Died 5 November 1938, New York City.

*

Thomas Dewing's active career pivots on the year 1900, and the idealized nostalgia and placid detachment that were hallmarks of *fin-de-siècle* art both here and abroad are dominant characteristics of his oeuvre. His art had passing contact with French Impressionism and its American cousin (particularly through his close friend William Merritt Chase) but was ultimately closer to the aestheticism of Whistler and the subdued world of the French Nabis, especially Maurice Denis. Dewing frequently referred to his paintings as "decorations," and in addition to groups of pictures made for that purpose, he designed stained glass and public murals.

Because some of the earliest patrons of the NMAA were avid Dewing collectors, the museum is home to twenty-three paintings, pastels, watercolors, and drawings, which together reveal the variety in his admittedly narrow stylistic range. The warm, glowing palette of *Music* (ca. 1895), for example, differs from his habitual cool tonality.

An intimate *concert à deux* set in a vaporous atmosphere, the scene is dated, like a dream of the past, by the startlingly long instrument *à la Watteau* (a theorbo or chitarrone). The sweeping curves and elegant balance of these women contrast strongly with the more complex and forceful arrangement of lines and planes that compose *A Reading* (1897). The sharp diagonal slice of the table top and the insistent asymmetry of the grouping add an astringent overtone rare in Dewing's art.

The artist's exquisite sensibility was well served by his capable draughtsmanship. His large chalk portrait of *Walt Whitman* (1875) displays linear refinement and yielding texture, and his *Head of a Girl* is poised and flawless, as the silverpoint medium requires.

The nostalgic bent of Dewing derives from the vogue for the art of Vermeer that arose in the 1890s, when rare paintings by the seventeenth-century Dutch master appeared in America. The first was *Woman with Water Jug*, which entered the Metropolitan Museum of Art in 1888. Paintings of a single woman in an incompletely defined interior thereafter figured prominently in Dewing's oeuvre. If Dewing's *Lady in White* was indeed executed around 1910, the 1908 exhibition of Vermeer's *Lady Writing a Letter* (now in the National Gallery of Art, Washington, D.C.) might be significant. It must be emphasized, however, that the insub-

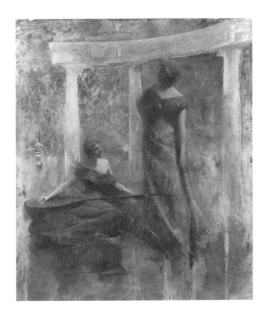

Dewing, *Music*, ca. 1895, oil on canvas, 108 × 91.4 cm (42½ × 36 in.). Gift of John Gellatly, 1929.6.32

Dewing, *A Reading*, 1897, oil on canvas, 51.3 × 76.8 cm (20¼ × 30¼ in.). Bequest of Henry Ward Ranger through the National Academy of Design, 1948.10.5

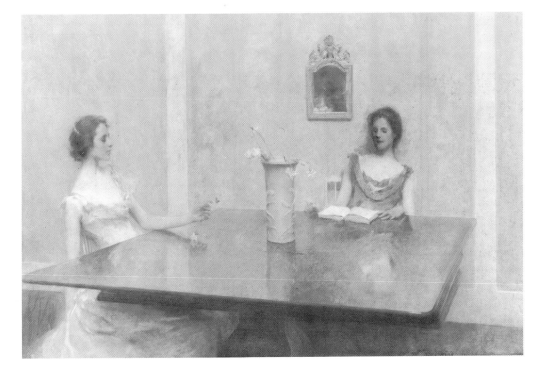

stantial fluidity and aesthetic day-dreaming of Dewing's painting has next to nothing to do with Vermeer's volumetric spaces and forms and the focused intellect of his subjects.

Lady in White, a lovely evocation of a woman seemingly entranced in an essentially empty interior, is typical of Dewing's late work. The formal unity of woman, chair, and cheval glass is suspended in a neutral world of faint and hazy tones. The mirror reflects nothing, and the woman's eyes are half closed. The effect, greatly enhanced by her poised right hand, is séance-like.

This wistful world was swept away by artistic and political upheavals. The dilemma of Dewing's work after 1900 was summed up by a contemporary commentator on *Lady in White*: "[She] stands a little apart as if turning to the demure restraint of the past century, and a little sceptical of the brilliant color, dancing sunshine, and aggressiveness of things modern." The adherents of "things modern" rejected Dewing's rarified and constrained world, and he in turn never adopted stylistic elements of modernism. Today, greater art-historical tolerance for different styles and a nostalgia for pre-Second World War days have restored his work to esteem.

Dewing, *Walt Whitman*, 1875, chalk on paper, 62.2 × 45.7 cm (24½ × 18 in.). Museum purchase, Robert Tyler Davis Memorial Fund, 1980.73

Dewing, *Head of a Girl*, silverpoint, 42.1 × 35.7 cm (16 9/16 × 14 1/16 in.). Gift of John Gellatly, 1929.6.28

Dewing, *Lady in White*, ca. 1910, oil on canvas, 66.6 × 51.3 cm (26¼ × 20¼ in.). Gift of John Gellatly, 1929.6.29

Abbott Handerson Thayer
Angel ca. 1889
signed lower right: *Abbott H. Thayer*; and lower left (partially obliterated): *[Ab]bott H. [T]h[a]y[er].*
oil on canvas, 92 × 71.5 cm (36¼ × 28⅛ in.)
Gift of John Gellatly, 1929.6.112

PROVENANCE
Purchased "on the easel" by A.A. Carey, 1887; Gellatly from the Rehn Gallery, 1923.

EXHIBITION HISTORY
Paris, Exposition Universale, 1889 (as *Corps Ailé*).
New York, The Metropolitan Museum of Art, *Memorial Exhibition of the Works of Abbott Handerson Thayer*, 1922.
Washington, D.C., Smithsonian Institution, *Centennial Exhibition of Paintings by Abbott Handerson Thayer*, 1949.
New York, Whitney Museum of American Art, *Art of the United States, 1670–1966*, 28 September–27 November 1966, cat. no. 273.
Brooklyn, The Brooklyn Museum, *The American Renaissance, 1876–1917*, 13 October– 30 December 1979 (then to the NMAA).

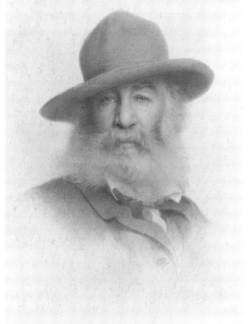

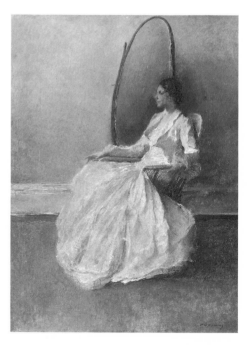

REFERENCES

Mrs. Arthur Bell, "An American Painter: Abbott H. Thayer," *International Studio* 6 (February 1899): 250 (illus.), 253.

"Abbott H. Thayer Appreciations," *Arts* (June–July 1921): 27 (illus.).

Helen M. Beatty, "Abbott H. Thayer," *Scribner's Magazine* 70 (September 1921): 380.

The Metropolitan Museum of Art Bulletin 17 (March 1922): cover illus.

Maria Oakey Dewing, "The Thayer Memorial Exhibition at the Metropolitan Museum of Art," *American Magazine of Art* 13 (May 1922): 149 (illus.), 150.

Nelson C. White, *Abbott H. Thayer, Painter and Naturalist* (Hartford, Conn., 1951), p. 51 (illus.).

Oliver Jensen, *The Nineties* (New York, 1967), p. 72.

Ross Anderson, *Abbott Handerson Thayer* (Syracuse, N.Y., 1982), p. 60 (illus.).

BIOGRAPHY

Born Boston, Mass., 12 August 1849. Art instruction from a local amateur, 1865. Brooklyn (N.Y.) Art School and National Academy of Design School, 1867. Married Kate Bloede, 1875. Studied in Paris, Ecole des Beaux-Arts, under Henri Lehman, an Ingres disciple; then with Jean-Léon Gérôme, 1875–76. Traveled in Germany, 1878. Returned to U.S. and settled in New York City, 1879. Death of two sons, 1880 and 1881. Frequent moves in New England and New York State. Vice-president and president, Society of American Artists, 1882–83. Onset of wife's mental illness, 1884; lasted until her death, 1891. Married Emma Beach same year. Charles Lang Freer became his first patron, 1892. 1901, after extensive Italian tour, moved permanently to Dublin, N.H. John Gellatly became second patron, 1903. From his knowledge and theory of coloration of animals in nature, developed camouflage for military use. One-man show, Carnegie Institute, 1919. Died 29 May 1921, Monadnock, N.H.

Thayer, *Minerva in a Chariot*, ca. 1894, oil on canvas, 96.7 × 136.4 cm ($38\frac{1}{8} × 53\frac{3}{4}$ in.). Gift of John Gellatly, 1929.6.121

Thayer, *Stevenson Memorial*, 1903, oil on canvas, 207.2 × 52.6 cm ($81\frac{7}{8} × 60\frac{1}{8}$ in.). Gift of John Gellatly, 1929.6.127

The task of assessing Abbott Thayer's contribution to American art is not made any easier by his fondness for painting women and children in allegorical garb. Modern viewers, often unaware of the diversity of his subject matter, have sometimes found his themes irrelevant, even while praising the improvisatory freedom of his technique. The range of the NMAA's holdings by him – forty-two oils, watercolors, and drawings – permits a broader view and fairer assessment.

The large oil study *Minerva in a Chariot*, for example, was Thayer's proposal for a decoration in the Boston Public Library. There seems to be no documentation, but according to oral history, Charles McKim, the architect of the library and Thayer's friend, asked him to decorate the staircase hall, and *Minerva* was designed for that purpose. While the vigor and speed of Thayer's brush are impressive in this sketch, particularly in the incisive curves describing horses and chariot, he failed to persuade the committee in charge, which opted for the famous French muralist Puvis de Chavannes. Thayer subsequently completed a mural in McKim's Walker Art Building at Bowdoin College; and in 1895 he was invited to join the team of artists decorating the new Library of Congress, but withdrew when asked to design a mosaic, which he considered an uncongenial task. Despite

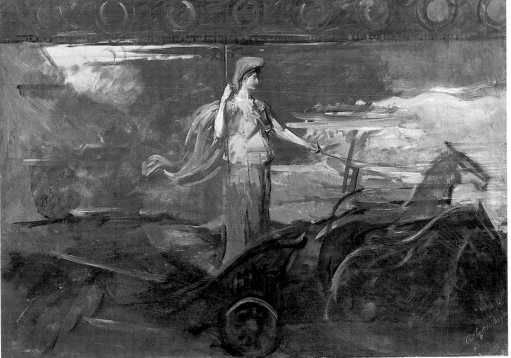

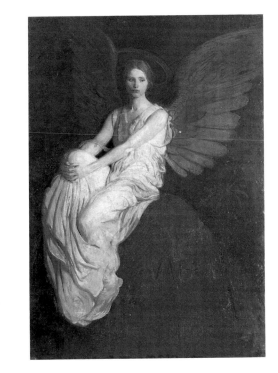

the importance of mural commissions during the decades of Thayer's maturity, neither his self-sufficient temperament nor his disinterest in multi-figure compositions disposed him in this direction.

In 1903, after prior attempts to produce a work commemorating the late Robert Louis Stevenson (died 1894), Thayer created the painting *Stevenson Memorial*. One of Thayer's remarkably down-to-earth angels sits on a large, domed rock, her right knee clasped in her hands, her gaze averted, her mien melancholy, and her posture part mourner, part guardian. While the rock suggests a tomb or grave monument, it also symbolizes the mountain behind Stevenson's Samoan home, upon which slopes the poet is buried. *Vaea*, the name of the mountain, is inscribed on the rock, and a palm tree stands to the right.

Thayer had difficulty painting this dark expanse of rock, and he asked a young apprentice, Rockwell Kent, for assistance. Kent (see p. 114) later recalled his reluctance to alter the painting significantly and his timid sketching in of some new forms. Thayer interrupted him impatiently, took up a "large stable broom," and brushed it vigorously over the rock, leaving striations that are clearly visible.

Satisfied, Thayer offered the painting to several of his habitual patrons, one of whom, J. J. Albright of Buffalo, bought it. He later sold it to John Gellatly, who soon presented it to the Smithsonian.

As a landscape painter, Thayer stands in an altogether different light. *Cornish Headlands* of 1898 is a strong case in point. The spare élan of his brushwork is appropriately matched with its subject and its era, i.e., the end of the century, after thirty years of radical French innovations from Courbet to Cézanne. His feeling for simplified design is greatly heightened in the absence of figures. (In this contrast between figure and landscape painting, Thayer to some extent parallels John Singer Sargent.) Two versions of *Cornish Headlands* exist, both painted in the summer of 1898 near St. Ives in Cornwall. One was bought by Charles Lang Freer and is in the Freer Gallery, Washington, D.C. Thayer's inscription on the back of this painting tells us that the two versions were done "on the same spot on different days, but at the same time of day." It was, of course, pure Impressionism to focus on capturing varied atmospheric effects, and the two paintings differ markedly in handling.

Note should be made of *Winter, Monadnock*, a serene watercolor, undated but probably done late in Thayer's career. The artist's second wife, Emma Beach Thayer, added her husband's name and her own initials to authenticate it and other unsigned works that were in the studio after his death. In the watercolor, Thayer's calligraphic brushwork and partiality for thin, dry surfaces is, if anything, more effective than it is in oil. The high viewpoint turns the snow carpet into a white field, where the play of blue shadows suggests an animation, a true forest spirit. Thayer lived a rustic existence in rural New Hampshire for the last twenty years of his life. His exhilaration in the presence of nature – reminiscent of Thoreau at Walden – resonates throughout this work.

Thayer, *Cornish Headlands*, 1898, oil on canvas, 76.5 × 101.8 cm ($30\frac{1}{8}$ × $40\frac{1}{8}$ in.). Gift of John Gellatly, 1929.6.115

Thayer, *Winter, Monadnock*, watercolor, gouache, chalk, and pencil on paperboard, 51.1 × 41.5 cm ($20\frac{1}{8}$ × $16\frac{3}{8}$ in.). Gift of John Gellatly, 1929.6.133

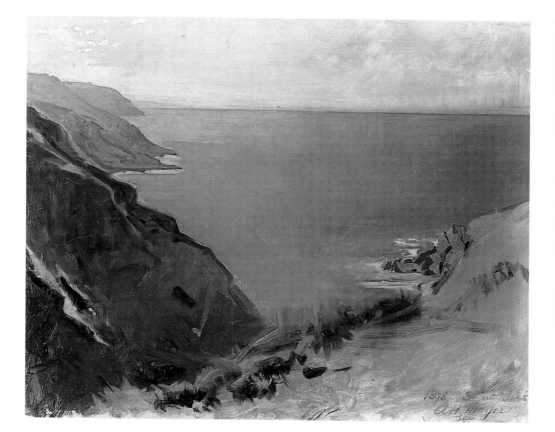

Elihu Vedder
The Cup of Death 1885 and 1911
signed lower left: *ELIHU VEDDER*; dated lower
right: *18V85/&/1911*
oil on canvas, 113.9 × 57 cm (44⅞ × 22½ in.)
Gift of William T. Evans, 1912.3.3.G

PROVENANCE
Purchased by William T. Evans from Macbeth
Gallery, New York, February 1912.

EXHIBITION HISTORY
New York, Macbeth Gallery, 1912.
Boston, The Doll and Richards Galleries, March
 1912.
New York, American Federation of Arts,
 traveling exhibition, *Thirty Paintings by
 Contemporary American Artists*, 31 August–
 8 September 1923, shown in Detroit, Michigan
 Art Institute; Nashville, Tenn.; Kansas City,
 Mo.; Peoria, Ill.; Memphis, Tenn.; Lincoln,
 Neb.; Clay Center, Kans.; New Orleans, La.
Richmond, Virginia Museum of Fine Arts, *The
 Main Currents in the Development of American
 Painting*, 16 January–1 March 1936, p. 29, cat.
 no. 59.
Charlotte, N.C., The Mint Museum of Art,
 22 October–31 December 1936.
New York, The American Academy of Arts and
 Letters, *Exhibition of the Works of Elihu Vedder*,
 12 November 1937–3 April 1938, cat. no. 113.
Washington, D.C., Howard University Gallery of
 Art, *Exhibition of Christian Art*, 12 November–
 23 December 1940.
Washington, D.C., National Collection of Fine
 Arts (now NMAA), *Turn-of-the-Century Paintings
 from the William T. Evans Collection*, 23 April–
 1 June 1959.
Billings, Mont., Yellowstone Art Center, *Inaugural
 Exhibition*, 18 October–20 November 1964.
New York, IBM Gallery, *Portrait of America:
 1865–1915*, 16 January–25 February 1967, cat.
 no. 26.
Berkeley, Calif., University Art Museum, *The
 Hand and the Spirit: Religious Art in America,
 1700–1900*, 28 June–27 August 1972,
 pp. 168–69 (illus.), cat. no. 114 (then to
 Washington, D.C., National Collection of Fine
 Arts [now NMAA]; Dallas [Tex.] Museum of
 Fine Arts; Indianapolis [Ind.] Museum of Art).
Washington, D.C., National Collection of Fine
 Arts (now NMAA), *Perceptions and Evocations:
 The Art of Elihu Vedder*, 13 October 1978–
 4 February 1979, pp. 114, 142, fig. 137 (then to
 The Brooklyn [N.Y.] Museum).

REFERENCES
Regina Soria, *Elihu Vedder: American Visionary
 Artist in Rome (1836–1923)* (Rutherford, N.J.,
 1970), pp. 194, 333, cat. no. 438 (illus. no. 32).
Theodore E. Stebbins, Jr., et al., *A New World:
 Masterpieces of American Painting, 1760–1910*,
 exh. cat. (Boston, 1983), pp. 301–3.

COMMENTS
A second version of the painting is in the Virginia
Museum of Fine Arts, Richmond. Anita Vedder,
the artist's daughter, explained the relationship
of the two versions in a letter of 21 May 1912 (see
Soria above).

> The picture of "The Cup of Death" bought by Mr.
> Evans [now in NMAA] was the original one painted.
> It was, however, left unfinished. The sombre tints
> which were intentional looked so dull against the studio
> walls of gray-green, that my father took a dislike to
> the picture, laid out another and repainted it entirely
> with another coloring more brilliant and rich. The
> copyright of this painting was got in 1887. The
> picture was bought, when exhibited in Boston, by Miss
> Susan Minns [now in Richmond]. The original picture
> remained always unfinished till 3 years ago we changed
> houses and for lack of other space was hung in our
> drawing room which has a pale pink tint. The tint of
> the room was a despair. But by a strange coincidence
> this picture looked remarkably well and the low gray
> tones with the contrast of the wall harmonized
> charmingly. My father became at once interested in it
> again, it was taken down and he finished it with
> pleasure. A new copyright was taken out on this
> picture in 1911 as there were slight differences in the
> drapery, and to protect the first copyright.

BIOGRAPHY
Born 26 February 1836, New York. 1844–49, in
Cuba with his family. 1854–55, studied painting
with Tompkins Harrison Matteson, Shelbourne,
N.Y. 1855–60, to Europe; studied painting at
Atelier Picot, Paris, and with Raffaello Bonaiuti,
Florence. Met *I Macchiaioli* (experimental Italian
artists), the Brownings, and other members of the
Anglo-American community in Florence. 1861,
New York. 1863, exhibited at National Academy
of Design, New York. 1865, elected academician,
National Academy. Met William Morris Hunt
and John La Farge. 1865, France. 1869, married
Elizabeth Caroline Beach Rosekrans, Glens Falls,
N.Y.; settled in Rome. 1872, son Alexander died.
1875, son Phillip died. 1876, London; met Pre-
Raphaelite artists George Watts and Edward
Burne-Jones; visited William Blake exhibit.
Idealization of form in his art dates from this

time. 1877–78, exhibited in International
Exhibition, Paris. 1879, New York; met architect
Stanford White, who obtained design commissions
for him. 1883, began illustrations for the *Rubáiyát*;
published 1884. 1889–90, visited Egypt. 1892,
commissioned to paint mural, Walker Art
Gallery, Bowdoin College, Maine. 1895, murals
for new Library of Congress. 1901, major
exhibition, Art Institute of Chicago. 1909, death
of wife. 1910, *Digressions of V* (autobiographical
sketches) published. Died 29 January 1923, Rome.

*

In addition to *The Cup of Death*, Vedder is
represented by two oils in the NMAA, a tiny *Monks
on the Appian Way* and the 1860 landscape *Volterra*.
There are also the magnificent drawings for *The
Rubáiyát of Omar Khayyám*, done in 1883–84 for a
publication by Houghton Mifflin. These brought
long-overdue fame to Vedder, and they are
collectively one of the jewels of the museum.
 Vedder had gone to Europe in 1856 at the age of
twenty and settled in Florence. There he became
associated with a group of young Italian artists,
later known as the *Macchiaioli*, who often gathered
at the Café Michelangelo. Painting in the open air,
these men developed a style in which flat patches of
color took precedence over drawing. The mood of
their paintings was, as a rule, consistently tranquil
and sunny. In 1860, toward the end of this Italian
sojourn, Vedder went on a sketching trip to
Volterra. While his previous landscapes had
accorded well with those of his Italian friends, his
paintings of the primal, volcanic landscape have an
intense, otherworldly appearance that marks them
as among the first thoroughly characteristic
examples of his art. His simplified treatment of the

Vedder, *Monks on the Appian Way*, ca. 1865, oil on
canvas, 8.3 × 21.6 cm (3¼ × 5 in.). Bequest of
Eleanor Kotz, 1976.29.1

facets of the earth's outcroppings, lying powerfully below the horizon, forcefully stamps the scene upon the mind's eye.

Of his fifty-six full-page illustrations for *The Rubáiyát*, one of the most potent is *Limitation*, inspired by the bleak verses 75 and 76, beginning with "The Moving Finger writes; and, having writ,/Moves on." The chained eagle is placed against a field of "stars bound together with their courses rigidly defined through space" (Vedder).

Vedder often blended Christian iconography with Omar's nihilism in a personal and curious manner. In another work, the figure called "the Magdalen" shrinks inward beneath the angry and very un-Christian verse above her: "Thou wilt not with Predestin'd Evil round/Enmesh, and then impute my Fall to Sin!" The despair that courses through the drawings – which are accompaniments to the verses, "parallel but not identical in thought" – was in considerable part an expression of the deep depression that followed the death of Vedder's eldest son, Philip, in 1875. But he had been a devotee of *The Rubáiyát* since 1871, when a friend had first read the verses to him while "in the grateful shade, out of an Etruscan cup, many were the libations of good wine poured on the thirsty earth, to go below and quench the fire of anguish in old Omar's eyes. Thus was the seed of Omar planted in a soil peculiarly adapted to its growth."

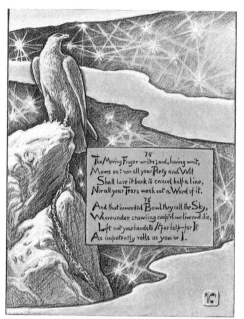

Vedder, *Limitation* (illustration for *The Rubáiyát of Omar Khayyám*), 1883–84, chalk, pencil, and watercolor on paper, 33.8 × 26.6 cm (13$\frac{5}{16}$ × 10$\frac{1}{2}$ in.). Gift of Elizabeth W. Henderson and museum purchase, 1978.108.38

Vedder, *Volterra*, 1860, oil on canvas, 31.1 × 64.9 cm (12$\frac{1}{4}$ × 25$\frac{1}{2}$ in.). Museum purchase, 1977.105

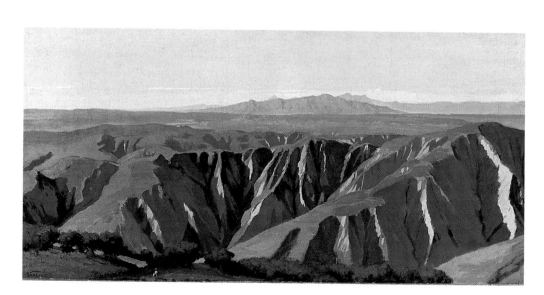

Kenyon Cox
An Eclogue 1890
signed lower left: *KENYON COX 1890*
oil on canvas, 122.5 × 153.6 cm (48 × 60$\frac{1}{2}$ in.)
Gift of Allyn Cox, 1959.10.1

PROVENANCE
The artist; Allyn Cox (his son), New York.

EXHIBITION HISTORY
New York, *Twelfth Exhibition of the Society of American Artists*, 1890, cat. no. 49.
New York, *Fourteenth Exhibition of the Society of American Artists*, 1892, cat. no. 64.
Chicago, Columbian Exposition, 1893, cat. no. 297 (medal).
Buffalo, N.Y., Pan-American Exposition, 1901, cat. no. 746.
Washington, D.C., National Collection of Fine Arts (now NMAA), *Academy*, 1975, cat. no. 55, p. 168 (illus.).

COMMENTS
The model for the seated figure with the auburn hair was Judy Baird, who also served as the model for Augustus Saint-Gaudens's *Diana* (see p. 214).

BIOGRAPHY
Born 27 October 1856, Warren, Ohio. Studied at McMicken Art School, Cincinnati, 1870–73, under Frank Duveneck. Visited Philadelphia Centennial and enrolled in Pennsylvania Academy of the Fine Arts, 1876. Paris, 1877–82, in studios of Carolus-Duran and, at the Ecole des Beaux-Arts, Cabanel and Gérôme. Exhibited at Paris Salon, 1879 and 1882. Returned to New York, 1883. Taught at Art Students League, 1884–1909. Illustrated Rossetti's "Blessed Damozel," 1886. Married painter Louise Howland King, 1892. Created murals for World's Columbian Exposition, Chicago, 1893. From 1896, painted numerous murals for, among others, Library of Congress; Walker Art Building, Bowdoin College, Maine; Minnesota State Capitol; Wisconsin State Capitol; Appelate Court House, New York; Iowa State Capitol. Member of Society of American Artists; elected associate of National Academy of Design in 1900, full member 1903. Awarded medals at Universal Expositions of 1889 and 1900. Medal of Honor for mural painting from Architectural League of New York, 1910. Published numerous articles and books, notably *The Classic Point of View*, 1911. Member, American Academy of Arts and Letters. Died 17 March 1919, New York City.

Augustus Saint-Gaudens
Violet Sargent 1890
signed and dated lower left in cartouche on seat:
A.S'.G./MDCCCLXXX FECIT
bronze, 126.9 × 86.4 cm (50 × 34 in.)
Gift of Mrs. John L. Hughes, 1970.39

EXHIBITION HISTORY
Brooklyn, N.Y., Brooklyn Museum, *The American Renaissance, 1876–1917*, 13 October–30 November 1980, cat. no. 259 (then to Washington, D.C., National Collection of Fine Arts [now NMAA]; San Francisco, Calif., The Fine Arts Museums of San Francisco; The Denver [Colo.] Art Museum).
New York, The Metropolitan Museum of Art, *Augustus Saint-Gaudens: Master Sculptor*, 19 November 1985–26 January 1986.

REFERENCES
John Dryfhout and Beverly Cox, *Augustus Saint-Gaudens: The Portrait Reliefs* (Washington, D.C., 1969), cat. no. 43.
Donald Miller, "Inspired Friendship," *Carnegie Magazine* 53 (April 1979): 5–11.

COMMENTS
The relief was impressed lower right by the foundry: *JABOEUF ET BEZOUT FONDEURS.*

BIOGRAPHY
Born 1 March 1848, Dublin, Ireland, of a French father and Irish mother; September, due to Potato Famine, family emigrated to U.S., settling in New York. 1861, apprenticed to a French stone cameo-cutter in New York, then to a shell cameo-cutter until 1867. During this period, took drawing classes at Cooper Union and National Academy of Design, New York. February 1867, to France to see Paris Exposition. 1868, entered Ecole des Beaux-Arts as a pupil of François Jouffroy; supported himself as a cameo-cutter. 1870, due to Franco-Prussian War, left Paris for Rome, where he lived for five years. 1875, returned to U.S. following severe illness. Worked briefly as mural painter under John La Farge. Became friends with architects Stanford White and Charles McKim, through whom he received important commissions. 1876, commission for Admiral Farragut Monument for Madison Square, New York (plaster exhibited 1880, Paris Salon, honorable mention). 1877, founder of Society of American Artists; married Augusta F. Homer; settled in Paris until 1880. Returned to U.S.; established studio in New York and, in 1885, in

Cornish, N.H. 1888–97, taught at Art Students League, New York. 1891, completed *Adams Monument*, Rock Creek Cemetery, Washington, D.C.; 1892, *Diana* for Madison Square Garden Tower. 1897, unveiled *General John A. Logan* (Chicago) and Shaw Memorial (Boston). 1897–1900, lived and worked in France. 1900, Grand Prix, Paris Salon; diagnosed as having cancer; returned to U.S. 1901, Gold Medal of Honor, Pan-American Exposition, Buffalo. 1904, Gold Medal of Honor, Universal Exposition, St. Louis. Elected member of Royal Academy, London, and French Legion of Honor. 1904, fire destroyed studio at Cornish. Died 3 August 1907, Cornish, N.H.

Saint-Gaudens, *Robert Louis Stevenson*, 1887 (modeled) and 1899 (cast), bronze mounted on wood, 27.7 × 44.5 × 2.2 cm (10⅞ × 17½ × ⅞ in.). Gift of the estate of Olin Dows, 1983.90.201

The sculpture collection of the NMAA includes eleven works by Saint-Gaudens, certainly the most famous American sculptor of his generation. Of these, the small relief portrait of Robert Louis Stevenson is especially memorable for its wistful charm. The relief is the first of several versions, and only three copies of it are known. It was replicated through the electrotype process, in which copper is deposited on a metal mold through galvanic action. Introduced by their mutual friend Will H. Low in the autumn of 1887, Stevenson and the sculptor quickly became fast friends. The portrait was made at the artist's request, and the finished relief was sent to Stevenson some years later. Although they never saw one another again after Stevenson's departure for Samoa in mid-1888, Saint-Gaudens wrote to Low, "My episode with Stevenson has been one of the events of my life. . . . I am in a beatific state."

Stevenson's battle with tuberculosis had begun about 1881, and in the relief he is depicted as an invalid, sitting up in bed with a book propped against his knees and a cigarette in his right hand. The delicacy of the modeling and the rhythmic grace of the folds of the bedclothes and curves of the pillows express the poet's fragile health. His sensitive head is placed in the corner of the upper part of the small panel, balanced by the rising figure of Pegasus and confronting blocks of verse from the poem "Underwoods," which he had just written and dedicated to Low. Infused with nostalgia, like the image of the poet himself, the verse concludes: "Where hath fleeting beauty

led/To the doorway of the dead/Life is over Life was gay/We have come the primrose way." Stevenson died in Samoa in 1894, aged forty-four.

The museum's bronze statuette of *Diana* reflects one of the artist's most ambitious and admired projects. In 1891, Saint-Gaudens finished a gigantic figure of the goddess, made of beaten copper, to serve as a weathervane atop the tower of Stanford White's new Madison Square Garden. The latter emulated a building in Seville, Spain, and Saint-Gaudens took his inspiration from a weathervane on the same structure. Poised in perfect balance on one toe, the one-ton, 18-foot goddess turned easily in the wind. Although 300 feet above the street, as soon as she was in place, both sculptor and architect realized the figure was too large. While Saint-Gaudens began work on a thirteen-foot version, the original was sent to Chicago to stand atop the Agricultural Building at the World's Columbian Exposition of 1893. ("When she arrived," declared the Chicago *Tribune*, "thousands blushed.") The second *Diana* was put in place 18 November 1893 and became a symbol of New York's Gilded Age. When the Garden was demolished in 1925, *Diana* went into storage until purchased by the Philadelphia Museum of Art in 1932.

The NMAA bronze, almost 25 inches high, is in fact a cast of the initial plaster study (now lost, but known through a photograph) for the first version of the *Diana*, which Saint-Gaudens evolved between 1886 and 1891. It differs from the second version in the inclusion of the crescent moon in the hair and in the greater torsion and more vigorous contours of the body. Above all, the process of creation is strikingly evident in the sketchy, active modeling of the surface. Significantly, this important study belonged to Stanford White before its acquisition by John Gellatly.

The plaster head of *Victory* (or *NIKH-EIPHNH*, as it is inscribed) was the second study (1902) for the head of the allegorical figure of the Sherman Monument. With the exception of the Shaw Memorial, Boston, no work preoccupied Saint-Gaudens for a longer period of time than the Sherman Monument, now at Grand Army Plaza, Fifth Avenue and Central Park South, New York. For ten years in studios in Cornish, New Hampshire, and Paris, he continued to work at and alter his tribute to General William Tecumseh Sherman, a man he knew and deeply admired. Although he occasionally professed embarrassment at his slowness in completing such commissions, he excused it by observing that "a sculptor's work

endures for so long that it is next to a crime for him to neglect to do everything that lies in his power to execute a result that will not be a disgrace. There is something extraordinarily irritating, when it is not ludicrous, in a bad statue."

The equestrian figure of Sherman, often considered the finest American example of this genre, seems to have given Saint-Gaudens relatively little trouble, at least in conception. In contrast, the ideal figure of Victory, which he elected to place at the forefront of his group, caused him continuing dissatisfaction. The inclusion of this figure displeased his friend Henry James, who wrote an otherwise laudatory article on the work for the *North American Review*. In a letter to James, the sculptor attempted to defend "the figure of Victory, Liberty, Peace (and what not besides I meant therein)."

It is because I feel so strongly the damnation of the whole business of war, that I made it, the very reason for which you want it otherwise! And there we are. Your reasons I am sure are better than mine, but, to paraphrase what Stevenson wrote in a book he gave me, "Each of us must have our way/You with ink and I with clay."

Saint-Gaudens's sincere passion for this figure explains the fact that as late as 1902, after a plaster version of the monument had already been exhibited, he created a second head. The model was Alice Butler of Windsor, Vermont. The strength of her features accorded well with the recently simplified forms of the equestrian group. Still, according to Homer Saint-Gaudens, the artist's son, the second head was not used for the final work, although the profile "was later reproduced in relief as the model for the new cent and the ten-dollar coin." The noble face, expressing sorrow and aspiration at the same time, has a strong and perhaps not coincidental kinship with Eugène Delacroix's *Liberty Leading the People* (1830), as does the entire finished figure on the monument.

These examples of Saint-Gaudens's sculpture, together with the relief of *Violet Sargent*, support the great reputation he enjoyed in his lifetime.

Saint-Gaudens, *Diana*, ca. 1891, bronze, 63.4 × 32 × 34.7 cm (24⅞ × 12⅝ × 13⅜ in.). Gift of John Gellatly, 1929.8.397

Saint-Gaudens, *Victory* (*NIKH-EIPHNH*), 1902, plaster, 22.9 × 12.7 × 12.7 cm (11 × 5 × 5 in.). Museum purchase, 1968.76

39

Richard La Barre Goodwin
Cabin-Door Still Life after 1886
signed, as if carved, lower left: *R. La Barre Goodwin*
oil on canvas, 142.7 × 86.6 cm ($56\frac{1}{4}$ × $34\frac{1}{8}$ in.)
Museum purchase in memory of the Reverend F. Ward Denys, 1970.41

PROVENANCE
Mr. Graham Williford, Fairfield, Tex.; Robert Schoelkopf Gallery, New York.

EXHIBITION HISTORY
Dallas, Tex., Dallas Museum of Fine Arts (dates not determined).

REFERENCES
Alfred Frankenstein, *After the Hunt* (Berkeley and Los Angeles, 1969).
————, *The Reality of Appearance: The Trompe l'Oeil Tradition in American Painting* (New York Graphic Society, 1970), pp. 128–30.

BIOGRAPHY
Born 26 March 1840, Albany, N.Y., son of a prolific portrait and miniature painter, Edwin Weyburn Goodwin. Studied in New York City, then worked for twenty-five years (from 1862) as itinerant portrait painter in New York State. During 1880s in Syracuse, N.Y. Began painting "cabin-door" still lifes around 1886; also painted landscapes. Early 1890s in Washington, D.C.; 1893–1900, Chicago; 1900–1902, Colorado Springs; 1902–6, California; 1906–8, Portland, Oreg.; 1908–10, Rochester, N.Y. Died 10 December 1910 in Orange, N.J.

40

Maria Oakey Dewing
Garden in May 1895
signed lower right: *Maria Oakey Dewing 1895*
oil on canvas, 60.1 × 82.5 cm ($23\frac{5}{8}$ × $32\frac{1}{2}$ in.)
Gift of John Gellatly, 1929.6.26

PROVENANCE
Milch Galleries, New York; John Gellatly, New York.

EXHIBITION HISTORY
New York, *Nineteenth Exhibition of the Society of American Artists*, 28 March–1 May 1897, cat. no. 276.
Buffalo, N.Y., Pan-American Exposition, *Exhibition of Fine Arts*, 1901, cat. no. 670 (as *The Rose Garden*, lent by John Gellatly).
Philadelphia, Pennsylvania Academy of the Fine Arts, *An Exhibition of Paintings by Maria Oakey Dewing*, 2–23 March 1907, cat. no. 2 (as *Rose Garden: Roses with Border of White Carnations*, lent by John Gellatly).
Washington, D.C., Corcoran Gallery of Art, *Second Exhibition, Oil Paintings by Contemporary American Artists*, 8 December 1908–17 January 1909, cat. no. 184.
Pittsburgh, Pa., Museum of Art, Carnegie Institute, *Thirteenth Annual Exhibition*, 29 April–30 June 1909, cat. no. 71.
Buffalo, N.Y., Buffalo Fine Arts Academy, Albright Art Gallery, *Fifth Annual Exhibition of Selected Paintings by American Artists*, 11 May–1 September 1910, cat. no. 70.
Philadelphia, Pennsylvania Academy of the Fine Arts, *The Pennsylvania Academy and Its Women, 1850 to 1920*, 3 May–16 June 1974, cat. no. 20, p. 35.
Windsor, Vt., Saint-Gaudens National Historic Site, *Exhibition of Cornish, N.H., Artists, 1885–1935*, 1 August–31 October 1976.
College Park, Md., University of Maryland Art Gallery, *Women Artists in Washington Collections*, 18 January–25 February 1979.
Montclair, N.J., Montclair Art Museum, *Down Garden Paths: The Floral Environment in American Art*, 1 October–30 November 1983.
New York, Whitney Museum of American Art, *Reflections of Nature: Flowers in American Art*, 1 March–20 May 1984.

REFERENCES
William H. Gerdts and Russell Burke, *American Still-Life Painting* (New York, 1971), pp. 88, 192.

Jennifer A. Martin, "The Rediscovery of Maria Oakey Dewing," *Feminist Art Journal* 5, no. 2 (Summer 1976): 24–27.
————, "Portraits of Flowers: The Out-of-Door Still-Life Paintings of Maria Oakey Dewing," *American Art Review* 4, no. 3 (December 1977): 48–55.
Charlotte Streifer Rubinstein, *American Women Artists* (Boston, 1982), pp. 141–43, figs. 4–30.
William H. Gerdts, *Down Garden Paths: The Floral Environment in American Art* (Cranbury, N.J., 1983), pp. 72–76.
Ella M. Foshay, *Reflections of Nature: Flowers in American Art* (New York, 1984), pp. 59–62.

COMMENTS
This work was painted out-of-doors in Cornish, N.H., where the artist had a summer house. Jennifer Martin identifies it with *Rose Garden: Roses with Border of White Carnations* in the 1907 Pennsylvania Academy exhibition.

BIOGRAPHY
Born Maria Richards Oakey, 27 October 1845, New York City. Probably in 1866, studied at Cooper Union School of Design for Women (New York) with William Rimmer and Robert Swain Gifford. From about 1867–69, studied at National Academy of Design, New York; also met and possibly studied with John La Farge. His flower paintings may have influenced her to specialize in this genre, for prior to 1881 she painted more portraits and figure paintings than still lifes. May have studied with William Morris Hunt in Boston during early 1870s. 1875, exhibited at Cottier and Company, New York. 1876, first trip to Europe, where she studied with Thomas Couture at Villiers-le-Bel, France; visited Italy and England. 1878, exhibited at the first exhibition of Society of American Artists. Showed regularly at National Academy of Design. Married Thomas Wilmer Dewing (see p. 82), 18 April 1881; lived in New York. After birth of daughter (1885), painted less frequently, though she collaborated with her husband, completing floral settings for his figures. From 1885 to early 1900s, spent summers in Cornish, N.H., art colony. 1907, one-woman show at Pennsylvania Academy of the Fine Arts. 1914, one-woman show at Knoedler & Co., New York. Died 13 December 1927, New York.

John Henry Twachtman
Round Hill Road ca. 1890–1900
signed lower right: *J H Twachtman*
oil on canvas, 76.8 × 76.2 cm (30¼ × 30 in.)
Gift of William T. Evans, 1909.7.64

PROVENANCE
The artist's wife; sold through Silas S. Dustin to
William T. Evans.

EXHIBITION HISTORY
Washington, D.C., National Gallery of Art (now
NMAA), *Catalogue of Paintings and Other Art
Objects Exhibited on the Occasion of the Opening of
the National Gallery of Art in the New Building of
the United States National Museum*, 17 March
1910, cat. no. 20.
New York, American Federation of Arts,
traveling exhibition, *Thirty Paintings by
Contemporary American Artists*, 1923, shown in:
Detroit, Michigan Art Institute; Nashville,
Tenn.; Kansas City, Mo.; Peoria, Ill.;
Memphis, Tenn.; Lincoln, Neb.; Clay Center,
Kans.; New Orleans, La.
Washington, D.C., National Collection of Fine
Arts (now NMAA), *Turn-of-the-Century Paintings
from the William T. Evans Collection*, 23 April–
1 June 1959.
Washington, D.C., The White House, 2 July
1959–19 January 1961.
New York, American Federation of Arts,
traveling exhibition, *American Impressionists: Two
Generations*, October 1963–May 1964, cat. no. 37.
Cincinnati, Ohio, Cincinnati Art Museum, *John
H. Twachtman*, 7 October–20 November 1966,
cat. no. 82.
Washington, D.C., The White House, 23 April
1968–1969.

REFERENCES
John Douglass Hale, "The Life and Creative
Development of John H. Twachtman" (Ph.D.
diss., Ohio State University, 1957), p. 567, no.
515 (illus. p. 370).

COMMENTS
Hale dates this painting 1890–1900, in
Twachtman's so-called Greenwich Period.

BIOGRAPHY
Born 4 August 1853, Cincinnati, Ohio. 1868–71,
attended evening drawing classes at Ohio
Mechanics Institute. 1871–74, studied at
McMicken School of Design; last year with Frank
Duveneck. 1875, studied privately with
Duveneck and traveled to Munich with him;
studied at Akademie der Bildenden Künste with
Ludwig von Löfftz, until 1878. 1877, to Venice
with Duveneck and William Merritt Chase. 1878,
returned to U.S. Included in first exhibition,
Society of American Artists, New York. 1879,
member, Society of American Artists. 1880,
taught at Duveneck's art school, Florence. 1881,
traveled to Netherlands with J. Alden Weir.
1883–85, lived in Paris; studied with G.R.C.
Boulanger and J.J. Lefebvre at Académie Julian.
1885, returned to U.S. 1886–87, Chicago. 1888,
settled in Greenwich, Conn. 1893, exhibited at
American Art Galleries, New York, with Monet,
Weir, and Paul-Albert Besnard. From 1893,
taught at Art Students League, New York; from
1894, at Cooper Union. 1893, Silver Medal,
World's Columbian Exposition, Chicago. 1894,
Temple Gold Medal, annual exhibition of
Pennsylvania Academy of the Fine Arts. 1898, co-
founder, with Weir and Childe Hassam, of The
Ten American Painters. 1900, exhibited with his
son, J. Alden Twachtman, at Cincinnati Art
Museum. 1901, one-man shows, Durand-Ruel
Galleries, New York, and Cincinnati Art
Museum. Died 8 August 1902, Gloucester, Mass.

*

John Twachtman's early death at forty-nine
deprived us of an artist whose work combined the
wistful mood of the *fin-de-siècle* and the impulse
toward abstraction of early modernism. Although
usually classed as an American Impressionist and
also linked to the delicate spirits of J. Alden Weir
and Thomas Dewing, Twachtman may have had

greater potential than any of these categories suggests.

His ten oils in the NMAA were all painted between 1890 and his death in 1902, and all were collected by John Gellatly and William T. Evans. Their taste for the gentle aestheticism and inwardness of those years is manifested by the large number of paintings by Dewing, Weir, Thayer, Inness, and Hassam that they bequeathed to the museum.

Twachtman infrequently dated his paintings, and their chronology on the whole is unclear, particularly since his style does not display distinctive shifts in the 1890s. Thus, *End of Winter* is only datable "after 1889." It is one of the artist's loveliest and, despite the muted palette, most varied winter scenes. The composition is subtle, featuring the delicate network of barren trees, receding diagonal of the brook, and stabilizing anchor of farm buildings at the horizon. The palette is enchanting, its blended strokes ranging from yellow and cream to gray and violet, with touches of pale green. With brook water flowing from the thaw, while snow and ice still lie on the banks, the painting is redolent of approaching spring.

Twachtman's *Niagara Falls* (ca. 1894) is an interesting contrast to the views by Alvan Fisher and George Inness (see pp. 30 and 80). The panoramic spectacle of the former and the hazy meditation of the latter are supplanted by the splashing immediacy of Twachtman's position at the base of the waterfall. A torrent pours over the lip of the cliff at the top of the picture and strikes the rocks only a few feet away from the viewer. The artist's paint-laden brush splatters the canvas in emulation of the spray of water. Unusually messy for the fastidious Twachtman, the painting is also uncommonly colorful, culminating in the intense lilac of the cliff and rocks. The color is his excited response to the turmoil of the falls; it is expressive, not descriptive.

The popularity of Gloucester, Mass., with many landscape painters of the nineteenth century was due to the special quality of light there. But in *Fishing Boats at Gloucester* (1901), Twachtman seems less interested in light than the complexity of his motif. The picture is almost startlingly dense in the context of his art. The diagonal sweep of the dock compresses the space and bundles the boats and boat houses into a tight, but deftly constructed, unit. Strong accents of dark purple articulate the pink-and-mauve palette. Although the sky is restricted to a small area, it is full of weather, and in it Twachtman again reveals his sensitivity to a particular place, season, and atmosphere.

Twachtman, *End of Winter*, after 1889, oil on canvas, 55.8 × 76.3 cm (22 × 30⅛ in.). Gift of William T. Evans, 1909.7.65

Twachtman, *Fishing Boats at Gloucester*, 1901, oil on canvas, 63.7 × 76.7 cm (25⅛ × 30¼ in.). Gift of William T. Evans, 1909.9.5

Twachtman, *Niagara Falls*, ca. 1894, oil on canvas, 76.1 × 63.7 cm (30 × 25⅛ in.). Gift of John Gellatly, 1929.6.142

Winslow Homer
High Cliff, Coast of Maine, 1894
signed twice at lower right: *HOMER*, in black; and *HOMER 1894*, in red on a canvas patch
oil on canvas, 76.5 × 97 cm (30⅛ × 38¼ in.)
Gift of William T. Evans, 1909.7.29

PROVENANCE
Sold by the artist to M. Knoedler & Co., 1903; purchased by William T. Evans, New York, 1903.

EXHIBITION HISTORY
Pittsburgh, Carnegie Institute, *Pittsburgh International Exhibition*, 7 November 1901– 1 January 1902, cat. no. 111 (illus.).
New York, The Union League Club, *Paintings by American Artists from the Collection of William T. Evans*, 10–12 December 1903, no. 18.
Montclair, N.J., Wentworth Manor, *American Paintings, Collection of William T. Evans*, July 1904, no. 73.
New York, National Arts Club, *American Paintings from the Collection of William T. Evans*, 8–18 November 1906, no. 23.
Philadelphia, Pennsylvania Academy of the Fine Arts, *102nd Annual Exhibition*, 21 January– 24 February 1907, no. 109.
Pittsburgh, Carnegie Institute, *Pittsburgh International Exhibition*, 11 April–13 June 1907, no. 223.
Pittsburgh, Carnegie Institute, *Pittsburgh International Exhibition*, 13 April–13 June 1908, no. 159 (illus.).
Washington, D.C., Corcoran Gallery of Art (on loan), 1909.
Washington, D.C., National Gallery of Art (now NMAA), *Catalogue of Paintings and Other Art Objects Exhibited on the Occasion of the Opening of the National Gallery of Art in the New Building of the United States National Museum*, 17 March 1910, no. 32.
New York, National Academy of Design, *Winter Exhibition*, 10 December 1910–8 January 1911, no. 215.
New York, Lotus Club, April 1912.
San Francisco, M.H. de Young Memorial Museum, *Exhibition of American Paintings*, 7 June–7 July 1935, no. 122.
Richmond, Virginia Museum of Fine Arts, *The Main Currents in the Development of American Painting*, 16 January–1 March 1936, cat. no. 57, pl. 57 (then to Washington, D.C., Corcoran Gallery of Art).

New York, Whitney Museum of American Art, *Winslow Homer Centenary Exhibition,* 15 December 1936–15 January 1937, cat. no. 28.

Pittsburgh, Carnegie Institute, *Centenary Exhibition of Works of Winslow Homer,* 28 January–7 March 1937, cat. no. 38.

Washington, D.C., National Gallery of Art (on loan), 15 May 1943–24 September 1957; 2 July 1958–7 January 1959; 30 March–3 April 1959; 10 November 1959–21 November 1960; 31 July 1961–21 February 1965 (?); 17 May 1962–10 April 1963; 16 April–17 September 1964; 3 December 1964–3 April 1966.

Pittsburgh, Carnegie Institute, *American Classics of the Nineteenth Century,* 18 October–1 December 1957 (then to, Utica, N.Y., Munson-Williams-Proctor Institute; Richmond, The Virginia Museum of Fine Arts; Baltimore [Md.] Museum of Art; Manchester, N.H., Currier Gallery of Art).

Washington, D.C., National Gallery of Art, *Winslow Homer,* 23 November 1958–4 January 1959, cat. no. 64 (then to New York, The Metropolitan Museum of Art, 29 January–8 March 1959).

Washington, D.C., National Collection of Fine Arts (now NMAA), *Turn-of-the-Century Paintings from the William T. Evans Collection,* 23 April–1 June 1959, p. 4.

Moscow, *American Painting and Sculpture* (USIA), 25 July–5 September 1959.

Toronto, The Art Gallery of Toronto, *American Painting 1865–1905,* 6 January–5 February 1961, cat. no. 37 (then to Winnipeg, Winnipeg Art Gallery Association; Vancouver, Vancouver Art Gallery; New York, Whitney Museum of American Art).

Waterville, Maine, Colby College Art Museum, *Maine and Its Artists 1710–1963,* 4 May–31 August 1963, cat. no. 62, p. 23 (illus.; then to Portland [Maine] Museum of Art; Boston, Museum of Fine Arts; New York, Whitney Museum of American Art).

Richmond, The Virginia Museum of Fine Arts, *Homer and the Sea,* Fall 1964, cat. no. 38.

Washington, D.C., National Collection of Fine Arts (now NMAA), *American Landscape: A Changing Frontier,* 28 April–19 June 1966, pl. 14.

Brunswick, Maine, Bowdoin College Museum of Art, *Winslow Homer at Prout's Neck,* 8 July–4 September 1966, cat. no. 32, pl. 32.

New York, IBM Gallery, *Portrait of America: 1865–1915,* 16 January–25 February 1967, cat. no. 10.

New York, Whitney Museum of American Art, *Winslow Homer,* 3 April–3 June 1973, cat. no. 57.

REFERENCES

Leila Mechlin, "Winslow Homer," *International Studio* 34 (June 1908): 133, 135 (illus.).

William H. Downes, *The Life and Works of Winslow Homer* (New York, 1911), pp. 9, 114, 170, 172, 215–17, 229, 232 (illus. opp. p. 190).

Lloyd Goodrich, *Winslow Homer* (New York, 1944), pp. 135, 153, 172, 175–76, 187.

———, *Winslow Homer* (New York, 1959), pl. 63.

Albert T. Gardner, *Winslow Homer* (New York, 1961), pp. 208, 241, 243.

Philip C. Beam, *Winslow Homer at Prout's Neck* (Boston, 1966), pp. 122–23, 125 (illus.).

COMMENTS

In her conservation report of December 1966 (curatorial files), Caroline C. Keck wrote: "There is every indication that [*High Cliff*] has been cut down along the right edge." She suggested that the signature patch was moved from the excised strip and that many passages in the sea and sky were reworked by the artist at a slightly later date than the initial execution.

BIOGRAPHY

Born 24 February 1836, Boston. 1854 or 1855, apprenticed to a Boston lithographer, J.H. Bufford. 1857, free-lance illustration. Contributed first drawing to *Harper's Weekly;* continued to draw for *Harper's* until 1875. 1859, moved to New York. 1859–61, studied at a drawing school in Brooklyn, then at National Academy of Design night school. 1861, visited Washington to cover Lincoln's inauguration and Army of the Potomac camped nearby; studied painting briefly with Frederick Rondel. 1862, accompanied the Peninsular Campaign in Virginia; painted first oils. 1863–65, Civil War illustrations and paintings; made some trips to the front. 1864, began painting rural subjects. 1864, elected associate, National Academy; 1865, elected academician. 1866, painted *Prisoners from the Front,* which he took to France late that year; it and one other work exhibited at Exposition Universelle, 1867. Late 1867, returned to New York. 1868–74, pursued dual career as illustrator and painter; often summered in White Mountains or Adirondacks. 1873, first series of watercolors, Gloucester, Mass. Spring 1881, to England; settled at Tynemouth on North Sea. May have returned to U.S. winter 1881–82, but was in England again by spring 1882. Returned to U.S. November 1882. Summer 1883, settled permanently in Prout's Neck, Maine. 1884,

traveled with a fishing fleet, which provided inspiration for many pictures. Winter 1884–85, first trip to Nassau and the Bahamas. From then until 1904, often wintered there or in Florida; spent summers and early falls in Adirondacks. Watercolors became increasingly important in his work. 1906, suffered long illness; May 1908, paralytic stroke. Produced no new works from fall 1905 to fall 1908; last works in 1909. Died 29 September 1910, Prout's Neck.

43

William Robinson Leigh
Sophie Hunter Colston 1896
signed and dated bottom left: *W.R. Leigh/1896*
oil on canvas, 183.8 × 103.9 cm ($72\frac{3}{8} \times 40\frac{7}{8}$ in.)
Museum purchase, 1983.6

PROVENANCE

The sitter, Sophie Hunter Colston (later Mrs. W.B. Cornwell); to her sister, Susan Colston; to her nephew, William Colston Trapnell; to his daughter, Nancy Trapnell Holmes.

BIOGRAPHY

Born 23 September 1866, Berkeley County, W.Va. Son of impoverished southern aristocrats. Privately educated. 1880–83, studied art with Hugh Newell at Maryland Institute, Baltimore. 1883–96 in Munich, where he studied at the Royal Academy, 1883–84; with Nicolas Gysis, 1885–86; with Ludwig von Löfftz, 1887; with Lindenschmit, 1891–92. 1891–96, produced six cycloramas. 1896, returned to New York. Illustrator for *Collier's* and *Scribner's.* Painted landscapes, portraits, and animal and figure compositions; little success. 1906, Santa Fe Railroad provided free transportation to the West in exchange for a painting; commissioned five more. Made a sketching trip through Arizona and New Mexico; most of career then devoted to depicting the West in all aspects. 1926 and 1928, joined two expeditions to Africa with the American Museum of Natural History, New York, and painted African cycloramas for the museum. Wide recognition came only in the 1940s. Elected to National Academy of Design, New York, 1955. Died 11 March 1955, New York. Contents of studio, including more than five hundred oils, given to Gilcrease Institute, Tulsa, Okla.

John Singer Sargent
Elizabeth Winthrop Chanler (Mrs. John Jay Chapman) 1893
signed and dated upper right: *John S. Sargent 1893*
oil on canvas, 125.4 × 102.9 cm (49⅜ × 40½ in.)
Gift of Chanler A. Chapman, 1980.71

PROVENANCE
The sitter's sister, Margaret Chanler (later Mrs. Richard Aldrich); to the sitter's son, Chanler A. Chapman.

EXHIBITION HISTORY
London, Royal Academy, *Annual Exhibition*, 1894, no. 61.
New York, National Academy of Design, *Loan Exhibition of Portraits of Women*, 1894.
Philadelphia, Pennsylvania Academy of the Fine Arts, *Sixty-sixth Annual Exhibition*, 21 December 1896–22 February 1897, cat. no. 288.
Boston, Copley Hall, *Sargent Loan Exhibition*, 1899.
Washington, D.C., Corcoran Gallery of Art, *Sixth Exhibition of Oil Paintings by Contemporary American Artists*, 17 December 1916–21 January 1917, cat. no. 221.
Pittsburgh, Carnegie Institute, *Twentieth Annual International Exhibition of Paintings*, 28 April–30 June 1921, cat. no. 303.
New York, Grand Central Galleries, *Retrospective Exhibition of Important Works of John Singer Sargent*, 23 February–22 March 1924, cat. no. 43, p. 46 (illus.).

REFERENCES
William Howe Downes, *John S. Sargent, His Life and Work* (Boston, 1925), pp. 36–37, 169–70.
David McKibbin, *Sargent's Boston* (Boston, 1956), p. 88.

BIOGRAPHY
Born 12 January 1856, Florence, Italy. 1865, to London to meet father on return from U.S. 1868, Spain and Switzerland. 1868–69, Rome, studio of painter Carl Welsch. 1869–70, Florence; studied at Accademia delle Belle Art. 1871–72, Dresden. 1874, Venice, Normandy, and Paris; studied with Carolus-Duran until 1878. 1876, first visit to U.S. 1877, exhibited first painting at Paris Salon; 1878, honorable mention. Exhibited with Society of American Artists at National Academy of Design, New York. 1879, Spain; met Henry Adams. 1880–83, in Morocco, Holland, Venice, London, Paris. 1884, exhibited *Mme. Gautreau (Mme. X)* at Salon; subsequent scandal resulted in move to London. 1885, took Whistler's old studio, which became his permanent residence. From 1887 on, exhibited at Royal Academy of Arts. 1887–88, to U.S., where he painted portraits of Mrs. Jack (Isabella Stewart) Gardner and other sitters in Boston and Newport. 1888, first Boston exhibition at St. Botolph Club. 1888–89, England with family. 1889, awarded Medal of Honor, Exposition Universelle, Paris; made Chevalier of Legion of Honor (officer, 1897). 1890, founding member, Société Nationale des Beaux-Arts, Paris; commissioned to paint murals for Boston Public Library (not completed until 1916). 1891, elected associate, National Academy of Design; academician, 1897. 1893, sent nine paintings to Chicago World's Fair. 1894, elected associate, Royal Academy of Arts; 1897, academician. 1899, one-man show, Copley Galleries, Boston. 1900, Medal of Honor, Exposition Universelle. 1901, visited Norway. 1907, awarded Gold Medal, Venice Biennale. 1909, given Ordre pour le mérite and Order of Leopold of Belgium. 1914, Gold Medal in Painting, National Institute of Arts and Letters and American Academy of Arts and Letters, New York. 1915, exhibited at Panama-Pacific Exhibition, San Francisco. 1916, began rotunda decorations for Boston Museum of Fine Arts (installed 1921). Essentially ceased painting portraits. 1918, official artist for Imperial War Museum, London. 1922, painted murals in Widener Library, Harvard University, Cambridge, Mass. 1924, retrospective, Grand Central Art Galleries, New York. Died 15 April 1925, London.

Cecilia Beaux
Man with the Cat (Henry Sturgis Drinker) 1898
signed lower right: *Cecilia Beaux*
oil on canvas, 121.9 × 87.8 cm (48 × 34⅝ in.)
Bequest of Henry Ward Ranger through the National Academy of Design, 1952.10.1

PROVENANCE
National Academy of Design, New York, 1927; assigned to the Brooklyn Institute of Arts and Sciences, New York, 18 May 1927; recalled according to terms of the bequest of Henry Ward Ranger and accepted by the Smithsonian Art Commission, 1952.

EXHIBITION HISTORY
New York, Society of American Artists, *Annual Exhibition*, 1900.
New York, Durand-Ruel Galleries, *Exhibition of Paintings by Cecilia Beaux*, 3–14 March 1903, no. 5.
Philadelphia, Pennsylvania Academy of the Fine Arts, *The 101st Annual Exhibition*, 22 January–3 March 1906, p. 31, no. 321.
New York, American Academy of Arts and Letters, *Exhibition of Paintings by Cecilia Beaux*, 1935, p. 14, no. 14.
Philadelphia, Pennsylvania Academy of the Fine Arts, *The 133rd Exhibition*, 1938(?), cat. no. 226
New York, National Academy of Design Special Exhibition, 8 May–25 July 1939, no. 226.
Philadelphia, Pennsylvania Academy of the Fine Arts, *The 150th Anniversary Exhibition*, 15 January–3 March 1955, p. 89, no. 133, illus. p. 87 (later included in a selection from that exhibition for an eight-month USIA tour of Europe).
Ranger Centennial Exhibition and Traveling Show, shown at: New York, National Academy of Design, 2 December 1958–5 January 1959; Charlotte, N.C., The Mint Museum of Art, 12 January–2 February 1959; Bradenton, Fla., Art League of Manatee County, 22 February–13 March 1959; Charleston, S.C., Gibbes Art Gallery, 27 April–27 May 1959; Raleigh, North Carolina Museum of Art, 6 June–7 July 1959.
Philadelphia, Pennsylvania Academy of the Fine Arts, *Cecilia Beaux, Portrait of an Artist*, 1974–75, cat. no. 55, p. 95 (also shown at the Indianapolis [Ind.] Museum of Art).

REFERENCES
The Paintings and Drawings of Cecilia Beaux (Philadelphia, 1955), p. 47.

Frederick D. Hill, "Cecilia Beaux, The *Grande Dame* of American Portraiture," *Antiques*, January 1974, p. 165.

Barbara Whipple, "The Eloquence of Cecilia Beaux," *American Artist*, September 1974, p. 174.

Elizabeth Graham Bailey, "Cecilia Beaux: Background with a Figure," *Art & Antiques*, March/April 1980, pp. 59, 60 (illus.).

COMMENTS

The painting has also been called *At Home* and *Man in White*.

BIOGRAPHY

Born Philadelphia, 1855. Before 1872, studied drawing with Dutch artist Adolf van der Whelen. 1875, fossil drawings on commission from U.S. Geological Survey. 1877–79, studied Pennsylvania Academy of the Fine Arts. First exhibited 1879. 1888, studied at Académie Julian, Paris. Worked in Concarneaux, Brittany; traveled in Italy. 1889, returned to Philadelphia. 1893, elected to Society of American Artists. 1895–1915, taught at the Pennsylvania Academy of the Fine Arts. 1896, France and England; exhibited at Champs-de-Mars, Paris. 1898, Gold Medal of Honor from Pennsylvania Academy. From 1899, a prominent portrait artist with many distinguished commissions and exhibitions. Virtually ceased painting after 1930. 1935, largest lifetime exhibition, American Academy of Arts and Letters. Died 7 September 1942, Gloucester, Mass.

Mary Cassatt
The Caress 1902
signed lower right: *Mary Cassatt*
oil on canvas, 83.4 × 69.4 cm ($32\frac{7}{8} \times 27\frac{3}{8}$ in.)
Gift of William T. Evans, 1911.2.1

PROVENANCE

Durand-Ruel Galleries, New York; Mills and Gibbs, New York; William T. Evans.

EXHIBITION HISTORY

Chicago, Art Institute of Chicago, *Annual Exhibition*, 1904 (awarded the Norman Wait Harris prize of $500, which the artist refused; gave to an art student to study in Paris).

Cincinnati, Ohio, Cincinnati Art Museum, *11th Annual Exhibition of American Art*, 1904, cat. no. 1.

Philadelphia, Pennsylvania Academy of the Fine Arts, *Seventy-third Annual Exhibition*, 1904.

Washington, D.C., Corcoran Gallery of Art, *Second Annual Exhibition of Oil Paintings by Contemporary American Artists*, Spring 1909.

New York, Lotus Club, 1910.

New York, American Federation of Arts, traveling exhibition, 1920–21, shown in: Davenport, Iowa; Moline, Mich.; Syracuse, N.Y.; Memphis, Tenn.; Oklahoma City, Okla.; Jackson, Mich.; Ann Arbor, Mich.

New York, American Federation of Arts, traveling exhibition, *Pictures of Children*, 1921–22, shown in: Louisville, Ky.; Roanoke, Va.; Savannah, Ga.; Charleston, S.C.; Richmond, Va.; Norfolk, Va.

San Francisco, Calif., The M.H. de Young Memorial Museum, *Exhibition of American Paintings*, 7 June–7 July 1935, cat. no. 73.

Charlotte, N.C., The Mint Museum of Art, *Inaugural Exhibition*, 22 October–31 December 1936.

Chapel Hill, N.C., The University of North Carolina, 15 January–20 February 1937.

Savannah, Ga., Telfair Academy, *Survey of American Art*, 1937.

Washington, D.C., Howard University, *Exhibition of American Paintings*, 2 May–14 June 1938.

Chicago, Art Institute of Chicago, *Half a Century of American Art (1888–1939)*, 16 November 1939–7 January 1940, cat. no. 32, p.10.

Utica, N.Y., Munson-Williams-Proctor Institute, *Expatriates: Whistler, Cassatt, Sargent*, 4–25 January 1953.

Washington, D.C., Corcoran Gallery of Art, *Twenty-fifth Biennial Exhibition of Contemporary American Oil Paintings*, 13 January–10 March 1957.

Washington, D.C., National Collection of Fine

Arts (now NMAA), *Turn-of-the-Century Painting from the William T. Evans Collection*, 23 April–1 June 1959.

Moscow, *American Painting and Sculpture* (USIA), 25 July–5 September 1959.

Moscow, Pushkin Museum, 1960.

Baltimore, Md., Baltimore Museum of Art, *Manet, Degas, Berthe Morisot and Mary Cassatt*, 1962, cat. no. 118.

Tokyo and Nara, *The Art of Mary Cassatt*, 1981, cat. no. 37 (illus.).

Miami, Fla., Center for the Fine Arts, *In Quest of Excellence*, 12 January–22 April 1984.

REFERENCES

National Gallery of Art (now NMAA) Catalogues: 1916, p. 125; 1922, p. 33; 1926, p. 43.

BIOGRAPHY

Born 22 May 1844, Allegheny City, Pa., near Pittsburgh. 1851, family moved to Paris. 1853, family moved to Heidelberg, Germany, and later Darmstadt. 1855, returned to America, to West Chester, Pa.; 1858, to Philadelphia. 1861–65, enrolled at the Pennsylvania Academy of the Fine Arts. 1866, to Paris to study art, largely independently. 1870, outbreak of Franco-Prussian War, returned to Philadelphia. 1871, moved to Parma, Italy. 1872, first showing at the Paris Salon, as Mary Stevenson. 1873, traveled in Spain, Belgium, and Holland; settled permanently in Paris. Met Louisine Waldron Elder, later (1883) Mrs. H.O. Havemeyer, who became her friend and patron. 1877, introduced to Degas, who asked her to join the Impressionist group. Parents and a sister came to live with her. 1878, sent pictures to exhibitions in the U.S. 1879, participated in fourth Impressionist exhibition (and again in 1880, 1881, and 1886). Included in Durand-Ruel Impressionist shows in London (1883) and New York (1886). 1891, first one-woman show at Durand-Ruel, Paris. 1892, began work on mural commission for Woman's Building of 1893 Chicago World's Fair. 1895, large one-woman show at Durand-Ruel, New York. 1898, visited America for first time since 1871. 1899, returned to Paris. 1904, named Chevalier of the Legion of Honor. 1908, last visit to America. 1910–11, traveled with her family in Near East. Returned to Paris in March because of brother's illness; he died in April. Suffered physical and mental beakdown. 1913, last works in pastel. Eyesight failed; operations for cataracts, 1915, 1917, 1919, 1921, the last leaving her almost blind. Died 14 June 1926 at her home, Château de Beaufresne.

Julian Alden Weir
Upland Pasture ca. 1905
signed lower left: *J. Alden Weir/Branchville*
oil on canvas, 101.2 × 127.6 cm (39⅞ × 50¼ in.)
Gift of William T. Evans, 1909.7.73

PROVENANCE
The artist; William T. Evans.

EXHIBITION HISTORY
Washington, D.C., Corcoran Gallery of Art, *Oil Paintings by Contemporary American Artists* (First Annual Exhibition), 1907, cat. no. 170.
Washington, D.C., National Gallery of Art (now NMAA), *Opening Exhibition of the National Gallery of Art*, 1910, p. 5.
New York, The Metropolitan Museum of Art, *J. Alden Weir Memorial Exhibition*, 17 March–20 April 1924, cat. no. 37, p. 6 (illus.).
New York, American Academy of Arts and Letters, *J. Alden Weir 1852–1919* (Centennial Exhibition), 1 February–30 March 1952, cat. no. 4, pl. 4.
New York, American Federation of Arts, traveling exhibition, *American Traditional Painters: 1865–1915*, October 1962–May 1963, shown at: Louisville, Ky., J.B. Speed Art Museum; Columbia (S.C.) Museums of Art and Science; Columbus (Ohio) Museum of Art; Seattle, Wash., Charles and Emma Frye Art Museum; Salt Lake City, Utah, Salt Lake Art Center; Peoria, Ill., Bergner's Downtown.
New York, IBM·Gallery, *Portrait of America: 1865–1915*, 16 January–25 February 1967, cat. no. 29.
New York, The Metropolitan Museum of Art, *J. Alden Weir: An American Impressionist*, 13 October 1983–3 January 1984, pp. 230, 235 (illus.; then to Los Angeles County Museum of Art and The Denver [Colo.] Art Museum).

REFERENCES
American Art News 4 (23 December 1905): 5.
Duncan Phillips, *Julian Alden Weir: An Appreciation of His Life and Work* (New York, 1922), illus.
Dorothy W. Young, *The Life and Letters of J. Alden Weir* (New Haven, Conn., 1960), p. 200.
Donelson F. Hoopes, *The American Impressionists* (New York, 1972), pp. 82–83 (illus.).
Richard S. Boyle, *American Impressionism* (Boston, 1974), p. 159.
Charles Eldredge, "Connecticut Impressionists: The Spirit of Place," *Art in America* 61, no. 4 (September/October 1974): 84ff.

BIOGRAPHY
Born 30 August 1852, West Point, N.Y. Studied painting with father, Robert Weir, and half-brother, John Ferguson Weir. 1870, to New York to study at the National Academy of Design. 1873, to Paris; studied with Jean-Léon Gérôme. 1874, traveled, studied, and painted in Brittany and Holland. 1876, traveled and studied in Spain. 1877, returned to New York; established studio. Same year, one of the founders of the Society of American Artists. 1880–81, traveled in Belgium and Holland. Acting as agent for American collectors, bought Manet's *Woman with a Parrot* and *Boy with a Sword*, now in the Metropolitan Museum of Art. 1880, honorable mention, Paris Salon. 1883, acting as agent, bought Rembrandt's *Portrait of a Man*, now in the Metropolitan. Settled in New York; also bought a home in Branchville, Conn. Married Anna Dwight Baker. Taught at Art Students League and Cooper Union. 1885, elected associate, National Academy of Design. 1886, elected academician, National Academy. 1888, won prize, American Art Association. 1891, exhibited landscapes, Blakeslee Galleries, New York. 1892, wife died; 1893, married Ella Baker, sister of first wife. 1893, commissioned to paint murals at World's Columbian Exposition, Chicago. 1898, exhibited at American Art Galleries with Monet, Twachtman, Paul Besnard; one of the founders of The Ten American Painters (American Impressionists); elected to National Institute of Arts and Letters. 1905, awarded Inness Gold Medal at National Academy of Design annual exhibition (for *Upland Pasture*, then titled *Pasture*). 1915, elected to American Academy of Arts and Letters. 1915–17, president, National Academy of Design. Died 8 December 1919, New York.

There has been a resurgence of interest in the art of Alden Weir, and the collection of eight oil paintings and a virtually complete survey of his more than one hundred forty etchings and drypoints in the NMAA allow a fair assessment of his achievement. Recurrent attempts to relate Weir to Impressionism are confounded by his art. No matter what lessons of light and color he may have learned from his French contemporaries, the dominant note of his painting is sobriety – in palette, composition, and mood.

The Open Book of 1891 is a case in point. The palette is similar to that of *Upland Pasture*, but paler, chalkier. There is little definition or variation in the hillside other than the division by shadow. While the steeply rising hill, which presses toward the picture plane and reduces the sky to a small triangular strip, has parallels in Monet and Japanese prints, the painting conveys no real suggestion of modernity or artistic exploration. The subject confirms the conservatism sensed in the style: the partly nude young woman seems clearly allegorical – probably a symbol of spring, virginity, or innocence. She holds a book with vague pastel images on its pages, some of which may be flowers, and her face is upturned in solemn inspiration. One suspects a book inspired the painting as well.

In *The Open Book*, Weir expressed the *fin-de-siècle* mood of wistful melancholy and introspection that is found in the art of many of his contemporaries. *A Gentlewoman* (1906) is further evidence of this. With her bent head and downcast eyes, the half-length

Weir, *The Open Book*, 1891, oil on canvas, 80.5 × 74 cm (31¾ × 29⅛ in.). Gift of Brigham Young University, 1929.6.157

figure projects an elegiac mood. But the image is far more substantial in treatment than *The Open Book*. The dress of silver gray elegance with pink trim and blue-and-green shadings has been brushed with vigor. The surface is vividly textured, sometimes with parallel striations, sometimes with jewel-like encrustations. The costume and her dark brown hair set off a pensive face of lovely, naturalistic flesh tones and shell pink lips. At first glance the pose seems straightforward, but there are unsuspected complexities of subtle contrapposto and vital internal rhythms, such as those in the sleeves.

From about 1887 until 1893, Weir was an ardent etcher. Of his experiments in the medium he later said: "I etched and drew on copper for the sole reason that it had the mystery of a new path." Once again the artist's innate conservatism is evident, this time in his stylistic reliance on earlier printmakers, particularly the Old Masters. One glance at the drypoint of his brother Dr. Robert F. Weir (1891), for example, reveals his debt to the portrait prints of Van Dyck. In fact, one of his first attempts at etching had been to copy Van Dyck's portrait of Lucas Vorsterman; in both we find the artifice of a sketchy body supporting a more fully modeled and detailed head. Reiterated contours and rapid, spontaneous strokes of the etching needle convey vitality and nervous energy, while the solid and focused head expresses intellectual conviction.

Weir spent the summer of 1889 on the Isle of Man and devoted his attention to a series of etchings of the harbor, fishermen, and landscape. *Boats at Peel, Isle of Man* is one of the finest of these essays in his new-found medium. As skillful in the atmospheric evocation of space as in the linear complexities of mast and rigging, Weir breaks no new ground in his choice and treatment of subject. Eugène Isabey had produced very similar subjects, though in lithography, nearly sixty years earlier; and Whistler's etched harbor scenes not only predated Weir's, but were much more ambitious in composition and chiaroscuro. These qualifications are not intended to denigrate Weir's achievement as an etcher. He was one of very few American *peintres-graveurs* at this time, and his love of the medium is patently clear from the pursuit, in his words, of "a certain charm that etching only possesses." The directness and uncalculated simplicity of his graphic work bespeaks the quiet modesty of the man.

Weir, *A Gentlewoman*, 1906, oil on canvas, 76.2 × 63.5 cm (30 × 25 in.). Gift of William T. Evans, 1909.7.72

Weir, *Portrait of Dr. Robert F. Weir*, 1891, drypoint, 20.1 × 15 cm ($7\frac{7}{8}$ × $5\frac{7}{8}$ in.). Gift of Brigham Young University, 1972.84.61

Weir, *Boats at Peel*, *Isle of Man*, 1889, etching, 29.9 × 22.5 cm ($11\frac{13}{16}$ × $8\frac{7}{8}$ in.). Gift of Brigham Young University, 1972.84.92

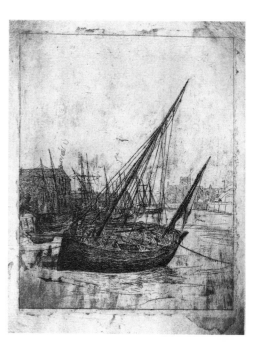

Childe Hassam
The South Ledges, Appledore 1913
signed lower right: *Childe Hassam 1913*
oil on canvas, 87 × 91.6 cm (34¼ × 36⅛ in.)
Gift of John Gellatly, 1929.6.62

PROVENANCE
According to Ralph Seymour, Gellatly's curator,
purchased by John Gellatly from Milch Galleries,
New York, 1928.

EXHIBITION HISTORY
New York, National Academy of Design, Winter
 Exhibition, 20 December 1913–18 January
 1914.

REFERENCES
Arts and Decoration 4, no. 4 (February 1914): 139
 (review of the National Academy exhibition
 cited above).
Donelson F. Hoopes, *Childe Hassam* (New York,
 1979), p. 80, pl. 30 (as *Sunny Blue Sea*).

Hassam, *Celia Thaxter in Her Garden*, 1892, oil on
canvas, 56.2 × 45.8 cm (22⅛ × 18⅛ in.). Gift of
John Gellatly, 1929.6.52

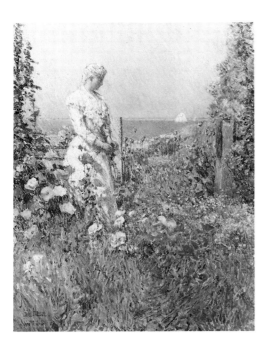

BIOGRAPHY
Born 17 October 1859, Dorchester, Mass.
Apprenticed to a Boston wood engraver, 1876.
Began work as illustrator. 1877–79, life class,
Boston Art Club. Studied also with William
Rimmer and Ignaz M. Gaugengigl, Boston. 1883,
toured Europe; large exhibition of watercolors,
Boston. Married Kathleen Maude Doane, 1884.
1886, to Paris for three years; studied briefly at
the Académie Julian. 1887–88, exhibited at the
Paris Salon. 1889, bronze medal at Exposition
Universelle, Paris. Settled in New York, 1889.
1890, summer trip to Gloucester and the Isles of
Shoals. 1892, bronze medal, Internationalen
Kunstaustellung, Munich. 1895, traveled to
Havana, Cuba; received Webb Prize, Annual
Exhibition, Society of American Artists. 1897,
third trip to Europe (Italy, France, London); also
founding member of The Ten American Painters
group. Taught at Art Students League, New
York. 1899, Temple Gold Medal, Pennsylvania
Academy of the Fine Arts annual exhibition.
1900, silver medal, Exposition Universelle, Paris.
1901, gold medal, Pan-American Exposition,
Buffalo. 1902, elected associate, National
Academy of Design. 1904, gold medal, Universal
Exposition, St. Louis. 1905, first one-man
exhibition, Montross Gallery, New York;
continued to exhibit there for thirty years. 1906,
elected academician, National Academy of
Design. 1908, first trip to West Coast. 1910, last
trip to Europe (France and Spain). Sesnan Gold
Medal from the Pennsylvania Academy of the
Fine Arts. 1913, exhibited in the Armory Show,
New York. 1914, one of only twelve American
painters included in the Panama-Pacific
International Exposition, Palace of Fine Arts, San
Francisco. 1915, renewed interest in etching and
from this time on devoted great attention to the
medium. 1917–18, series of patriotic flag
paintings marking American involvement in
World War I. Major exhibitions at Worcester Art
Museum, Chicago Art Institute, City Art
Museum of St. Louis. 1919, major retrospective at
Macbeth Gallery, New York. 1920, elected to
American Academy of Arts and Letters. 1926,
retrospective at Durand-Ruel Galleries, New
York. Gold Medal, Philadelphia Sesqui-centennial
Exposition. 1929, exhibitions at California Palace
of the Legion of Honor, San Francisco, and
Albright Art Gallery, Buffalo. 1934, awarded Gold
Medal for Distinguished Services to the Fine Arts
by Association of American Art Dealers, New
York. Died 27 August 1935, East Hampton, N.Y.

Few American painters have been as critically
acclaimed and successful during their lifetime as
Hassam. He was one of the earliest importers of
French Impressionism into this country, beginning
in 1889, during a period in which many Americans
looked once more to Europe for cultural
inspiration.

One of the most popular Impressionist subjects
was a woman in a garden or meadow, aglow in
sunlight or caressed by gentle shade, in quiet
meditation. Hassam's success in transplanting the
themes and style of Monet and Renoir to America
can be judged from *Celia Thaxter in Her Garden*
(1892). The small, intimate picture celebrates the
artist's friend and her oft-painted garden on
Appledore, in the Isles of Shoals. Thaxter, poet and
naturalist, wrote a book about the site. *An Island
Garden*, published posthumously in 1895, was
illustrated by Hassam, who began work the year of
this genre portrait. The flowers of this "old-
fashioned" garden swirl and rise around her still
figure, which is robed in white and set against the
red, pink, and green garden and blue ocean and
sky. The painting is an affirmation of Thaxter's
writing: "Flowers have been like dear friends to
me, comforters, inspirers, powers to uplift and to
cheer."

Hassam painted *Ponte Santa Trinita* in 1897, on his
third trip to Europe. The pale harmony of green,
blue, cream, and yellow suggests the transition
from late spring to early summer in Florence. The
River Arno and Michelangelo's great bridge,
gently and regularly brushed in, span the picture in
broad, leisurely rhythms. As in the preceding
painting, Hassam shows himself more deeply in
tune with Monet's Impressionism than most
American artists. Later that same year, he became
a founding member of "The Ten American
Painters," who were inspired in different ways and
degrees by French Impressionism.

After the First World War, Hassam's Im-
pressionism became, in a non-pejorative sense,
mannered. Colors were more intense and abstract
and his style was lusher and more decorative.
Tanagra (The Builders, New York) of 1918 is a major
example of this late phase. The "mahogany" table
top, for instance, is a dazzling field of deep reds,
blues, yellows, orange, and white. The woman's
arms are also multi-colored in an exaggerated
rendition of Impressionist color-in-shadow. The
painting's title refers to the ancient Greek figurine,
from Tanagra in Boetia, of an elegantly dressed
woman – here paralleled by the modern American
woman of means who holds it. Hassam's cultural
synthesis is elaborate and piquant. The urban

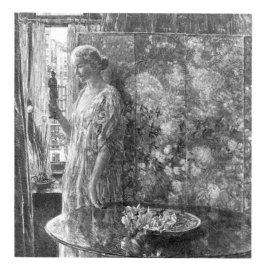

figure stands in front of an oriental screen, and the Greek statuette is silhouetted against the apartment window, through which we see not only the city but also a skyscraper under construction (hence the subtitle). On another level, the artist has painted an urban version of Celia Thaxter in her garden. Here the city dweller stands lost in thought, like Thaxter, before a screen representing a garden (and merges with it in a similar way) and is also flanked by a bowl of flowers and the tall stems of the amaryllis. Ancient and modern, East and West, town and country, active and contemplative lives – these stimulating dichotomies lend substance to a painting that at first seems merely a record of a chic and sheltered life.

Hassam, *Tanagra (The Builders, New York)*, 1918, oil on canvas, 149.2 × 149 cm ($58\frac{3}{4} \times 58\frac{3}{4}$ in.). Gift of John Gellatly, 1929.6.63

Hassam, *Ponte Santa Trinita*, 1897, oil on canvas, 57 × 85.3 cm ($22\frac{1}{2} \times 33\frac{5}{8}$ in.). Gift of John Gellatly, 1929.6.61

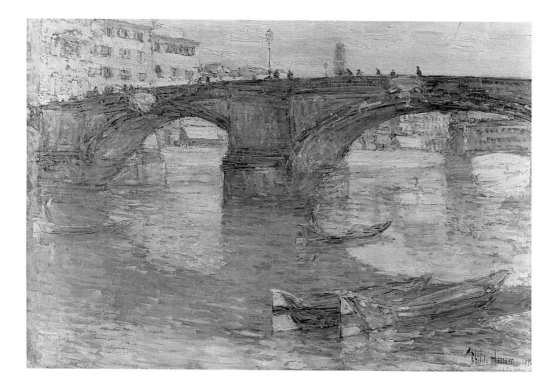

Maurice Prendergast
Summer, New England 1912
signed lower left: *Prendergast*
oil on canvas, 48.9 × 69.9 cm ($19\frac{1}{4} \times 27\frac{1}{2}$ in.)
Gift of Mrs. Charles Prendergast, 1976.124

PROVENANCE
The artist; Mr. and Mrs. Charles Prendergast, the artist's brother and sister-in-law.

COMMENTS
The dating is based on a pencil inscription on the backing: "SUMMER, NEW ENGLAND, 1912/19 × 27."

BIOGRAPHY
Born 10 October 1859, St. John's, Newfoundland, Canada. 1861, family moved to Boston. 1873, formal education ended at eighth grade. Apprenticed to commercial-art firm; learned graphic design and illustration. About 1886–87, traveled abroad with brother, Charles. 1891–94, studied in Paris with Jean Paul Laurens, Joseph Blanc, and Benjamin Constant at Académie Julian; with Gustave Coutois at Atelier Colorossi. 1894, returned to Boston. With Charles, managed frame shop, 1896–97. In 1897 and 1899, one-man shows at Chase Gallery, Boston. 1897, exhibited for first time in New York at Watercolor Society. 1898, exhibited Pennsylvania Academy of the Fine Arts; first exhibition at Boston Watercolor Club, resulting in patronage of fellow painter Sarah Choate Sears and others. 1898–99, traveled in Italy and France, producing many watercolors. 1900, exhibited at Art Institute of Chicago. 1901, awarded Bronze Medal for Watercolor, Pan-American Exposition, Buffalo, N.Y. 1901, one-man show Cincinnati Art Museum. 1905, one-man show Macbeth Gallery, New York. 1908, exhibited with The Eight at Macbeth Gallery. 1909–10, France. 1912, exhibited at the Union League Club and the Cosmopolitan Club, New York. 1913, included in the Armory Show. 1914, moved to New York. 1914–22, summers in New England. 1917, exhibited with William Glackens and John Marin, Bourgeois Galleries, New York. 1922, exhibited with brother Charles, Brummer Gallery, New York. 1923, awarded Corcoran Bronze Medal and Third Clark Prize, Corcoran Biennial. Died 1 February 1924, New York.

Rockwell Kent
Snow Fields 1909
signed lower right: *ROCKWELL KENT 1909.*
oil on canvas mounted on linen, 96.5 × 111.7 cm
(38 × 44 in.)
Bequest of Henry Ward Ranger through the
National Academy of Design, 1981.75

PROVENANCE
Purchased from Macbeth Gallery through the
Henry Ward Ranger Fund by the Council of the
National Academy of Design, 1932; assigned to
the Minneapolis Institute of Arts; recalled by the
National Museum of American Art under the
terms of the Ranger Bequest.

EXHIBITION HISTORY
Pittsburgh, Pa., Carnegie Institute, *Rockwell Kent*,
 no. 36 (as *Snow Fields, The Berkshires*).
Philadelphia, The Art Alliance, *Rockwell Kent*,
 November 1925, no. 12.

REFERENCES
Rockwell Kent, *It's Me, O Lord: The Autobiography
 of Rockwell Kent* (New York: Dodd, Mead &
 Co., 1955), illus. opp. p. 43.
David Traxel, *An American Saga: The Life and
 Times of Rockwell Kent* (New York, 1980).

COMMENTS
The work was also known as *Winter in the
Berkshires* and *Snow Fields, The Berkshires*.

BIOGRAPHY
Born 21 June 1882, Tarrytown Heights, N.Y.
1887, father died. 1895, traveled to Dresden,
Holland, and England with his aunt Jo, an artist.
1896–1900, attended Horace Mann School, New
York. 1900–1902, studied architecture at
Columbia University, New York; studied in
summer art programs of William Merritt Chase.
1902, entered Chase's New York School of Art,
on scholarship; studied with Robert Henri and
Kenneth Hayes Miller. 1903, apprenticed to
Abbott Handerson Thayer, Dublin, N.H. 1904,
two works shown at National Academy of Design,
New York. 1908, one-man show, Clausen
Galleries, New York. 1904–13, worked
intermittently as architectural draughtsman for
Ewing and Chappel, New York. 1904, joined
Socialist party, a crucial event in his life. Summer
1905, first visit to Monhegan Island, Maine,
where he built a house the next year. Married
Kathleen Whiting, 1908. 1910, with Henri
organized *Exhibition of Independent Artists* in

competition with National Academy annual show.
1911, organized *An Independent Exhibition of the
Paintings and Drawings of Twelve Men*, Society of
Beaux-Arts Architects, New York. 1914, moved
to Brigus, Newfoundland; 1918, Alaska. Before
1920, exhibited at Whitney Studio Club, New
York. 1920, one-man show, M. Knoedler & Co.,
New York. 1925, one-man show, Wildenstein &
Co., New York. 1928, moved to the Adirondacks,
N.Y. 1934, one-man show at Macbeth Gallery,
New York. 1939, painted mural, *The Power of
Electricity*, General Electric Company Building,
New York World's Fair. Illustrated many books,
including his own travel journals. Published
philosophical and travel writings, including
Wilderness: A Journal of Quiet Adventure in Alaska
(1920), *Rockwellkentiana* (1933), *This Is My Own*
(1940), *It's Me, O Lord* (1955), *Of Men and
Mountains* (1959). 1962, elected honorary member,
Academy of Art of the USSR. 1967, received
Lenin Peace Prize and donated part of award to
North Vietnam. Died 13 March 1971,
Plattsburgh, N.Y.

Robert Henri
Blind Spanish Singer 1912
signed lower right: *Robert Henri*
oil on canvas, 104 × 84 cm (41 × 33⅛ in.)
Gift of J.H. Smith, 1967.41

PROVENANCE
Estate of Mrs. Robert Henri; J.H. Smith, Aspen,
Colo.

EXHIBITION HISTORY
New York, The Metropolitan Museum of Art,
 A Memorial Exhibition of the Work of Robert Henri,
 9 March–19 April 1931, cat. no. 52 (illus.).
New York, Fifth Avenue Galleries of Grand
 Central Art Galleries, Inc., *Robert Henri Today*,
 9–28 January 1939, cat. no. 10 (as *Blind Spanish
 Singer, Madrid, 1912*).
New York, Hirschl & Adler, *Robert Henri: A
 Commemorative Exhibition*, 31 March–30 April
 1954, cat. no. 6 (as *The Blind Spanish Dancer
 [sic]*).
New York, Anderson Galleries, *Works of Art
 Donated for the Benefit of American-British-French-
 Belgian Permanent Blind War Relief Fund*, 11–25
 May 1968, p. 148.
New York, The Gallery of Modern Art, *Robert
 Henri Retrospective*, 14 October–14 December
 1969.
Jacksonville, Fla., The Cummer Gallery of Art,
 Robert Henri/George Bellows Exhibition,
 22 January–8 March 1981.

REFERENCES
Mahonri Sharp Young, *American Realists: From
 Homer to Hopper* (New York, 1974).

COMMENTS
According to the catalogue of the 1931 Henri
exhibition at the Metropolitan Museum (see
above), this painting was executed in Madrid in
1912. While Henri may have been influenced by
Spanish paintings of urban poverty by Velázquez,
Murillo, and others – artists whose technique he
admired – it is as likely that it was a real woman
seen in Spain that prompted the picture. Indeed,
she also appears in a painting in the Hirshhorn
Museum and Sculpture Garden, Washington,
D.C., *Blind Singers*, datable 1913, a year after the
NMAA work. In the Hirshhorn version she is
accompanied by another woman and is much
smaller. The repetition of the figure emphasizes
the studio focus of Henri's art, as opposed to the
view that he is a recorder of raw reality.

BIOGRAPHY

Born Robert Henry Cozad, Cincinnati, Ohio, 24 June 1865. Family moved to Nebraska; 1882, father shot a man in self-defense and family fled to Denver then Atlantic City, living under assumed names. Robert adapted his middle name as his last (pronouncing it Hen-rī). 1886–88, studied with Thomas Anshutz and Thomas Hovenden at Pennsylvania Academy of the Fine Arts. 1888–91, to Paris; studied at Académie Julian under Bouguereau, and at Ecole des Beaux-Arts. 1891, further study at Pennsylvania Academy, with Robert Vonnoh. 1892–95, taught at Philadelphia School of Design for Women. 1895–97, went to Paris, Holland, and Belgium with William Glackens; exhibited in Paris Salon. 1897, one-man show at Pennsylvania Academy. 1898, married Linda Craige, his student. 1898–1900, Paris. 1899, painting purchased by French government. 1900, settled in New York. 1902, exhibition at Macbeth Gallery. Began teaching at William Merritt Chase's New York School of Art. 1903, elected to Society of American Artists. 1904, exhibited at National Arts Club with Glackens, John Sloan, and George Luks. 1907, withdrew work from National Academy of Design exhibition when paintings by Glackens, Luks, and others rejected. 1908, organized first exhibition of The Eight (Henri, Glackens, Sloan, Luks, Shinn, Davies, Lawson, and Prendergast) at Macbeth Gallery. Death of wife, 1905; married Marjorie Organ, his student, 1908. Resigned from New York School of Art, 1908; opened Henri School of Art, 1909. Students included George Bellows, Stuart Davis, Edward Hopper, Rockwell Kent. 1910, helped organize *Exhibition of Independent Artists*, the first non-juried exhibition in U.S. 1911–18, taught at Modern School. Traveled widely in U.S. and abroad. From 1915–28, taught and lectured at Art Students League. 1916, served on organizing committee of Forum Exhibition of Modern American Painters. 1923, published *The Art Spirit*, his philosophy of art. Died 12 July 1929, New York.

Ernest Lawson
Gold Mining, Cripple Creek 1929
signed bottom left: *E. Lawson*
oil on canvas, 101.6 × 127.4 cm (40 × 50¼ in.)
Bequest of Henry Ward Ranger through the National Academy of Design, 1949.10.2

PROVENANCE

Purchased with the Henry Ward Ranger Fund by the Council of the National Academy of Design, 10 April 1930; assigned to the Kanawha County Public Library, Charleston, W.Va., 24 April 1930; recalled by the National Collection of Fine Arts (now NMAA) under the terms of the Ranger Bequest.

EXHIBITION HISTORY

New York, National Academy of Design, *105th Annual Exhibition*, 20 March–6 April 1930, cat. no. 199.
New York, National Academy of Design, *Henry Ward Ranger Centennial Exhibition*, 25 September–12 October 1958 (then to Washington, D.C., National Collection of Fine Arts [now NMAA]; Charlotte, N.C., The Mint Museum of Art; Bradenton, Fla., Art League of Manatee County; Jacksonville [Fla.] Art Museum; Charleston, S.C., Gibbes Art Gallery).
New York, ACA Galleries, *Exhibition of Works of Ernest Lawson*, 27 November–24 December 1976.
Tucson, Ariz., University of Arizona Museum of Art, *Exhibition of the Works of Ernest Lawson*, 4 February–4 March 1979.
Huntington, N.Y., Heckscher Museum, *Seven/Eight*, 18 June–1 August 1982.
Edinburgh, Royal Scottish Museum, *Treasures of the Smithsonian*, 12 August–5 November 1984.

COMMENTS

Cripple Creek is in Colorado, near Colorado Springs, where the artist taught at Broadmoor Academy beginning in 1927.

BIOGRAPHY

Born 22 March 1873, San Francisco, Calif. Drew from an early age. 1888, Kansas City; apprenticed to a traveling salesman who taught textile-design techniques. Studied briefly with Ella Holman at Kansas City Art Institute. 1889, to Mexico City with family; worked as engineering draughtsman and studied evenings at San Carlos Art School. 1890, to New York to study at Art Students League (with John Twachtman). Later studied

with Twachtman and J. Alden Weir at their Cos Cob, Conn., school. 1893, to Paris to study at Académie Julian; that summer met Alfred Sisley. 1894, exhibited in Salon des Artistes Français. Returned to U.S.; married Ella Holman; short trips to France and Canada. 1898, settled in New York, in Washington Heights area, which became a frequent subject. 1904, first prize for painting and a silver medal, St. Louis Universal Exposition. 1906, moved to Greenwich Village. Met William Glackens and Dr. Albert Barnes, an important patron. 1908, elected associate, National Academy of Design, but was one of The Eight who exhibited at the Macbeth Galleries, New York, to protest academy's conservatism. 1910, featured in *Exhibition of Independent Artists*, first non-juried show in the U.S. 1913, helped organize Armory Show, in which he exhibited three works. 1915, Gold Medal, Panama-Pacific International Exposition, San Francisco. 1916, Corcoran Silver Medal and Second Clark Prize, Corcoran Biennial. Trip to Spain, 1916–17. Elected academician, National Academy of Design, 1917. Awarded Inness Gold Medal, National Academy, 1917. Awarded Temple Gold Medal, Pennsylvania Academy of the Fine Arts annual exhibition, 1920. Medal of the First Class, Carnegie International, 1921. Taught at Kansas City Art Institute, 1926; and Broadmoor Academy, Colorado Springs, 1927. Travel to France. 1929–30, included in *Paintings by Nineteen Living Americans*, Museum of Modern Art. Awarded Saltus Gold Medal, National Academy, 1930. Moved to Coral Gables, Fla., 1936. Drowned, 18 December 1939, Miami, Fla.

Paul Manship
Salome 1915
signed on base behind drapery: *Paul Manship.*
ⓒ *1915*
bronze, 48 × 34 × 26 cm (19 × 13⅝ × 10¼ in.)
Gift of the estate of Paul Manship, 1966.47.34

PROVENANCE
The artist.

EXHIBITION HISTORY
Washington, D.C., Smithsonian Institution,
 *A Retrospective Exhibition of Sculpture by Paul
 Manship*, 23 February–16 March 1958,
 cat. no. 72.

Manship, *Wrestlers*, 1908, bronze, 32.8 × 19.7 ×
19 cm (12⅞ × 7¾ × 7 7/16 in.). Gift of the estate of
Paul Manship, 1966.47.32

Manship, *Diana*, 1925, bronze, 164.8 × 105.4 ×
45.7 cm (64⅞ × 41½ × 18 in.). Gift of Paul
Manship, 1965.16.32

Manship, *Actaeon*, 1925, bronze, 120.6 × 134.6 ×
38.1 cm (47½ × 53 × 15 in.). Gift of Paul Manship,
1965.16.33

BIOGRAPHY
Born 24 December 1885, St. Paul, Minn.
1892–1903, attended Mechanical Arts High
School and evening classes at St. Paul Institute
School of Art. 1903, left school to work as
designer and illustrator. 1905, to New York.
Studied at Art Students League; assistant to
Solon Borglum. 1906–1908, studied at
Pennsylvania Academy of the Fine Arts under
Charles Grafly. 1909–12, on scholarship at the
American Academy, Rome; traveled in Italy and
Greece. Returned to America, 1912; exhibited at
Architectural League of New York. 1913, married
Isabel McIlwaine. First important commissions
for garden and architectural sculpture from New
York architects Charles Platt and Welles
Bosworth. Won Helen Foster Barnett Prize,
National Academy of Design, New York, for
Centaur and Dryad. 1914, won George D. Widener
Memorial Gold Medal, Pennsylvania Academy of
Fine Arts. Awarded Gold Medal, Panama-Pacific
International Exposition, San Francisco, 1915.
1916, exhibited in Cincinnati, Baltimore,
Indianapolis, Milwaukee, New York. Elected
member, National Academy of Design; elected to
National Sculpture Society and Architectural
League of New York. 1920, elected to National
Institute of Arts and Letters. 1921, won medal,
American Independent Artist; gold medal,
American Institute of Architects. 1922–26, lived
in Paris. 1926, gold medal, Sesqui-centennial

Exposition, Philadelphia. 1927, established
permanent residence in New York. 1932, elected
to American Academy of Arts and Letters. 1932,
member of the Smithsonian Art Commission,
advisory board to the NMAA; served for more
than twenty-five years, fourteen as chairman.
1933, *Prometheus Fountain* installed, Rockefeller
Plaza, New York. 1935, exhibition at Tate
Gallery, London. 1937, large one-man show at
Corcoran Gallery of Art. 1942–48, vice president,
National Academy of Design. 1945, Gold Medal
for Sculpture, National Institute of Arts and
Letters. 1946, corresponding member, Académie
des Beaux-Arts, Institute of France. 1948–54,
president, American Academy of Arts and
Letters. 1958, retrospective exhibition,
Smithsonian Institution. Died 31 January 1966,
New York.

✳

Manship, for twenty-five years a member of the
Smithsonian Arts Commission, gave the NMAA
more than one hundred fifty of his sculptures,
spanning his entire career. One of the earliest of
these is the bronze *Wrestlers* of 1908, a small, but
vigorous work from his student days. Reflecting
the young artist's study of modeling techniques, it
shows a knowledge of the sculpture of Rodin, either
directly or through the intermediaries of Solon
Borglum or Isidore Konti, with whom Manship had
apprenticed. Bold and sensuous, the bronze

combines anatomical exaggerations and daringly balanced counter-thrusting forces. The exaggerations and roughly worked surface are the legacy of Rodin, as is the fragmentary quality of the figure.

After three years of study at the American Academy in Rome, Manship returned to the United States, where he soon began to create garden sculpture on commission from architects. The exposure to classical art in Rome and the decorative demands of garden pieces led him away from expressive surfaces and compositional irregularities toward a smoother, more balanced and rhythmic style.

This aspect of Manship's art is often associated with the polished, streamlined, architectural and decorative style Art Deco; the revival of interest in Manship's sculpture of the twenties and thirties is linked to the style's renewed popularity.

A much-admired example from this period is the pair of sculptures *Diana* and *Actaeon* (1925). Ingeniously supported by curling plant forms, humans and animals seem transfixed in ascent. In a complex invention, Diana races to the left, as though fleeing the male intruder, and simultaneously turns head and bow back to send an (unseen) arrow at the unlucky Actaeon. He, with arm outstretched like an Olympic competitor, is in full extension, even while he presses a hand to his wounded side and turns his head toward the viewer. His metamorphosis has begun and the ears and horns of a stag have appeared – sufficient to draw the attack of his own dogs. Although not bas-reliefs, the two pieces are emphatically planar, with every element compressed and aligned.

Manship had a considerable reputation as a bird and animal sculptor, and in his charming and inventive gateway (1952) for the William Church Osborne Memorial Playground in New York's Central Park, he created a narrative and very whimsical work in which natural forms are gracefully and elegantly stylized. The gate is a series of scenes from Aesop's Fables; in the one reproduced here, he depicts the story of the Fox and the Crow. The fox, mouth open in foxy speech, praises the crow, and a legend on the sign above tells the outcome: "The Crow listened to the Fox's flattery & dropped the Cheese." Among the many admirable details, the cattails are especially noteworthy. Curving sveltely upward in front of the fox, they are a visualization of the smooth-tongued hyperbole offered to the gullible crow.

Manship, *The Fox and the Crow*, 1952, bronze, $102 \times 105.5 \times 5$ cm ($40\frac{1}{8} \times 41\frac{1}{2} \times 2$ in.). Gift of the estate of Paul Manship, 1966.47.3

H. Lyman Saÿen
The Thundershower 1917–18
inscribed and signed lower left: *THE THUNDERSHOWER/LYMAN SAŸEN*
tempera on wood, 91.4×116.8 cm (36×46 in.)
Gift of H. Lyman Saÿen to his nation, 1967.6.19

PROVENANCE
The artist; daughter, Ann Saÿen, Philadelphia.

EXHIBITION HISTORY
New York, New York Society of Independent Artists, 20 April–12 May 1918 (exh. cat.; illus.)
Washington, D.C., National Collection of Fine Arts (now NMAA), *H. Lyman Saÿen*, 25 September–1 November 1970, pp. 22–23, 28, cat. no. 32, p. 68.
Washington, D.C., National Collection of Fine Arts (now NMAA), *Pennsylvania Academy Moderns, 1910–1940*, 9 May–6 July 1975, cat. no. 34.
Philadelphia, Philadelphia Museum of Art, *Philadelphia: Three Centuries of American Art*, 11 April–10 October 1976, cat. no. 440, p. 517.

REFERENCES
Hilton Kramer, "Discovering H. Lyman Saÿen," *New York Times*, 11 October 1970.
Abraham A. Davidson, *Early American Modernist Painting, 1910–1935* (New York, 1981), pp. 232–37 (illus.).

BIOGRAPHY
Born Henry Lyman Saÿen, 25 April 1875, Philadelphia. 1891, graduated Central Manual Training School. Worked for manufacturer and importer of scientific equipment. 1893, citation from World's Columbian Exposition, Chicago, for design of large induction coil. 1895–96, worked as designer of precision instruments and electrical circuitry for production of X-rays. Secretary of Electrical Section of Franklin Institute, Philadelphia. 1897, designed and patented self-regulating X-ray tube. At University of Pennsylvania laboratories of physics, worked to perfect techniques for medical diagnostic radiography. 1898, awarded John Scott Medal, Franklin Institute. Enlisted for service in Spanish-American War; placed in charge of medical X-ray laboratory, Fort McPherson, Ga.; contracted typhoid fever. After long convalescence enrolled, 1899, at Pennsylvania Academy of the Fine Arts, under Thomas Anshutz. Won several prizes for posters. Worked as illustrator, commercial artist, and designer of electrical instruments while

studying at the academy. 1901, Silver Medal, Pan-American Exposition, Buffalo, for improved design of his X-ray tube. 1902, developed a device to permit use of roentgenography in treatment of the eye. 1903, married Jeannette Hope, designer and illustrator. Won national competition for design of four lunettes for room in U.S. Capitol; completed September 1905. 1904–6, with Anshutz, experimented with fabrication of pastels and paints. 1906, the Saÿens were commissioned by Rodman Wanamaker to go to Paris to design catalogues and posters for his department stores. 1907, met Leo and Gertrude Stein. Studied with Matisse, 1907–8. 1909–13, showed annually at the Salon d'Automne. 1912, elected a sociétaire of the Salon d'Automne. 1914, returned to Philadelphia; first one-man show, Philadelphia Sketch Club. 1915–17, included in annual *Philadelphia Water Color Exhibition*, Pennsylvania Academy. 1916, one-man exhibition, Philadelphia Sketch Club. With Morton Schamberg, organized and showed in *Philadelphia's First Exhibition of Advanced Modern Art*, McClees Galleries. 1917, included in annual *Exhibition of Contemporary American Art*, Peabody Institute Galleries, Baltimore. Died 27 April 1918, Philadelphia.

*

When the complete works of Saÿen were presented to the NMAA by his daughter, it was under the credit line "Gift of H. Lyman Saÿen to his nation." The unusual designation belies the fact that at his death in 1918 at the age of forty-three, Saÿen had produced a small, but distinguished, body of modernist work that was scarcely known outside of Philadelphia or the artist's own circle.

Scientist/inventor as well as painter, Saÿen was primarily influenced by Henri Matisse, with whom he studied in Paris from 1907 to 1908. His small panel *Notre Dame* was made during this time – indeed, it echoes Matisse's more distant views of the cathedral painted in 1902 from his quai St. Michel apartment. Saÿen's view appears to be from quai St. Michel at river level. It is probable that it was inspired by Matisse's paintings and quite possible that it was in the nature of an assignment. *Notre Dame* is basically Fauve, both in its strong color and its simplified structure. Although tentative in some respects, it displays an organizational clarity that is characteristic of Saÿen's work.

His *Decor Slav* of 1915 was painted shortly after his return to the United States, one of a group of brilliantly colored landscapes done at Bethayres, Pa., at the home of the painter Carl Newman, whose studio Saÿen often shared. This simple scene of a table in a suburban garden is highly decorative, with strong non-objective colors and broad curves and assertive verticals and horizontals combining for a rhythmic, spontaneous effect. Saÿen, who disliked titling his images, here alludes to the stage designs of the Russian painter Léon Bakst, whose work for the Diaghilev Ballet in Paris from 1909 was quite influential. Interestingly, in early 1917 Saÿen himself designed backdrops for a play presented at the annual Artists' Masque of Philadelphia.

His last works, like *The Thundershower* (p. 122), mark a strong shift from his freely handled landscapes. In *Daughter in a Rocker*, a collage and tempera on plywood (1917–18), he orders his surface with rigorous clarity. While the curves and arcs convey a rocking motion, the assertive diagonals counter this. Attention is drawn forcefully to the head, which is presented in two simultaneous views in the Cubist manner and yet is remarkably expressive of alert childhood within the strictly controlled composition. The vivid patterns, like those in *The Thundershower*, recall Matisse, but the heavy black outlines and areas of pure white point to a new synthesis in his tragically brief career. His inventive intelligence is always apparent. Alice B. Toklas, recalling the artist's years in Paris, said that Gertrude Stein "had a very strong feeling for Saÿen. She believed in him. . . . He was very, very shrewd. He knew everything that was going on and why."

Saÿen, *Notre Dame*, ca. 1907, oil on canvas, 34.8 × 26.4 cm (13¾ × 10⅜ in.). Gift of Col. Harrison K. Saÿen, 1967.137

Saÿen, *Decor Slav*, ca. 1915, oil on canvas, 76.5 × 100 cm (30⅛ × 39⅜ in.). Gift of H. Lyman Saÿen to his nation, 1967.6.6

Saÿen, *Daughter in a Rocker*, 1917–18, tempera and collage on wood, 91.4 × 61 cm (36 × 24 in.). Gift of H. Lyman Saÿen to his nation, 1967.6.4

Morris Kantor
Synthetic Arrangement 1922
signed and dated bottom left: *M. Kantor 1922*
oil on canvas, 196.5 × 141 cm (77⅜ × 55½ in.)
Museum purchase, 1966.53

PROVENANCE
Bertha Schaefer Gallery, New York.

EXHIBITION HISTORY
Ann Arbor, Mich., University of Michigan,
 probably 1958.
New York, Zabriskie Gallery, *A Decade of
 American Cubism 1913–1923*, 1958.
Davenport, Iowa, Davenport Municipal Art
 Gallery, 1964.
Washington, D.C., National Collection of Fine
 Arts (now NMAA), *Roots of Abstract Art in
 America, 1910–1930*, 1 December 1965–
 16 January 1966.
Edinburgh, Royal Scottish Museum, *The Modern
 Spirit: American Painting 1908–35*, 19 August–
 10 September 1977 (then to London, Hayward
 Gallery).
Washington, D.C., National Museum of American
 Art, *Recent Trends in Collecting: Twentieth Century
 Painting and Sculpture from the National Museum of
 American Art*, 12 February–28 March 1982.

REFERENCES
Hilton Kramer, "Month in Review," *Arts* 33
 (October 1958): 46, 48 (illus.).

COMMENTS
This painting should not be confused with
another of the same title, but dated 1923 and
measuring 46 × 54 in., shown in the exhibition
Arts of the United States: 1670–1966, Whitney
Museum of American Art, New York (exh. cat.,
illus. p. 83), then in the collection of Mr. and
Mrs. Arthur G. Altschul. The Altschul painting is
probably the subject of Kantor's comments
forwarded from the Bertha Schaefer Gallery and
now in the files of the NMAA. It is also possible
that the Altschul painting was the one exhibited
at the University of Michigan and the Zabriskie
Gallery, and the one referred to by Hilton
Kramer in *Arts* (see above).

BIOGRAPHY
Born 1896, Minsk, Russia. Arrived in U.S., 1911.
Lived in garment district of New York City.
1916, wishing to become a cartoonist, attended
Independent School of Art; student of Homer
Boss. Turned to painting; early work largely
abstract, with elements of Cubism and Futurism.
1923, exhibited in Independent Artists Exhibition.
1927, studied in Paris. Around 1928, concerned
with the human scene as witnessed from his New
York apartment windows; some of these works

suggestive of Surrealism. 1929, exhibited at
Brummer Gallery, New York. 1931, won first
prize and Logan Medal at Chicago Art Institute.
1936, began teaching at Art Students League,
New York; continued until 1963. Won third prize
and bronze medal at Corcoran Gallery of Art,
1938. Won Temple Medal, Pennsylvania
Academy of the Fine Arts, annual exhibition,
1940. In 1947, exhibited in UNESCO show in
Paris. Summers of 1958 and 1959, visiting artist at
University of Michigan, Ann Arbor. 1960, in
annual exhibition of the Federation of Modern
Painters and Sculptors. 1962, one-man show at
Bertha Schaefer Gallery, New York, where he
often exhibited. Died 1974.

Kantor, *Self-Portrait*, 1918, oil on linen, 56.1 ×
45.7 cm (22⅛ × 18 in.). Gift of Mrs. Morris
Kantor, 1976.146.1

Kantor, *Dancer*, 1928, oil on linen, 117 × 76.6 cm
(46⅛ × 30⅛ in.). Gift of Mrs. Morris Kantor,
1976.146.6

Kantor, *Girl with Cigarette*, 1940, oil on linen,
101.1 × 91.6 cm (39⅞ × 36⅛ in.). Gift of Mrs.
Morris Kantor, 1976.146.25

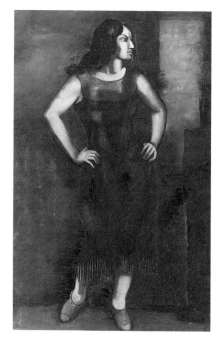

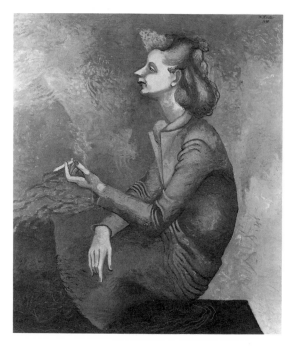

The NMAA is the primary repository for the paintings of Morris Kantor. His youthful modernism, sometimes abstract, always entirely avant-garde in its formal vocabulary, and his mature figurative style in its many variations may be studied in depth in the nearly one hundred works in the collection.

In Kantor's 1918 *Self-Portrait*, the columnar neck *à la* Modigliani, the blunt, parallel slats of paint, the non-naturalistic color, the rather coarse, unpolished surface, all bear witness to his commitment to contemporary art. In addition, the restrained aggressiveness of the image and the somberness of the palette reveal the artist's personal style. The exaggerated verticality and insistent symmetry of neck and nose and the stylized simplification overall produce an hieratic image, remote and awesome as a Byzantine Christ figure. The expressive palette runs from blue black in the hair through blue in the face and brick red in the background. Although the modeling is strong, it is not a particularly sculptural image. Rather, shadows hold the image to the picture plane. The chin and neck, for example, are bound together rather than distinguished by shadow. In its Slavic seriousness and taciturnity, this *Self-Portrait* suggests contemporary works by Max Weber, Alexei Jawlensky, and Marc Chagall.

How soon and how completely Kantor abandoned the Cubist vocabulary of his 1922 *Synthetic Arrangement* can be seen in his 1928 *Dancer*. The woman seems to be a cross between Jules Pascin's Parisian models and Picasso's monumental, Neo-classical figures. This same uneasy marriage is seen in the specificity of the costume and the vagueness of the setting. Picasso's influence is also evident in the emphatic lines that define the contours, especially of the arms and hands. The dark tonality, however, is Kantor's own, as is the vague feeling of foreboding.

It is less easy to invoke other artists in speaking of Kantor's 1940 *Girl with Cigarette*. The precise and fluent drawing of the strikingly individual profile of the girl and of her poised hands fix her indelibly in the mind's eye. If the painting borders on caricature, Kantor invests his model with a redeeming confidence that forestalls mockery. The neat echo of shapes and pert attitudes of head and left hand draw our attention to the cigarette, which in a sense animates the painting; the accumulation of tremulous, swirling lines, dense but insubstantial, seems a visualization of its smoke. This girl is very much of her time; in proportion, fashion, and attitude she typifies the working woman of the war years.

Romaine Brooks
Self-Portrait 1923
signed lower right (covered by frame): *Romaine 1923*; inscribed, lower left, with her symbol
oil on canvas, 117.5 × 68.3 cm (46¼ × 26⅞ in.)
Gift of the artist, 1966.49.1

PROVENANCE
The artist.

EXHIBITION HISTORY
Paris, Salon de la Société des Artistes Indépendants, Spring 1923.
Paris, Galerie Jean Charpentier, 20 March–April 1925.
London, L'Alpine Club Gallery, 2–20 June 1925.
New York, Wildenstein Galleries, 20 November–31 December 1925.
Washington, D.C., National Collection of Fine Arts (now NMAA), *Romaine Brooks, "Thief of Souls,"* 24 February–4 April 1971, cat. no. 22, p. 80.
Baltimore, Md., Walters Art Gallery, *Old Mistresses: Women Artists of the Past*, 16 April–18 June 1972.

REFERENCES
L'Art et les artistes 27 (May 1923): 307–314 (illus.).
Revue de l'art ancien et moderne, 1 April 1925, illus.
Vogue (Paris), 1 June 1925, p. 34 (illus.).
The Sketch, 17 June 1925, p. 528 (illus.).
Art & Decoration, June 1925, p. 27 (illus.).
International Studio, February 1926, p. 46 (illus.).
Réalités, December 1967, p. 96 (illus.).
Romaine Brooks: Portraits – Tableaux – Dessins (Paris, 1952).
Meryle Secrest, *Between Me and Life: A Biography of Romaine Brooks* (New York, 1974).

BIOGRAPHY
Born Romaine Goddard in Rome, 1874, to American parents. 1882–86, attended St. Mary's Hall, Burlington, N.J. 1886, joined mother and brother in London, her parents having separated. 1887–90, attended convent school in northern Italy; 1891–95, Mademoiselle Tavan's Private Finishing School for Young Ladies, Geneva, Switzerland. 1896–98, lived in Paris. 1898–99, moved to Rome to study painting at La Scuola Nazionale and Circolo Artistico. 1899–1900, returned to Paris. 1900–1901, Paris, Capri, Nice; death of brother. 1902, death of mother. 1903–4, married and separated from John Ellingham Brooks. 1904, London. 1905, returned to Paris; studied with Gustave Courtois; painted seriously. 1910, met Gabriele d'Annunzio; first one-woman exhibition, Galeries Durand-Ruel, Paris. 1913, exhibited in *Prima Esposizione internazionale d'arte della 'Secessione'*, Rome. 1914, painted Jean Cocteau's portrait. 1915, met Natalie Barney. 1920, awarded Croix de la Légion d'Honneur. 1925–26 exhibitions in Paris, London, New York, Chicago. About 1930, began writing (unpublished) memoirs, *No Pleasant Memories*. 1931, major exhibition of drawings, Paris. 1935–36, took a studio in Carnegie Hall, New York. 1940–67, lived in Florence; joined by Natalie Barney. Wrote second volume of memoirs, *A War Interlude, or on the Hills of Florence During the War*, 1940–45. 1967, moved to Nice, where she died 7 December 1970.

*

In the five years preceding her death in Nice, France, at the age of ninety-six, Romaine Brooks gave twenty-three of her paintings and a group of her drawings to the NMAA. The artist's friendship with Natalie Barney and her sister Laura Dreyfus Barney, who donated Barney Studio House and its collection to the Smithsonian, led to the artist's interest in the institution. The gift most fully represents the achievement of this once-acclaimed artist, whose work and life were eclipsed by a radical change of international taste. Melancholy and more than a little corrupt, to a post-war public her paintings must have seemed symbolic of a decadent era. Since the 1970 NMAA exhibition *Romaine Brooks, "Thief of Souls,"* however, her work has attracted a new, admiring audience.

Le Trajet ("the voyage"; painted about 1911, though later inscribed with the date 1900) remains startling in its peculiar brand of eroticism. Not merely lesbian, but almost necrophiliac, the suspended nude is concentrated and unequivocal. The model was the dancer and actress Ida Rubinstein, who played the androgynous central role in d'Annunzio's *Martyrdom of Saint Sebastian*, which was produced in Paris in 1911. Brooks also painted her on a number of subsequent occasions. The spear-like shape upon which the nude lies may be interpreted as a huge, white wing floating in black space. The artist used a similar design on her writing paper; the nightmare feeling of doomed flight was deeply personal. Despite its strong directional thrust, the wing is restrained by its placement close to the left edge of the painting and anchored by the falling black mass of the woman's hair. The striking, contoured shape derives from the art of Gauguin, as does its symbolic weight.

Brooks, *Una, Lady Troubridge*, 1924, oil on canvas, 127.3 × 76.4 cm (50⅛ × 30⅛ in.). Gift of the artist, 1966.49.6

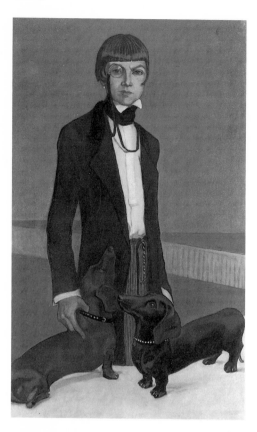

Una, Lady Troubridge (1924) was another redoubtable member of Romaine Brooks's inner circle. Until she was introduced to Radclyffe Hall, Una was married to Admiral Sir Ernest Troubridge. She fell in love with and left her husband for Hall, who was named co-respondent by the admiral in an extraordinary lawsuit. Although Brooks was fond of Una, she could not suppress a satirical thrust at the affected costume of her friend. The attenuated figure in striped trousers and elegant black coat, high collar, and neck cloth, topped off with a severe and monocled face, lent itself too readily to caricature of the Max Beerbohm variety. The sitter was devoted to the raising of thoroughbred dogs, and the dachshunds on the show table were a championship pair given to her by her lover. Brooks uses the animals compositionally to form a plinth for the columnar figure, as well as to reveal a not-altogether-pleasant will to control in their mistress's strong hand, thumb inserted through the collar, that forces one dog's head upward.

After 1936 Romaine ceased to paint and her work was seldom seen. During the war she wrote her memoirs while living in Florence with Natalie Barney. Only in 1961, at the age of eighty-seven, did she paint a final portrait. The sitter was a long-time friend, the Duke Uberto Strozzi, and the unfinished rendering of this descendant of a famous family was a remarkable achievement after twenty-five years of painterly inactivity. Strozzi lived alone in the family palace in Florence; Brooks lived alone in a small villa in Fiesole. The bond of age and frank sympathy that had grown up between them made possible a portrait that combines passivity with impatience. The Duke is a wraith-like figure energized with a jolt of nervous agitation. He had written to her of his meanderings in empty corridors, "a solitary and harassed ghost!" And she, after compelling him to sit silent and suffocating in the hot studio, remarked that "I must hurry to get you framed, . . . the frame may help to keep you in your chair." When she broke off work on the portrait, it was to avoid spoiling the delicate balance of this complex interpretation. The dark and much-marked eye socket, large but indistinct, invites us to contemplate the sitter's inner life instead of his outer features. Never fully at peace with herself, Brooks did not allow her sitters real peace either. The thinly painted figure does not surrender itself to the enveloping black armchair but persists, as it were, in energetic objection to intimations of mortality.

Brooks, *Le Trajet*, ca. 1911, oil on canvas, 115.2 × 191.4 cm (45⅜ × 75⅜ in.). Gift of the artist, 1968.18.3

Brooks, *Le Duc Uberto Strozzi*, 1961, oil on canvas, 115.2 × 99.8 cm (45⅜ × 39⅜ in.). Gift of the artist, 1968.18.7

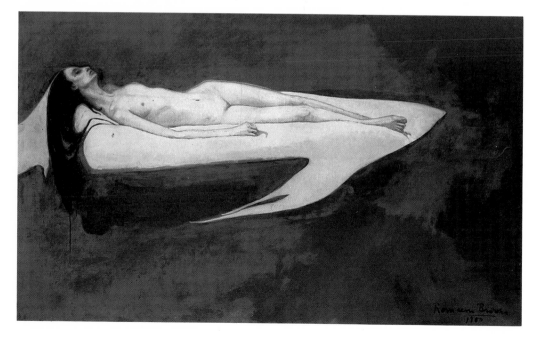

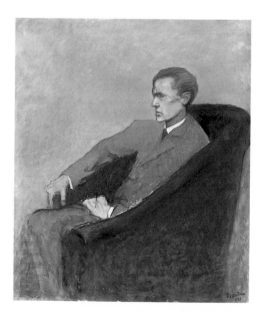

Helen Lundeberg
Double Portrait of the Artist in Time 1935
signed lower right: *Lundeberg*
oil on fiberboard, 121.3 × 101.6 cm (48 × 40 in.)
Museum purchase, 1978.51

PROVENANCE
Purchased from the artist.

EXHIBITION HISTORY
Hollywood, Calif., Stanley Rose Gallery, *Post-Surrealists and Other Moderns*, May 1935.
Los Angeles, Los Angeles County Museum of Art, *Fourth Quarterly Exhibition of Area Artists*, January–February 1948.
San Francisco, San Francisco Museum of Modern Art, *Painting and Sculpture in California: The Modern Era*, 3 September–21 November 1976, pp. 70 (illus.), 98, cat. no. 53 (then to National Collection of Fine Arts [now NMAA], Washington, D.C.).
Denver, Colo., Denver Art Museum, *First Western States Biennial Exhibition*, 7 March–15 April 1979 (then to National Collection of Fine Arts [now NMAA], Washington, D.C.; San Francisco Museum of Modern Art; University of Hawaii at Manoa; Seattle [Wash.] Art Museum; Illinois State University, Center for the Visual Arts; Santa Fe, N. M., Sweeny Center).
San Francisco, San Francisco Museum of Modern Art, *Lorser Feitelson and Helen Lundeberg: A Retrospective Exhibition*, 2 October–16 November 1980, cat. no. 7, p. 56 (illus.).
Munich, West Germany, Haus der Kunst, *American Paintings: 1930–1980*, 14 November 1981–31 January 1982.
New York, Graham Gallery, *Helen Lundeberg: Paintings through Five Decades*, 20 October–4 December 1982, p. 8, cat. no. 1.

REFERENCES
Joseph E. Young, "Helen Lundeberg: An American Independent," *Art International* 15 (20 September 1971): 46ff.
June Harwood, "Feitelson/Lundeberg," *SourceBook*, April 1973, pp. 34–35.
Charlotte Streifer Rubinstein, *American Women Artists* (Boston, 1982), pp. 252–54, figs. 6–19.

COMMENTS
The painting within the painting exists. Titled *Artist, Flowers and Hemispheres* and dated 1934, it is in the collection of the San Francisco Museum of Modern Art.

BIOGRAPHY
Born 24 June 1908, Chicago. 1912, family moved to Pasadena, Calif. 1930, graduated from Pasadena Junior College; studied art at Stickney Memorial School of Art, Pasadena, with Lawrence Murphy, then Lorser Feitelson (whom she married). 1931, exhibited first painting, at annual exhibition of Fine Arts Gallery of San Diego. 1933, included in Los Angeles Museum annual exhibition; first one-woman show, Stanley Rose Gallery, Hollywood; one-woman exhibition, Assistance League, Los Angeles; produced easel paintings for Federal Public Works of Art Project, Los Angeles. 1934, with Feitelson, participated in first group showing of Post-Surrealist painting, Centaur Gallery, Hollywood. 1935, included in group exhibition of Post-Surrealism at San Francisco Museum of Art and Brooklyn Museum. 1936, invited to show in *Fantastic Art, Dada, Surrealism*, Museum of Modern Art, New York; completed two murals for Works Progress Administration/Federal Art Project. 1938–42, many other murals for the WPA/FAP. 1942, group exhibition, *Americans 1942: Eighteen Artists from Nine States*, Museum of Modern Art. 1950, First Purchase Award, Los Angeles County Museum of Art annual. 1952, included in Pittsburgh International, Carnegie Institute. 1953, retrospective, Pasadena Art Institute. 1958, joint retrospective with Feitelson, Scripps College, Claremont, Calif. 1962, included in *Geometric Abstraction in America*, Whitney Museum of American Art, New York. 1965, switched to acrylics. 1971, retrospective, La Jolla Museum of Contemporary Art, Calif. 1974, one of nine painters included in opening exhibition of Los Angeles Institute of Contemporary Art. 1978, Feitelson died. 1980, retrospective with Feitelson, San Francisco Museum of Modern Art. 1982, retrospective at Graham Gallery, New York. Lives in Los Angeles.

Ivan Le Lorraine Albright
The Farmer's Kitchen ca. 1933–34
unsigned
oil on canvas, 91.5 × 76.5 cm (36 × 30⅛ in.)
Transfer from U.S. Department of Labor, 1964.1.74

PROVENANCE
Public Works of Art Project (PWAP), Ill. (Region 10); transferred to U.S. Department of Labor, 21 January 1935.

EXHIBITION HISTORY
Washington, D.C., Corcoran Gallery of Art, *National Exhibition of Art by the Public Works of Art Project*, 24 April–20 May 1934, no. 107.
Chicago, The Art Institute of Chicago, *Retrospective: Ivan Albright*, 3 October–27 December 1964 (then to Whitney Museum of American Art, New York).
Düsseldorf, West Germany, Stadtische Kunsthalle, *American Modern Art between the Two World Wars*, June–15 August 1979 (then to Zurich, Switzerland, Kunsthaus, and Brussels, Belgium).
Mexico City, Museo del Palacio de Bellas Artes, *La pintura de los Estados Unidos de museos de la ciudad de Washington*, 15 November–31 December 1980.

REFERENCES
Michael Croydon, *Ivan Albright* (New York, 1978), pp. 55, 97; pl. 46.

COMMENTS
The model has been identified as Mrs. George Washington Stafford (by Croydon, above), a Warrenville, Ill., resident whose husband also posed for Albright.

BIOGRAPHY
Born Chicago, 20 February 1897. Studied with father, who was student of Eakins. Studied architecture at Northwestern University and University of Illinois, 1915–16. Service in First World War, 1918–19, as Army medical draughtsman. Studied at Art Institute of Chicago, 1920–23; Pennsylvania Academy of the Fine Arts, 1923; and National Academy of Design, 1924. Divided his time between Warrenville, Ill., and the Southwest, 1924–29. Painted with PWAP, 1933–34. 1938, taught at the Art Institute of Chicago. 1942, elected associate academician, National Academy of Design. 1943–44, commissioned to paint the portrait for the film

The Picture of Dorian Gray. Exhibited with twin brother, Malvin, at the Associated American Artists Galleries, New York (1945) and Chicago (1946). 1946, married Josephine Medill Patterson Reeve; moved to Chicago. 1950, elected academician, National Academy of Design. 1963, exhibition at the Tate Gallery, London. Moved to Woodstock, Vt. Retrospective, Art Institute of Chicago and Whitney Museum of American Art, 1964–65. William Benton (later U.S. ambassador to UNESCO) became his primary patron, buying paintings sight unseen. 1969, visiting artist at Dartmouth College. Died 18 November 1983, Woodstock, Vt.

59

S. (Spencer) Douglass Crockwell
Paper Workers 1934
signed and dated upper right: *DOUGLASS CROCKWELL/'34*
oil on canvas, 91.7 × 122.4 cm ($48\frac{1}{4} \times 36\frac{1}{8}$ in.)
Transfer from U.S. Department of Labor, 1964.1.152

PROVENANCE
Public Works of Art Project (PWAP), 1934; Department of Labor.

EXHIBITION HISTORY
Washington, D.C., Corcoran Gallery of Art, *National Exhibition of Art by the Public Works of Art Project,* 24 April–20 May 1934.
Columbia, S.C., Columbia Museum of Art, *Art under the New Deal,* 12 February–10 March 1969, cat. no. 9.
Hamilton, N.Y., Gallery Association of New York State, *New Deal for Art,* traveled to approximately ten locations in New York State, November 1976–November 1977, cat. no. 5, p. 77.
Washington, D.C., National Museum of American History, *FDR: The Intimate Presidency,* 29 January–31 July 1982.

BIOGRAPHY
Born 29 April 1904, Columbus, Ohio. Lived in Glens Falls, N.Y., when with PWAP. Work included in the 1934 exhibition of the PWAP at the Corcoran Gallery of Art. Died in Glens Falls, 30 November 1968.

Ralston Crawford
Buffalo Grain Elevators 1937
signed lower right: *RALSTON CRAWFORD*
oil on canvas, 102.1 × 127.6 cm ($40\frac{1}{4} \times 50\frac{1}{4}$ in.)
Museum purchase, 1976.133

PROVENANCE
Gift of artist to Thomas C. Adler, Cincinnati, Ohio (whose wife was a sister-in-law of the artist); Carl Solway Gallery, Cincinnati.

EXHIBITION HISTORY
San Francisco, M.H. de Young Museum, *Ralston Crawford,* before 1977 (unconfirmed information from label on back of painting).
Paris, Musée National d'Art Moderne, Centre Pompidou, *Les Réalismes entre révolution et réaction, 1919–1939,* 17 December–20 April 1981.
Berlin, West Germany, Staatlichen Kunsthalle, *American Realism 1920–1940,* 16 May–26 June 1981.
San Francisco, San Francisco Museum of Modern Art, *Images of America: Precisionist Painting and American Photography,* 9 September–7 November 1982 (toured to four other locations).

BIOGRAPHY
Born 5 September 1906, St. Catharines, Ontario, Canada. 1926–27, sailed on tramp steamers to Caribbean, Central America, California, New Orleans. Studied at Otis Art Institute, Los Angeles. Worked in Walt Disney's studio. 1927–30, studied at Pennsylvania Academy of the Fine Arts and Barnes Foundation, Merion, Pa. 1932–33, to Europe, where he studied in Paris at Académie Colorossi and Académie Scandinave; toured Spain, Italy, Balearic Islands. 1933, studied at Columbia University. 1934, first one-man show, Maryland Institute of Art, Baltimore. Taught at Art Academy of Cincinnati, 1940–41 and 1949; Buffalo Fine Arts Academy, 1942; Brooklyn Museum School, 1948–49. 1950–68, made many trips to New Orleans to photograph musical life of the city. 1952–57, taught at New School for Social Research, New York. 1953, retrospective exhibition, University of Alabama; visiting artist, University of Michigan. 1954–55, traveled in France and Spain. 1958, retrospective exhibition, Milwaukee Art Center; visiting artist, University of Colorado. Exhibited lithographs in London. Taught at Hofstra College, 1960–62. Photographic research consultant, Tulane University, Archive of New Orleans Jazz, 1961.

1961–62, retrospective exhibition of lithographs, University of Kentucky. 1963–73, traveled widely in Europe, Caribbean, and U.S. Died 27 April 1978, Houston, Tex.

61

Moses Soyer
Artists on WPA 1935
signed and dated lower right: *M Soyer/35*
oil on canvas, 91.7 × 107 cm ($36\frac{1}{8} \times 42\frac{1}{8}$ in.)
Gift of Mr. and Mrs. Moses Soyer, 1961.61

PROVENANCE
The artist.

EXHIBITION HISTORY
West Orange, N.J., YM-YWHA of Essex County, *WPA Artists, Then and Now,* 1967 (exh. cat.; illus.).
Syracuse, N.Y., Syracuse University, *Moses Soyer: A Human Approach,* 3–26 January 1972 (then to Tyler [Tex.] Museum of Art; Greensboro, University of North Carolina, Weatherspoon Art Gallery; Little Rock, Arkansas Arts Center; Birmingham [Ala.] Museum of Art; The Canton [Ohio] Art Institute).
Washington, D.C., National Museum of American History, *FDR: The Intimate Presidency,* 29 January–31 July 1982.
New York, American Federation of Arts, traveling exhibition, *Social Concern and Urban Realism: American Painting of the 1930s,* April 1983–October 1984, shown in: New York, District 1199; Boston, Boston University Art Gallery; Anchorage [Alaska] Historical and Fine Arts Museum; Laurel, Miss., Lauren Rogers Library and Museum of Art; Youngstown, Ohio, The Butler Institute of American Art; West Palm Beach, Fla., Norton Gallery and School of Art).

REFERENCES
Charlotte Willard, *Moses Soyer* (New York, 1962), fig. 30.
"A Sampler of New Deal Murals," *American Heritage* 21, no. 6 (October 1970): 45 (illus.).
William Morris, ed., *The American Worker* (Washington, D.C., 1976).
Joshua C. Taylor, *America as Art* (Washington, D.C., 1976), p. 260 (illus.).
Russell Lynes, "The Birth of the Boom," *Architectural Digest,* February 1984, p. 38 (illus.).

COMMENTS

Painters working on Works Project Administration/Federal Art Project had to consign work done to the government in exchange for wages. Soyer executed *Artists on WPA* on his own time, so it remained in his possession. Three large canvases now in the NMAA, identified as *Children at Play*, *Children at Play and Sport I*, and *Children at Play and Sport II*, are all assumed to come from the mural project referred to in this painting.

BIOGRAPHY

Born 25 December 1899, Borisoglebsk, Russia. 1913, emigrated with family to Philadelphia, then settled in New York. 1925, became U.S. citizen. 1914–17, studied at Cooper Union for the Advancement of Science and Art, New York. About 1918–19, studied with Charles C. Curran, National Academy of Design, New York; studied with Robert Henri and George Bellows. About 1919–24, studied at Educational Alliance Art School, New York; taught there, 1924–26. Traveling scholarship to Europe, 1926–28. 1929, one-man show, J.B. Neumann's New Art Circle, New York. From about 1929–34, taught at Contemporary Art School, New Art School, New School for Social Research. About 1935–39, worked on WPA/FAP, Mural Division, New York. 1936, one-man show, Kleemann Galleries, New York. 1936–37, exhibited Boyer Galleries, Philadelphia. 1939, with brother Raphael, painted two murals, U.S. Post Office, Kingsessing, Pa. 1939–40, one-man show, Little Gallery, Washington, D.C. 1940–43, one-man exhibitions at Macbeth Gallery, New York. 1943–50, included in the Carnegie annual exhibitions. From 1944, one-man shows at ACA Gallery, New York. In Whitney annual, 1947, 1952, 1955–56, 1963. 1963, elected academician, National Academy of Design. 1966, elected member, National Institute of Arts and Letters, New York. 1968, one-man show, Reading (Pa.) Public Museum and Art Gallery. 1970, one-man show, Albrecht Art Museum, St. Joseph, Mo. 1972–73, retrospective, Syracuse University, N.Y. Died 3 September 1974, New York City.

William H. Johnson
Man in a Vest ca. 1939–40
Signed lower left: *W.H. Johnson*
oil on canvas mounted on board, 76.2 × 61 cm (30 × 24 in.)
Gift of the Harmon Foundation, 1967.59.1118

PROVENANCE

The artist; the Harmon Foundation, 1956.

EXHIBITION HISTORY

New York, The New York Public Library, Countee Cullen Branch, 5 December 1956–1 March 1957.
Washington, D.C., Howard University, 3–28 February 1958.
New York, The City College, Great Hall, *The Evolution of Afro-American Artists: 1800–1950*, 15 October–8 November 1967 (catalogue; illus.).
New York, The Studio Museum in Harlem, *Invisible Americans: Black Artists of the Thirites*, 19 November 1968–2 February 1969, cat. no. 20.
Washington, D.C., National Collection of Fine Arts (now NMAA), *William H. Johnson, 1901–1970*, 5 November 1971–9 January 1972, pp. 18, 92, cat. no. 62 (illus.; as *Young Man in a Vest*).
State Department – USIA tour: *Works by William H. Johnson*, May 1972–July 1973 (seven cities in Europe and Africa).

COMMENTS

The painting was formerly known as *Young Man in a Vest*, but it seems clear that an older, white-haired man was intended by the artist.

BIOGRAPHY

Born 18 March 1901, Florence, S.C. Sporadic education; worked to help support family. About 1918 went to New York; worked at odd jobs. 1921–26, studied at National Academy of Design. 1923–26, studied summers with Charles W. Hawthorne at Cape Cod School of Art in Provincetown, Mass.; won various prizes at National Academy school. 1926, to Paris on money raised by Hawthorne. First one-man show at Students and Artists Club, Paris, 1927; second one-man show in Nice, 1928–29. 1929, met Holcha Krake, Danish weaver and ceramist. November 1929, returned to New York; lived in Harlem. 1930, received William E. Harmon Award for Distinguished Achievement among Negroes. Included in *Exhibit of Fine Arts by American Negro Artists*, International House, New

York; in Harmon Foundation *Traveling Art Exhibit of the Work of Negro Artists, 1930*. May 1930, left for Denmark, where he married Holcha Krake. 1930–35, lived in village of Kerteminde. 1931, included in *Exhibition of the Work of Negro Artists*, presented by the Harmon Foundation at The Art Center, New York. 1932, traveled to Tunisia via Germany and France; studied ceramics and did watercolors. 1933, in *Exhibition of Works by Negro Artists*, National Museum of Natural History, Smithsonian Institution. Exhibited in Oslo. Met Edvard Munch. 1937–38, traveled throughout Scandinavia; in three-man exhibition circulated by American Federation of Arts. November 1938, returned to New York. 1939, painted religious works; joined Works Progress Administration/Federal Art Project. 1941, included in *American Negro Art: Nineteenth and Twentieth Centuries*, The Downtown Gallery, New York. 1942, awarded certificate of honor for "distinguished service to America in Art," National Negro Achievement Day. 1943, wife died of cancer. 1946, one-man exhibition at New York Public Library, 135th Street Branch; returned to Denmark. 1947, large exhibition at Kunsthallen, Copenhagen. Traveled to Norway, where he was hospitalized. Returned to New York and entered Central Islip State Hospital, Long Island, with paresis. 1956, Harmon Foundation acquired all of his works. 1956–57, retrospective exhibition at New York Public Library. 1967, Harmon Foundation closed; 1,154 works, together with archival material, given to National Collection of Fine Arts (now NMAA). Died 13 April 1970 in the hospital, Islip.

*

The NMAA owns 177 paintings and a large number of watercolors, gouaches, drawings, and prints by Johnson. The very richness of this holding makes it difficult to choose three or four paintings with which to chart his career. A superior and original talent who was subjected to the multiple pressures of racism, expatriation, and the Great Depression, Johnson was able nevertheless to develop and produce steadily for more than twenty years. Paresis, however, eventually accomplished what social and economic hardship could not, and his mental deterioration was hastened by his wife's death from cancer in 1943. His career was soon ended, and in late 1947 he entered a mental hospital, where he spent the remaining twenty-three years of his life.

After moving to New York from his native South Carolina, Johnson managed to save enough

money in three years to enroll in 1921 in the National Academy of Design, where his teacher was Charles Hawthorne. Hawthorne's unstinting support of the young black was as generous as his instruction was invaluable. The result of his teaching is unmistakably clear in Johnson's *Self-Portrait*, painted about 1924, in which he closely

and successfully emulates Hawthorne's sculptural modeling, strong contrasts of light and shadow, and serious mood.

After graduation in 1926, Johnson was able to go to France (on money raised by Hawthorne) for an intended stay of three years. Although he returned to New York and South Carolina for about six months in 1929–30, he returned to Europe, this time to Denmark, and married a Danish weaver and ceramist whom he had met in France. He lived in Scandinavia until 1938. This period saw the production of the most cosmopolitan of his paintings and prints. Outstanding among these is *Sun Setting, Denmark* (ca. 1930–32). In this painting the earth and sea heave and swell in stunning and irrepressible rhythms. The energized brushstrokes are evidence of Johnson's knowledge of the art of Van Gogh, and the color and distortions speak the language of Chaim Soutine and German and Scandinavian Expressionism. In its imbuing of nature with extreme emotion, the painting is Nordic in character and demonstrates the young American's remarkable facility in absorbing modern art as well as the timeless romanticism of the northern European world view.

In an interview in 1935, Johnson spoke of himself as "one who is at the same time both a primitive and a cultured painter." It is a sentiment that has been shared by many Expressionist artists. In Johnson's case, it acquires additional meaning from the unexpected turn that his subject matter and

style took soon after he returned to the United States in 1938. In his words, his goal was "to give, in simple and stark form, the story of the Negro as he has existed." Religious and rural scenes, musicians, the John Brown history, Lincoln, black women ("Women Builders," he called them), Harlem – these were the subjects that occupied him for the remainder of his tragically brief career.

To express these subjects, Johnson deliberately chose a "primitive" style, that of the untutored or folk painter. Flat, brightly colored shapes with strong contours; an emphasis on repetition and pattern; narrative directness; and a profound and moving dignity were characteristics of this new mode. Occasionally Johnson leavened his sobriety with spirited charm, as in *Café* (1939–40), with its delightful contrast of square torsos with dancing legs (of the furniture as well as the couple). Despite his choice of a primitive style – which was favorably received by the critics – Johnson did not abandon some of the Expressionist devices of which he had shown himself master. In *I Baptize Thee* (ca. 1940), for instance, the exaggerated size of the hands tells the story. In his figure paintings of the thirties, he used distorted heads, not hands (there seldom *were* any hands), but the expressive principle remained the same. The conjunction of this distortion with the methods of folk art cannot entirely disguise the painting's sure sophistication. The sober eloquence of *I Baptize Thee* typifies the high achievement of the art of William H. Johnson.

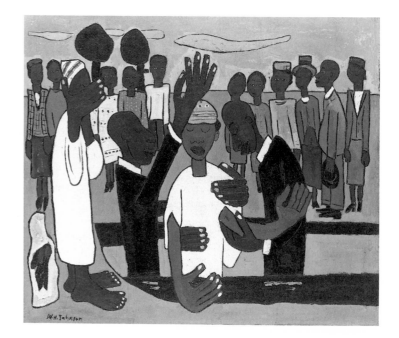

Johnson, *Self-Portrait*, 1921–26, oil on canvas, 75.5 × 60.4 cm (29¾ × 23¾ in.). Gift of the Harmon Foundation, 1967.59.679

Johnson, *Sun Setting, Denmark*, 1930–32, oil on burlap, 52.7 × 64.5 cm (20¾ × 25⅜ in.). Gift of the Harmon Foundation, 1967.59.720

Johnson, *I Baptize Thee*, ca. 1940, oil on burlap, 96.5 × 111.8 cm (38 × 44⅛ in.). Gift of the Harmon Foundation, 1967.59.977

Johnson, *Café*, ca. 1939–40, oil on panel, 92.7 × 72 cm (36½ × 28⅜ in.). Gift of the Harmon Foundation, 1967.59.669

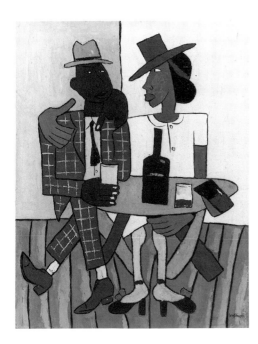

Theodore Roszak
Construction in White 1937
signed on reverse: *Theodore Roszak*
wood, masonite, plastic, acrylic, plexiglass;
203.8 × 203.8 × 46.4 cm (80¼ × 80¼ × 18⅛ in.)
Gift of the artist, 1968.50

PROVENANCE
The artist.

EXHIBITION HISTORY
New York, Whitney Museum of American Art, *The 1930s: Painting and Sculpture in America*, 15 October–1 December 1968, cat. no. 86 (illus.).

REFERENCES
Sam Hunter and John Jacobus, *American Art of the Twentieth Century* (New York, 1972), p. 272, pl. 502.

COMMENTS
Two smaller, almost identical versions of this work exist. The earlier, dated 1935 and made of wood, plastic, and lacquer (18⅜ × 18⅜ × 2⅜ in.), is considered a maquette for the NMAA piece. It was exhibited at the Washburn Gallery, New York, 5 January to 4 February 1978 (*Sculpture and Works on Paper from the 1930s and 1940s*). The second version, dated 1940 and made of wood and plastic (36 × 36 in.), may be considered a reduction of the NMAA piece. It was lent by the Pierre Matisse Gallery, New York, for the Museum of Modern Art exhibition *Abstract Painting and Sculpture in America*, 23 January–25 February 1951 (cat. p. 83 [illus.]).

BIOGRAPHY
Born 1 May 1907, Poznan, Poland. 1909, emigrated with family to Chicago. 1921, became U.S. citizen. Studied at School of the Art Institute of Chicago, 1922–25, 1927–29. Studied with Charles Hawthorne and George Luks, National Academy of Design, New York, 1926; attended Columbia University. 1928, first one-man show (lithographs), Allerton Galleries, Chicago. Received American Traveling Fellowship. 1929–30, Anna Louis Raymond Fellowship for European Study. 1931, Louis Comfort Tiffany Foundation Fellowship. Since 1932, included in annual exhibitions of Whitney Museum of American Art. 1933, included in *A Century of Progress*, Art Institute of Chicago. 1935, one-man show, Nicholas Roerich Museum, New York. 1936, one-man show, Albany (N.Y.) Institute of

History and Art. 1937–39, worked in Easel Division, Works Progress Administration/Federal Art Project, New York. 1938–40, instructor, Design Laboratory, New York. 1940, one-man shows at Julien Levy Gallery and The Artists' Gallery, New York. 1941–56, taught at Sarah Lawrence College, Bronxville, N.Y. Since 1951, annual one-man shows at Pierre Matisse Gallery, New York. 1951, purchase prize for sculpture, first São Paulo Bienal. 1953, designed bell tower and chapel, Massachusetts Institute of Technology, Cambridge. 1956–57, retrospective, Walker Art Center, Minneapolis, and Whitney Museum of American Art. 1958, included in Exposition Universelle et Internationale de Bruxelles; 1960, Venice Biennale. 1964, elected member, National Institute of Arts and Letters. Beginning 1968, on Art Commission of the City of New York. Died 1981.

64

George L.K. Morris
Industrial Landscape 1936–50
signed bottom right: *MORRIS*
oil on canvas, 125.6 × 161.2 cm (49½ × 63½ in.)
Gift of anonymous donor, 1968.49

PROVENANCE
The Downtown Gallery, New York.

EXHIBITION HISTORY
Minneapolis, Minn., Walker Art Center, *Fifth Biennial Purchase Exhibition of Contemporary Painting*, October 1950 (as *Faces of Industry*).
New York, The Downtown Gallery, *George L.K. Morris: Exhibition of New Paintings*, 30 January–17 February 1951, cat. no. 13.
Washington, D.C., Corcoran Gallery of Art, *George L.K. Morris: A Retrospective Exhibition of Paintings and Sculpture, 1930–64*, 1–30 May 1965, cat. no. 11.
Wilkes-Barre, Pa., Sordoni Art Gallery, *Students of the 'Eight': American Masters, ca. 1910–ca. 1960*, 12 April–17 May 1981, cat. no. 32.

COMMENTS
The unusual dating of this canvas reflects the initial research of Melinda Anne Lorenz (8 August 1977, NMAA files) and is exploratory rather than definitive. The earliest known exhibition of this

painting was in 1950 at the Walker Art Center, where a press release announced that the show was a "survey of painting done within the past two years." No date was assigned to the work there or in its next showing at the Downtown Gallery, but in 1965 at the Corcoran Gallery of Art the date was given as 1936, a date also inscribed on the back of the canvas. Two other dates on the back, 1944 and 1950, have been painted over in black. Lorenz observes that the grid/perspective device used in *Industrial Landscape* is not found before 1943. The assumption that the painting was reworked is complicated by·the fact that the surface shows little evidence of it. Lorenz notes that Morris is known to have "worked in series, on separate canvases over a long period of time until the 'final state' satisfied him, and in many cases he dated these final states with beginning and end dates." The proper dating of the canvas is therefore problematic.

BIOGRAPHY
Born 14 November 1905, New York City. Graduated 1924, the Groton School; 1928, Yale University. Studied painting at Art Students League with John Sloan and Kenneth Hayes Miller. Studied in Paris with Fernand Léger and Amédée Ozenfant at the Académie Moderne. Traveled widely, spending a lot of time in Paris. 1933, first one-man exhibition at Valentine Dudensing Gallery. 1935, one-man exhibition at Museum of Living Art, New York. 1937–39, editor of *Plastique*, Paris. 1937–43, editor of *Partisan Review*. 1938, one-man exhibition at Passedoit Gallery, New York. 1946, one-man exhibition at Galerie Colette Allendy, Paris. One-man exhibitions at the Downtown Gallery, New York, 1943, 1944, 1950, 1964, 1967. President, American Abstract Artists, of which he was a founder, 1948–50; exhibited annually with the group. 1965, retrospective exhibition at Corcoran Gallery of Art, Washington, D.C.; awarded Joseph E. Temple Gold Medal, Pennsylvania Academy of the Fine Arts. 1971, retrospective exhibition, Hirschl & Adler Galleries, New York. 1973, awarded Saltus Gold Medal, National Academy of Design. Died 26 June 1975, Stockbridge, Mass.

65

Richard Pousette-Dart
Untitled, ca. 1936–40
unsigned
bronze, 63 × 49.8 × 60.5 cm ($24\frac{3}{4} \times 19\frac{7}{8} \times 23\frac{7}{8}$ in.)
Gift of Mr. and Mrs. Frederic E. Ossorio, 1969.171

PROVENANCE
Acquired from the artist, summer 1960, by Mr. and Mrs. Frederic E. Ossorio.

COMMENTS
The artist's only bronze, the work was cast before 1945 at the Kunstnieder foundry, New York (comments by the artist, 1975, curatorial file memorandum).

BIOGRAPHY
Born 8 June 1916, St. Paul, Minn.; son of artist/writer Nathaniel Pousette-Dart. 1918, moved to Valhalla, N.Y. 1936, studied Bard College, Annandale-on-Hudson, N.Y. 1938–50, lived in New York City. 1941, one-man show, The Artists' Gallery, New York. 1943, 1945, 1946, one-man shows, Willard Gallery, New York. 1947, one-man show, Peggy Guggenheim's Art of This Century gallery, New York. 1948–61, 1964, 1967, one-man exhibitions at Betty Parsons Gallery, New York. 1949–72, included in Whitney Museum of American Art annuals. 1951, in *Abstract Painting and Sculpture in America*, Museum of Modern Art, New York; 1955, *The New Decade*, Whitney Museum and tour; 1961, *American Abstract Expressionists and Imagists*, Solomon R. Guggenheim Museum, New York. 1951, awarded Guggenheim Foundation Fellowship. 1959, received Ford Foundation grant. 1958, moved to Suffern, N.Y., where he still resides. 1959–61, taught at New School for Social Research, New York; 1965, at School of Visual Arts, New York. 1963, retrospective, Whitney Museum of American Art. 1965, included in *New York School: The First Generation: Paintings of the 1940s and 1950s*, Los Angeles County Museum of Art; 1969, *The New American Painting and Sculpture: The First Generation*, Museum of Modern Art. 1969, one-man shows at Washington University, St. Louis, and Museum of Modern Art; 1970, at Obelisk Gallery, Boston.

66

William Zorach
Victory 1944
signed and dated behind lower right leg: *ZORACH 1944*
marble, 107.3 × 39.9 × 31.4 cm ($42\frac{1}{4} \times 15\frac{5}{8} \times 12\frac{3}{8}$ in.)
Gift of Mrs. Susan Morse Hilles, 1971.76

PROVENANCE
Tessim Zorach and Dahlov Ipcar, the artist's children.

EXHIBITION HISTORY
New York, Whitney Museum of American Art, *William Zorach*, 14 October–29 November 1959, p. 63 (illus.; then to Miami, Fla., The Joe and Emily Lowe Art Gallery; The Columbus [Ohio] Gallery of Fine Arts; Cincinnati, Ohio, The Contemporary Arts Center).
New York, Bernard Danenberg Galleries, *Sculpture by William Zorach (1887–1966)*, 1–19 December 1970, pp. 31 (illus.), 48, cat. no. 32.

BIOGRAPHY
Born 28 February 1887, Eurburg, Lithuania. 1891, emigrated with family to Ohio. 1902–6, studied at Cleveland School of Art. 1907–10, studied at Art Students League, New York. To Paris, 1910–11, where he studied with Jacques-Emile Blanche. 1911, exhibited in Salon d'Automne, Paris; returned to Cleveland and worked as lithographer. 1912, first one-man show at Taylor Gallery, Cleveland; married Marguerite Thompson; moved to New York. 1913, included in Armory Show; 1916, *The Forum Exhibition of Modern American Painters*, Anderson Galleries, New York; 1917, Society of Independent Artists annual exhibition. Exhibited with wife at Daniel Gallery, New York, 1915–18; and at Dayton Art Institute, Ohio, 1922. 1917, produced first wood sculptures. 1922, ceased painting. 1924 and 1928, one-man shows at C.W. Kraushaar Galleries, New York. From 1929, taught at Art Students League; 1936–39 and 1950–51, at Columbia University. 1930–31, included in *Painting and Sculpture by Living Americans*, Museum of Modern Art, New York. From 1931, one-man shows at The Downtown Gallery. 1931–32, awarded Logan Medal, International Watercolor Exhibition, Art Institute of Chicago. Sculpture commissions included Radio City Music Hall, New York, 1932; U.S. Post Office, Benjamin Franklin Station, Washington, D.C., 1935–37; Mayo Clinic, Rochester, Minn., 1954; Municipal Court

Building, New York, 1958. 1950 and 1969, retrospectives at Art Students League. 1955–57, vice-president, National Institute of Arts and Letters. 1961, Gold Medal for Sculpture, National Institute of Arts and Letters. 1958, 1961, 1964, included in Pittsburgh International, Carnegie Institute; 1965, *Roots of Abstract Art in America, 1910–1930*, National Collection of Fine Arts (now NMAA), Washington, D.C. Died 15 November 1966, Bath, Maine.

Zorach, *Floating Figure*, 1922, plaster, 21.6 × 81.4 × 15.3 cm (8½ × 32 × 6 in.). Gift of Tessim Zorach and Dahlov Ipcar, 1968.154.3

Zorach, *Figure of a Girl (Dahlov): Innocence*, plaster, 124.8 × 21.6 × 26 cm (49⅛ × 8½ × 10¼ in.). Gift of Tessim Zorach and Dahlov Ipcar, 1968.154.143

Since sculpture in the second half of the twentieth century has taken a radically different turn toward additive, open forms, William Zorach's achievement in direct carving, an approach he did much to re-establish in the years between the two world wars, is less obvious but no less important. The NMAA's collection of 155 of his works in various media – many of them plaster casts – represents all phases of his distinguished career.

The striking sculpture of 1922 *Floating Figure*, here shown as a plaster cast, was first executed in African mahogany. Zorach purchased the wood from an old ship's captain, who had brought it to America some forty years earlier. The irregular shape of the wood was a determining factor in the conception of the piece; Zorach developed its graceful, yet tense, curve into a figure reclining in a trance-like state. He had been swimming a lot at the time, and this, too, was a factor in producing the blend of movement and stasis, or "animated suspension." Less obvious, and perhaps unconscious, was his use of a pose that echoes a traditional type of nude with frontal pelvis, typified by Titian's *Venus with the Lute Player* (the Metropolitan Museum of Art, New York).

First carved in wood about 1928, *Figure of a Girl (Dahlov): Innocence* was cast in bronze (edition of 8) that same year. This plaster version, although patinated to resemble bronze, strongly retains the appearance of wood carving. The completely closed form, totem-like, reflects Zorach's affinity for primitive art. The psychology of the sculpture, however, is sophisticated. The features of the girl

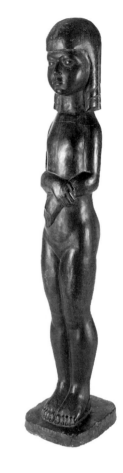

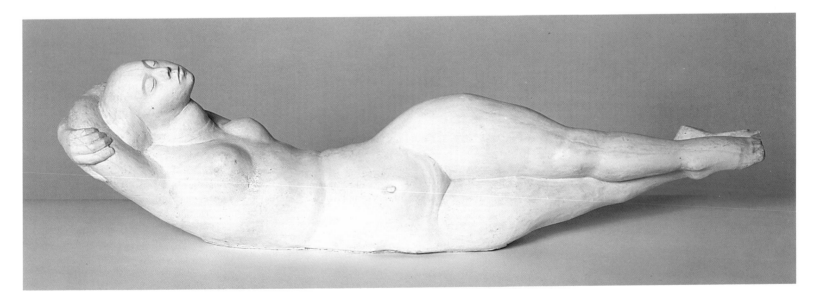

are those of the artist's daughter. Apparently a child, her face and the full shape of her legs already hint at maturity. The contrast between the rectilinear constraint of the arms and head and the bold curve of the legs conveys a compelling sense of becoming, of growth.

The NMAA's half-length marble of *The Artist's Daughter* is a 1946 replica of the damaged original done in 1930. It is one of the most moving of Zorach's portraits of Dahlov, here matured into a young woman. Throughout the artist's work one finds a glowing sensuality combined with a passionate affirmation of family; this sculpture embodies that union. The surfaces have a caressing, palpable finish. The homogeneous broad forms contrast somewhat with the porous character of the stone, which suggests a fragility that transfers to the sitter. Zorach's ability to generalize or idealize from the particular might manifest itself here in the textured base, which suggests, to the fanciful, the body of a mermaid.

In 1937 the artist submitted a plaster model of *Pioneer Family Group* to a Dallas, Texas, competition. Although the jury first selected his entry, public objection to nudity in public sculpture forced it to reconsider; ultimately the commission was awarded to another artist. This group, monumental in scale, summarized the pioneer spirit in terms of the nuclear family, much as Leutze had done in *Westward the Course of Empire* (see p. 56). In broad and forceful masses, Zorach built upward from the kneeling mother and daughter to the son who caps that group to the father who embraces the family, even as he stands slightly apart, a link to the larger world. The sexual roles are clearly assigned: nurturing and education to the woman, generation and protection to the man. If these stereotypes are less fashionable today, they were sincerely embraced by Americans at the time, and in Zorach's formulation they carry conviction.

Andrew Wyeth
Dodges Ridge 1947
signed in script lower left: *Andrew Wyeth*
egg tempera on fiberboard, 104.1 × 121.9 cm
(41 × 48 in.)
Gift of S.C. Johnson & Son, Inc., 1969.47.75

PROVENANCE
Mrs. Ralph Sargent; Mr. R.F. Woolworth; The S.C. Johnson & Son Collection – *ART:USA*.

EXHIBITION HISTORY
ART:USA tours: 1963–64; 1965–67.
Washington, D.C., The White House,
 9–18 January and 1 February–August 1968.
Washington, D.C., Smithsonian Institution,
 September–October 1971.
New Brunswick, N.J., Rutgers University Art
 Gallery, *Realism and Realities: The Other Side of
 American Painting, 1940–1960*, 17 January–
 21 March 1982 (then to Montgomery [Ala.]
 Museum of Fine Arts and College Park,
 University of Maryland Art Gallery).

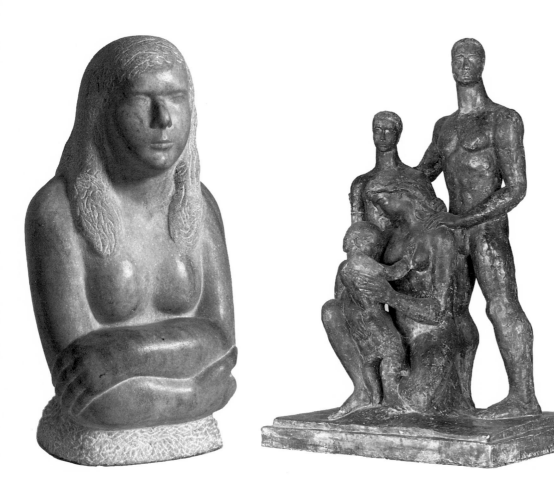

Zorach, *The Artist's Daughter*, 1946, marble, 64.3 × 31.2 × 26.8 cm ($25\frac{1}{4}$ × $12\frac{1}{4}$ × $10\frac{3}{4}$ in.). Gift of Tessim Zorach, 1968.25

Zorach, *Pioneer Family*, plaster, 59.7 × 41.2 × 27.3 cm ($23\frac{1}{2}$ × $16\frac{1}{4}$ × $10\frac{3}{4}$ in.). Gift of Tessim Zorach and Dahlov Ipcar, 1968.154.121

REFERENCES

Lee Nordness (ed.) and Allen S. Weller (text), *ART:USA:NOW* (Lucerne, Switzerland, 1962), p. 315 (illus.).

COMMENTS

The painting has also incorrectly been titled *The Scarecrow*. The shirt and crosspole structure is instead a "scaregull," to keep seagulls from the blueberry fields. Dodges Ridge is located in West Rockport, Maine.

BIOGRAPHY

Born 12 July 1917, Chadds Ford, Pa., the son of illustrator and painter N.C. Wyeth, who instructed him in art. Family divided each year between Chadds Ford and New England, especially Port Clyde, Maine; a habit Wyeth has continued. Ill as a child, he was educated at home. 1932, submitted drawings to an exhibition at Delaware Art Center. 1936, exhibited at Art Alliance, Philadelphia. 1937, first one-man show, Macbeth Gallery, New York; work, mostly watercolors, sold out. 1940, married Betsy James. Learned tempera technique from Peter Hurd, his brother-in-law. 1941, exhibited temperas at Macbeth Gallery. 1943, included in *American Realists and Magic Realists* at Museum of Modern Art, New York. October 1945, accidental death of father. After this tragedy, began to focus more on painting people. 1952, Gold Medal, American Watercolor Society. 1963, first artist to receive Presidential Freedom Award. 1965, Gold Medal, National Institute of Arts and Letters. 1966, major exhibitions, Pennsylvania Academy of the Fine Arts, Baltimore Museum of Art, Whitney Museum of American Art, Art Institute of Chicago. 1970, retrospective, Boston Museum of Fine Arts. 1973, *The Art of Andrew Wyeth*, M.H. de Young Memorial Museum, San Francisco. 1976–77, one-man exhibition, Metropolitan Museum of Art. 1977, first trip to Europe; inducted into French Academy of Fine Arts (only American artist so honored since Sargent). 1978, elected honorary member, Soviet Academy of the Arts. 1984, exhibition of works from his collection, Brandywine River Museum, Chadds Ford. Lives in Chadds Ford.

Paul Cadmus
Bar Italia 1953–55
unsigned
tempera on pressed-wood panel, 95.3 × 115.6 cm ($37\frac{1}{2} \times 45\frac{1}{2}$ in.)
Gift of S.C. Johnson & Son, Inc., 1969.47.54

PROVENANCE

The S.C. Johnson & Son Collection

EXHIBITION HISTORY

New York, Midtown Galleries, 24 October–9 November 1956.
New York, Whitney Museum of American Art, 14 November 1956–6 January 1957.
New York, Midtown Galleries, 11–29 June and 24 September–16 October 1957.
Philadelphia, Pennsylvania Academy of the Fine Arts, 24 January–23 February 1958.
Detroit, The Detroit Institute of Arts, 18 March–13 April 1958.
New York, New York Coliseum, *ART:USA:59*, 3–19 April 1959.
New York, National Institute of Arts and Letters, March 1961.
ART:USA tours: 1963–64; 1965–67.
New York, Whitney Museum of American Art, *Human Concern/Personal Torment*, 14 October–30 November 1969 (then to Berkeley, Calif., University Art Museum, 20 January–1 March 1970).
Oxford, Ohio, Miami University Art Museum, *Paul Cadmus, Yesterday and Today*, March–December 1981, cat. no. 33, p. 76.

REFERENCES

Lee Nordness, "The Johnson Collection," *Art Gallery Magazine*, May 1968, p. 40.
Lincoln Kirstein, *Paul Cadmus* (New York, 1984), pp. 82–85.

BIOGRAPHY

Born 17 December 1904, New York City. 1919–25, studied at National Academy of Design. 1925, won Tiffany Foundation scholarship and entered Joseph Pennell's lithography class at Art Students League. 1928–31, worked as sketch artist and layout designer for New York advertising agency. 1931, traveled in Europe. 1932–33, settled in Mallorca, but traveled in Germany, Austria, Italy. Late 1933, returned to U.S.; joined Public Works of Art Project. 1934, his painting *The Fleet's In!* removed from first PWAP exhibition in Washington; national controversy and scandal. 1936, commissioned by

Treasury Relief Art Project to paint murals for Port Washington (N.Y.) Post Office. 1937, first one-man exhibition at Midtown Galleries, New York. 1938, designed scenery and costumes for ballet *Filling Station* (music by Virgil Thomson and choreography by Lew Christensen). 1940, commissioned by *Life* magazine to paint documentation of violent 1922 labor struggle; work rejected. Began to paint in tempera. 1942, included in *Three American Painters* at Baltimore Museum of Art; 1943, in *Magic Realism* at Museum of Modern Art; 1950, in *American Symbolic Realism* at Institute of Contemporary Art, London. 1952–53, lived in Florence. 1961, awarded grant by National Institute of Arts and Letters. 1974, elected to American Academy and Institute of Arts and Letters. 1979, membership in National Academy of Design. 1981, first major retrospective at Miami University Art Museum, Oxford, Ohio. 1983, one-man exhibition of drawings, Midtown Galleries, New York.

*

From late in 1933 until 1939, Cadmus was involved with the New Deal art projects. The story of the uncomfortable relationship between painter and projects has often been told. In 1934 he had exhibited *The Fleet's In*, which had scandalized the Navy hierarchy and been withdrawn from the first Public Works of Art Project exhibition at the Corcoran Gallery. Notwithstanding that imbroglio, Cadmus was commissioned by the Treasury Relief Art Project (TRAP) in 1936 to paint four works known collectively as *Aspects of Suburban Life* for the Art in the Embassies Program. Cadmus also planned to use these paintings as preliminaries for mural decorations.

One painting in the series, *Main Street*, was separated from its three companions when it was promptly returned by the U.S. Embassy in Ottawa as "unsuitable"; it's steamy sexuality was a reprise of *The Fleet's In*. The three remaining paintings, however – which are now in the NMAA – satirize a wide variety of social types, with only slight sexual innuendo. Seen from left to right as one supposes they were meant to be, *Polo*, *Public Dock*, and *Golf* compositionally form a unifying arch. (It is not clear how *Main Street*, which is about a foot longer than the others, would have fit into this hanging scheme.) The works are also united through the hot red, pink, orange, and yellow hues that are distributed among them.

Cadmus's use of Renaissance compositional devices is at full tide in these paintings. All three depict a worm's eye view, like that found in his

1933 *Y.M.C.A. Locker Room*. The viewpoint emphasizes the frenzied activity of *Polo* and *Public Dock* and the age disparity between the caddy and golfers in *Golf*. It thus also provides a point of view, or commentary. The first two paintings achieve their effect through a contrast of actors and onlookers, while in the quieter and somehow slightly menacing *Golf*, Cadmus seems to suggest varying degrees of impotence among the golfers, in contrast to his ostentatiously virile caddy.

Night in Bologna (1958) shows Cadmus in a much less agitated mood. Borrowing Bologna's famous arcades for his setting, he produces a new perspective on sexual hunger and loneliness. The soldier eyes the prostitute, the prostitute eyes the traveler, and the traveler eyes the soldier. Transitory lust is caught in a timeless environment, emotional need is parcelled into architectural cells. The soldier, beginning and end of this round dance, is spotlighted downstage like the *primo tenore* of a provincial opera company. His constrained and self-conscious pose is strangely affecting. According to Cadmus,

> *the color in the picture was used symbolically — related to the Seven Deadly Sins. The soldier is in red light (Lust), the woman is in golden-yellow light (Money, Avarice), the traveler is in a green light (Envy). Auden once said sometime somewhere that "homosexuality is a form of Envy," it is a desire for the maleness of the male.*

Night in Bologna, an image of lasting resonance and one of Cadmus's major works, combines narrative with a setting that recalls the haunted Italian vistas of Giorgio de Chirico in the second decade of the century.

Cadmus, *Night in Bologna*, 1958, tempera on panel, 128.6 × 89.5 cm (50⅝ × 35¼ in.). Gift of the Sara Roby Foundation, New York

Cadmus, *Aspects of Suburban Life*, 1936, oil and tempera on fiberboard: *Polo*, 80.4 × 116 cm (31⅝ × 45¾ in.); *Public Dock*, 80.5 × 133.7 cm (31⅝ × 52⅝ in.); *Golf*, 80.5 × 127 cm (31¾ × 50 in.). Transfers from the U.S. Department of State, 1978.76.1–3

George Tooker
The Waiting Room 1959
signed lower left: *Tooker*
egg tempera on wood, 61 × 76.2 cm (24 × 30 in.)
Gift of S.C. Johnson & Son, Inc., 1969.47.43

PROVENANCE
The S.C. Johnson & Son Collection – *ART:USA.*

EXHIBITION HISTORY
ART:USA tours: 1963–64; 1965–67.
San Francisco, M.H. de Young Memorial
Museum, *George Tooker: A Twenty-five Year
Survey*, 13 July–2 September 1974, cat. no. 14
(illus.; then to Chicago, Museum of
Contemporary Art; New York, Whitney
Museum of American Art; Indianapolis [Ind.]
Museum of Art).
Los Angeles, David Tunkl Fine Art, *George Tooker*,
15 March–26 April 1980, cat. no. 6 (illus.).
Norfolk, Va., The Chrysler Museum, *American
Figure Painting, 1950–1980*, 16 October–
30 November 1980.
New Brunswick, N.J., Rutgers University Art
Gallery, *Realism and Realities: The Other Side of
American Painting, 1940–1960*, 17 January–
21 March 1982 (then to Montgomery [Ala.]
Museum of Fine Arts; College Park, Md.,
University of Maryland Art Gallery).
Washington, D.C., Hirshhorn Museum and
Sculpture Garden, *Utopian Visions in Modern
Art: Dreams and Nightmares*, 8 December
1983–12 February 1984, cat. no. 110 (illus.).

REFERENCES
Lee Nordness (ed.) and Allen S. Weller (text),
ART:USA:NOW (Lucerne, Switzerland,
1962), p. 351 (illus.).

BIOGRAPHY
Born 5 August 1920, Brooklyn, N.Y. 1938,
graduated from Phillips Academy, Andover,
Mass. 1942, B.A., Harvard University. 1942–43,
U.S. Marine Corps Officers Candidate School.
1943–45, studied at Art Students League, New
York, with Reginald Marsh, Kenneth Hayes
Miller, Harry Sternberg. Under Marsh's
influence, began painting in egg tempera. Used
repetitive figure types at Miller's suggestion;
looked to Sienese and Florentine trecento for
models. 1950, participated in group exhibition at
Edward Hewitt Gallery, New York, with Paul
Cadmus, Jared French, Andrew Wyeth. Traveled
to England. 1954, commissioned to design stage
sets for Gian-Carlo Menotti's *The Saint of Bleeker
Street*. 1960, grant from National Institute of Arts
and Letters. 1965–68, taught at Art Students
League, New York. Included in exhibitions at
Museum of Modern Art, Whitney Museum of
American Art, Metropolitan Museum of Art,
New York; Corcoran Gallery of Art, Washington,
D.C.; and Art Institute of Chicago. 1967,
included in Venice Biennale; retrospective,
Dartmouth College. 1974–75, retrospective, M.H.
de Young Memorial Museum, San Francisco.
1979, included in *From All Walks of Life*, National
Academy of Design. 1983, elected to American
Academy of Arts and Letters. Lives in Hartland, Vt.

Edward Hopper
People in the Sun 1960
signed lower right: *EDWARD HOPPER*
oil on canvas, 102.6 × 153.5 cm (40 × 60 in.)
Gift of S.C. Johnson & Son, Inc., 1969.47.61

PROVENANCE
The S.C. Johnson & Son Collection – *ART:USA*

EXHIBITION HISTORY
ART:USA tours: 1963–64; 1965–67.
Washington, D.C., Smithsonian Institution, Great
Hall, *Smithsonian Institution 125th Anniversary*,
26 September–31 October 1971.
New York, Whitney Museum of American Art,
Edward Hopper: The Art and the Artist,
23 September 1980–18 January 1981, p. 297,
pl. 426 (then to: London, Hayward Gallery,
Arts Council of Great Britain; Amsterdam,
Stedelijk Museum; Düsseldorf, Stadtische
Kunsthalle).

REFERENCES
Lee Nordness (ed.) and Allen S. Weller (text),
ART:USA:NOW (Lucerne, Switzerland,
1962), p. 25 (illus.).

BIOGRAPHY
Born 22 July 1882, Nyack, N.Y. 1899–1900,
studied with Correspondence School of
Illustrating, New York; 1900–1906, at New York
School of Art with Robert Henri, William Merritt
Chase, and Kenneth Hayes Miller. 1906,
illustrator for C.C. Phillips & Company, New
York; traveled to Paris. 1907, London, Holland,
Berlin, Paris; returned to New York and
supported himself with commercial art and
illustration. 1908, included in exhibition at
Harmonie Club building. 1910, included in first
Exhibition of Independent Artists, organized by
Henri and others; traveled to Paris and Spain.
Summered and painted in Gloucester and other
New England spots from 1912. Included in 1913
Armory Show. Moved to 3 Washington Square
North, New York, his home for the rest of his
life. 1915, began etching. 1917, included in first
annual exhibition of American Society of
Independent Artists. 1918, in exhibition of
Chicago Society of Etchers. 1920, first one-man
exhibition at Whitney Studio Club, New York.
1923, showed in four exhibitions, including
Pennsylvania Academy of the Fine Arts and
Brooklyn Museum. 1924, married Josephine
Verstille Nivison; sell-out exhibition of
watercolors at Frank K.M. Rehn Gallery,

New York, enabled him to leave commercial work and paint full time. 1928, made last print. 1930, first summer on Cape Cod, where the Hoppers continued to go from then on. 1931, honorable mention and award, First Baltimore Pan–American Exhibition. 1932, refused membership in National Academy of Design, which had previously rejected his paintings. 1932–33, included in first Whitney Museum of American Art Biennial. 1933, retrospective exhibition at Museum of Modern Art. 1935, Temple Gold Medal, Pennsylvania Academy. 1937, awarded First W.A. Clark Prize and Corcoran Gold Medal, Corcoran Gallery of Art. 1941, extensive summer automobile trip to West Coast; 1943, tour of Mexico. 1945, Logan Art Institute Medal and Honorarium, Art Institute of Chicago. Elected member of National Institute of Arts and Letters. 1950, retrospective exhibition at Whitney Museum of American Art. 1952, one of four artists chosen to represent U.S. in Venice Biennale. 1955, Gold Medal for Painting, National Institute of Arts and Letters in the name of the American Academy of Arts and Letters. 1956, Huntington Hartford Foundation fellowship. 1962, exhibition, *The Complete Graphic Work of Edward Hopper*, Philadelphia Museum of Art. 1964, major retrospective, Whitney Museum of American Art. 1966, Edward MacDowell Medal. Died 15 May 1967, in his studio, New York. Later the same year, his work was featured in the U.S. Exhibition, Bienal de São Paulo 9.

71

Jacob Lawrence
The Library 1960
signed lower right, on book: *Jacob Lawrence 60*
tempera on fiberboard, 60.9 × 75.8 cm
(24 × 29⅞ in.)
Gift of S.C. Johnson & Son, Inc., 1969.47.24

PROVENANCE
The S.C. Johnson & Son Collection – *ART:USA*

EXHIBITION HISTORY
ART:USA tours: 1963–64; 1965–67.
Washington, D.C., The White House, December 1968.
Washington, D.C., National Collection of Fine Arts (now NMAA), *Art by Black Americans: 1930–1950*, 19 October–6 December 1971.

REFERENCES
Joan Adams Mondale, *Politics in Art* (Minneapolis, Minn., 1972), pp. 30 (illus.), 31.

BIOGRAPHY
Born 7 September 1917, Atlantic City, N.J. 1930, moved to New York. 1932, studied Harlem Art Workshop. 1934–37, attended Works Progress Administration classes, 141st Street Studio. 1937–39, studied at American Artists School, New York. 1938, one-man show at Harlem YMCA. 1939, one-man show at Baltimore Museum of Art. 1938–39, worked on WPA/Federal Art Project, Easel Division, New York. 1939, won second prize, American Negro Exposition, Chicago. 1940–42, received Rosenwald Fund Fellowship. 1941, 1943, 1945, one-man shows at The Downtown Gallery, New York. 1946, taught at Black Mountain College, N.C.; awarded Guggenhiem Foundation Fellowship. 1947, 1950, 1953, one-man shows at The Downtown Gallery. 1953, grant from National Institute of Arts and Letters. 1954, included in annual exhibition of Whitney Museum of American Art (and many times thereafter); received Chapelbrook Foundation Fellowship. 1954–56, national secretary, Artists Equity; 1957, president, New York chapter. 1956–71, taught at Pratt Institute, Brooklyn. 1960–61, retrospective exhibition circulated by American Federation of Arts. From 1963, one-man shows at the Terry Dintenfass Gallery, New York. 1965, elected member, National Institute of Arts and Letters. 1965, taught at Brandeis University, Waltham, Mass.; 1966, at New School for Social Research, New York; 1967, at Art Students League, New York; from 1972, at University of Washington, Seattle. 1972, mural commission, state Capitol, Olympia, Wash. 1974–75, retrospective exhibition, Whitney Museum of American Art. 1980 and 1984, murals installed at Howard University, Washington, D.C. Lives in Seattle.

Charles Burchfield
Orion in December 1959
signed with monogram and dated, lower left:
CB/1959
watercolor on paper, 101.6 × 76.2 cm (40 × 30 in.)
Gift of S.C. Johnson & Son, Inc., 1969.47.53

PROVENANCE
S.C. Johnson & Son, Inc.

EXHIBITION HISTORY
Buffalo, N.Y., Charles E. Burchfield Center, State University College at Buffalo, *Burchfield Paintings from Museums and Private Collections from Different Countries*, 16 October 1968–16 February 1969.
Utica, N.Y., Munson-Williams-Proctor Institute, Museum of Art, *The Nature of Charles Burchfield: A Memorial Exhibition*, 9 April–31 May 1970.

REFERENCES
Lee Nordness (ed.) and Allen S. Weller (text), *ART:USA:NOW*, vol. 1 (New York, 1963), p. 65 (illus.).

BIOGRAPHY
Born 9 April 1893, Ashtabula Harbor, Ohio. 1898, after death of father, family moved to Salem, Ohio. 1912–16, attended the Cleveland School of Art (now the Cleveland Institute of Art). 1916, moved to New York to study on scholarship at the National Academy of Design; left after first day. One-man exhibition at Cleveland School of Art. 1918–19, U.S. Army. 1921, moved to Buffalo. 1922, married Bertha L. Kenreich. 1924–28, exhibited with the Montross Gallery, New York. From 1929, devoted full time to painting. 1936, *Fortune* magazine commission to paint Pennsylvania railroad yards and, in 1937, Texas and West Virginia mines. 1944, Chancellor's Medal, University of Buffalo. 1946–48, received honorary degrees from Kenyon College, Harvard University, Hamilton College. 1949–52, taught at University of Minnesota, Art Institute of Buffalo, Ohio University, Buffalo Fine Arts Academy. 1958, elected to the American Academy of Arts and Letters; Gold Medal, 1960. 1963, became art consultant for New York State University College at Buffalo. 1966, Charles Burchfield Center established at State University College at Buffalo. Died 10 January 1967, Buffalo.

Milton Avery
Spring Orchard 1959
signed bottom left: *Milton Avery 1959*
oil on canvas, 127 × 168.3 cm (50 × 66¼ in.)
Gift of S.C. Johnson & Son, Inc., 1969.47.52

PROVENANCE
Grace Borgenicht Gallery, New York;
The S.C. Johnson & Son Collection – *ART:USA.*

EXHIBITION HISTORY
ART:USA tours: 1963–64; 1965–67.
Urbana, University of Illinois, *Contemporary American Painting and Sculpture*, 1966.
Washington, D.C., National Collection of Fine Arts (now NMAA), *Milton Avery*, 12 December 1969–30 January 1970, cat. no. 101 (then to The Brooklyn Museum and the Columbus [Ohio] Gallery of Fine Arts).
Houston, Tex., University of Houston, Sarah Campbell Blaffer Gallery, *Milton Avery: Avery in Mexico and After*, 28 August–4 October 1981 (then to: Mexico City, Museo de Arte Moderno de Mexico; Monterrey, Mexico, Museo de Monterrey; Caracas, Venezuela, El Museo de Bellas Artes; Newport Beach, Calif., Newport Harbor Art Museum).
New York, Whitney Museum of American Art, *Milton Avery*, 15 September–5 December 1982, cat. no. 110, p. 35; N.B. pp. 186–92 (then to: Pittsburgh, Pa., Museum of Art, Carnegie Institute; Fort Worth, Tex., Fort Worth Art Museum; Buffalo, N.Y., Albright-Knox Art Gallery; Denver, Colo., The Denver Art Museum; Minneapolis, Minn., Walker Art Center).

REFERENCES
Lee Nordness (ed.) and Allen S. Weller (text), *ART:USA:NOW* (Lucerne, Switzerland, 1962), p. 69 (illus.).
Hilton Kramer, *Milton Avery: Paintings 1930–1960* (New York, 1962), pl. 2.
Una E. Johnson, *Milton Avery, Prints & Drawings, 1930–1964*, with commemorative essay by Mark Rothko, exh. cat. (New York, 1966).
"The Quiet One," *Time*, 16 March 1970.

BIOGRAPHY
Born 7 March 1885, Sand Bank (later Altmar), N.Y. 1898, family moved to Wilson Station, Conn. 1901–24, worked at blue-collar jobs in manufacturing and as insurance file clerk. Between 1905 and 1918, enrolled in classes at Connecticut League of Art Students, Hartford. 1911, began to list his occupation as artist. 1915, first public exhibition of his works. 1925, moved to New York City. 1926, married Sally Michel, an artist. Attended Art Students League through 1938. Supported by wife, began to paint full time. 1927, showed in Independents' exhibition, New York. 1932, started making drypoint prints. 1938, worked briefly in the Works Progress Administration/Federal Art Project. 1944, first one-man show, at Phillips Memorial Gallery, Washington. 1947, first retrospective exhibition, Durand-Ruel Galleries, New York. 1949, suffered major heart attack. Began making monotypes. 1952, first trip to Europe; retrospective exhibition at the Baltimore Museum of Art. 1960, retrospective at Whitney Museum of American Art. Suffered second heart attack. Died 3 January 1965, New York City.

William Baziotes
Scepter 1960–61
signed lower right: *Baziotes*
oil on canvas, 167.6 × 198.4 cm (66 × 78⅛ in.)
Gift of S.C. Johnson & Son, Inc., 1968.52.15

PROVENANCE
The S.C. Johnson & Son Collection – *ART:USA.*

EXHIBITION HISTORY
ART:USA tours: 1963–64; 1965–67.
New York, The Solomon R. Guggenheim Museum, *William Baziotes: A Memorial Exhibition*, 1965.
Newport Beach, Calif., Newport Harbor Art Museum, *William Baziotes*, Spring 1978 (and subsequent tour).
New York, Marlborough Gallery, *William Baziotes: Late Work, 1946–1962*, February–March 1971 (extensive bibliography in catalogue).

REFERENCES
Lee Nordness (ed.) and Allen S. Weller (text), *ART:USA:NOW* (Lucerne, Switzerland, 1962), p. 263 (illus.).

BIOGRAPHY
Born 11 June 1912, Pittsburgh. Family moved to Reading, Pa., 1913. Worked for stained-glass company about 1931–32. Moved to New York, 1933. Studied with Leon Kroll at the National Academy of Design, 1933–36. Taught for the Works Progress Administration/Federal Art Project, 1936–38. 1938–40 worked on WPA Easel Painting Project. 1941, married Ethel Copstein. 1944, first one-man show at Peggy Guggenheim's Art of This Century gallery, New York. 1948, founded "Subjects of the Artist" school with David Hare, Robert Motherwell, Barnett Newman, Mark Rothko. 1949–52, taught at Brooklyn Museum Art School and New York University; 1950–52, at Museum of Modern Art; 1952–62, at Hunter College, New York. Died 6 June 1963, New York City.

Helen Frankenthaler
Small's Paradise 1964
unsigned
acrylic on canvas, 254 × 237.7 cm (100 × 93⅝ in.)
Gift of George L. Erion, 1967.121

PROVENANCE
George L. Erion.

EXHIBITION HISTORY
New York, Whitney Museum of American Art,
 Helen Frankenthaler (retrospective organized
 with The Museum of Modern Art),
 20 February–6 April 1969 (then to: London,
 Whitechapel Art Gallery; Hannover,
 Germany, Orangerie Herrenhausen; Berlin,
 Kongresshalle).
Jacksonville, Fla., Jacksonville Art Museum,
 Frankenthaler exhibition, mid-November
 1977–30 June 1978 (dates include travel to
 Fort Lauderdale [Fla.] Museum of the Arts and
 Orlando, Fla., Loch Haven Art Center).
Mexico City, Museo del Palacio de Bellas Artes,
 *La pintura de los Estados Unidos de museos de la
 ciudad de Washington*, 15 November–
 31 December 1980.
Munich, Haus der Kunst, *American Painting:
 1930–1980*, 14 November 1981–31 January
 1982.

REFERENCES
Eleanor Munro, *Originals: American Women Artists*
 (New York, 1979), pp. 207–24.
Charlotte Streifer Rubinstein, *American Women
 Artists* (Boston, 1982), pp. 326–30.

BIOGRAPHY
Born 1928, New York City. Studied art with
Rufino Tamayo at the Dalton Schools, New
York; with Paul Feeley at Bennington College,
1945–49. Graduate work in art history at
Columbia University. In 1950 worked with Hans
Hofmann. First one-woman exhibition 1951,
Tibor de Nagy Gallery, New York. That same
year saw Jackson Pollock's work and adopted his
method. In 1952 painted *Mountains and Sea*, first
large stain/soak painting, which influenced Morris
Louis and Kenneth Noland. 1958, married Robert
Motherwell (until 1971). 1959, first prize at the
Paris Biennale. 1960, first retrospective
exhibition, Jewish Museum, New York. In 1962
began using mainly acrylic paints. 1966, one of
four U.S. representatives at Venice Biennale.
1969, retrospective at Whitney Museum of
American Art. 1975, one-woman show at the
Corcoran Gallery of Art, Washington, D.C.
1977–78, one-woman show at Jacksonville Art
Museum.

Morris Louis
Faces 1959
acrylic on canvas, 231.8 × 345.5 cm (91¼ × 136 in.)
Museum purchase from the Vincent Melzac
Collection, 1980.55

PROVENANCE
Vincent Melzac Collection.

EXHIBITION HISTORY
London, Hayward Gallery, The Arts Council of
 Great Britain, *Exhibition of Paintings by Morris
 Louis*, 1974.

BIOGRAPHY
Born Morris Bernstein, 28 November 1912,
Baltimore, Md. 1929–33, studied at Maryland
Institute for the Promotion of the Mechanic Arts
and School of Fine and Practical Arts, Baltimore.
1934, mural commission, Baltimore High School
library. 1935, elected president, Baltimore
Artists' Association. 1936, participated in David
Siqueiros's experimental workshop, New York.
1937–40, Easel Division, Works Progress
Administration/Federal Art Project, New York.
1939, included in *American Art Today*, New York
World's Fair. 1947, moved to Washington, D.C.;
met and worked with Kenneth Noland. From
1948–52, included in Maryland Artists Annual,
Baltimore Museum of Art (won prizes for best
modern work, 1949 and 1950). 1954, included in
Emerging Talent, Kootz Gallery, New York.
1952–62, taught at Washington Workshop
Center. 1953 and 1955, one-man shows at

Louis, *Aurora*, 1958, acrylic on canvas,
237 × 444.3 cm (93¼ × 174⅞ in.). Museum
purchase from the Vincent Melzac Collection,
1980.57

Washington Workshop Center. 1957, first New York one-man show, Martha Jackson Gallery. In 1960, one-man shows at Institute of Contemporary Arts, London; Bennington College, Vt.; and Galleria dell'Ariete, Milan. 1961–62, included in *American Abstract Expressionists and Imagists*, Solomon R. Guggenheim Museum, New York. Also in 1962, included in *Art since 1950*, Seattle World's Fair. Died 7 September 1962, Washington, D.C.

*

The paintings by Louis in the NMAA are all grand in scale. *Faces* (1959) is a monumental 8-by-11 feet, yet it seems almost compact compared to the increased width and greater openness of *Aurora* (1958; about 8-by-14½ feet). A "Veil" painting like *Faces*, *Aurora* is also more varied in its elements. Against a warm white field, Louis places a tripartite form with a central mass framed by two plumes or spouts, which seem to have separated from the center. The central veil is brown and rose at the left, giving way to ochre, yellow, and blue at the right. The flanking plumes are charcoal with brown and a hint of pink (left) and green (right). These plumes appear to be leaking color from their outer edges like showers from a cloud, enhancing the collecting-pool effect of the elliptical shape at the bottom. Louis modifies the static, hieratic implications of the large canvas and dominant forms by shifting the veils off-center, as well as by tilting the forms to the right.

Beta Upsilon, an acrylic of 1960 from the series *Unfurleds* begun that year, is startling in its lateral expansion. Only slightly taller than *Aurora*, its width is more than twenty feet. At this size the painting surface is more like a wall than a discrete unit *on* a wall. In an extraordinary departure from his prior work, and in a reversal of traditional pictorialism, Louis has pushed color to the extreme edges of the painting, leaving the central expanse of unprimed, creamy muslin to command the viewer's attention. This undisturbed area is distantly flanked by rivulets of color, which flow from the side edges (in fact, from *around* the edges) diagonally to the bottom. On the left the colors are generally deeper in tone, including purple, brown, deep green, cranberry, and mahogany; on the right, lighter and brighter, with vivid green, orange, yellow, blue, and hot pink. The latter side seems more aggressive than the left, creating considerable tension across the uninhabited terrain between – which is not perceived as space or surface, but as a passive continuum between the two streams of color. *Beta Upsilon* is about these relationships and is, in that sense, a very straightforward painting. One of the last statements in Louis's too-brief life, it is also representative of perhaps the most radical color painting of mid-century.

Louis, *Beta Upsilon*, 1960, acrylic on canvas, 260.4 × 618.5 cm (102½ × 243½ in.). Museum purchase from the Vincent Melzac Collection, 1980.5.6

Franz Kline
Merce C 1961
unsigned
oil on canvas, 236.2 × 189.4 cm (92 × 68 in.)
Gift of S.C. Johnson & Son, Inc., 1969.47.64

PROVENANCE
The S.C. Johnson & Son Collection – *ART:USA*

EXHIBITION HISTORY
ART:USA tours: 1963–64; 1965–67.
International Art Program, *The Disappearance and
Reappearance of the Image*, 15 November 1968–
31 December 1969 (in Bucharest, Timisoara,
and Cluj, Romania; Bratislava and Prague,
Czechoslovakia; and Brussels).
Mexico City, Museo del Palacio de Bellas Artes,
*La Pintura de los Estados Unidos de museos de la
ciudad de Washington*, 15 November–
31 December 1980.
Edinburgh, Royal Scottish Museum, *Treasures of
the Smithsonian*, 8 August–5 November 1984.

REFERENCES
Lee Nordness (ed.) and Allen S. Weller (text),
ART:USA:NOW (Lucerne, Switzerland,
1962), p. 193 (illus.).
Harry F. Gaugh, *Franz Kline: The Color
Abstractions*, exh. cat. (Washington, D.C.).

BIOGRAPHY
Born 23 May 1910, Wilkes-Barre, Pa. 1917, father
committed suicide. 1919–25, attended Girard
College, Philadelphia (free boarding school for
fatherless boys). Family moved to Lehighton, Pa.,
where Kline attended high school. 1931–32,
Boston University and night classes at Boston Art
Students League. 1935–38, London. February
1938, moved to New York. Married Elizabeth V.
Parsons. 1939–42, painted murals for bars.
1940–44, exhibited in Washington Square art
show. 1942, exhibited in National Academy of
Design's annual exhibition. 1943 and 1944, won
the National Academy's annual S.J. Wallace
Truman Prize. 1946, wife entered Central Islip
State Hospital for mental illness; recurrent
hospitalizations in 1940s and 1950s; painted his
first abstract work. 1947, continued abstraction
with "white paintings." During mid-forties, in
contact with Willem de Kooning and Jackson
Pollock. 1950, first one-man exhibition at Egan
Gallery, New York; also represented in *Young
Painters in U.S. and France* at Sidney Janis Gallery,
New York. 1951, co-organizer of *Ninth Street Show*,
New York. Summer 1952, taught at Black
Mountain College; 1953–54, at Pratt Institute
night school. 1954, one-man show of large
paintings, Institute of Design, Chicago; nine
paintings included in *Twelve Americans*, Museum of

Kline, *Palmerton, Pa.*, 1941, oil on canvas,
53.5 × 69 cm (21 × 27⅛ in.). Museum purchase,
1980.52

Kline, Untitled, 1961, acrylic on canvas,
184.2 × 269.3 cm (72½ × 106 in.). Museum
purchase from the Vincent Melzac Collection,
1980.5.1

Modern Art. Work shown at Venice Biennale. 1957, in *Eight Americans*, Sidney Janis Gallery. Five pictures in *The New American Painting*, circulated in Europe by Museum of Modern Art. 1960, ten works in Venice Biennale; awarded Italian Ministry of Public Instruction Prize; June–July, traveled in Italy, then returned to U.S. Honorable mention, Guggenheim International Award Exhibition. 1961, awarded Flora Mayer Witknowsky Prize at the 64th American Exhibition, Art Institute of Chicago. Rheumatic heart condition discovered. 1962, suffered heart attack in February; unable to paint. Died 13 May 1962, New York.

＊

From 1935 to 1938, at a time when many American painters were employed by the Works Progress Administration, Kline was studying in London. Nevertheless, the Depression-era themes of city and labor that were important to many WPA artists were adopted by Kline as well when he returned to America and settled in New York City. In *Palmerton, Pa.* (1941), the artist depicted a rural equivalent of urban bleakness. Palmerton, near Kline's home town of Wilkes-Barre, is portrayed as a dingy, unprosperous hill town. The palette seems tinged with soot, buildings cluster insubstantially against the hillside, and even the train is deprived of a sense of power or speed. Although it is stretching it to claim to perceive the roots of his mature Abstract Expressionist work in this small painting, Kline does fill the canvas from bottom to top with hills, and spatial recession is sacrificed to an overall surface of broadly painted forms. The painting was exhibited in 1943 at the annual exhibition of the National Academy of Design and won the $300 S.J. Wallace Truman Prize.

Kline's large, gestural, black-and-white canvases established his reputation in 1951 and became synonymous with his name in the public mind. In addition to *Merce C*, the museum owns another major black-and-white Kline of 1961, an untitled work. Using acrylic paints, he produced a complex surface in which white is admixed with gray tones. As always, Kline painted the white as much as the black; it is not black *on* white but a dynamic dialogue between the two. The racing horizontals across the bottom supply a sure sense of gravity, but also refuse to respect the lateral boundaries of the canvas. Their great trajectory pushes the edge outward, and the slightly tilted verticals, like the stack of an ocean liner, add to the sense of speed.

Although he is often thought of as only working in black and white, in fact Kline used color throughout his career. While black-and-white paintings dominated the early fifties, about 1956 color began to reassert itself in his work. Two paintings of modest size in the museum, both from the end of the decade, represent this development. *Blueberry Eyes* (1959–60) reverberates with the deep, saturated blue of the fruit. Simultaneously dynamic and structural like the black-and-white paintings, it differs from them in that the warm color suggests spatial or atmospheric depth. An untitled oil-on-paper painting (ca. 1959), despite its small size ($24 \times 18\frac{1}{4}$ in.), is more complex and agitated in drawing and structure, and more varied and intense in color. Black is used as well for the skeletal shape brushed brashly over the red, green, and yellow field. Both of these late color paintings embody a vein of emotionalism that Kline mined toward the end of his life. Cut short by his death at fifty-one, Kline's developing art is full of confidence, as evidenced by this imposing late work. Like the large, late black-and-whites in the NMAA, Kline's color works suggest enormous potential that was destined to remain unrealized.

Kline, *Blueberry Eyes*, 1959–60, oil on paperboard, 101.7×75.5 cm ($40\frac{1}{8} \times 29\frac{3}{4}$ in.). Gift of the Woodward Foundation, 1982.57

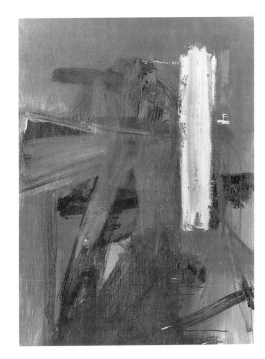

Kline, Untitled, 1959, oil on paper, 61×46.4 cm ($24 \times 18\frac{1}{4}$ in.). Museum purchase, 1971.259

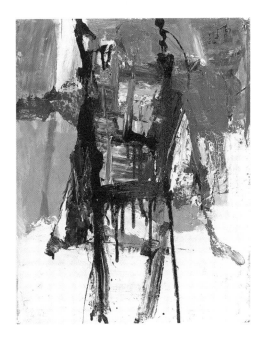

Robert Rauschenberg
Reservoir 1961
unsigned
oil, pencil, fabric, wood, and metal on canvas,
plus two electric clocks, rubber tread wheel, and
spoked wheel rim, 217.2 × 158.7 × 37.4 cm
($85\frac{1}{2} \times 62\frac{1}{2} \times 14\frac{3}{4}$ in.)
Gift of S.C. Johnson & Son, Inc., 1969.47.70

PROVENANCE
Leo Castelli Gallery, New York, 1961;
The S.C. Johnson & Son Collection – *ART:USA.*

EXHIBITION HISTORY
New York, Leo Castelli Gallery, *Robert
 Rauschenberg,* November 1961.
ART:USA tours: 1963–64; 1965–67.
Washington, D.C., National Collection of Fine
 Arts (now NMAA), *Robert Rauschenberg,*
 30 October 1976–2 January 1977, cat. no. 87,
 pp. 1 (illus.), 113 (illus.; then to: New York,
 The Museum of Modern Art; San Francisco
 Museum of Modern Art; Buffalo, N.Y.,
 Albright-Knox Art Gallery; Chicago, The Art
 Institute of Chicago).
Mexico City, Museo del Palacio de Bellas Artes,
 *La Pintura de los Estados Unidos de museos de la
 ciudad de Washington,* 15 November–
 31 December 1980, cat. no. 85, p. 211 (illus.).
Miami, Fla., Center for the Fine Arts, *In Quest of
 Excellence,* 12 January–22 April 1984,
 cat. no. 197.

REFERENCES
Lee Nordness (ed.) and Allen S. Weller (text),
 ART:USA:NOW, (Lucerne, Switzerland,
 1962), p. 431 (illus.).
Andrew Forge, *Rauschenberg* (New York, 1969),
 p. 217 (illus.).
Calvin Tomkins, *Off the Wall: Robert Rauschenberg
 and the Art World of Our Time* (New York,
 1980), pp. 222–23.

BIOGRAPHY
Born 22 October 1925, Port Arthur, Tex.
Christened Milton; adopted name "Bob" in late
1940s; became known as "Robert." 1942, drafted
into U.S. Navy, San Diego. 1945, discharged.
1947, studied at Kansas City Art Institute. 1948,
to Paris; studied at Académie Julian. 1948–49,
studied with Josef and Anni Albers at Black
Mountain College, N.C.; there, met John Cage
and Merce Cunningham. Moved to New York.
Through 1952, studied at Art Students League
with Morris Kantor, then Vaclav Vytlacil. 1951,

included in *Artists Annual* at Ninth Street Gallery,
New York. First one-man exhibition, Betty
Parsons Gallery, New York. 1952, summer
painting at Black Mountain College; Europe in
fall with Cy Twombly. 1954, began long working
relationship with Merce Cunningham and Dance
Company. 1958, one-man show at Leo Castelli
Gallery, New York; invited to show at "Festival
of Two Worlds," Spoleto, Italy. 1958–60, series of
drawings based on Dante's *Inferno.* Included in
1958 Pittsburgh International, Carnegie Institute.
1959, participated in *Documenta,* Kassel, West
Germany; *V Bienal de São Paulo,* Brazil; *Premiere
Biennale de Paris;* and *Sixteen Americans,* Museum of
Modern Art, New York. 1961–62, one-man
exhibitions in Paris, Milan, New York, Los
Angeles; made first lithograph on commission
from Tatyana Grosman of Universal Limited Art
Editions. Won Ohara Museum Prize, *Third
International Biennial Exhibition of Prints,* National
Museum of Modern Art, Tokyo. 1963, major
retrospective exhibition, Jewish Museum, New
York. 1964, major retrospective, Whitechapel
Gallery, London; won grand prize for painting at
Venice Biennale, the third American to do so;
won gold medal at Corcoran Biennial exhibition.
Major retrospective, Walker Art Center,
Minneapolis, Minn. 1967, began collaborating on
lithographs with Gemini G.E.L., printing and
publishing firm, Los Angeles. 1971, built studio
on Captiva Island, Fla. 1973, comprehensive
exhibition of prints, Southern Illinois University,
Carbondale. 1977–78, major retrospective,
National Collection of Fine Arts (now NMAA),
Washington, D.C.

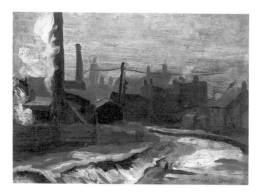

Davis, *Newark,* 1910, oil on wood, 22.5 × 32.6 cm
($8\frac{7}{8} \times 12\frac{7}{8}$ in.). Gift of Nathaly Baum, 1974.73

Stuart Davis
Int'l Surface No. 1 1960
signed lower right: *Stuart Davis*
oil on canvas, 144.8 × 114.3 cm (57 × 45 in.)
Gift of S.C. Johnson & Son, Inc., 1969.47.55

PROVENANCE
The S.C. Johnson & Son Collection – *ART:USA.*

EXHIBITION HISTORY
New York, The Downtown Gallery, 35th
 Anniversary Exhibition, October 1960.
Des Moines, Iowa, Des Moines Art Center,
 February–March 1961.
New York, American Academy of Fine Arts,
 Annual Exhibition, January–February 1962.
Seattle, Wash., Seattle World's Fair, *Art Since
 1950,* April–October, 1962.
Waltham, Mass., Brandeis University, *American
 Art Since 1950,* November–December 1962.
ART:USA tours: 1963–64; 1965–67.

REFERENCES
Lee Nordness (ed.) and Allen S. Weller (text),
 ART:USA:NOW (Lucerne, Switzerland),
 1962, p. 73 (illus.).
James Elliott, "Premiere," *Los Angeles County
 Museum of Art Bulletin,* 14, no. 3 (1962): 3–15,
 fig. 15.

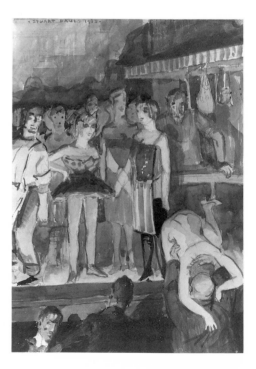

BIOGRAPHY

Born 7 December 1894, Philadelphia. 1910, left school in East Orange, N.J., to study art with Robert Henri in New York (until 1913). Exhibited with the Independents (including Henri, Sloan, Bellows, Hopper, Kent); Armory Show, 1913. 1913–16, magazine covers, drawings, cartoons. 1917, first one-man show, New York. Map-maker during last year of First World War. 1920–23, portrait drawings for *The Dial*. 1925, one-man show at Newark Museum, N.J. 1927, one-man show at The Downtown Gallery, New York, which became his dealer. 1928, Paris. 1929, returned to New York. 1931–32, taught at Art Students League, New York. 1932, mural for Radio City Music Hall; in mural exhibition, Museum of Modern Art, New York. 1933, Federal Art Project (later absorbed into Works Progress Administration). Murals under the WPA, 1933–39. 1938, married Roselle Springer. 1940–50, taught at New School for Social Research, New York. 1941, retrospective exhibition at Cincinnati Modern Art Society and Indiana University. 1945, retrospective exhibition, Museum of Modern Art. 1951, in the first Bienal, São Paulo, Brazil. 1952, Guggenheim Fellowship. 1956, 28th Biennale, Venice. Elected to National Institute of Arts and Letters. 1957 retrospective at Walker Art Center, Minneapolis, Minn. 1958, won Solomon R. Guggenheim Museum International Award; 1960, second Guggenheim International Award. Died 24 June 1964, New York.

Growing up in an artistic environment, Davis was aware from childhood of perhaps the earliest movement of modern art in the United States, the group known as "The Eight." Four of its members – John Sloan, George Luks, Everett Shinn, and William Glackens – worked for Davis's father, art editor of the Philadelphia Press. Stuart thus grew up with the men and their art; when he decided to study painting, it was in the studio of the leader of the group, Robert Henri, and his fellow students included George Bellows.

Newark (1910) is testimony to these beginnings. At the time, Davis had been living in East Orange, N.J., and had just dropped out of high school to study with Henri. His choice of an industrial slum as subject was in line with the gritty urban scenes favored by many of The Eight. Davis was uncompromising in his evocation of the dreary and impersonal jumble of factories and houses, and he employed broad and "messy" brushwork to further the effect.

In 1912 Davis left Henri's school and set up his own studio in Hoboken, N.J. His fresh and mildly bawdy watercolor *Babe La Tour* of that year (the date on the work, 1913, was a later error) records his experience of the mainly working-class nightlife. Stylistically, the work is closest to the illustrations of his friends William Glackens and John Sloan, who arranged for Davis to contribute drawings to the liberal publication *The Masses* this same year. Babe La Tour was the professional name of Jesse M. Lang, a noted burlesque performer. Davis depicts her standing, arms akimbo, and

Davis, *Babe La Tour*, 1912, watercolor and pencil on paper, 38 × 28 cm ($14\frac{15}{16}$ × $11\frac{1}{16}$ in.). Gift of Henry M. Ploch, 1983.84

Davis, *Abstract Landscape*, ca. 1936, oil on canvas, 58.8 × 76.8 cm ($23\frac{1}{8}$ × $30\frac{1}{4}$ in.). Transfer from General Services Administration, 1972.80

Davis, *Composition*, 1935, oil on canvas, 56.4 × 76.5 cm ($22\frac{1}{4}$ × $30\frac{1}{8}$ in.). Transfer from General Services Administration through Evander Childs High School, 1975.83.1

watching while another performer is pulled into the orchestra by an overly enthusiastic patron. The watercolor was one of five accepted for the 1913 Armory Show. Aside from the prestige of inclusion, the exhibition gave Davis his first view of Gauguin, Matisse, and the Cubists, among other European modern artists.

Two Works Progress Administration paintings reveal an aspect of Davis's style in the mid-thirties. *Composition* (1935) and *Abstract Landscape* (ca. 1936) are both deeply indebted to Synthetic Cubism and Cubist collage. The overall flatness of the picture surface, despite some schematic shading and color recessions, is made more emphatic by his "cutting out" or silhouetting of the pictorial unit and contrasting it starkly against a white surface. The device may derive from paintings of about 1930 by Fernand Léger, whose work was exhibited in New York 1931 to 1932.

Abstract Landscape appears to be a compression of images from the New York docks, with suggestions of wharves, buoys, harbor and dock lights, rigging, lading hooks, and the water itself. *Composition*, on the other hand, might be called a "WPA still life," since it includes the shovel and broom of manual labor and the palette and brushes, as well as a sculptured bust, of artistic (also "manual") labor. Artistic labor, needless to say, dominates the image.

In *Memo* (1956), Davis eliminates most concrete references to things in the real world, in contrast to the earlier works discussed or his later *Int'l Surface No. 1* (see p. 172). At the bottom, three letters on their sides are cropped by the edge. They may read *ANY* or be part of a longer word. One of the artist's familiar X-shapes and an irregular figure *8* complete the alphanumerical characters. Symbols and associative meanings are secondary to the development of the pictorial image. The compact color blocks in the bottom left are a foundation for the linear skeleton of light on dark that occupies the rest of the canvas. This evolving, open-work structure, bluntly expressive and upward-tending, represents the more restrained and unornamented side of Davis's art.

Robert Indiana
The Figure Five 1963
signed, titled, and dated on back in stencil:
ROBERT INDIANA USA THE FIGURE FIVE
oil on canvas, 152.4 × 127.2 cm (60 × 50⅛ in.)
Museum purchase, 1984.51

PROVENANCE
The artist.

EXHIBITION HISTORY
Minneapolis, Minn., Walker Art Center, *Richard Stankiewicz – Robert Indiana*, 22 October–24 November 1963 (then to Boston, Institute of Contemporary Art).
Washington, D.C., The White House, *White House Festival of the Arts*, 1965.
Washington, D.C., National Collection of Fine Arts (now NMAA), *Hard-Edge Trend*, 13 July–18 September 1966.

REFERENCES
John W. McCoubrey, *Robert Indiana*, exh. cat. (Philadelphia, 1968), p. 27.
Virginia M. Mecklenburg, *Wood Works: Constructions by Robert Indiana*, exh. cat. (Washington, D.C., 1984), p. 35, fig. 19.

BIOGRAPHY
Born Robert Clark, New Castle, Ind., 13 September 1928. Studied at John Herron School of Art, Indianapolis, 1945–46; at Munson-Williams-Proctor Institute, Utica, N.Y., 1947–48; at Art Institute of Chicago, 1949–53. Scholarship student, Skowhegan (Maine) School of Painting and Sculpture, summer 1953; and University of Edinburgh, Scotland, 1953–54. Moved to New York, 1954. Early work showed influence of Ellsworth Kelly. 1960, first New York showing in group exhibition at Martha Jackson Gallery. Began making assemblages and constructions from junk objects. 1961, began *American Dream* series; included in *The Art of Assemblage*, Museum of Modern Art, New York. 1962, group exhibition at Sidney Janis Gallery, New York. 1963, two-man exhibition with Richard Stankiewicz, Walker Art Center, Minneapolis; included in Dorothy Miller's *Americans, 1963*, Museum of Modern Art; group exhibition at Albright-Knox Art Gallery, Buffalo, N.Y. 1964, group exhibition Tate Gallery, London, and Museum des 20. Jahrhunderts, Vienna. 1965, included in *The New American Realism*, Worcester Art Museum, Mass. 1968, exhibited at Museum of Modern Art, São Paulo, Brazil; *Documenta 4: Internationale Austellung*, Kassel, West Germany; retrospective, Institute of Contemporary Art, University of Pennsylvania, Philadelphia. 1973, exhibition at New York Cultural Center; 1977, University of Texas, Austin. 1978, moved to island of Vinalhaven, Maine. 1984, exhibition at NMAA, *Wood Works*.

Davis, *Memo*, 1956, oil on canvas, 91.4 × 71.1 cm (36 × 28 in.). Gift of the Sara Roby Foundation, New York

Ilya Bolotowsky
Vibrant Reds 1971
signed lower right, in script: *Ilya Bolotowsky/71*
acrylic on canvas, 183.3 × 122.5 cm
($72\frac{1}{8}$ × $48\frac{1}{4}$ in.)
Gift of Ira S. Agress, 1973.33

PROVENANCE
Grace Borgenicht Gallery, New York.

EXHIBITION HISTORY
New York, Whitney Museum of American Art,
Annual Exhibition, 1972, p. 22 (illus.).
New York, The Solomon R. Guggenheim
Museum, *Ilya Bolotowsky*, 1974, cat. no. 56,
pp. 9–32, 86 (illus.).

BIOGRAPHY
Born 1 July 1907, Petrograd, Russia. 1920, with
family fled revolutionary Russia to Istanbul,
Turkey, where 1921–23 attended a French
school. September 1923, family moved to U.S.
1924–30, studied art at National Academy of
Design; painted in a semi-abstract, figurative
style. 1929, became U.S. citizen. Won Louis
Comfort Tiffany Foundation Scholarships, 1929
and 1930. First one-man exhibition, New York,
1930. About this time, saw the Suprematist
abstractions of Malevich in New York. Traveled
in Europe, 1932. 1933, discovered the art of
Mondrian and Miro; painted first abstract works.
1935–41, worked on Works Progress
Administration mural project; his abstract murals
among the first in U.S. 1936, co-founder of
American Abstract Artists. Drafted into U.S.
Army, 1942; served in Alaska, 1943–45 and
collected Eskimo and Northwest Coast Indian art.
Adopted and developed Mondrian's Neo-Plastic
style. 1947, married Meta Cohen. 1946–48, acting
head of art department, Black Mountain College,
N.C. 1948–57, taught at University of Wyoming,
Laramie; 1954–56, Brooklyn College; 1957–65,
State Teachers' College, New Paltz, N.Y. 1961,
began painted columns, cylinders, and posts.
1963–64, taught Hunter College, New York;
1965–71, University of Wisconsin, Whitewater;
1969, University of New Mexico, Albuquerque.
1971, awarded National Institute of Arts and
Letters prize for abstract painting. 1973, awarded
John Simon Guggenheim Memorial Foundation
grant. 1974, retrospective exhibition,
Guggenheim Museum. Died 22 November 1981,
New York City.